# Surrealism and Architecture

*Surrealism and Architecture* examines a long-overlooked topic: the relationship of surrealist thought to architectural theory and practice. This is a historically informed examination of architecture's perceived absence in surrealist thought, surrealist tendencies in the theories and projects of modern architecture and the place of surrealist thought in contemporary design methods and theories.

The book contains a diversity of voices, methodologies, and insights to bring into sharp focus what is often suppressed in the histories of the modernist avant-garde. Of all the artistic modernisms affecting the design of buildings and cities, surrealism has been the least explored, yet the surrealist critiques of rationalism, formalism, and ideology are questions imbedded in the legacy of modern architecture. In these 21 essays, the role of the subconscious, the techniques of defamiliarization, and critiques of social forces affecting the objects, interiors, cities and landscapes of the twentieth century are revealed in the works of Breton, Dali, Aragon, Le Corbusier, Niemeyer, Kiefer. Hejduk, Tschumi, and others ranging across the history of modern art and architecture. This far-ranging collection examines the theoretical, visual, and spatial practices of writers, artists, architects, and urbanists with particular emphasis on the critique of the everyday world-view, offering alternative models of subjectivity, artistic processes and effects, and the imaginative production of meanings in the built world.

With the renewed interest in the surrealist movement, this timely collection of illustrated essays is the first to look at the architectural possibilities of this distinct modern artistic movement that was interdisciplinary and international. This book offers a variety of models for analysis of interdisciplinary artistic practice; it will be of interest to scholars in the histories of modernism, students and practitioners of art and architecture, cultural studies, and urban studies.

**Thomas Mical** completed his doctorate on Nietzschean thought in De Chirico's metaphysical paintings. He completed his professional architecture degree at Harvard, and he has worked as a designer in Tokyo and Chicago, and writes on surrealism, cinema, and urbanism. He has taught and lectured on surrealism in the US, Europe, and the Middle East. Currently he is Assistant Professor of Architectural History and Theory at Carleton University in Ottawa, Canada.

# Surrealism and Architecture

**Edited by Thomas Mical**

Routledge
Taylor & Francis Group

LONDON AND NEW YORK

First published 2005 by Routledge
2 Park Square, Milton Park, Abingdon, Oxon OX14 4RN

Simultaneously published in the USA and Canada
by Routledge
270 Madison Ave, New York, NY 10016

Reprinted 2006

*Routledge is an imprint of the Taylor & Francis Group*

© 2005 Thomas Mical, selection and editorial; individual chapters, the contributors

Typeset in Univers by Wearset Ltd, Boldon, Tyne and Wear
Printed and bound in Great Britain by TJ International, Padstow, Cornwall

*British Library Cataloguing in Publication Data*
A catalogue record for this book is available from the British Library

*Library of Congress Cataloging in Publication Data*
A catalog record for this book has been requested

ISBN 0-415-32519-6 (hbk)
ISBN 0-415-32520-X (pbk)

# Contents

# Contents

# Contributors

**Bryan Dolin** graduated from the University of Oklahoma in 2002 with a Bachelor of Fine Arts in Art, with a thesis on Matta. He is a graduate student in Film and Television Production at the University of Bristol, England.

**Jill Fenton** is a PhD candidate in Cultural Geography at Royal Holloway, University of London. She has two forthcoming publications in geography and surrealism in the journals *Antipode* and *Cultural Geographies* and has contributed to the review of the Paris group of the surrealist movement. She is a member of the London Surrealist Group.

**Krzysztof Fijalkowski** is a Senior Lecturer in Critical Studies, Norwich School of Art and Design, and an Associate Lecturer at the School of World Art Studies, University of East Anglia. Having completed a doctorate on the surrealist object in 1990, his published work has focused above all on an interest in surrealism, including *Surrealism Against the Current: Tracts and Declarations* (Pluto 2001, edited and translated jointly with Michael Richardson). He is also active as a curator, and has participated in exhibitions and publications produced by international surrealist groups in Britain, France, the Czech Republic, Spain and the Netherlands.

**Jacqueline Gargus** is an Associate Professor of Architecture at the Ohio State University, where she teaches architectural history, theory and design. She has previously taught at the Technical University, Vienna and at Harvard University. A graduate of Wellesley College and the University of Pennsylvania, Gargus has received numerous academic and design awards, including Senior Fulbright Fellowships to both Germany and Austria. She is author of many articles and translations, as well as a book on a formal approach to architecture, *Ideas of Order*.

**Alexander Gorlin** AIA is principal of Alexander Gorlin Architects in New York. A graduate of the Cooper Union and the Yale School of Architecture, he is a Fellow of the American Academy in Rome as a winner of the Rome Prize 1984. His books include the monograph *Alexander Gorlin: Buildings and Projects* and *The New American Townhouse*. He has written for *Architectural*

*Record*, *The New York Times*, and the *Princeton Landscape Journal*. His practice includes residences, affordable housing, synagogues, apartment towers and community centers, and he has won a number of AIA Awards for Excellence in Design.

**Kari Jormakka** studied architecture and philosophy in Otaniemi University of Technology, Helsinki University and Tampere University of Technology in Finland (M.Arch. 1985, Ph.D. 1991, Habilitation 1993). He has taught at several international universities, including the Bauhaus University in Weimar, Ohio State University, University of Illinois at Chicago, and Vienna University of Technology, where he currently is Professor of Architectural Theory. He has published nine books and numerous articles on architecture.

**Nadir Lahiji** holds a Ph.D. in architecture from the University of Pennsylvania. He is the co-editor of the critical anthology titled *Plumbing: Sounding Modern Architecture*, Princeton Architectural Press, 1997. He has taught in a number of universities, including the University of Pennsylvania, Pratt Institute, University of Cincinnati, Georgia Tech, and the Lebanese American University.

**Jean La Marche** is an Associate Professor of the Department of Architecture, University at Buffalo-SUNY and was Acting Chair, 2002–2003. Dr La Marche is the author of *The Familiar and the Unfamiliar in Twentieth-Century Architecture* and has published in journals, including *Environment and Planning B*, and written several articles in the *Encyclopedia of Twentieth Century Architecture*. He has lectured and participated in workshops, seminars, and juries at the Architektskolen in Aarhus in Denmark, the Akademie der Künste in Berlin, as well as several universities in North America. Dr La Marche has also received awards for his architecture and design work, some of which has been exhibited in the National Architectural Museum in Washington, D.C.

**Silvano Levy** has published extensively on surrealism, with studies on René Magritte, E.L.T. Mesens and Paul Nougé. His research on the surrealist group in England began with a film on Conroy Maddox and the book *Conroy Maddox: Surreal Enigmas* (1995), while a wider interest in the movement led to the publication of *Surrealism: Surrealist Visuality* (1996, 1997) as well as *Surrealism* (2000). Levy has curated national touring exhibitions of the work of Maddox and Desmond Morris, and published a monograph on the latter entitled *Desmond Morris: 50 Years of Surrealism* (1997), which was followed by the enlarged re-edition *Desmond Morris: Naked Surrealism* (1999) and *Desmond Morris: Analytical Catalogue Raisonné 1944–2000* (2001). Silvano

Levy's major monograph on Maddox, *The Scandalous Eye. The Surrealism of Conroy Maddox*, was published by Liverpool University Press in 2003. Dr Levy is a senior lecturer at Keele University, England.

**Lewis.Tsurumaki.Lewis** (LTL) is an architecture and research partnership founded in 1993, located in New York City, and dedicated to exploring the inventive possibilities of architecture through a close examination of the conventional and the overlooked. Lewis Paul Lewis is a fellow of the American Academy in Rome, as the winner of the 1998–1999 Mercedes T. Bass Rome Prize in Architecture. He is a faculty member at Princeton University School of Architecture. Marc Tsurumaki is an Adjunct Professor of Architecture at Parsons School of Design and a Visiting Critic at Columbia University. David J. Lewis is the Director of the M.Arch Program at Parsons School of Design.

**Fernando Magallanes** is Associate Professor of Landscape at North Carolina State University. His travel, research, drawings and competition entries have advanced his search for historical and cultural influences impacting designers and designs, and he is pioneering the field of landscape surrealism.

**Thomas Mical** is Assistant Professor of Architecture at Carleton University. He completed his professional Master in Architecture at Harvard, and a doctorate on Nietzschean thought in de Chirico's metaphysical paintings. He has practiced and taught architectural design theory internationally, and is currently doing work on stealth landscapes and the phenomenology of blurred space.

**Spyros Papapetros** completed an interdisciplinary doctoral program in the theory and historiography of art and architecture at the University of California at Berkeley in 2001 and is now a faculty member in the School of Architecture at Princeton University. He has been a Getty postdoctoral fellow affiliated with the Warburg Institute and a visiting fellow at the Canadian Centre for Architecture. He is currently completing a book titled *On the Animation of the Inorganic: Art, Architecture, History (A book of modern wonders)*.

**Stephen Phillips** is a Ph.D. Candidate in the History and Theory Department at Princeton University School of Architecture. He is the principal designer in the California-based firm of Stephen Phillips Architects (SPARCHS) and teaches at the University of California, Berkeley, and the Southern California Institute of Architecture (SCI-Arc). He received his B.A. with Distinction in Architecture from Yale University, and his M.Arch. with the Paul Phillipe Cret

Award for best studio thesis from the University of Pennsylvania. His current architecture projects explore continuous tension shell technology in residential design.

**David Pinder** is Lecturer in Geography at Queen Mary, University of London. His research focuses on urbanism and the politics of urban space. He is particularly interested in utopian visions of cities in relation to histories of modernist urbanism, including the interventions of the surrealists and situationists, and in terms of the possibilities of a revived utopianism today. Among his publications is the forthcoming book *Visions of the City: Utopianism, Power and Politics in Twentieth-Century Urbanism* (Edinburgh University Press, 2005).

**Gray Read** is an Assistant Professor at the School of Architecture, Florida International University, in Miami. She holds a doctorate in Architecture from the University of Pennsylvania and has written on literary allusions in Le Corbusier's design. Her current work concerns theatre and architecture in 1920s Paris, in particular the spatial improvisation of *Art et Action*, an experimental theatre company. Her book on the topic, *Quintessential Theatre/Architectural Improvisation*, is in process.

**Raymond Spiteri** is Lecturer in Art History at Victoria University of Wellington, New Zealand. His research focuses on the culture and politics of surrealism. He is co-editor of *Surrealism, Culture and Politics* (Ashgate, 2003), and is currently working on a study of the Breton-Bataille polemic, among other diversions.

**M. Stone-Richards** is Visiting Assistant Professor in English and Comparative Literature, Stonehill College. Working between philosophical poetics and modern/contemporary art cultural studies, he has published widely in English and French on surrealism, Debord, and phenomenology and psychoanalysis. He has most recently finished a book of essays on *Surrealism and the Work of Culture* and is currently preparing a set of studies on *Time and Aggressivity* (Akerman, de Keersmaeker, Abramovic, Prynne, Lachenman and Blanchot).

**Dickran Tashjian** is Professor Emeritus of Art History at the University of California, Irvine. He has written extensively on Cornell in *Joseph Cornell: Gifts of Desire* (Miami: Grassfield Press, 1992) and *A Boatload of Madmen: Surrealism and the American Avant-Garde, 1920–1950* (New York: Thames and Hudson, 1995).

**Richard J. Williams** is Lecturer in History of Art at the University of Edinburgh. He studied at Goldsmiths' College London, and the University of Manchester, and previously taught art history at John Moores University, Liverpool. His first book, *After Modern Sculpture* (Manchester, 2000), concerned the critical discourse around sculpture in the 1960s, particularly in New York. His current research concerns critical responses to the modern city. His new book, on the contemporary English city, is due to appear in 2004.

**James Williamson** studied architectural history and theory at the Architectural Association and received his MA degree at Cranbrook Academy of Art. He has won numerous awards and honors, including a First Place in the Shinkenchiku Competition and two grants from the Graham Foundation, and has been published in numerous professional journals. Williamson has taught at several American universities, including Harvard, Columbia, Cornell, and The Cooper Union. Presently he is working on *SAVED!: Architecture and Religion: the Continuity of the Religious Imagination in Contemporary Architecture* (with Renata Hejduk) and *The Suicide Masques*, a collection of essays on the architect John Hejduk.

# Acknowledgments

The editor is grateful to Michelle Green for patient guidance through the long process of forming this anthology, and to Caroline Mallinder for enthusiastic support of the project and commissioning the anthology.

Many authors contributed, and there are many more who unfortunately could not be included in this work. The book began humbly as a moderated panel of the Society of Architectural Historians annual conference in Toronto in 2001, and has grown to include a large number of scholars offering diverse topics, methodologies, and insights developed over many decades. The editor wishes to thank each of the contributors for their sustained efforts to bring the discussion of surrealist thought and practice in modern architecture into focus, and to establish a solid basis for further analysis and insight in this under-explored area.

The completion of this anthology was funded by a research grant from the University of Oklahoma Vice-President for Research.

The editor is grateful for the following publishers and authors for permissions to reprint material in the collection: an earlier version of Nadir Lahiji's " . . . The gift of time: Le Corbusier reading Bataille" originally appeared as "The gift of the open hand: Le Corbusier reading Georges Bataille's 'La Part Maudite' ", in *The Journal of Architectural Education* (September 1996) vol. 50, no. 1, pp. 50–67. An earlier version of Alexander Gorlin's "The ghost in the machine" originally appeared as "The ghost in the machine: surrealism in the work of Le Corbusier", in *Perspecta: The Yale Journal of Architecture* vol. 18, 1982. An earlier version of Jean La Marche's "Surrealism's unexplored possibilities in architecture" originally appeared as "The negotiated construction project", in *Intersight IV*, SUNY-Buffalo.

# Illustration credits

The authors and publishers gratefully acknowledge the following for permission to reproduce material in the book. Every effort has been made to contact copyright holders for their permission to reprint material. The publishers would be grateful to hear from any copyright holder who is not acknowledged here and will undertake to rectify any errors or omissions in future editions of the book.

# Chapter 1

# Introduction

*Thomas Mical*

Architecture, as materialized desires achieved through subjective imagination and thoughtful cultural production, polymorphously draws from sources outside its own discrete disciplinary boundaries. Much of the premodern history of architectural theory can be read as the search to identify exactly that which distinguishes architecture from mere construction, and the shifting answers always lie outside utilitarian making. Architecture, even modern architecture, as an incomplete discipline incapable of autonomy or completion, is open to these associations, and it is doubtful if the sacrificial tropes on classical temples, or the original impulse to make these temples, were entirely rational or discipline-specific.[1] The science of geometry and musical harmony, and the artistic practices of painting and sculpture, in particular, became fetishes in the design and construction of classical and neo-classical architecture, as if the desires informing architecture necessarily precede and exceed their material boundaries. These "supplements" to premodern architectural construction are in effect an expression of a necessary fundamental lack in architecture, masking the incompleteness of mere building with aesthetically instrumentalized materialization of desires. Premodern architectural theory seeks to describe and rationalize these "others" of building. It is often the case that for architecture to exist, it must paradoxically stage the re-emergence of its own excluded desires. In each work of architecture, the utilitarian needs can be satisfied, but the desire cannot: the "blind spot" of desire is the longing for a lost origin.[2] Hence the obsession over the history of architecture in premodern architectural theory – in this view, architectural history cannot be the history of style, but the history of lacks, desires, supplements, and new desires.

1

The prevalent assumption that modern architecture's dehistoricized formations were overtly political statements, positing instrumental reason over bourgeoisie desires reconfigured as ideology, appears to suppress the excesses of architectural desire in favor of austere constructions under the guise of rationalism. Modern architecture, erupting from the challenge of industrialization to the neo-classical order, is therefore often read as an instrumental language of technologically described voids. Yet even in its extreme ascetic manifestations, works of modern architecture could not overcome the tendency to draw upon the fetish of art and technology, specifically the contemporaneous movements of modern art. Expressionism, Futurism, Constructivism, and Cubism (Purism) resonate within modern architecture, and are now inseparable from the historiography of the modern.[3] The least-examined artistic practice informing modern architecture is surrealism: architecture as the "blind spot" in surrealist theory and practice, and surrealist thought is the "dark secret" of much modernist architecture – they are mutually understated or absent in most scholarship.[4] To address the status of desire in modern architecture, much can be learned from a critical examination of architecture's haunting presence in surrealist thought, surrealist tendencies in the theories and projects of modern architecture, and the theoretical and methodological concerns of surrealism informing past and future urban architecture. The essays collected in this anthology attempt to describe that which lies outside of the instrumental construction logic in modern architecture, and after.

Surrealism, as a movement, was almost always interdisciplinary; it was originally an avant-garde movement that eventually crossed cultures, contexts, and media forms, much like modern architecture's emergence. To date, the status of architecture within surrealist thought remains undecidable – of the creative arts, it is only architecture that remains as the unfulfilled promise of surrealist thought. The dialogue between material representations and the (incomplete) subjectivity of the modern world, a dialogue of forms and spaces where irrational meanings and experiences are produced, lies at the heart of any surrealist architectural project: "their paintings and poems were characterized by images of searching and finding, of veiling and revealing, of presence and absence, of thresholds and passages, in a surrealized universe in which there were no clear boundaries or fixed identities."[5]

Modern architecture in the interwar period overtly drew upon rationalism in the form of instrumental logic, *mono*-functionalism to order the inherited world, and objective fact over subjective effect. The radical shift in the philosophical and political grounding of the spaces of life in the interwar period of "high modernism" are rarely made more explicit than in surrealism's critique of this dominant rationalist orthodoxy. Within the diverse

spatial practices of the surrealist group, such as "objective chance," the goal is explicit:

> All the logical principles, having been routed, will bring [each person] the strength of that objective chance which makes a mockery of what would have seemed most probable. Everything humans might want to know is written upon this screen in phosphorescent letters, in letters of desire.[6]

All of the topics addressed in contemporary surrealist scholarship have a place in architectural thought, as the rethinking of craft, materiality, symbolism, imagery, social order, domesticity, urbanism, technologies, and divided cultures and contexts.[7]

There is not one surrealism, but many, and the significant variance between surrealist practices may function as an under-explored and expansive conceptual territory for architectural thought. Before functionalism, before formalism, there is thought forming in response to the possibilities of architecture to encode desires. For this reason, Breton's claim that surrealism is simply "pure psychic automatism, by which one intends to express verbally, in writing, or by any other method, the real functioning of the mind" is an architectural premise.[8] When he adds "surrealism is based on the belief in the superior reality of certain forms of association heretofore neglected, in the omnipotence of dreams, in the undirected play of thought,"[9] he is pointing towards techniques of representation that escape the Weberian cage of determinism. It is exactly these certain forms of association liberated in automatic processes that are excluded in modernist-rationalist architectural rhetoric, and it is the very same excluded associations that return to haunt the sites of rationalism, as a repressed "other." Psychic automatism allows the author (or artist) to engage the "real" through the unseen movements of the imagination, a method that explicitly rejects the mechanisms of control, taste, calculation, and judgment. The automatic process erases the notion of the integrated rational subject in favor of its others – this tendency towards the multiplicity of voices expands the subject beyond the processes of reason – to the point of rendering the author as a "mere recording instrument"[10] for the imaginary. Breton offers the possibility of surrealism as a means of recovering architecture from the symbolic, and points towards diverse artistic practices proceeding historically from the written to the visual and into the spatial, although his understanding of the spatial is often blinded by the primacy of the (surrealist) object.

Consider Breton's 1935 Prague lecture "Surrealist Situation of the Object," which follows Hegel in situating architecture as the poorest of the

arts, poetry the richest.[11] For Hegel, architecture is the most base of the arts, made of earth, timber, and stone; the stones are outside art, and the distinction between architecture and building is slight. Breton's vision of surrealistic practices drew upon the role of estrangement in art, the slippage between form and content Shlovsky described as defamiliarization: "by making the familiar strange, we recover the sensation of life . . . art exists to make one feel things, to make the stone stony."[12] Jameson describes this defamiliarization as "a way of restoring conscious experience, of breaking through deadening and mechanical habits of conduct, and allowing us to be reborn to the world in its existential freshness and horror."[13] Vidler follows this logic in describing a "spatial estrangement" dominant in the sociology of modern urbanism.[14]

We would expect that Breton would see the phenomenal stoniness of stone as the point of sensual estrangement that could draw architecture up from building towards poetry, overcoming a lack. But Breton, in the same lecture, cites the modernism of the Art Nouveau movement as the first among all the arts to move towards surrealism by excluding the external world and turning towards the inner world of consciousness, of expressing the inner world visually, citing Dalí:

> No collective effort has managed to create a world of dreams as pure and disturbing as these art nouveau buildings, which by themselves constitute, on the very fringe of architecture, true realizations of solidified desires, in which the most violent and cruel automatism painfully betrays a hatred of reality and a need for refuge in an ideal world similar to those in a childhood neurosis.[15]

Breton was incapable of understanding the design/making/meaning of architecture as Dalí could, and explained the "concrete irrationality" of modern architecture in the superficial exception of a wavy wall of Le Corbusier's Swiss Pavilion of the Cité Universitaire in Paris. Breton was blind to the surrealist tendencies in this phase of the controversial modernist's work: Corbu's collection of "objets a reaction poétique," and use of object-types in this pavilion and other projects, is very close to Breton's terminology and concerns.[16] Breton noted surrealist sculptures often incorporate the found object, because "in it alone we can recognize the marvelous precipitate of desire" where "chance is the form making manifest the exterior necessity which traces its path in the human unconscious."[17] We may see an example of this "awakening" in the imagery of Le Corbusier.[18] Many of the avatars of surrealist imagery are in his work, as if illustrating a citation by Cocteau: "in

the countryside we saw two screens and a chair. It was the opposite of a ruin ... pieces of a future palace."[19] The surrealist precursor Giorgio de Chirico once wrote: "and yet, so far as I know, no one attributes to furniture the power to awaken in us ideas of an altogether peculiar strangeness."[20] The strangeness of the sentient object figures significantly in de Chirico's metaphysical interiors and exteriors, and the defamiliarized technical object in space recurs as a fundamental formal strategy for modern architecture, one can easily imagine Hans Bellmer's *poupee* at home in a Corbusian villa, a objectified body of fragments inhabiting a sanitized "machine for living." Le Corbusier's modular man and the ascetic sensuality of the modernist villa historically follow the instrumentalized fetish of the irregular body informing modernist functionalism and construction. Yet the irregular surrealist body of semiotic impulses, banished from the prismatic rationalist volumes of an industrialized world, returns as its uncanny guest.

Can the Bretonian categorization of surrealist objects apply to spaces?[21] Rarely, because architecture is procedurally distinct from sculpture, though for Breton the distinction is malleable. Breton came closest to imagining a surrealist architecture in his references to Dalí's paranoiac-critical double-image, "a spontaneous method of irrational knowledge based upon the critical and systematic objectification of delirious associations and interpretations."[22] Breton described the ability of the surrealist object to fuse two distinct images to produce "uninterrupted successions of latencies" from the "hidden real" of their origins, a technique common to architectural theory.[23]

Desire forms and informs architecture, even modern architecture, where the technology of crafted details (fragments) are submerged into construction. The details of modern architecture, objectified markers of desire, like the sculptures inhabiting classical temples, register constellations of associative meanings. Thus modern architecture's fetish of technology, as a supplement, marks the suppression of irrational desires, of ornament and historicism, and tends towards an architecture of blank walls within a totalizing oceanic space. The medium of modern architecture is not stone, but space. Architecture must remain void to function and incomplete to produce effects, because architecture can only be completed in the spatial immersion of the subject. The construct of the body-in-space, the consistent epistemological basis for premodern architectural pleasure and meaning, is inherently lacking in most modern architecture. The semiotic impulses of the self, fluid and formless, move easily through the formless continuity of modern domestic spaces and urban contexts. This is the locus of the formless in architecture – modernism's space without qualities, emptied of inner experience, the vaporous undecipherable spaces of the "in-between" where

the paradoxes of interiority and exteriority are to be resolved by the perceptive subject.

Any thorough description of surrealist space is absent from the primary works, though the question figures significantly in the essays of this anthology. There are as many surrealist spaces as there are surrealist works, though many of the paintings of surrealism proper sustain an apparent neo-Victorian *ether*space – such as the painted landscapes of Magritte, Tanguy, Míro, and Dalí – where the lost content of partial objects lingers as an irrational latency, rich with associations and potential effects, the register of all that is suppressed in the spaces of modern architecture, as in the disquieting urbanism of Giorgio de Chirico's metaphysical paintings. It is within the metaphysical paintings that the crisis of modernist representation investigated by the surrealists is first played out architecturally, as these haunted exilic spaces clothe modern spaces in the dream language of the classical, de Chirico painted architecture as the site of subjective (uncanny) effects produced by the fusion of decontextualized fragments, human or spatial.[24] This suturing of objects within derelict spaces invokes an overlap of the lost content of objects. Max Ernst's over-paintings follow from this technique, which Krauss equates with the Freudian wax tablet and "to the mental operations of memory and thus to that part of his topological model given over to the unconscious."[25] We can see an immediate correspondence to modernist architectural thought, where the selective process of negation of a context, argued along the lines of functionalism, efficiency, hygiene, or clarity begin in the mind of the designer. What we learn from the knowledge of the under-painting is the persistence of those excluded elements (literal objects or objectified desires) within a hidden landscape beneath or behind the optical – the operative negation inherent in much avant-garde modern architecture. The dilemmas of pictorial space in surrealist representations (the formless in-between where the paradoxes and conflicts of interiority/exteriority are suspended visually as indeterminacy) reappear in many contemporaneous works of modern architecture – for example, the early houses of Mies van der Rohe or Louis Barragan. In these projects and those works described within this anthology, it appears that surrealist representation harbors not only an optical unconscious but also a spatial unconscious.

The task of architecture is to give form to the transgressive and formless desires of the subject, often reduced in modern architecture to voids within rationalized frames or thin membranes. The voided spaces of modernity are frequently reductivist, abstracted, hygienic, homogenized, and continuous – designed to suppress the individuated, coarse, theatrical, perverse, or the traumatic.

For surrealism, and by extension surrealist architecture, reason shrivels in the representation of all that is irrational that tugs upon the desiring subject. Surrealist thought offers a repeatable process of experiencing and representing space that is other than rational, yet grounded in individual subjectivity. Surrealism does not intend to disfigure the subject, but to substantiate perception, often through

> a marvelous faculty of attaining two widely separate realities without departing from the realm of our experience, of bringing them together and drawing a spark from their contact; of gathering within reach of our senses abstract figures endowed with the same intensity, the same relief as other figures; and of disorienting us in our own memory . . .[26]

Surrealist space has the possibility of overcoming rationalism to bring the oneiric "underworld" to the surface of perception. Michael Hays has argued correctly that individuals, "by virtue of their complex and multiple historical and cultural affiliations, always exceed the subjectivities constructed by architecture."[27] David Lomas, paraphrasing Blanchot, states: "the subject of surrealism is defined by the coordinates of a space of multiplicity" troping the interiority of the self and the interiority of (architectural) space.[28] Events are located in spaces colored by perception; even the pristine instrumental voids of modern architecture, when occupied, are the territories of overlaps and slippages, condensations and displacements that challenge the rational-mechanical model of subjectivity. If the design of a transparently rational and optimal architecture begs the eruption of that which it has excluded, then the promise and lessons of surrealist architecture in our late modern world is an urgent concern.

This anthology is organized topically, not necessarily chronologically. The first section addresses the possibilities of architectural thought and practice in the primary sources of surrealism, beginning with Krzysztof Fijalkowski's insightful examination of the domestic spaces in the lives of the surrealists. Gray Read turns to Aragon's writings to contrast the role of light and darkness between theater and the city. The meanings of the autobiographical spaces of Joseph Cornell are Dickran Tashjian's contribution. Bryan Dolin looks at the spatial paintings of Latin American surrealist (and former architect) Matta, followed by Silvano Levy's examination of Magritte's transformation of Albertian space in the works of British surrealist Conroy Maddox. This section concludes with Spyros Papapetros's theories of the history and potential of the organic to challenge the fundamentals of architecture from Dalí.

Within modern architecture lies a secret history of surrealist thought, and differential efforts towards this project form the second section of this anthology. A revised version of Alexander Gorlin's seminal essay on the surrealist imagery in the works of Le Corbusier is reprinted here, as is Nadir Lahiji's sustained examination of Bataille's influence upon Corbusier. Surrealist thought in the speculative biotechnical architecture proposed by Kiesler is the topic of Stephen Phillips's chapter. Two Italian villas, the "il Girasole" and the Casa Malaparte are explored by Lewis.Tsurumaki.Lewis and Jacqueline Gargus, respectively.

Paris was the urban tableux for the surrealist experiment, and the third group of essays establish the question of surrealist space as an urban necessity. David Pinder's chapter clarifies the dialogue of surrealism and modernity in the urban contexts of Le Corbusier's thinking, while Raymond Spiteri's text examines the role of monuments in the surrealist critique of the city's symbolic function. Urban projections in Paris of recent surrealists are examined by Jill Fenton. Fernando Magallanes provides a seminal essay in the emergent field of surrealist landscape studies, and Richard J. Williams critiques the surrealist intentions and effects in Niemeyer's built Brasília. The section concludes with a provocative intellectual history of surrealist architecture and urbanism through the contemporary by Michael Stone-Richards.

The final section addresses surrealism in contemporary architectural theory and practice. Jean La Marche documents a pedagogy informed by surrealism, Kari Jormakka situates Tschumi's early advertisements for architecture within a broad intellectual project, and James Williamson offers insights into the influential practices of the late John Hejduk.

Like the discipline of architecture itself, this anthology is incomplete. There are a great many voices that could not be included, and by necessity the work has been limited to English-language scholars. The surrealist tendency in modern and contemporary architecture can also be found in certain practices of Latin America, Japan, and Central Europe not specifically addressed in this anthology. Significant advancements in understanding the possibility of an architecture that engages the creative processes and provocative effects of surrealism are still unwritten. Within each chapter are multiple approaches for rethinking the conventions of architectural thought and practice. Each of the essays included are independently clear; in their entirety they are an "open work" containing multiple interpretations, methodologies, and topics that resonate or compete, pointing toward further inquiries. Surrealism in architecture is incomplete – even now, new strategies for architectural design and analysis, an architecture of desire, and erotics of architecture are being developed as a pursuit of meaning in architecture.

## Notes

1   For a description of the sacrifical tropology of classical temples, see G. Hersey, *The Lost Meaning of Classical Architecture*, Cambridge, Mass.: MIT Press, 1988.

2   This psychoanalytic anaclitic model is transposed from the discussion of repetition and desire contra mere satisfaction in R. Krauss, *The Optical Unconscious*, Cambridge, Mass.: MIT Press, 1993, p. 140.

3   Modern architecture textbooks here include, but are not limited to, the influential L. Benelovo, *History of Modern Architecture* (vol. 2, trans. Bary Bergdoll), Cambridge, Mass.: MIT Press, 1977; V. Lampugnani, *Encyclopedia of 20th Century Architecture*, New York: Abrams, 1986; M. Tafuri and F. Dal Co. *Modern Architecture* (vols. 1–2, trans. Robert Wolf), New York: Rizzoli, 1976; K. Frampton, *Modern Architecture: A Critical History*, London: Thames and Hudson, 1985; and H. Heynen, *Architecture and Modernity*, Cambridge, Mass.: MIT Press, 1999.

4   Though there have been isolated essays, lectures, and footnotes in the area of architecture and surrealism, the most influential English-language text remains the out-of-print D. Veseley (ed.) *AD: Architectural Design*, vol. 48, no. 23, London 1978.

5   J. Mundy (ed.) *Surrealism: Desire Unbound*, New York: Princeton University Press, 2001, p. 13.

6   A. Breton, in C. Poling, *Surrealist Vision and Technique*, Atlanta: Emory University, 1996, p. 65.

7   A. Breton, *Manifestoes of Surrealism* (trans. R. Seaver and H. Lane), Ann Arbor, University of Michigan, 1972, pp. 274–278.

8   Breton, *Manifestoes of Surrealism*, p. 26.

9   Ibid.

10   See J. Chénieux-Gendron, *Surrealism* (trans. Vivian Folkenflik), New York: Columbia University Press, 1990, p. 55.

11   A. Breton, "Surrealist Situation of the Object," in Breton, *Manifestoes of Surrealism*, p. 259.

12   V. Shlovsky, "Art as Technique," in L. T. Lemon and M. J. Ries (eds) *Russian Formalist Criticism*, Lincoln: University of Nebraska Press, 1965, p. 12.

13   F. Jameson, *The Prison-House of Language*, Princeton, New Jersey: Princeton University Press, 1972, p. 52.

14   A. Vidler, *The Architectural Uncanny*, Cambridge, Mass.: MIT Press, 1992, p. 11.

15   Dalí, writing in 1930, cited in Breton, "Surrealist Situation of the Object," in Breton, *Manifestoes of Surrealism*, p. 261.

16   This association is described in K. Frampton, *Le Corbusier*, New York: Thames and Hudson, 2001, p. 204.

17   Ibid., p. 65.

18   See, for example, Le Corbusier's terrace of the De Beistegui penthouse, Paris, 1930–1, in Alexander Gorlin's "The Ghost in the Machine," included in this anthology, and C. Rowe and F. Koetter, *Collage City*, Cambridge, Mass.: MIT Press, 1978, p. 141, where this space is used to illustrate Le Corbusier's adoption of (cubist) collage in architecture, though its visual effect obviously operates closer to surrealist practices.

19   J. Cocteau, "Opéra," cited in de Chirico, "Statues, Furniture, and Generals," in G. de Chirico, *Hebdomeros*, Cambridge, Mass.: Exact Change, 1992, p. 246.

20   De Chirico later adds: "pieces of furniture abandoned in the wild are innocence, tenderness, sweetness amidst blind and destructive forces," in G. de Chirico, "Statues, Furniture, and Generals," p. 246.

21   Breton includes the ready-made, the weathered object, found object, interpreted found

object, surrealist object proper in his essay "The Crisis of the Object," in P. Waldberg, *Surrealism*, London: Thames and Hudson, 1965, p. 86, though he here omits the category he participated in directly: the poem-object.

22  Dalí, in Breton, *Manifestoes of Surrealism*, p. 274.

23  Breton, "Crisis of the Object," in Waldberg, *Surrealism*, p. 86.

24  See T. Mical, "The Origins of Architecture, after de Chirico," in *Art History*, London: vol. 26, no. 1, February 2003, pp. 78–99.

25  Krauss, *Optical Unconscious*, pp. 54 and 57. H. Foster in *Compulsive Beauty*, Cambridge, Mass.: MIT Press, 1993, p. 81, sees this as a primal scene, where "its contradictory scale, anxious perspective, and mad juxtaposition" are inherited from de Chirico, where "in the construction of the scene that the trauma is created, the charge released in the subject, the *punctum* is inscribed in the viewer . . ."

26  A. Breton, preface to the Max Ernst Exhibit, Paris, May 1921, quoted in D. Ades, *Photomontage*, London: Thames and Hudson, 1976, p. 115.

27  M. Hays, *Modernism and the Posthumanist Subject: The Architecture of Hannes Meyer and Ludwig Hilberseimer*, Cambridge, Mass.: MIT Press, 1992, p. iv.

28  D. Lomas, *The Haunted Self: Surrealism, Psychoanalysis, Subjectivity*, New Haven, Conn. and London: Yale University Press, 2000, p. 203. The citation neatly describes the necessity of rendering surrealist and psychoanalytic subjectivity as a mutable dialogical space.

## Chapter 2

# 'Un salon au fond d'un lac'

## The domestic spaces of surrealism

*Krzysztof Fijalkowski*

It is only to be expected that today's commentators, historians and curators of surrealism should attend above all to the movement's public face. After all, it is through its books and magazines, exhibitions, café meetings and public demonstrations that the surrealist movement has addressed its audiences, and through adopting radical and active group positions that it has presented itself as a current of social as well as cultural thought. What seems most relevant, then, about André Breton's often cited 'simplest surrealist act' – 'to go down into the street, revolvers in hand' – is precisely the call to leave the safety of one's private space and embrace the thrill of the public world.[1]

An inevitable result of this emphasis is that surrealism's domestic environments – the physical spaces in which surrealists have resided, worked and played – and in consequence a cornerstone of the lived experience of surrealism's day-to-day engagement with architectural space, have been overlooked or at best seen in static terms as simply a fascinating but essentially 'given' decor around individuals and events. Material culture approaches to the domestic environment, however, suggest ways in which the look and contents of a home present dynamics that are altogether more

complex and revealing; as Daniel Miller has proposed, for example, domestic space can be seen as 'both a site of agency and a site of mobility, rather than simply a kind of symbolic system that acts as the backdrop or blueprint for practice and agency'.[2]

More surprising, perhaps, is the way in which critical reflections on the dialogues and encounters between surrealism and architecture have also tended to overlook this lived domestic experience as a potentially fruitful starting point. When recent writings have discussed the theorization or representation of architectural space by surrealists of the inter-war years, they have generally emphasized an express opposition to dominant trends in Modernist architecture, and drawn attention both to the movement's advocacy of counter-Modernist trends (notably Art Nouveau buildings and *art brut* structures like the Facteur Cheval's Palais idéal) and to its calls during the 1930s for architectural but largely imaginary spaces embodying myth, unconscious meaning and the uncanny.[3] In consequence this approach has had the effect of presenting surrealism's engagement with architectural space in often simplified, homogeneous and imaginative terms, as a kind of draft project left for others to complete. In refocusing here on surrealists' actual domestic environments (in this case concentrating reluctantly on just the 1920s and 1930s), the intention is to argue that from this perspective surrealism's relationship to architecture is more complex and various than at first appears, to identify a number of key trends in these spaces, and in particular to examine the idea of the surrealist 'home' as a physical term in the dialectics of public versus private action that remain central to surrealism's social commitment.

A discussion of the fabric and appearance of surrealist domestic spaces, however, reveals a number of problems that might make the notion of the surrealist home of dubious value. First and foremost, these are considerations which would appear so far down the list of priorities of a politicized collective movement that its participants would be expected to reject its relevance vigorously; certainly, it would be entirely misleading to suggest that there has ever been a deliberate surrealist 'position' on its chosen domestic spaces (let alone on interior design), and the fact that in the 1930s and 1940s popular notions of a 'surrealist style' arrived precisely from the movement's patrons, imitators and commercial proselytizers makes this a problematic ground for the movement. But just as importantly the very notion of the 'home', with its implications of a repressive stability, a stultifying family environment and a seat for bourgeois morality and politics, would seem to make this a space synonymous with all that surrealism found contemptible. Surrealist writing and imagery repeatedly condemns the idea of the (bourgeois) home as an odious, venomous or ideologically saturated space: the place where outrages against the Papin sisters or Violette Nozières could be

committed in secret; the place that Fantômas should righteously ransack. Breton, just one of a number of the founding surrealists whose early home lives had been less than idyllic, would write in 1949: 'Personally I must pay homage to those rare works driven by that subversion which alone can measure up to individual resistance against general domestication'[4] – and this distrust of the domestic can be traced everywhere from the Chinese box of the apartment in *Un Chien andalou* to the frenzied theatre of the nursery in contemporary Czech surrealist Jan Švankmajer's animation of *Jabberwocky*.

The reverse of this coin, however, is that for surrealists in the 1920s and 1930s, the domestic interiors of their turn of the century child-hoods could also be the fading scenery of the alluring, the exotic and the uncanny. Max Ernst's collage novel cycles like *Une Semaine de bonté* played out their fantasies in these outdated rooms, while Michel Leiris could later evoke with great fondness the childhood home as a lost place of wonder and enchantment.[5] Walter Benjamin repeatedly points to the implicit and explicit affinities between surrealism and the nineteenth century's 'dreamy epoch of bad taste' in interior design, 'wholly adapted to the dream', highlighting the latter's vogues for the collecting of ephemera and exotica, of bizarre decor and furniture, and of its strange reversals of private and public space. Benjamin reads surrealism specifically as a glimpse of the ruins of the nineteenth-century bourgeoisie, those of a vanished epoch that more than ever exalted in self-protective dwelling,[6] and for all of its rejection of the domestic and its longing for the exotic and the other, surrealism must also be seen as a search for a rootedness through wandering, of new places through the revolt against order, of the *heimlich* in the *unheimlich*. The privi-leged figure for this home, for Breton, is the castle, a 'palace of the imagina-tion' that is repeatedly invoked, along with a longing for this utopian space to become real; a deliberately social space (as opposed to the private space of the bourgeois family unit) in which to gather all those friends of common intent and from whose bastioned heights the prospects could be scanned. Actual surrealist spaces, too, appealed to this desire for a place in which one might both dwell *and* survey: Breton was to describe his Gradiva gallery, for instance, as

> a dream of a space as small as you like, but from which one could see without leaning out the greatest, the most daring construc-tions under way in people's heads, of a place from which one might overcome that retrospective viewpoint we are accustomed to adopt for true creation.[7]

Small wonder, then, that surrealism of the 1920s and 1930s could find little

to approve of in the modernizing debates within contemporary architecture and decorative arts (though we will see later that this might not be quite the blanket rejection one expects). The founding years of the Paris group were also the period of increasing popularity of the new styles in European and especially French interior design, culminating in the Exposition des Arts Décoratifs of 1925. Issue 5 of *La Révolution surréaliste* contained a sarcastic critique of the exhibition by Louis Aragon, who lamented its 'desert of walls' built to the rhythms of factories and hangars, and noted how the new spirit of Deco design – whose public was meant to be seduced by its elegance and rich finish – in fact measured everything solely by utility; here, he argued, one found the financial sense of the word 'modern': to get rid of art since it isn't useful unless it goes with the décor.[8] When the functional subtext of Art Deco became the explicit rationale of Modernist architecture, Surrealists would apparently have little but contempt for such notions of progressive design. Le Corbusier in particular appears as a *bête noir* for the Paris group, held as an arch-rationalist antithesis of surrealism's call for a poetic, inward creative drive by Breton who was to follow Hegel in labelling architecture as the most elementary art form and boast of the revenge of the 'irrationally wavy' walls of the Swiss Pavilion.[9] Painter André Masson's views were more forthright:

> I will always hate the horrors of the 'industrial age' and the hideous claims of all those mechanics, from the inventor of the death ray to Mr. Le Corbusier who dreams of getting the whole human race (or what's left of it after his learned colleague) to live in a columbarium (a pigeon hole for everyone).[10]

One thing likely to have irked the Paris surrealists in the architecture and interior design of these trends was their emphasis on the reduction or suppression of decoration and ornament – the very elements of buildings and their furnishings that would most interest someone like Salvador Dalí. Popularizing French magazines of the mid-1920s such as *L'Art vivant*, for instance, carried, alongside articles on contemporary painting and architecture, some forthright advice on new furnishing and decoration styles, and its regular feature on 'Modern Living' exhorted its readers to make a clean sweep of the fussy trappings of the nineteenth century:

> Don't hesitate to get rid of those adventitious ornaments. They're ugly, they're good for nothing, not even as decoration, and they prevent you from the means of a simple, sober décor, which goes best with modern practice.[11]

2.1
**André Breton's
studio, 42 rue
Fontaine, 1980s**
Photo Dawn Ades

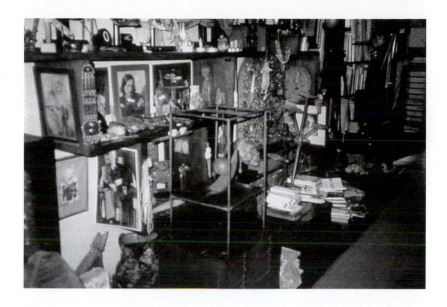

Equally under suspicion, however, were the apparently elitist positions sup-
ported by the new spirit in design; the Exposition des Arts Décoratifs pro-
moted its aesthetic through presenting models for the homes of wealthy and
fashionable society figures, and in France the vast majority of finished exam-
ples of Modernist architecture were luxurious private rather than social proj-
ects. Whilst it may be debatable to what extent Parisian surrealists of the
period could genuinely focus on social issues, what is relevant here is
the sense in which surrealist appropriation of lived space aimed to inhabit not
the private sphere as such but the dialectic between the personal and the
collective, and the complex to and fro between the closed/occulted and the
public/exhibited politics, spaces and actions that formed the hub of French
surrealism's problem of the inter-war years.

The defining example of a surrealist home, both in its appearance
and its articulation of this tension between private and public space, is the
apartment at 42 rue Fontaine that was home to the movement's guiding spirit
André Breton (Figure 2.1). In fact, Breton occupied not one but two addresses
here, moving in to a top floor studio on 1 January 1922 not long after his
wedding to Simone Kahn, and then to more spacious quarters on the floor
below in 1946; but his presence in this building for over forty years clearly
signals a sense of rootedness and elective location. As an archetypal surrealist
interior, crammed with his collections of artworks, objects and books, Breton's
home appears as an extraordinary combination of *Wunderkammer*, alchemist's
lair and archive. The effect on the visitor was powerful (as the present writer
can attest), and among those who grew to know it a myth developed of an

enchanted, magnetized space. Jean-Louis Bédouin, for example, explained his first visit there 'as if the adolescent I was then had crossed a threshold of initiation, beyond which the world one could actually live in began'.[12]

The furnishings in the apartment appear to have been simple, unmatched and probably second-hand, with textiles tending to be cosy but straightforward non-western fabrics and rugs, and walls washed a uniform dusty neutral shade; all of these practical details were, of course, all but invisible behind the myriad objects and artworks around them. Thus the background style of Breton's home, evolving gradually over nearly half a century, certainly bore little resemblance to the fashions of interior design being promoted and popularized in France over the 1920s and 1930s, whether Art Deco chic or glass and steel modern. Far more influential in its appearance and its belvedere qualities would have been the top-floor flat on the boulevard St Germain belonging to Guillaume Apollinaire, where Breton had been a regular visitor until the poet's death in 1918:

> The apartment was tiny, but had a dangerous twist: one had to thread one's way between furniture laden with African and oceanic fetishes, mixed up with strange objects and the shelves on which the piles of books with their old yellow covers resembled, as he put it, 'mounds of butter'. [. . .] On the walls, which were fairly low, the paintings hung almost without interruption were so many vistas onto exotic or unknown worlds.[13]

Interiors combining crowded collections, unexpected objects and the outlook of an intellectual environment were not rare in Europe between the wars – Breton's visit to Freud's apartment for instance, where one guesses he would have seen Freud's study, was made only a couple of months before moving into rue Fontaine – but they were becoming both unfashionable and unusual. Such models for the home seem consigned rather to the vanishing interiors of the nineteenth century, those that for Benjamin represent an all-encasing carapace, one that

> bears the impression of its occupant. In the most extreme instance, the dwelling becomes a shell. The nineteenth century, like no other century, was addicted to dwelling. It conceived the residence as a receptacle for the person, and it encased him with all his appurtenances . . .[14]

It might be pointed out that this desire for a home space for the Breton couple was not necessarily the norm among their friends and colleagues

at the time. Many of those participating in Paris Dada and early surrealism lived much less stable lives in hotel rooms (as indeed Breton had done for some time before), and several continued to live in hotels for many years to come. But certainly the rue Fontaine studio bears all the hallmarks of a lair secreted around its occupant to the point where dwelling and dweller seem inseparable, one that might shelter the poet from the outside world and nurture his projects. Julien Gracq for one emphasized this small, closed and secretive aspect in describing its rooms as dark and crammed with objects, and by 1947 a notice on the door dissuaded the casual caller with the message: 'Visitors by appointment only; no interviews'.[15] But this rather sombre picture misrepresents the reality of Breton's home. For one thing, the larger second studio was far from being a small space, and by Parisian standards the main room in particular felt relatively spacious; above all, though few contemporary photographs reflect this clearly, one whole wall was dominated by enormous north-facing studio windows, allowing a generous amount of light and air helped by the height above the boulevard de Clichy below. So if this is a shell, it is one that faces the street, high out of reach but open literally and metaphorically onto the world in a manner less suggestive of the transparency of glazed Modernist architecture or of Foucauldian controlling vision than as a series of revelations and positions from which to see, be seen and make visible. It is in this sense, then, that Breton might be seen to really inhabit the apparently idealized 'maison de verre' he describes in *Nadja*, a space in which opacity might be banished for clarity and where it is not the occupant's security but his identity that is at stake:

> As for myself, I'll continue to inhabit my house of glass, from where I'll always be able to see who is coming to see me, and where everything is hung from the ceilings and walls as if by magic [. . .] where sooner or later *who I am* will be revealed.[16]

Breton's choice of the location visible from this window, of course, was far from random. Just off the place Blanche and the busy boulevards skirting the butte Montmartre from the place de Clichy, rue Fontaine could be both close to cafés and studios (the daily surrealist café would be held for many years at the Cyrano just a step away, and several surrealist artists had studios nearby) yet still be in a district that had not entirely succumbed to fashionable *tout-Paris* (or to the bohemian pretensions of Montparnasse): still in essence a working-class district with local atmosphere and colour (in particular the fabled hidden pleasures of its night life). Every year the boulevard right below Breton's window would host street fairs, as though an Apollinaire poem had come to life, where

> from the Boulevard Clichy, the *fête foraine* throws out the smell of waffles and candyfloss, of acetylene and lions in cages mingled

with that of spent firecrackers and of undercooked sauerkraut from the ample worker's canteen.[17]

Rue Fontaine, then, could be read as a potentially fertile location for relationships between work and play, the social and the personal, and it is in particular as a working environment that Breton's home should also be appreciated. In Walter Benjamin's reading of the nineteenth-century interior it was the gradual alienation of the bourgeoisie from its workplace that lead to the emergence of the private home.[18] A surrealist home like Breton's, on the other hand, could be seen to recast this process through its status as a place of unalienated work. Habitually referred to as a 'studio' or an *atelier* – Agnes de la Beaumelle calls it a 'construction site' and 'the real "factory" of surreal-ism' – Breton's apartment was above all a place in which to think and write, but it was also a space for both serious and more relaxed collective activity.[19] After the daily café meetings, group members would frequently accompany Breton home to prolong the evening with discussions, editorial and planning sessions, games and experiments, and a number of significant group events, such as the trance experiences of the *époque des sommeils* or the Dalí 'trial' of February 1934, took place here. Like a number of other surrealist homes, rue Fontaine thus functions very much as a social space; and it was also, of course, one not inhabited by Breton alone but shared with his partners, who must also all have had a hand in shaping its look and contents.[20]

Most spectacularly, though, the apartment was also home to the accumulation and installation of Breton's legendary collections, a living museum of objects that would have spoken eloquently to their keeper of memories and encounters, places and journeys, of friendship and love; in a sense, rue Fontaine is built of these objects just as the Facteur Cheval's Palais idéal was constructed from its accidental accretion of stones. In con-trast to the look of a museum or archive, or of most nineteenth-century col-lectors' homes, however, these displays strike the viewer above all for the extraordinarily complex way in which categories and distinctions between types of objects are blurred and ignored. The wall facing the door to the main room, frequently reproduced in photographs and now partially recreated in the Centre Pompidou, is particularly rich in these confrontations: geological specimens gather dust under Giacometti's *Suspended Ball*; a wooden New Guinea korvar statue sits staring at a painting by Toyen; a jawbone lies by a Tibetan bronze; a photograph of Elisa hangs at the epicentre of intricate stepped shelves laden with things.[21] Less frequently photographed were the adjoining and opposite walls, where shelf upon shelf of books placed Breton's library in direct contact with the other collections, and it is clear that the worth of these ensembles lay not simply in their discrete systems of

order and value but in the complex and subtle relationships between images, objects and ideas as each painting, flea-market find and bound volume spoke to its neighbours and its owner. Breton seems to have appreciated the space of his collections above all as a privileged place for reflection and reverie on their account, writing for example of his oceanic objects that

> personally I often feel the need to return to them, to wake up looking at them, to hold them in my hands, to talk to them, to accompany them back to the places they came from so as to reconcile myself with the places I am now.[22]

A significant purpose of Breton's home was thus to shelter a physical and intellectual collection of objects whose prime function was to locate the self within the wider world outside. The status of these collections as poetic rather than archival or taxonometric encounters was further enhanced by the inevitable shifts and rearrangements of their display, open to the dynamics of change and accident. Even the progression of an object into the collection could be subject to such forces, and Bédouin describes how on a typical occasion with a newly acquired New Guinea sculpture Breton 'had "walked it around" for a few days, from a shelf to a table, from one corner of the studio to the other, looking for the inevitable place that was destined for it'.[23] With books, objects and artworks received and donated, bought and sold, each one a messenger from another person, the incessant trade between the interior and the outside world was thus expressed through the studio's objects as well as its visitors.

While the studio at 42 rue Fontaine was clearly the exemplary surrealist interior, to be echoed in many other locations over the years, its style and aesthetic was by no means the only model for the surrealist home. In particular, the popular image of a 'surrealist interior design', one drawing on wildly disparate sources and dramatic fantasies, was probably far more intriguing to the wider public than Breton's initiates' eyrie. The origins of this fantasy style might be traced in particular to the legendary shared house at 54 rue du Château in Montparnasse, home to surrealist group members such as Yves Tanguy, Marcel Duhamel, Jacques Prévert and Georges Sadoul during the second half of the 1920s. André Thirion, a frequent guest and later occupant of the house, has described the premises at length, with its green-painted furniture placed incongruously out in the yard, its walls hung with unbleached canvases framed with sticks or else plastered with film posters, the mottled linoleum floor strewn in one corner with black leather mattresses, and its copious collections of records, books, strange objects and stolen shop signs (the latter also visible in a Man Ray photograph reproduced in Thirion's book showing a lavatory hung with posters and

with a crucifix for a chain-pull). As a kind of alternative headquarters for collective surrealist activity, the rue du Château household was well known for its contrasts to the rue Fontaine, in particular in its eclectic tastes in popular culture. But that its inhabitants were not insensitive to contemporary interior design issues, albeit in a highly unorthodox manner, is implied by Thirion's account, which for example describes a sumptuously comfortable bedroom hung with jazzy wallpaper by Jean Lurçat and alabaster lamps by Pierre Chareau, two leading figures in Deco applied arts.[24]

By the late 1930s, surrealist exhibition installations (themselves ambiguously domestic spaces where surrealist furniture lurked among incongruous evocations of natural or urban environments) offered their public a chance to see for themselves just how effective the surrealist transformation of interior space might be. The arch promoter of this spectacular and highly influential 'fantasy surrealist' style, upon which much of the discussion of the encounters between surrealism and architecture has been based, was of course Salvador Dalí. A vociferous supporter of Art Nouveau architecture and design, and famous for his extravagant lifestyle in the flamboyant theatre of his home in Port Lligat, for example, Dalí's widely promoted tastes were clearly an influence on well-known eccentric homes like those of the collector Edward James, as well as on the style of other mass-market showcases such as fashion magazines and the cinema. It might be argued, however, that this apparent trend in surrealist interior design was not at all reflective of actual surrealist homes (just as surrealists only rarely actually used the surrealist furniture they designed). Even in Dalí's case, given that most of the expansion of his Port Lligat house came in the decades after the war, and that Dalí and Gala did not move into their first Parisian flat that really echoed the baroque atmospheres and exotic fauna of his painting until late 1937, the fruition of this style can be placed during and after his divergence from the Parisian surrealist group, after which time the latter insisted that Dalí's interests could no longer be classified as authentically surrealist.[25] In fact, descriptions and images of the Dalí couple's home from July 1932 near the parc Montsouris, at 7 rue Gauguet (a newly built Modernist building), indicate an interior which, far from reflecting 'fantasy' tendencies, suggests a pared-down elegance consistent with progressive early 1930s design, with minimal furniture and décor. Henri Pastoureau, a regular participant in 'factional' meetings here along with Roger Caillois, Jules Monnerot and Étienne Léro in the winter of 1932–33, remembers a drawing room that was 'enormous, furnished in a modern manner with no discernible influence from Dalí', and Brassaï's photograph from this period shows Dalí and Gala posing in a bright, rather bare and open interior decorated with a few carefully chosen objects and paintings, and simple tubular steel furniture.[26]

More recent commentators on surrealism's contributions to architectural debate, such as Anthony Vidler, have concentrated in particular on articles contributed by Dalí and others during the 1930s to the luxurious journal *Minotaure*, with the implicit possibility that their ideas might suggest blueprints for actual building design. But given that in the early and mid-1930s, Dalí was living in a home that reflected many of the values of contemporary Modernism, his writings on architecture and design published in *Minotaure* and elsewhere take on a rather different value – one that explored the notion of unconscious or irrational readings of architectural space but without necessarily wishing to imagine these as rationalizable models for real built environments – and this same ambiguity may be discerned in a number of the key *Minotaure* articles in question. Dalí's promotion of Art Nouveau design in 'On the Terrifying and Edible Beauty of Art Nouveau Architecture', in particular the buildings of Gaudí, drew attention to elements of its 'terrifying and sublime ornamental' nature. But Dalí, wishing both to rescue a by-now outmoded style from its popular reception and at the same time refuse its appropriation by modernist design, emphasized the essentially inexplicable morphology of its appearance, and insisted that this was not a question of simply replacing 'the "right angle" and "golden section" formula with the convulsive-undulating formula [which] can ultimately only produce an aesthetic that is just as miserable as the last, even if the change might be temporarily less boring'.[27] The 'delirious concrete' of Art Nouveau is thus an irrational upsurge from the past, not a project for the future.

Other surrealists too contributed to this forum, notably the painter Roberto Matta who had graduated in architecture from Santiago University and gone on to become a successful interior designer, before moving to Europe where he was to work with Gropius and Le Corbusier (for whom he produced drawings for the Ville Radieuse).[28] The spring 1938 issue of *Minotaure* published Matta's *projet-maquette* for an apartment in which an unorthodox use of materials and space would introduce eroticism and inter-uterine motivations into a home that could 'push forcefully [its] inhabitant into the centre of the ultimate theatre where he becomes everything, its argument and actor, the stage and this silo in which he can live in silence among its rags'.[29] Once again, the exchange between inside and outside was a primary feature of this dwelling, for as Matta was to say of it later:

> A house must function like a heart, with a systole and a diastole, outside and inside. You must recharge your batteries at home, and in the street as well. This is one of the principal ideas of *Mathématique sensible*, the politico-economic significance of this energy.[30]

As a former employee in Corbusier's office – and it's tempting to read the *projet-maquette* as a feminizing riposte to Modernist architecture's paternalistic values – Matta can be assumed to be fully aware of both the feasibility of his idea and the status of a 'project-model' as a conceptual step on the path to a real building. But despite the repeated references to space in general and architectural space in particular throughout his paintings and writings, there seems to be little to suggest that these are envisioned as literal construction blueprints; what we do know, however, is that by the end of the previous summer, having been thrown out after living on the drawing-room sofa in the apartment of a wealthy friend, Matta had been obliged to find a *pension* with no money and just a suitcase of possessions, an ejection from the bourgeois home that might well make one dream of an idealized and all-nurturing space.[31]

A third key article referring to architecture in *Minotaure* was Tristan Tzara's 'On a Certain Automatism of Taste' of 1933. As several commentators have pointed out, Tzara's discussion of the unconscious motivations of taste includes an appeal (prefiguring Matta's project) for a rounded, irregular inter-uterine architecture reminiscent of a cave or a yurt, and insists that '"modern" architecture, as hygienic and bereft of ornament as it wishes to appear, has no chance of surviving [. . .] since it is the total negation of the image of the dwelling'.[32] What seems astonishing, however, is that at the time of writing these lines Tzara should be living in a domestic space that in many ways embodied the very antithesis of this philosophy. A short walk up the hill from rue Fontaine, Tzara's house on avenue Junot had been commissioned by him from the architect Adolf Loos in 1925 and completed in 1926 (Figure 2.2). The two men knew each other well, having met in Zurich (Kenneth Frampton suggests that Tzara was instrumental in Loos's move to Paris in 1923), and it would appear that the house was designed in close collaboration.[33] The house is an important one in Loos's *œuvre*, but architectural historians have tended to see Tzara as a Dadaist, inviting somewhat slender connections between the building and Dada ideas. In fact, despite the well-known rupture between Tzara and the former Dadaists around Breton, the former had always maintained contacts with surrealist group members (notably René Crevel), and was reconciled with Breton in 1928; by 1929, Tzara was a key member of the surrealist group and would remain so until 1935 (longer, then, than the duration of Paris Dada), residing at avenue Junot throughout, so that his occupancy of this classic of Modernist architecture should really be read in the context of surrealism rather than that of Dada.

It is true, of course, that Loos's position in the history of Modernist architecture is ambiguous, and the Tzara house cannot be read as a straightforward contradiction of surrealism's position on Modernist building

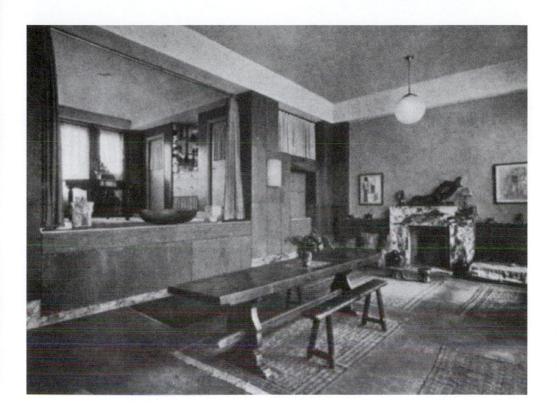

2.2

**Interior, Tristan Tzara's house,** *c*.**1930**

design. Often seen as a forerunner of functionalism, it is perhaps Loos's espousal of abstraction and simplification, in particular the famous 1908 essay 'Ornament and Crime' in which he argues for the removal of ornament as the crowning proof of cultural evolution, that best places him as a precursor for architects such as Le Corbusier; but critics have also stressed the ways in which his buildings could embody the irrational, using contrast, play and surprise within symmetry to exercise rationality while simultaneously breaking its rules. The apparent austerity of Loos's houses stemmed from his belief that 'use determines the forms of civilized life, the shape of objects', part of his determination to sweep away the bourgeois domestic clutter of nineteenth century and Jugendstil interiors[34] – qualities unlikely to endear his work to a surrealist audience. But Loos also conceived a house as a protective shell, one that should say as little as possible on the outside and hide its secrets within: for him the home was a protective shelter for the psyche that balanced the private and public and allowed dwelling in the modern age, and in 1930 Tzara was to pay homage to Loos's determination to attain 'a human possibility of clarity, within the hub of social activity'.[35] The Tzara house in particular, with its sternly symmetrical rectangular elevation, hides a play of rooms and unexpected spaces that Benedetto Gravagnuolo

terms a 'chess game in space', in which an intimate place for the private self is constructed through an internal drama of looking and revealing, rather than through the prospect of the outside world from one big room found at rue Fontaine.[36]

Loos was in any event happy to accept that his clients would impose their own ideas and styles on his buildings, and although at first glance its interiors were far more formal and contemporary than Breton's, Tzara's home, too, housed a formidable collection of books, archival documents, artworks and, above all, non-Western art (though in a number of ways Tzara's collecting and understanding of the latter also contrasted with that of Breton).[37] Photographs of the Tzara house show spacious, simplified interior spaces with veiled windows, parquet floors and broad neutral walls, solid, rustic-looking wooden furniture, relatively few paintings and a conspicuous but not overpoweringly crowded display of non-Western objects; an austere entrance stairwell was offset by a pair of African carvings.[38] And, like rue Fontaine, this could also function very much as a working environment, since from 1929 surrealist group meetings were frequently held here (particularly for political discussions, it would seem), so that avenue Junot quickly became a new headquarters for Parisian surrealism.[39] At the heart of the house's labyrinth was Tzara's study, the one room that recalled rue Fontaine, where Tzara would work surrounded by his books, manuscripts and objects like an erudite seeker within his den.[40] Thus, although quite distinct from other surrealist interiors of the time in its closer fidelity to a Modernist style, a parallel set of dialectics between inside and outside, private and social space, seeing and seeking that characterizes a home such as Breton's can still be discerned.

The most extreme example of a complex relationship between surrealism and Modernist architecture is probably that of Karel Teige. Writer, critic, designer and collagist, Teige was the leading theorist of the thriving Czech surrealist group from soon after its inception in 1934, yet he was also – and in some cases at the same time – a leading proponent of functionalism, making a major contribution to debates on contemporary architecture in Europe between the wars. That this apparently mutually exclusive set of ideas could be entertained simultaneously is in part a result of the special circumstances of Czech surrealism's development out of Devětsil, an avant-garde group bringing together fine and applied arts (including architecture) within a lively forum of debate, and of the fact that many of the Czech surrealists of the period managed to reconcile artistic, commercial and radical political demands in ways that were quite distinct from the circumstances of their Parisian colleagues. But Teige was also prepared to live by his ideas, and in 1927–28 he commissioned the architect Jaromir Krejcar to 'purify' his

neo-Renaissance style family home at Černá ulice 14 in a functionalist manner, providing top-floor flats for himself and his partner Jožka Nevařilová; and then in 1937–38 (at the height of the pre-war Czech surrealist group's activities) constructed a functionalist house at U Šalamounky 5 in Smichov, designed by Jan Gillar. Both homes reflected many of Teige's ideas on the minimum dwelling and on social housing, notably in the way they included communal service areas but insisted on maintaining separate studio dwellings for Teige and Nevařilová as a way to maintain an inviolate privacy against the bourgeois institution of the conjugal bedroom. The few photographs available of this second home, taken after Teige's death in 1951, show discreet, spare and serious interiors with no trace of tendencies towards either fantasy or accumulation (other than of books), and contemporary accounts tell how even Teige's collection of artworks was all stored in cupboards, to be taken out when necessary.[41]

It could be argued, then, that the 1920s and 1930s homes of Dalí, Tzara and Teige indicate that surrealism's apparently intractable opposition to Modernist architecture and interior design is at the very least more nuanced than it at first appears. Though these examples might have been exceptional in comparison to rue Fontaine's orthodoxy, the disparity between imagined and actual spaces they suggest (as though the former might stand as an 'architectural unconscious' of the latter), and the divergences in tastes they represent, nevertheless act to undermine the notion of a unified 'style' in the movement's experience of domestic environments. One final pairing of examples must suffice to suggest the range of spaces in which surrealists lived their daily lives, a diversity that can be seen to parallel the way in which the movement has been able to produce such stylistically varied works out of shared intellectual positions. At least one well-known figure, René Magritte, appears to have been happy to take on the disguise of an arch-bourgeois lifestyle, in a home where only his paintings among the Empire-style furniture and carefully dusted baubles broke an atmosphere described by George Melly as one of an 'inspired banality' also found in so many of Magritte's paintings, where extraordinary revelations always take place in the dullest of interiors.[42] Magritte's long-time friend and collaborator Paul Nougé was also responsible for a body of texts and photographs (made from 1929–30 but published after his death) documenting uncanny eruptions within the featureless mediocrity of the middle-class home, *Subversion des Images*.[43] In the images, seen by Marcel Mariën as an important influence on Magritte, friends, including Magritte, pose as startled houseguests staring at an empty mantelpiece, locked in mirror games or threatened by a pair of gloves in the spare room. The book's final image, *The Reader*, shows a young man who

has apparently retreated to the attic to find some peace and quiet among a dilapidated mess and jumble of bric-a-brac, as if it were the chaos of the unconscious that signifies the private mind, away from the order of the social world below (Figure 2.3). Between chaos and order, inside and outside, private and social, surrealism finds a restless dwelling.

2.3
**Paul Nougé, *The Reader*, 1929–30**

## Notes

1  On this tension, see, for example, S. Suleiman, 'Between the Street and the Salon: The Dilemma of Surrealist Politics in the 1930s', in L. Taylor (ed.) *Visualising Theory: Selected Essays from V.A.R. 1990–1994*, London: Routledge, 1994, pp. 143–58. Suleiman's argument is that surrealism gradually, if unintentionally, abandoned street politics for salon socializing; but as we shall see, surrealists preferred their rooms more complex and less comfortable – in Rimbaud's words, 'at the bottom of a lake' – and what follows below might be the beginnings of a refusal of Suleiman's position.

2  D. Miller, 'Behind Closed Doors', in D. Miller (ed.) *Home Possessions: Material Culture Behind Closed Doors*, Oxford: Berg, 2001, pp. 1–19 (p. 12).

3  An example of this approach, that concentrates on surrealist texts on architecture but, as we shall see, ignores the domestic spaces in which they were written, might be the chapter 'Homes for Cyborgs' in A. Vidler, *The Architectural Uncanny*, Cambridge, Mass.: MIT Press, 1992, pp. 147–64. Paradoxically, this essay has been reprinted in a collection subtitled precisely *The Suppression of Domesticity in Modern Art and Architecture* (C. Reed (ed.) *Not At Home*, London: Thames and Hudson, 1996).

4  A. Breton, 'Le Mécanicien', in *La Clé des champs*, Paris: Pauvert, 1979, pp. 213–23 (p. 220). The French adjective *domestique* also has strong implications of both tameness and subservience.

5  See, for example, the sections such as '. . . Reusement', 'Habillé-en-cour' and 'Perséphone' in M. Leiris, *Biffures*, Paris: NRF/Gallimard, 1988.

6  References here are to W. Benjamin, *The Arcades Project*, Cambridge, Mass.: Belknap Press/Harvard UP, 1999, pp. 213, 220–21, 898.

7  'Gradiva', in A. Breton, *La Clé des champs*, pp. 24–28 (p. 26). For references to the castle see, for example, 'Limites non-frontières du surréalisme', in *La Clé des champs*, pp. 13–24 (pp. 20–23), and 'Il y aura une fois' in A. Breton, *Clair de terre*, Paris: NRF/Gallimard, 1966, pp. 99–105, pp. 99–100, where the reference to Huysmans's idea of the palace is made on p. 99.

8  L. Aragon, 'Au bout du quai, les Arts Décoratifs', in *La Révolution surréaliste*, no. 5, October 1923, pp. 26–27.

9  A. Breton, 'Situation surréaliste de l'objet', in *Position politique du surréalisme*, Paris: Pauvert, 1971, pp. 22–30 (pp. 24–25).

10  André Masson, letter to D.-H. Kahnweiler, 1 January 1935, in *Les Années surréalistes: Correspondance 1916–1942*, Paris: La Manufacture, 1990.

11  G. Rémon, 'L'Habitation d'aujourd'hui: Avant-propos', in *L'Art Vivant*, no. 1 (1925), pp. 11–13 (p. 13).

12  J.-L. Bédouin, 'La Constellation André Breton', in *L'Œuf sauvage*, 1992, p. 21. The contents and appearance of this second atelier, maintained for a further thirty-five years after Breton's death by his widow Elisa, have only just been dismantled at the time of writing. Despite the considerable outcry at the sale of Breton's collections, the resulting catalogue *André Breton: 42, rue Fontaine* (Paris: CamelsCohen, 2003, 8 vols and DVD) now provides the most comprehensive archive of documentation of the premises.

13  A. Breton, 'Ombre non par serpent mais d'arbre', in *Perspective cavalière*, Paris: NRF/Gallimard, 1970, pp. 33–37 (p. 35). Photographs of Apollinaire's flat can be found in W. Rubin (ed.) *'Primitivism' in 20th Century Art*, New York: Museum of Modern Art, 1984 (2 vols), vol. 1, pp. 144 and 312. Breton contrasted this space with the coldness of 'the almost bare room in which Pierre Reverdy received visitors' (A. Breton, *Entretiens*, Paris: Gallimard, 1969, p. 48); a second contrast of the period would have been the stylish interiors of the couturier and collector Jacques Doucet, for whom Breton worked with considerable

reluctance, it would seem. It appears, though, that Breton also strongly disliked the Éluards's home in Eaubonne, with its murals by Max Ernst and its mass of apparently randomly chosen pictures (letter to Simone Breton, November 1923, cited by A. De la Beaumelle, 'Le Grand atelier', in *André Breton: La Beauté convulsive*, Centre Pompidou, Paris 1991, pp. 48–63 (p. 62)).

14  Benjamin, *Arcades Project*, pp. 220–21.

15  J. Gracq, 'En Lisant et écrivant', reprinted in *André Breton: 42, rue Fontaine*, p. 7 (each volume); Bédouin, 'La Constellation André Breton', p. 27.

16  Breton, *Nadja*, Paris: NRF/Gallimard, 1964, p. 18 (the emphasis is Breton's). The theme of clarity and visibility is a reminder, of course, that Breton's early notion of the 'inner model' for painting theorizes surrealist art in terms of interior and exterior, in which painting is also explicitly presented in terms of being a 'window' looking onto a view – in other words from inside to outside (A. Breton, *Surrealism and Painting*, Paris: Gallimard, 1965, pp. 2–3). Henri Lefebvre would read surrealism's wish 'to decode inner space and illuminate the nature of the transition from this subjective space to the material realm of the body and the outside world, and thence to social life' as one of its key theoretical innovations (H. Lefebvre, *The Production of Space*, Oxford: Blackwell, 1991, p. 18).

17  Thora Dardel, quoted in F. Buot, *Tristan Tzara: L'Homme qui inventa la révolution Dada*, Paris: Grasset, 2002, p. 179.

18  Benjamin, *Arcades Project*, p. 226.

19  De la Beaumelle, 'Le Grand atelier', p. 48. This article cites letters (p. 55) from Breton to his wife indicating that, in the early days at least, Breton resented the intrusion of so many people and so much activity in their home.

20  One suspects that this must have been especially true in the case of Breton's first wife Simone, who was not only an important part of the intellectual climate for both Breton and the group during the 1920s but who also appears to have shared responsibility for the couple's art collection. It seems inconceivable that the appearance of the first Breton studio was not also a result of her preferences and ideas, and this is an area that would merit considerable development.

21  Once catalogued and placed behind the toughened glass in the Centre Pompidou, of course, the complex organism of Breton's collection becomes *Le Mur d'André Breton*, where Breton is given authorial status for a set of objects now read as a deliberate conceptual installation, and where once fluid readings become fixed in predominantly art-historical terms (see, for example, W. Hoffman, 'Un Réalisme ouvert et fermé à la fois', *La Révolution surréaliste*, Paris: Centre Pompidou, 2002, pp. 361–65).

22  A. Breton, 'Océanie', in *La Clé des champs*, pp. 177–81 (p. 181).

23  Bédouin, 'La Constellation André Breton', p. 27. On Breton's collecting habits, where the argument is that an initially closed collection built up of projected desires around the owner gradually became a more public installation, see P. Scopelliti, 'Breton et Tzara collectionneurs', *Mélusine*, no. 17, 1997, pp. 219–32. Scopelliti suggests (p. 229) that Freud also had similar rituals for new acquisitions to his collection.

24  A. Thirion, *Revolutionaries Without Revolution*, London: Cassell, 1975, pp. 86–91. The illustrations also show a slightly scruffy view of Louis Aragon's studio in rue Campagne Première in 1931, where a Miro drawing and a North American totem carving sit next to a large Gustav Klutsis poster – a degree of informality the rue Fontaine seems never to have aspired to.

25  I. Gibson, *The Shameful Life of Salvador Dalí*, London: Faber and Faber, 1997, p. 378. A photograph of this apartment at 88 rue de l'Université is to be found in the second section of the exhibition catalogue *Salvador Dalí* (Paris: Centre Pompidou, 1979), p. 73. Significantly, the couple seem to have used it as a semi-public showcase for Dalí's work, with journalists invited for personal 'private views'.

26  M. Secrest, *Salvador Dalí: The Surrealist Jester*, London: Collins, 1988, p. 138; H. Pas-
    toureau, *Ma Vie surréaliste*, Paris: Maurice Nadeau, 1992, pp. 150–51. Brassaï's portrait of
    the Dalís is reproduced in A. Sayag and A. Lionel-Marie (eds) *Brassaï: 'No Ordinary Eyes'*,
    London: Thames and Hudson, 2000, p. 160. Gibson (*Shameful Life*, p. 300), quotes Dalí's
    opinion of the building as an example of 'auto-punitive architecture [. . .] the architecture of
    poor people' that was quite out of step with his thirst for luxury, but the fact remains that
    the Dalís chose and continued to live in the apartment for five years, so that 'not being able
    to have Louis XIV bureaus, we decided to live with immense windows and chromium tables
    with a lot of glass and mirrors'. Secrest (*Salvador Dalí*, p. 159) cites Julien Lévy as remem-
    bering the Dalís moving home to the Villa Seurat, remodelled in white stucco for them
    around 1936 by the architect Emilio Terry, and again notes the visitor's surprise at finding an
    elegant and almost bare interior rather than the 'surrealist' extravagance he had expected;
    but Villa Seurat is right behind rue Gauguet, and this may also refer to the first apartment.

27  S. Dalí, 'De la beauté terrifiante et comestible de l'architecture Modern' Style', *Minotaure*,
    nos. 3–4 (1933), pp. 69–76 (p. 70).

28  For biographical details on Roberto Matta, see D. Bozo (ed.) *Matta*, Paris: Centre Pompidou,
    1985, pp. 265–67.

29  [Roberto] Matta Echauren, 'Mathématique sensible – Architecture du temps', *Minotaure*,
    no. 11 (Spring 1938), p. 43.

30  Matta interview cited in Bozo, *Matta*, p. 267.

31  *Interview de Matta*, special issue of *Ojo de aguijon*, nos. 3–4 (April 1986), p. 62.

32  T. Tzara, 'D'un certain automatisme du goût', *Minotaure*, nos. 3–4 (1933), pp. 81–84 (p. 84).

33  Kenneth Frampton, 'Introduction', in Y. Safran and W. Wang (eds) *The Architecture of Adolf
    Loos*, London: Arts Council, 1985, p. 12; Buot, *Tristan Tzara*, p. 204. Buot recounts (p. 205)
    that Tzara had also supported Le Corbusier's 1925 Esprit Nouveau pavilion by helping to
    organize its opening event. The avenue Junot house is always referred to in the literature as
    the Tzara house (by implication, Tristan Tzara). We know that in 1924 Tzara had few funds
    (ibid., p. 156). But Tzara married the surrealist painter Gréta Knutson in August 1925, and
    Knutson's family (whose wealth came precisely from architecture and town planning) gave
    the couple money for the new house (ibid., p. 202); the house, and its interiors, must surely
    have been the result of both Tzara and Knutson's tastes and ideas.

34  Adolf Loos (1929), cited in Safran and Wang, *Adolf Loos*, p. 64. Christophe Tzara would later
    remember how uncomfortable his parents' house was (Buot, *Tristan Tzara*, p. 206).

35  Tristan Tzara cited in Safran and Wang, *Adolf Loos*, p. 78.

36  B. Gravagnuolo, *Adolf Loos*, Milan: Idea Books, 1982, p. 188; Gravagnuolo reads the Tzara
    house in terms of poetics and estrangement, and relates its design to the films of Hans
    Richter. On the complexity of the gaze in Loos's interior spaces, see, for instance,
    B. Colomina, 'The Split Wall: Domestic Voyeurism', in B. Colomina (ed.) *Sexuality and
    Space*, Princeton, New Jersey: Princeton Papers on Architecture, 1992, pp. 73–128; Colom-
    ina notes Loos's contention that his often veiled windows are 'only there to let light in, not
    to let the gaze pass through' (p. 74).

37  See Scopelliti, 'Breton et Tzara collectionneurs'. From 1928, the two men would often
    collect together and exchange objects (Buot, *Tristan Tzara*, p. 244).

38  The best selection of images of the interiors of the Tzara house may be found in H. Kulka,
    *Adolf Loos*, Vienna: Löcker Verlag, 1979, n.p. The available documentation all shows the
    interiors without any occupants, so these inevitably appear more formal – emphasizing their
    'design' quality – than the images of rue Fontaine, which tend to include the Bretons and
    their friends.

39  Buot, *Tristan Tzara*, p. 252; J. Gaucheron and H. Béhar, 'Chronologie de Tzara', in *Tristan
    Tzara, Europe*, nos. 555–56 (July/August 1975), p. 235.

40  For a description of Tzara's study at his rue de Lille home after the war, see J. Gaucheron, 'Esquisse pour un portrait', *Tristan Tzara, Europe*, nos. 555–56 (July/August 1975), p. 34.

41  K. Srp, *Karel Teige*, Prague: Torst, 2001, p. 14. Photographs and plans of Teige's homes can be found in K. Srp (ed.) *Karel Teige 1900–1951*, Prague: Galerie hlavního města Prahy, 1994, pp. 88–91, and E. Dluhosch and R. Švácha (eds) *Karel Teige 1900–1951*, Cambridge, Mass.: MIT Press, 1999, pp. 123–28. These last two works also contain documentation on Teige's background and his complex relationship both to surrealism and to functionalism. For a broader discussion of Czech surrealism and architecture, see R. Švácha, 'Surrealismus a architektura', in L. Bydžovská and K. Srp, (eds) *Český surrealismus 1929–1953*, Prague: Argo/Galerie hlavního města Prahy, 1996, pp. 268–79.

42  G. Melly, 'Bourgeois Visionaries', *American Home and Garden*, November 1984, pp. 48–59 (p. 50); Melly reports that Magritte 'never interfered with his wife's taste'. Photographs of the Magritte home after the painter's death are found in B. Stoeltie, 'After Magritte', *The World of Interiors*, April 1986, pp. 142–49.

43  P. Nougé, *Subversion des images*, Brussels: Les Lèvres nues, 1968.

# Chapter 3

# Aragon's armoire

*Gray Read*

In the 1920s, when modern architects called for clarity and light, surrealist poet Louis Aragon described essential architecture as darkness, defined by its interiors and its closures. In plays and prose poems, Aragon evoked the box, the coffin, the room, and objects themselves – particularly manufactured objects – as containers that hold dark mysteries within. His prose lingers at doors, lids, and the visible surface of objects, exploring them as boundaries between light and dark where visible and invisible rub against one another. At these boundaries, Aragon gathered sparks of poetry in the friction between outside and inside, light and dark, as well as between words and substance. As formative Surrealist texts, much of what Aragon wrote in the early 1920s recognized ordinary buildings and objects as thresholds to a kingdom of the marvelous.

Aragon's play, *L'Armoire à glace un beau soir*, published in 1923, and his novel, *Paysan de Paris*, of 1926, can be read as complementary explorations of architectural thresholds between dark and light.[1] The play centers on a piece of furniture, an armoire, as a mythic architecture of enclosure that holds its interior darkness between a husband and wife. The novel is a stroll through Aragon's favorite haunts in Paris: an aging commercial arcade slated for demolition and a nineteenth-century landscape park, the Passage de l'Opera and le Parc de Buttes Chaumont respectively. In both the play and the novel, Aragon describes architecture as atmosphere and as boundary, building a subtle poetry of perception that moves easily between fact and dream.

Aragon engaged architecture and objects not as metaphors but as real spaces which one might enter and inhabit. He describes buildings twice,

once as matter-of-fact structures seen objectively, then again from a subject-
ive point of view, as expanding realms that one experiences physically in gra-
dations of shadow, limitless interiors, and strange artificial illumination. The
most powerful architectural moments he found at thresholds which he
describes as points of friction where two realms are simultaneously present
yet unresolved in their differences. To Aragon, they offer instants of poetic
paradox in the physical world that escape definition to stand open to imagina-
tion. In Aragon's writing, architecture is modern insofar as it is inscrutable,
resisting the light of rational explanation, and offering flight to reverie.

Through architecture, Aragon developed a critique of rationalism
based in duality.[2] In *Paysan de Paris* he wrote:

> light is meaningful only in relation to darkness and truth pre-
> supposes error. It is these mingled opposites which people our
> life, which make it pungent, intoxicating. We only exist in terms of
> this conflict, in the zone where black and white clash. And what
> do I care about white and black? Their realm is death.[3]

Only in tension or in friction are life and poetry generated, as rubbing a rabbit
fur along a glass rod generates sparks of electricity.[4]

From a broader point of view, the scintillation of darkness is an old
romantic trope nurtured among the Surrealists in night-time strolls and the
half-light of dreams and drugs. If light is reason, then darkness is error, temp-
tation and love. In the romantic tradition, night is woman, deepening into the
little death of sexual pleasure. Aragon and André Breton in particular
appended Sigmund Freud's theories of sexuality and Marxist materialism to
this general romantic sensibility.[5] They found desire and dreams to be lights
within darkness generated by contrasting images as they rub against one
another, setting both mind and body on edge and opening them to the
uncanny. Breton adopted Isadore Ducasse, the Comte de Lautreamont's
well-known definition of beauty, as "the chance meeting on a dissecting
table of a sewing machine and an umbrella." The sewing machine and the
umbrella make love.[6]

Aragon's interest in architecture and the experience of the city
was integral to this romantic literary tradition. Ducasse's definition of beauty
is found in his novel, *Les Chants de Maldoror*, and follows a description of
the quality of darkness that befell the Rue Vivienne in Paris at 8.00 p.m.
when the shops closed and the gas lights were extinguished. Ducasse
describes luxurious shop window displays as sprays of dazzling light sud-
denly shuttered and dark "like a heart that stops loving." Ducasse prowled
the streets of Paris in the 1860s finding poetry in the stark contrasts

between the luxurious image of the City of Light and its dusky passions. In the 1920s, Aragon walked the same streets to find similar shops now aged and worn in the Passage de l'Opera, one block from the rue Vivienne. In returning to Ducasse's haunts, Aragon found new qualities of light and darkness in friction at boundaries, thresholds and enclosures. Aragon discovered architecture through descriptions of existing places as well as in fiction, where he could press spatial phenomena to their limit, actually designing places in words.

Aragon explored the emotional and sexual sparks generated at architectural thresholds most pointedly in his play *L'Armoire à glace un beau soir*. The drama presents the armoire as a simple enclosure that serves as the underlying device driving the action, and then expands the implications of its architecture outward to engulf the audience. Initially the play leads the audience through three layers of enclosure from outside the curtain to a scene inside a room to the hidden interior of the armoire. Outside the curtain, several small nonsensical scenes take place: a mother and child encounter a soldier; the President and a black general grant permission for Siamese twin sisters to marry separately; a man with an extremely long nose rides by on a tricycle, and Théodore Fraenkel (one of the Surrealist group) announces that the play is about to begin. The characters exit as the curtain opens and stagehands bring a large armoire with a mirrored door onto the scene. A wife, Lénore, stands in front of the armoire with her arms crossed. Her husband Jules, holding a new hammer, returns from a journey to greet his wife warmly. She responds in fear, pleading with him not to open the armoire. The bulk of the play revolves around their overtures toward one another as their suspicions spin into elaborate lovers' games which test their affections. Is she concealing a rival in the armoire? If so, is her lover suffocating?

The armoire remains the central character of the drama, holding a mystery that opens the speculative imaginations of the couple and of the audience. The armoire shifts identity in the course of the play from refuge to tomb to a partner in dialogue returning more questions than answers in its reflective gaze. At first, Lenore protects the armoire with her body, suggesting that a violation of the box would violate her.[7] Jules carries the hammer as a tool that "can drive nails and pull them out,"[8] domestic and creative actions of a husband and a builder. Yet Lenore reads the hammer as a weapon that can force entry, harm her, and destroy the box. Jules says that has traveled the world yearning for home. "At the moment of return, the white walls offer great caresses."[9] He returns to the house, the woman, and the armoire as embedded enclosures of marital intimacy, yet she resists. Initially, Jules interprets her protestations as a game of hide-and-seek that he is disinclined

to play. He agrees never to open the armoire, "I will be happy to be a dog curled up before my Lenore at the gates of Paradise."[10] She prods him, "Odds, I have a lover."[11] Jules plays his part reluctantly out of love and habit, never believing her story: "However they hide, surely the husband will kill them."[12] The closed door of the armoire focuses the intrigue, raising his ardor as he balances on the edge of the game. Only when Lenore steps aside to allow him to open the armoire does he stop short. When she demands that he open the armoire he resists, suddenly lost, as if Pandora has left him responsible for opening her box. Finding himself slipping outside of the game, he pleads with her to prevent him from opening the door.

Immobile before the armoire, both stand fixed in place by its mirrored presence. He approaches: "This vertical lake separates you, my lambs,"[13] a reflecting surface above an unknown depth. Contemplating a possible rival within the armoire, Jules sees only himself, the cuckold, enclosed in the frame of the mirror. Their tensions encircle the closed box. Finally he breaks the glass with his hammer, she cries, he follows her offstage and the audience waits as dusk darkens the scene. He returns disheveled – but from lovemaking or from murder? He opens the armoire and the characters from the prologue emerge like clowns from a car. In halfdarkness, the door is opened, yet the riddles of the inner plot remain unsolved. When the characters of the prologue re-emerge, they return the play to its outermost layer, as if inside were outside all along. The President recites a love poem, and then the lights dim to blackness. When the house lights rise, the curtain stands open yet the stage is empty.

At one level, the drama can be read as a parody of romantic comedy. The woman alternately guards and offers entry to her armoire as the man approaches and retreats. At this level, the play is corrosively funny, exaggerating the tropes of sexual parry to an audience familiar with each move in the game. In contemporary music hall skits, armoires usually contained lovers, or at least voyeurs, and the scene of a husband returning to an unfaithful wife's boudoir had been played a thousand times. In *Paysan de Paris*, Aragon commends nickel dramas with titles such as *Saucy Springtime*, and *Flower of Sin*. "This type of theatre whose sole aim, whose sole means, is love itself is without a doubt the only one offering us a truly modern dramaturgy free of all fakery."[14] He argues that the most obviously contrived dramas are the most modern in that they contain their own parody. Aragon also praised humor in *Traité du Style*, a scurrilous diatribe hurled at contemporary literature, published in 1928. Humor, he writes, is the negative condition of poetry, the acid that strips away anti-poetry. "Humor can be found in all the great poets . . . humor is what gives an image its force."[15] Aragon found humor in the same manufactured objects that he pressed for

their surreal qualities. "Humor is what soup, chickens, and symphony orchestras lack. On the other hand, road pavers, elevators, and crush hats have it."[16]

The armoire is likewise a ridiculous object, an errant house within the house that modern architects tried to eliminate by designing built-in closets, integral to the wall. Independent of its surroundings, the armoire is a miniature that compresses the spatial features of architecture to an essence: an enclosure with a door that can open and close. *L'Armoire à glace un beau soir*, presents this essential architectural situation as a premise, and the scene plays out almost of its own accord. The armoire and two lovers (or perhaps three) engage one another in a friction generating sparks of passion that illuminate the power of architecture to conceal and reveal. The pettiness of the scene and the banality of the object only heighten its poignancy, for the drama could be any couple confronting any door.

Aragon engaged the armoire with a long and inquisitive playfulness that teased several possible readings out of the object.[17] The armoire as a threshold between light and dark, inside and outside, shifts its identity in the course of the play. After the prologue skits, the story begins when the armoire is wheeled onto the stage as an independent, portable object, a box that is small compared to the stage and the hall. The actors are lit, the house lights dim and the interior of the armoire is presumably dark. As the play proceeds, the brightness on stage grows dimmer while light reflected in the mirror becomes comparatively brighter until the armoire appears as a source of light in the only photograph of the play's performance (Figure 3.1).[18] Toward the end of the play, the stage lights have dimmed to a tenebrous haze as if the audience were also inside a box. At this moment, Jules opens the armoire and the prologue characters emerge. Suddenly, the armoire is no

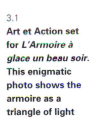

3.1
**Art et Action set for *L'Armoire à glace un beau soir*. This enigmatic photo shows the armoire as a triangle of light**

longer a container but a threshold leading from the performance hall out to a surrounding dark space backstage where the characters must have waited during the play. The lights then dim to black in both hall and stage leaving the audience in complete darkness so they no longer perceive the enclosure of the room. When the lights return, the characters of the play have retreated from the stage, perhaps passing back through the doorway of the armoire into an area beyond the view of the audience but open to the night of the city beyond. When the audience can again see their surroundings, the hall seems small and empty compared to the imaginative possibilities of the city into which the characters have escaped. This series of reversals, between light and dark as well as between inside and outside, shifts the audience's perception of their position architecturally. At the end of the play, when the audience is making a mental transition from the story back to reality, Aragon moves the fictional space of the play out into the real space of the city at night. Aragon defined the marvelous as "the eruption of contradiction within the real."[19] He suggests that the city might be both fictional and real simultaneously, as experienced through its enclosures.

In his later autobiography, *Je n'ai jamais appris à ecrire*, Aragon recalled the early years of Surrealism as a time of creative uncertainty. In the book, Aragon presented a single painting by Henri Matisse, *Porte-fenêtre* (French window), in which a window swings open to frame depthless black (Figure 3.2). In *Paysan de Paris*, he described the power of this darkness in contrast to light:

> There exists a black kingdom which the eyes of man avoid because its landscape fails signally to flatter them. This darkness, which he imagines he can dispense with in describing the light is error with its unknown characteristics, error which demands that a person contemplate it for its own sake before rewarding him with the evidence about fugitive reality that it alone could give.[20]

Darkness is a kingdom or a landscape, suggesting that its territory may extend well beyond the limits of light and reason. The French *errer* means to wander or roam. In *Paysan de Paris*, Aragon released himself into the city at dusk in the first flush of spring to find "strange flowers of reason to match each error of the senses."[21] If light is reason and darkness error then only where the two meet does one glimpse fugitive reality as if at a threshold.

While *L'Armoire à glace un beau soir* plays around the outside of an architectural threshold between light and dark, testing the emotional tension of enclosure, *Paysan de Paris* enters into shadows that resist the light of reason. "The gateway to mystery swings open at the touch of human

3.2
**Henri Matisse,**
***Porte-Fenêtre,***
**1914 (private**
**collection). This**
**painting appears**
**in Aragon's**
**memoires,** *Je n'ai*
*jamais appris à*
*ecrire*

weakness and we have entered the realms of darkness."[22] In the embrace of the crepuscular Passage de l'Opera other kinds of light emerge slowly from the darkness of material itself, as dim lights appear to brighten when the eye accommodates. Aragon describes this solid light as glaucous, "the whole fauna of human fantasies, their marine vegetation, drifts and luxuriates in the dimly lit zones of human activity, as though plaiting thick tresses of darkness."[23] Light within the passage has substance like water or like hair that sweeps against the body as one moves. Then quickly the darkness of the passage is lit with the "quality of pale brilliance of a leg suddenly revealed

under a lifted skirt."[24] In Aragon's prose, gaslights and desires flash within the air of the passage as phosphorescent sea creatures that glow when touched. The passage is an urban aquarium that contains a languid atmosphere to sustain its creatures, shape their bodies, and carry their light.

The quality of this light generated by material darkness becomes more tangible at a threshold where the poet finds himself suspended in a double light, between reality and dream. In the Passage de l'Opera he finally arrives at an opening to another street:

> Where the grotto gapes deep back in a bay . . . in the farthest reaches of the two kinds of daylight which pit the reality of the outside world against the subjectivism of the passage. Like a man at the edge of the depths, attracted equally to the current of objects and the whirlpools of his own being. Let us pause at this strange zone where all is distraction, distraction of attention as well as inattention, so as to experience this vertigo.[25]

At the grotto, he pauses between two kinds of daylight, one from outside and one from within. Light from outside the passage draws him out of the depths of poetic rumination, to take stock of his own position both architecturally and as a writer. At this threshold, he is illuminated twice: by light cast from real objects outside and by light emanating from his own subjective reveries within the passage. Two kinds of light, objective and subjective, balance one another in equal measure for one fragile instant. "Like a woman adorned with all the magic spells of love when daybreak has raised her skirt of curtains and penetrated the room gently."[26] Such disorientation also marks the moment after a play has finished and before the actors take their bows, when the story and the city are present simultaneously.

Outer light and inner light correspond with two contemporary descriptions of the phenomenon of vision. By the nineteenth century, most scientists, such as Thomas Young and Hermann Helmholtz, accepted Newton's description of light as a wave that enters the eye from outside. In 1802, they posited that the eye has three color receptors that simply respond to wavelengths of the light that they receive.[27] On the other hand, an Aristotelian tradition, embraced by artists and rendered somewhat scientific in Goethe's *Treatise on Color*, holds that the eye itself generates light.[28] Goethe investigated colors that appeared when eyes were closed, in after-images and illusions, observing that these phenomena must be produced by the eye itself. He concluded that light and color are created within the eye and mind rather than outside. Aragon notes, "scholarly men have taught me that light is a vibration . . . but do not account for what is important to me about light

... things which are the stuff of miracles."[29] Dreams, hallucinations, and sexual desire constituted for the surrealists sources of inner light generated out of corporeal darkness that is not received from outside but perceived within. For Aragon, the atmospheres and thresholds of architecture offer moments of spatial suspension between light and dark that give way to this dual experience.

The architecture that Aragon created in his prose: the armoire, the Passage de l'Opera, the grotto, and other places not considered here, can be seen as an alternative description of modern architecture.[30] Although Aragon wrote about buildings and places rather than designed them, his words construct a series of images that specify an approach to architecture. If we accept Aragon's conviction that vision and imagination were indivisible then we can read his descriptions even of existing buildings such as the Passage de l'Opera, as new constructions that bear some weight as design. The character of Aragon's buildings is clear. They are not seen from outside but from within; their form is unknown, but their light is finely tuned. Each space holds its light or darkness as a container holds a fluid or an atmosphere to support a particular kind of life within. In Aragon's architecture, thresholds between different atmospheres are moments of suspension and distraction, open to unforeseen possibilities generated in the friction between two realms. The more distant those atmospheres and the more powerful their interaction, the stronger their poetic potential as they touch. Thresholds offer a position both outside and inside simultaneously, where one may read a place objectively and experience it subjectively at the same time. In this scenario, architectural design would not be a process of composition but of alchemy, rubbing atmospheres and/or things together to see what sparks they produce. The surrealist modernity that Aragon described was sensuous, caressing the body in half-light, merging human and object and open to the possibilities of darkness.

## Notes

1   "The mirrored wardrobe one fine evening," in L. Aragon, *L'armoire à glace un beau soir*, in L. Aragon (ed.) *Le Libertinage*, Paris: Gallimard, 1924, in L. Aragon, *The Libertine* (trans. Jo Levy), London: Calder Publications, 1995. See also L. Aragon, *Le Paysan de Paris*, Paris: Gallimard, 1926, translated as L. Aragon, *Paris Peasant* (trans. Simon Watson Taylor), Boston: Exact Change, 1994.

2   Aragon adopted Hegel's method of dialectical reasoning as filtered through Karl Marx. He rejected Hegel's idealism in favor of a social materialism yet married materialism, with creative imagination.

3   Aragon, *Paris Peasant*, p. 10.

4   Rubbing a fur pelt along a glass rod was a common classroom demonstration of electricity. The sexual allusion is obvious.

5  Aragon met both André Breton and Philippe Soupault in 1917 during the First World War when they were part of a medical corps stationed at a psychological hospital in Val-de-Grace. Breton introduced them to Sigmund Freud's ideas. Aragon had read Marx by 1920 when he attended a Congress of the Socialist Party at Tours. In *Anicet ou le Panorama roman* (1921), Aragon wrote that the world was governed by minds that reasoned only on the basis of their own hypotheses. The Surrealist writers identified strongly with Marxism from the beginning. In 1923 they changed the name of their journal to *La Révolution surréaliste*, and later to *Le Surréalisme au service de la révolution*. See L. Becker, *Louis Aragon*, New York: Twayne, 1971, pp. 15–18. In 1928 Aragon met Elsa Triolet, a dedicated Russian Revolutionary who became his beloved wife.

6  I. Ducasse, *Maldoror & the Complete Works of the Compte De Lautréamont* (trans. Alexis Lykiard), Cambridge, Mass.: Exact Change, 1994, p. 193.

7  In French, both architecture and armoire are feminine nouns.

8  Aragon, *The Libertine*, p. 92.

9  Ibid., p. 94.

10  Ibid.

11  Ibid.

12  Ibid., p. 96.

13  Ibid., p. 102. This line redefines the armoire not simply as a hiding place but as an active player. It follows a short sequence in which a neighbor enters looking for her errant husband, momentarily relieving the tension between Lénore and Jules. When the neighbor exits they resume teasing one another, but Lénore will not let their game stray too far from the armoire.

14  Aragon, *Paris Peasant*, p. 108.

15  L. Aragon, *Traité Du Style*, Paris: Gallimard, 1928, p. 69.

16  Ibid., p. 67.

17  Aragon's Dada poems appeared in *Feu de joie* and *Le Mouvement perpétuel* in 1920 and 1926 respectively.

18  *L'Armoire à glas un beau soir* was performed in Paris in 1926 without Aragon's permission by L'Assaut, a company associated with Art et Action, an experimental theatre company. Partisans of the Parisian leftist avant-garde, which included both Aragon and the directors of Art et Action, questioned the validity of the artist's rights as a form of private ownership, so the absence of permission may well be a sign of approval.

19  Aragon, *Paris Peasant*, p. 204.

20  Ibid., p. 6.

21  Ibid., p. 10.

22  Ibid., p. 14.

23  Ibid., p. 13.

24  Ibid., p. 12.

25  Ibid., p. 47.

26  Ibid.

27  See H. Helmholtz, *Helmholtz's Treatise on Physiological Optics* (trans. James Southall), New York: Dover, 1962.

28  See J. Goethe, *Goethe's Theory of Color* (trans. Herb Aach), London: Studio Vista, 1971. An Aristotelian tradition describes the eye as a beacon that illuminates the scene before it.

29  Aragon, *Paris Peasant*, p. 9.

30  Another essay in Aragon's 1926 collection, "Le Libertinage," describes the apartment of a woman named Matisse. Each room is an architectural expression of a mood or state of being.

# Chapter 4

# "Home poor heart"
# The architecture of Cornell's desire

*Dickran Tashjian*

Home, poor heart, you cannot rediscover
If the dream alone does not suffice.
                    Friedrich Hölderlin, "To Nature"[1]

The Grand Hotel Home, Poor Heart has been here all along. The
architect did not so much build it as find it. But finding it was itself
a major architectural achievement for it had been so long lost it
was thought lost forever. It was found, the architect explained, by
pining for it.
                    Robert Coover, "The Grand Hotel Home, Poor Heart"[2]

Joseph Cornell and Surrealist architecture: the conjunction seems tenuous,
built on quicksand, as though we know what Surrealist architecture was, or
might be, something like that *New Yorker* cartoon, which tried to imagine a
"Surrealist family" at home during the Surrealism extravaganza at the
Museum of Modern Art in 1936.[3] Even though scattered examples of mar-
velous buildings surface in Surrealist work – survey the urban scapes and
empty streets in de Chirico's paintings, or enter the mysterious chateaux
imagined by André Breton – architecture does not immediately come to mind
when Surrealism is conjured up. No less problematic are Cornell's surrealist

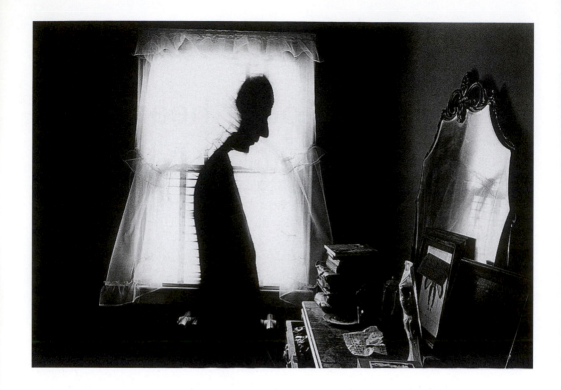

4.1
**Joseph Cornell**
© Duane Michals.
Courtesy Pace/Mill
Gallery, New York

inclinations, hardly the certainty that once allowed easy pigeonholing. One senses, too, that Cornell's manual dexterity was largely limited to paper and scissors, where his skills were unsurpassed. Eventually he learned how to construct the wooden shells that he turned into his signature boxes. But he was not an inventive builder in the easy manner of, say, Man Ray, whose witty objects suggest that he could dream with his hands.[4] With these caveats, is it possible to draw up a blueprint of Cornell's Surrealist architecture?

Let us begin by considering some boxes with architectural motifs that imply or overtly display specific architectural sites. Their significance varies within the scheme of the work. *Rose Castle* (1945) presents an engraved façade of a French chateau, which, according to Diane Waldman, probably reminded Cornell of the Plaza Hotel off Central Park in Manhattan.[5] Here surmise points to a specific site with perhaps little more than personal resonance for the artist. But knowing Cornell, that might be enough, since this miniaturized palace is certainly wonderful to behold. In another box, celebrating the young Lauren Bacall (untitled, but known as *Penny Arcade for Lauren Bacall*, 1945–1946), architecture offers a biographical detail. The viewer can spy New York skyscrapers, the Chrysler Building among them, in a frieze above the actress's face. While suggesting Bacall's Manhattan days

as a fashion model before she went to Hollywood, these towers contribute to the penny arcade as a synecdoche for the "city in its nocturnal illumination," as Cornell suggested in retrospect.[6] In yet another instance, an architectural motif is virtually submerged in a larger design, and can be easily overlooked; yet it speaks powerfully to Cornell's thematic concerns. Sandra Leonard Starr has pointed out the significance of the Pitti Palace and the Church of San Lorenzo in Florence, fragments of their ground plans collaged in *Object (Medici Slot Machine)* of 1942. From these slight visual elements, Starr establishes a web of associations that suggest spiritual renewal for the young Medici prince looking out at the viewer from the center of the box.[7]

The disparity between the visual subtlety of architectural motif in *Object (Medici Slot Machine)* and its thematic significance highlights the ways that Cornell characteristically deployed architecture as a trope in his boxes. His inclination to analogize was not limited to architectural motifs, but was part of an overarching aesthetic and cognitive preoccupation predicated ultimately on his Christian Science faith; analogizing derived from his intense literary interests and led him to modulate metaphor between visual and verbal realms. This practice was particularly suited for Cornell's metier in collage and assemblage, where juxtapositions are paramount. At play here is visual analogy, which Barbara Stafford has defined as a "metamorphic and metaphoric practice" for generating connections, always a desideratum in Cornell's sensibility.[8] As we shall see, this transformative process, predicated on his spiritual desire, conditioned the very making of his art as well as his use of space and structure in the work. Making and metamorphosis were not restricted to his cramped workspace but extended into Manhattan. Navigating its "immense horizontal and vertical disorder," as the anthropologist Claude Lévi-Strauss once noted, left its indelible mark on Cornell's art.[9]

Transforming the box

In developing his art, which first appeared in a 1931 Surrealist exhibition at the Julien Levy Gallery in Manhattan, Cornell began with flat collage and proceeded to add shallow rectangular frames, akin to Victorian shadow boxes, to his repertoire of forms, finally constructing rectangular boxes of varying depth with a front glass enclosure; these were set horizontally or vertically for frontal viewing. Cornell, however, never abandoned collage. He continued to deploy paper cutouts and glue both on the interior and exterior sides of his boxes. Cornell transcended what was seemingly a limited format by varying the interior structure of his boxes while exploring the possibilities of visual analogy. This dual strategy transformed his boxes, as Cornell himself

understood, in once referring to "one much patched up 'shell' (empty box) from a state of miserable neglect blossoming into a Cinderella-like splendor . . ."[10]

Metaphor comes into play in the generic architectural categories for boxes that Cornell made in series. Thus we have a "dovecote" or "aviary" series, which is related in turn to his "habitat" series. From shelters for animals (primarily birds), Cornell turned to a "hotel" series – but again usually nothing so specific as the Plaza or the Ritz. Finally, there is a "pharmacy" series and a "museum" series. These series denote architectural categories mainly by way of their titles, and, in any case, these categories are remarkably fluid, as some interior structures (such as grids) and motifs serve more than one category. Yes, we might surmise aviaries from the collaged birds that populate such boxes, but the "hotels" gain their identity as a series primarily from an evocative application of title to visual display.[11] Categories and boxes exert mutual attraction. The boxes serve as visual analogies for the category, often synonymous with the title, which in turn establishes a provisional identity for the box.

The transformation generated by the interdependence of box and title/category necessarily begins with the empty container, the box that will become something else, especially when a form of architecture is at stake. So when is a box not a box? We can approach this question by considering a claim offered by the critic Carter Ratcliff: Cornell's "surrealism succeeds by enclosing a bit of American space in the 'European architecture' of his boxes. The open side of a Cornell box is turned toward France in a parody of a mirror; its other sides are turned against the American space – they exclude it to make it vanish."[12] However dubious one may find notions of "American space," once posited by John McCoubrey in attempting to define an American art,[13] Ratcliff commandeers a recurring metaphor applied to Cornell's work by implicitly characterizing his boxes as shelter. "European architecture" thus protects the contents of the box from an alienating "American space," shapeless and expansive, an horizon of "unobstructed light." At its extreme, the metaphor brings to mind a soddy built on the flat prairie – a shelter for pioneer farmers against harsh winter winds sweeping across the Midwestern plains.

A soddy seems a far cry from Cornell's home on 3708 Utopia Parkway in Queens – a small, two-story Dutch colonial, a distinctly middle-class domicile. Yet the image of shelter points to a basic, perhaps *the* basic, architectural structure. Cornell's earliest objects have been rightfully called containers, which were at the outset often small circular pillboxes that held tiny objects. Mysterious and magical though they are, these small boxes are containers nonetheless. The larger, rectangular boxes that Cornell began to

build in the late 1930s also contained objects, such as small glasses or balls or clay pipes. Though the boxes remain containers, their powers of metaphor often evoke architectural possibilities, just as the smaller objects were once thought to be toys (resembling puzzles), albeit for adults.[14]

Grasping these metaphorical possibilities, Cornell categorized another series under the rubric of "pharmacy": these boxes contain small bottles, jars, or vials (often in rectangular grids) evoking the corner drugstore. Related boxes generically fell under the category of "museum." In both of these series, boxes are no longer mundane containers, but as containers they allude to specific social institutions and in turn suggest the corresponding institutional site. In a similar fashion, boxes that suggest games (and in some instances are actually playable) allude to urban spaces that were amusement zones with penny arcades, as with *Penny Arcade for Lauren Bacall*. Still other boxes suggest a theater, with a glassed-in frontal proscenium stage, most often for ballerinas, who were Cornell's favorite performers. While theatre boxes offer the closest approximation of a building-type model in miniature, all of the generic architectural boxes provide visual clues that are usually confirmed by their titles.

Once we have accepted this fundamental transformation – we are now before a dovecote, theater, or a museum, not merely a container – our response to the transformational work of Cornell's visual analogies is yet further conditioned, most often in affirmative ways by Breton's conception of the marvelous. Cornell's historical proximity to Surrealism in New York during the 1930s provided a ready-made interpretive context for this response. (Note my own characterization of his palace series as "wonderful.") Thus viewers routinely evoke a sense of the marvelous in describing their response to Cornell's boxes and collages. According to Breton, in his first "Manifesto of Surrealism" (1924), "the marvelous is always beautiful, anything marvelous is beautiful, in fact only the marvelous is beautiful." As the affirmative heart of Surrealism, the marvelous emerges from "*a juxtaposition of two more or less distant realities,*" as Breton approvingly quotes the poet Pierre Reverdy.[15] Such a definition of the marvelous as a species of visual analogy or verbal metaphor would appear to be tailor-made for Cornell's assemblage, itself predicated on juxtaposition.

In recent years, however, this affirmative view of Surrealism has been challenged, and it has carried over to Cornell, despite his preference for what he called "white magic" as against his sense of "deviltry" among some Surrealists.[16] Even as his palaces are marvelous in their luminosity (one of the characteristics of the marvelous image, according to Breton),[17] there is something nonetheless disquieting about Cornell's architecture. His dovecotes are often empty, their emptiness suggestive of abandonment. Pharmacies and

museums are sealed shut. The glass front to his boxes is as much a barrier as a window that allows us to view the interior. We press our noses to the glass with desire to see and touch treasures within, and desire turns to frustration. Invitations are seemingly tendered and then withdrawn. Not only are we denied access but also our vision is partially blocked. Boxes hold secrets.

The glass front as a window is an architectural element (both literal and metaphorical) that Cornell occasionally exploits from within by setting a face against the glass looking out at the viewer. This reversal of gaze is disconcerting, as Julien Levy, his face overflowing the frame of a blue glass, peers out at the viewer from a shallow interior space (*Portrait of Julien Levy*, Daguerrotype-Object, 1936). Cornell deploys a similar close-up in his homage to Lauren Bacall, who looks out at us with a sidelong glance. A sense of entrapment and claustrophobia has led to the charge that Cornell "imprisons" his women in these boxes.[18] Whatever we might think of such an indictment, the metaphor of imprisonment reveals the extent to which the box has been transformed – in this instance into a prison. Shelter – as implied by aviary, habitat, hotel, palace, and museum – has become a source of unease rather than refuge, safety, and hospitality.

## At home/not at home

This shift in interpreting Cornell's boxes corresponds to a shift in thinking about Surrealism. In recent years, Rosalind Krauss has brought Georges Bataille to the fore as a dark counterbalance to Breton, and Hal Foster has come to identify the marvelous with the uncanny.[19] As Nicholas Royle has amply demonstrated, the uncanny is a complicated and complex term indeed, involving, among other qualities, "hesitation and uncertainty," "ghostliness," unpredictability, "being double," and "at odds with our-selves." He finally claims: "The uncanny is a key to understanding both modernity and so-called postmodernity."[20] Against this global claim, a more telling proposal for Cornell: the uncanny begins at home. In *The Architectural Uncanny*, Anthony Vidler returns to the German "heimlich" and "unheim-lich." These two terms are related and translate as "homeliness" and "unhomeliness." Domesticity, order, comfort, loving family – all that we associate with home – play against disruption and disorder, leading to unease and alienation. The very center of bourgeois life is threatened from within.[21]

The uncanny begins at home – at 3708 Utopia Parkway in Cornell's case. His address has been a contradictory source of bemusement, on the one hand, seemingly apt for an artist who could produce so many benign and charming boxes, yet, on the other, an anomalous middle-class

enclave beyond the pale of bohemian quarters for avant-garde artists who came to Manhattan precisely to escape their bourgeois origins. This binary is not quite adequate for Cornell, who negotiated several social and cultural zones during the course of his daily existence. Unable to "leave everything [and] . . . set off on the roads," as Breton had once urged, Cornell developed a compromise pattern of excursion and return.[22] From his suburban neighborhood in Queens, where he made his boxes, he commuted to the garment district where he worked for more than a decade, and during off hours visited high cultural institutions (New York Public Library, Metropolitan Museum of Art, ballet performances, the Metropolitan Opera) and artist friends in Greenwich Village. At the same time, he also prowled the bookstalls of lower Manhattan, as well as specialty shops in seedy Times Square, in an obsessive quest for the material that was so essential for his collage and box-making.[23] In his wanderings, this quintessential urban artist was always tethered to Utopia Parkway – discovered treasures, their retrieval home, and transformations in basement studio inextricably linked.

At home, Cornell was the ever-dutiful son who cared for his widowed mother and Robert, his younger brother who suffered from cerebral palsy. A Christian Scientist who eventually taught at Sunday school, Cornell commuted to Manhattan for almost two decades in desultory employ until deciding to become a freelance graphic designer by the end of the 1930s. His was not an idyllic life but certainly one that met middle-class expectations. He was born on Christmas Eve, coinciding with a major American holiday that centered on the family at the hearth, lovingly engaged in the exchange of gifts in a celebration that emphasized children. The family idyll was disrupted by the death of his father. Although young Cornell attended Phillips Academy in Andover, Massachusetts, he did not matriculate at Harvard or Yale University, which would have been the birthright of Andover students at that time. Instead he was constrained to support his widowed mother as well as his siblings. The family moved from Nyack, New York, eventually to their small house in Queens, where Cornell lived his entire adult life as a bachelor. Surely Cornell harbored some regrets for what might have been, and in any case retained memories of an idyllic childhood.[24]

Looking back late in her life, Cornell's mother praised Joseph and Robert: "Sometimes I feel no one Mother deserves two such devoted sons as mine. Never thinking of themselves – only what they could do for me – and needless to say my single aim was what I might do for them." Entangled though they were in idealized relationships, it was ultimately their deep care for one another that generated daily frustrations and disappointments. Living in close quarters as they did, with Robert virtually helpless, domestic relations were inevitably strained on occasion. Home life could be "claustrophobic," as

Cornell once complained to Marianne Moore, and no matter how much he found Robert a "joy," he also confessed a " 'ball and chain-linked' feeling" toward his brother, who required constant care. Adding to the unhomeliness of their household was Cornell's admission of frequent migraines, "head-splitting business" and "depressing lethargy." Cornell was clearly at odds with himself, displaying a pattern of contradiction and ambivalence that runs throughout his letters, notes, and diary entries.[25]

Against this dismal litany of household woes Cornell was able nonetheless to find what he called "the transforming moment," appreciating "great joys that unfold in our little quarter-acre . . . Despite bewildering never-ending crises upon crises." His favorite sanctuary at his doorstep was "in the back yard under the Chinese quince tree . . ." A 1969 photograph of Cornell situates him reposed in an Adirondack chair, at home within himself, radiating a beatific quality: "[W]hat a moment what an eternity in a moment," as he recorded on another occasion in his diary. Unlike his mother, who idealized her life with her children through a one-dimensional template, Cornell moved between the polarities of "vile days of sluggishness – depressing lethargy" at one extreme and "a serenity rarely attained" at the other.[26] Homeliness and unhomeliness were inextricably bound together, as the uncanny took its toll on Cornell.

Cornell's quests for those moments of grace were integral to his art making, a process that extended from Utopia Parkway to Manhattan and back again. As matriarch of the household, his mother exerted a sense of order that clearly was not Cornell's. Initially working late into the night at the kitchen table in cramped quarters, he was eventually constrained to move his workplace to the basement and the garage. Displacement and homecoming were central tropes in the self-examinations of his diary entries. Often lost in "endless and hopeless chaos" in his cellar workshop, he nonetheless claimed to be able to see his way "through this labyrinth and feel at home enough among it many 'bypaths of romance' . . ." Against the satisfactions and frustrations of the workshop were the enticements of going into Manhattan, what Cornell ironically called his "metropomania" or "wanderlust." Excursions were often fruitful, fueling an "anticipatory pleasure" for an outward-bound Cornell, who could experience a "morning felicity of city life" that lent "a transcendental touch of joy," or a "beautifully poetic mood" while in the vicinity of Manhattan's Bryant Park.[27]

Cornell's mission was to rescue ephemera, by definition short-lived and vulnerable to the depredations of a callous world, to bring his discoveries back to Utopia Parkway, ultimately to find them a home in the appropriate box or collage surface. The lure of the hunt was not, however, always successful. In his diary, Cornell complained about a "miserable

muddle stemming from 42nd Street jaunt evening & its unrelenting fiasco."
Even the joy of rescuing an ephemeral treasure was mitigated upon returning
home, noted by a disgruntled Cornell: "Return to the HOUSE more a night-
mare of clutter than ever – adding fuel to the fire with more loot in shopping
bags."[28] Transformations in reverse: his home now a cluttered house, his
treasures now mere loot. Dream become nightmare.

This sad turn of a day, however, obscures the way that home and
not-home, studio and hunt were two sides of the same coin, dramatized by
Cornell's return, as he stood at the threshold of Utopia Parkway, not so much
caught between two zones as hovering in the ambivalence of his desires.
While household difficulties could send him out the door, he always looked
back, rarely escaping except in a transgressive dream: "[L]ast night escapist
dream," he wrote, "but wonderful – into train not knowing destination – set
off without paying fare." More often, he recognized conflicting desires,
recording, with some relief, "One of best days at home (feeling right without
having to get away)." On another occasion, he decided to go to the garden,
where he experienced "gratitude" for "being rid of a feeling of always
wanting to be somewhere else." "Mental clearing," so necessary for
working in basement, was "so often coincident with shaving and getting
ready to go out. The feeling of creation that so often only seems to come
with leaving home and is invariably lost on returning."[29]

This unsettling from within suggests that Cornell's empty hotels
were hardly homes away from home but way stations to undisclosed desti-
nations. Cornell's art struck closer to home after the deaths of Robert and his
mother. In 1966 he sadly noted: "[C]losing time creeping up already (this
phenomenon of 'empty house' living)."[30] What was closing down? The
house or his life? In 1972, just before his death, Cornell invited Duane
Michals to take a series of photographs at Utopia Parkway. In what
amounted to collaboration, the photographer's images of Cornell were self-
portraits of the artist at home – but a home that is gray and desolate, visited
by the uncanny. Matching the desolation of the house, Cornell himself
becomes a wraith, staring into an empty mirror, haunted by his losses and,
ultimately, by his dreams.

Imaginary solutions

*Home, Poor Heart (For Hölderlin)*, a light-filled collage of the 1960s, alludes to
a line that Cornell noted in his copy of Frederic Prokosch's 1941 translation of
Hölderlin's poems. "To Nature" concludes: "Home, poor heart, you cannot
rediscover/If the dream alone does not suffice." Speaking across the

centuries in homage to the poet, Cornell responds with an image of a young woman in Victorian dress, turned away from the viewer. Standing in an indeterminate space, she looks over an Alpine vista as two doves glide toward her. The bright colors and clarity of this edenic scene match the imagery of the poem, whose narrator's "heart, which once was filled with heaven,/Now lies sterile as a field of stone." Cornell made at least four different versions of this collage. The one illustrated in Figure 4.2 is titled *Isle of Children*,

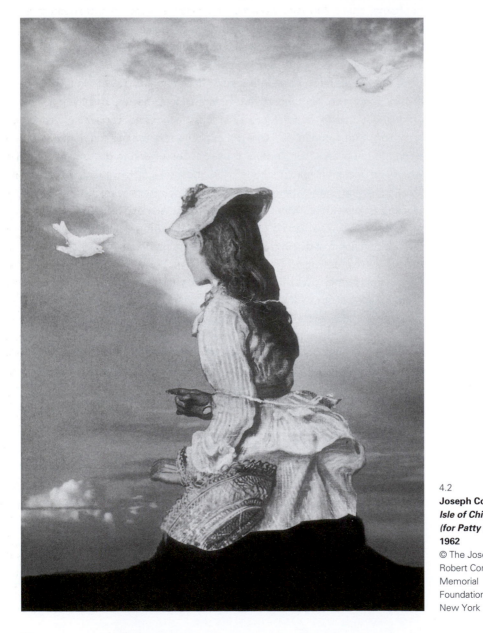

4.2
**Joseph Cornell,**
***Isle of Children***
***(for Patty Duke),***
**1962**
© The Joseph and
Robert Cornell
Memorial
Foundation/VAGA,
New York

lending emphasis to childhood, and shows the young woman elevated above the Alpine tree line and standing against the sky. On the back of the collage Cornell pasted a silhouette of an urban skyline. Was Manhattan a source of alienation or a treasure-ground of ephemera that would retrieve a golden past? Recalling the poem years later, Cornell would have increasingly identified with the narrator's spiritual despair. The collage's title, excised from the poem, is thus ambiguous. By concentrating on home and heart while omitting the crucial conditional clause, is Cornell relying on the dream alone to take him home, or does he sense Breton's admonition, "Existence is elsewhere"?[31] The doves have not alighted.

## Notes

1   F. Hölderlin, *Some Poems of Friedrich Hölderlin* (trans. F. Prokosch), Norfolk, Conn.: New Directions, 1943, n.p.

2   R. Coover, *The Grand Hotels (of Joseph Cornell)*, Providence, R.I.: Burning Deck, 2002, p. 58.

3   See C. Rose, "A Surrealist Family Has the Neighbors in to Tea," cartoon, *The New Yorker* (January 2, 1937), p. 19.

4   This is not to say that Cornell was not an excellent craftsman in designing and realizing the interior (and exterior) surfaces of his boxes, including the set-up of interior elements.

5   D. Waldman, *Joseph Cornell: Master of Dreams*, New York: Harry N. Abrams, 2002, p. 38.

6   Cornell claimed in 1962 that "the 'penny arcade' [of the Bacall box] symbolizes the whole of the city in its nocturnal illumination/sense of awe and splendor/its overwhelming poetic 'richesse' available for not even a penny – appealing side of it despite violence in darkness" (Archives of American Art, Microfilm Roll 1061, frame 458). The documentary aspect of the skyscrapers is reiterated in another tower – an eighteenth-century French folly called, in the Chinese manner, "Pagode de Chantdeloup" – that served as the prototype for the "Crystal Cage" Cornell constructed as dossier portrait for Berenice.

7   S. Starr, *Joseph Cornell: Art and Metaphysics*, New York: Castelli, Feigen, Corcoran, 1982, pp. 39–49.

8   B. Stafford, *Visual Analogy: Consciousness as the Art of Connecting*, Cambridge, Mass.: MIT Press, 1999, pp. 8–9.

9   C. Lévi-Strauss, *View from Afar* (trans. J. Neugroschel and P. Hoss), New York: Basic Books, 1985, p. 258.

10   Diary entry, Archives of American Art, Microfilm Roll 1059, frame 588.

11   Yet another grouping involving celestial motifs might be titled an "observatory" series, yet in the main they are not. So much for consistency in identifying a site by generic title.

12   C. Ratcliff, "New York Letter," *Art International* 14 (September 1970), p. 90.

13   See J. W. McCoubrey, *The American Tradition in Painting*, New York: George Braziller, 1963.

14   For a summary account of Cornell's early work as "toys," see D. Tashjian, *A Boatload of Madmen: Surrealism and the American Avant-Garde, 1920–1950*, New York: Thames and Hudson, 1995, pp. 245–246.

15   A. Breton, "Manifesto of Surrealism," in *Manifestoes of Surrealism* (trans. R. Seaver and H. Lane), Ann Arbor: University of Michigan Press, 1969, pp. 14, 20.

16   For Cornell's attempts to distinguish himself from the Surrealists, see Tashjian, *A Boatload of Madmen*, pp. 242–243.

17  Breton, "Manifesto of Surrealism," p. 37.

18  "Imprison" is my word, to encapsulate, perhaps simplistically, a complex psychological argument presented by Jody Hauptman, especially in her discussion of the Bacall box in J. Hauptman, *Joseph Cornell: Stargazing in the Cinema*, New Haven, Conn.: Yale University Press, 1999, pp. 55–83.

19  See, for example, R. Krauss, *L'Amour fou: photography & surrealism*, New York: Abbeville Press, 1985, and H. Foster, *Convulsive Beauty*, Cambridge, Mass.: MIT Press, 1995.

20  N. Royle, *The Uncanny*, New York: Routledge, 2003, Chapter 1, "The Uncanny: An Introduction," pp. 1–38.

21  A. Vidler, *The Architectural Uncanny: Essays in the Modern Unhomely*, Cambridge, Mass.: MIT Press, 1992, pp. 3–14.

22  Breton, quoted in M. Nadeau, *The History of Surrealism* (trans. R. Shattuck), New York: Macmillan, 1968, p. 67.

23  For the best itinerary of Cornell's peregrinations around Manhattan, see A. Temkin, "Habitat for a Dossier," in *Joseph Cornell/Marcel Duchamp ... in Resonance*, Ostfildern-Ruit, Germany: Cantz Verlag, 1999, pp. 79–94.

24  For Cornell's biography, see D. Solomon, *Utopia Parkway: The Life and Work of Joseph Cornell*, New York: Farrar, Straus, and Giroux, 1997.

25  I have trawled Cornell's comments directly from his material deposited at the Archives of American Art (henceforth "AAA") and distilled in M. Caws (ed.) *Joseph Cornell's Theater of the Mind: Selected Diaries, Letters, and Files*, New York: Thames and Hudson, 1993 (henceforth cited as "Caws"). Mother's letter to dancer Tilly Losch, January 2, 1966 (Caws, p. 323); TLS to Marianne Moore, May 30, 1945 (Caws, p. 123); diary entry, May 20, 1963 (Caws, p. 304); letter to Wayne Andrews, March 10, 1967 (Caws, p. 356); diary entry, October 3, 1968 (Caws, p. 408); diary entry, July 14, 1956 (Caws, p. 210).

26  Diary entry, December 29, 1961 (Caws, p. 286); letter to Jackie Monnier, undated (Caws, p. 305); letter to Mina Loy, July 3, 1951 (Caws, p. 175); diary entry, January 14, 1962 (Caws, p. 286); diary entry, July 14, 1956 (Caws, p. 210); diary entry, December 29, 1969 (Caws, p. 447).

27  TLS to Marianne Moore, May 30, 1945 (Caws, p. 123); letter to Charles Henri Ford, June 16–17, 1957 (Caws, p. 228); diary entry, January 18, 1958 (Caws, p. 231); diary entry, August 15, 1944 (Caws, p. 111); diary entry, June 11, 1956 (Caws, p. 208); diary entry, August 23, 1956 (Caws, p. 213).

28  Diary entry, May 26, 1969 (Caws, p. 428); diary entry, January 31, 1970 (Caws, p. 450).

29  Diary entry, September 29, 1959 (Caws, p. 245); diary entry, April 15, 1946 (AAA, Roll 1059, frame 8); diary entry, August 17, 1945 (Caws, p. 120); diary entry, February 20, 1945 (AAA, Roll 1055, frame 921).

30  Diary entry, September 28, 1966 (Caws, p. 342). Cornell quoted Victor Seroff on Maurice Ravel (Caws, p. 439): "After the death of his mother Ravel never returned to their apartment at 4, avenue Carnot; his friends persuaded him to stay away from the place where every object brought painful memories of his loss. For almost 4 years Ravel did not have a home of his own" (*Maurice Ravel* [New York: Holt, 1953]).

31  "To Nature," *Some Poems of Friedrich Hölderlin*, n.p.; Breton, "Manifesto of Surrealism," p. 47. Breton's concluding lines to the manifesto run: "It is living and ceasing to live that are imaginary solutions. Existence is elsewhere."

# Chapter 5

# Matta's lucid landscape

*Bryan Dolin*

> Matta tore away from gravity and plunged into the ether.
>
> Patrick Waldberg, *Surrealism*[1]

It is unfortunate that Roberto Antonio Sebastián Matta Echaurren's artwork was trapped within a bordered canvas; otherwise it might have exploded into the most vibrant structural designs and psychic panoramas ever seen. As a second generation Surrealist, Matta was a commanding Latin American artistic pioneer for the twentieth century. He is best known for his dazzling "inscape" paintings, which sought to search the interior depths of the psyche analogous to evocative metaphors of the natural landscape.[2] But from an early beginning in Chile, Matta's drawings reveal unique otherworldly forms that stem from a powerfully introspective and experimental consciousness. Dazzling, exotic, morphological mayhem is as much a theme in Matta's early work as an architectural framework in Euclidian and non-Euclidian geometry.[3] His journey to Paris in the 1930s to work for Le Corbusier set the tone for a lifetime of rhythmic, humorous, colorful, chaotic, and wildly emotive art. He firmly believed "reality can only be represented in a state of perpetual transformation," and his initial pictures reflect that sentiment through many provocative forms.[4]

A service to his charming character, Matta was more than willing to discuss his own art, and the words he used often balanced eloquent critiques with punning, tongue-in-cheek observations. Additionally, intricate theories and whimsical thinking are luminously reflected from even his most basic pencil sketches. The drawings Roberto Matta produced as a young man in the late 1930s provide the influential maturity and creative basis for his entire body of work.

Matta shares his very personal abstracted methodology in his art.[5] After graduation from programs in architecture and interior design at the Catholic University of Santiago in Chile around 1935, he caught his first glimpse of Europe while serving in the Merchant Marine. A young, imaginative visual lyricist, Matta began a significant series of drawings that documented his observations of the geographic and biological wonders of modern earth. Over the course of these travels he explored highly wrought models of plants and vegetation by probing their organic cross-sections and neurological forms. There was an individual, internal mode that harmonized concepts of Matta's universe as illustrative references to an ever-changing landscape.[6] He wasn't merely a practitioner so much as a pioneer for the subconscious. Notably, during these formative years (between 1935 and 1937) prior to joining the Surrealist movement, Matta worked faithfully with crayons and pencils before ever even considering using a paintbrush.

Geometric models and spaces behave as enigmatic labyrinths in Matta's earliest drawings. He felt that his drawings were about "landscapes at the speed of botany, prayers in the true sense of the term, exercises of individual poetry related to desires sometimes unknown."[7] One particular journey in the spring of 1935 from Peru to Panama laid the foundation for an early paper composition, *The Isthmus of Panama*.[8] Employing only pencils and watercolors, Matta physically mapped the southern peninsula, representing its full landmasses through two tangled nude figures (Figure 5.1). Curling tentacles drift like coastal boundaries as the naked mingle within the drawing resembling free-floating microorganisms, but a subtle use of shadow underneath the characters suggests a grounded geographic placement. There is certainly an early flirtation with Matta's fascination in biological structures in *Isthmus*.[9] As he noted, "plants and embryonic forms are intuitively understood as transformations akin to human changes."[10] While people live in symbiotic alliance with the natural world, Matta is asserting the existence of both conscious and subconscious associations in the biological and psychological sense. This drawing's imaginative organic style boldly distresses the common map as navigational fodder for the *compos mentis*.

As morphology imparts a recurring narrative of reality, *Isthmus*'s reflection mirrors Matta's career push to Europe.[11] While in France during the late 1930s he developed a thematic tendency to depict landscapes as subconscious scenery. Matta's close friend, the art critic Onslow Ford, described these terrains as being full of "maltreated nudes, strange architecture, and vegetation."[12] As an architect for Le Corbusier from 1935–37, Matta masterfully honed his design skills but continued to work with the exploration of space in his own pictures by rapidly applying the automatist practices introduced to him by new friends Salvador Dalí and André Breton.[13] Matthew

5.1

**Roberto Matta, *The Isthmus of Panama*, 1935, pencil and watercolor and paper, 9½ in × 14½ in (24.1 cm × 36.8 cm)**

Gale described this initial impact on art when he observed: "[Matta's] visionary works in crayon carried some of the charge of [André] Masson's early automatic drawings but were fired with an intense use of psychic concentration."[14]

Matta quickly took to automatism, which he defined as the ability to "read at the speed of events . . . the irrational and rational run parallel and can send sparks into each other and light the common road."[15] Although he favored his own internal observations over the popular fascination with Sigmund Freud, his unique outlook and experimentation won him approval with Surrealist headmaster Breton. Matta elaborated: "A landscape is at peace whenever there is no visible catastrophe. Life is not just anthropomorphic, it is also feats of boldness, equations, and bursts of energy."[16] Mathematics and science were clearly playing as pivotal a role in Matta's drawings as aesthetics. Matta believed one could learn as much about art from Albert Einstein as Freud.[17]

Though leaving behind the daily practice of architecture after joining the Surrealists in 1937, Matta's trade in structural modernism had given him a powerful and technical command over intricate Euclidian methods of spatial representation.[18] Space would take on a new role as his drawings respond to Breton and Paul Éluard's notion of a "physics of poetry."[19]

An untitled graphite and crayon on paper drawing from 1938 exhibits a departure from Matta's original automatist examinations of hollowed vegetables and fauna in favor of investigating the landscape as a breeding ground for grids and abstract figures (Figure 5.2). Within this environment pale sprouting phallic forms punctuate a bright, latticed panorama. Above a dune-marked horizon hover three planetary orbs. Directly below these moon rocks, Matta distributes three holes that suck all the

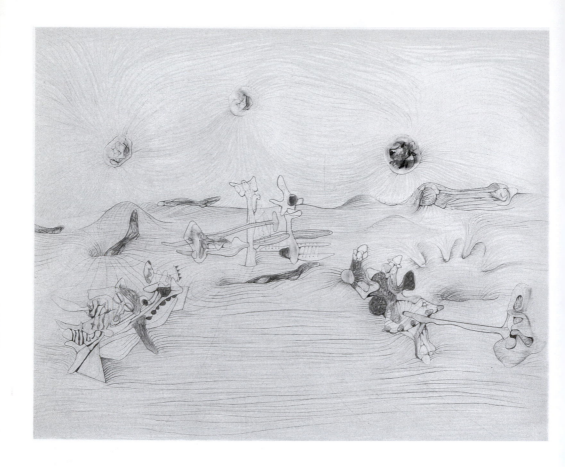

foliage to an unknown destination. Anthropomorphic configurations and organic growths within the drawing begin to take on erotic human forms emerging from the earth.[20] Matta has certainly made the most out of using only primary and secondary colors, literally applying only yellow, blue, red, and green to scrutinize the spasmodic chaos unfolding on paper. Author Valerie Fletcher commented that Matta succeeded at vividly representing a "physical space with its intersections and transformations in dynamism."[21]

Surrealists believed that organic forms were in harmony with growth and vitality, a contention that people could visually relate to raw structure over geometric abstraction.[22] Biomorphism, the concept developed by Jean Arp during the 1910s, revealed the depiction of "organic, semiabstract shapes derived from elemental sources in nature such as clouds, water, eggs, rocks, plants, and microscopic organisms."[23] Matta's biomorphic shapes appeared in convulsive spaces, using free association over constructed rigidity.[24] His colleague Octavio Paz wrote of such drawings that they displayed "a marriage of passion and a cosmogony of modern physics and eroticism."[25]

5.2
**Roberto Matta, Untitled, 1938, graphite and crayon on paper, 18 in × 22½ in (45.7 cm × 57.2 cm)**

The exploration of botanical science in Matta's art gave way to the study of his own psychological morphology beyond 1938. Matta had characterized subconscious morphology as thought in graphic form, a means of displaying visually the many different conditions of consciousness.[26] Providing a decorative thematic identity, the new horizon took on the shapes of large, unbalanced linear webs that were spread into his earliest oils. These paintings broke up the canvas into bold, thick grids that performed like ink-stained clouds of thought being trapped in the mind. Matta's intrepid swirling of color, using brushes and household rags created semi-transparent spaces and subconscious abstract symbols. These "inscapes," as they became known, acted like radiant dreamscape windows for the hidden psyche and produced both two- and three-dimensional effects on the same plane.[27] His penchant to use few colors continued, but new, fantastic sights of inestimable realities emerged. Valerie Fletcher elaborated: "[Matta] painted abstract images of states of continuous evolution, whose metamorphosing colored forms express a primordial struggle for equilibrium in a cosmos dominated by opposing forces."[28] The inscapes resembled Matta's inner self as they took on both conscious and subliminal forms by showing the uninterrupted conversions between mental statuses.[29]

Before his voluntary exile to New York with other Surrealists during the Second World War, Matta continued to enlarge his visual style, with linear webbing as the new, perspective-skewed landscape. Biomorphic forms were persistently utilized to become benchmark architecture. There was a push toward figure-based paintings later in his lifetime, but Matta's work always maintained a youthful sense of technical wonder and awed excitability. A renegade creativeness dictated his poetic balance between the landscape and groundless for the rest of his long career. Definitely an early influence on the Abstract Expressionists, Matta's perspective always seemed a few steps ahead of his contemporaries As he spiritually alleged, "A world is a nexus of vibrations."[30]

Born of an inner reality, Roberto Matta's drawings of the 1930s suggested, in pure construction, surrealist dream world landscapes never before perceived.[31] Nicholas Calas astutely expressed Matta's work as "replacing the repressed microcosm with the unobtainable macrocosm."[32] The many influences he obtained, physical and internal, indefinite and multifaceted, facilitated in creating an ever-evolving artistic vision that spanned seven decades. Matta's identifiable imagery and techniques were masterfully culled from countless acquaintances, and certainly from the personal landmark events of his history. An automatist soothsayer, he acted as a visionary guide for technologies unimagined. Octavio Paz further suggested Matta was "an isthmus, not between continents but between centuries."[33]

Roberto Matta's purpose to surpass the escalating makeover of progressive perception opened the Surrealist movement to new observations in art and the natural world.[34] Constructed in a poetic manner, his drawings provide a metaphorical critique on our own inner lives and personal intimacies. Matta always carried beyond the canvas; the movement one can see in his work is a private glimpse to the progress of the artistic mind. He tapped into his own subconscious like few ever will and pulled forth a sweltering psychoanalytic beauty that was in harmonious conflict with physical reality. The prophetic poet of psychological morphology, Matta will be remembered for redefining the subjective landscape. As an automatist architect for the surreal, a lucid demeanor fit his otherworldly ideas like a glove. Roberto Matta has left his mark on the earth and is now probably breathing the poetry in space.

## Notes

1 P. Waldberg, *Surrealism*, London: Thames and Hudson, 1965, pp. 38–40.

2 V. Fletcher, *Crosscurrents of Modernism: Four Latin American Pioneers*, Washington: Smithsonian Press, 1992, pp. 231–281.

3 M. Sawin, *Roberto Matta: Paintings and Drawings 1937–1959*, Beverly Hills, Calif.: Latin American Masters/México, DF: Galería López Quiroga, 1997.

4 Sawin, *Roberto Matta*, p. 5. Swain also notes that "Using these multiperspectival transparent structures in combination with opaque planes and translucent washes Matta created spaces that seemed to break the time barrier in the sense that they represented many places and points in time."

5 E. Smith, "Crushed Jewels, Air, Even Laughter," in *Matta in America: Paintings and Drawings of the 1940s*, Chicago and New York: Museum of Contemporary Art, 2001, pp. 11–29.

6 Smith, "Crushed Jewels," p. 20.

7 V. Ferrari, *Matta: Entretiens Morphologiques*, Notebook No. 1, 1936–1944, London: Sistan, pp. 30–31, quoted in Fletcher, *Crosscurrents of Modernism*, p. 241.

8 Fletcher, *Crosscurrents of Modernism*, p. 241.

9 Fletcher, *Crosscurrents of Modernism*, p. 239.

10 E. Carrasco, *Matta conversacione*, Santiago: Ediciones Chile y America, CESOC, 1987, pp. 59–60, quoted in Fletcher, *Crosscurrents of Modernism*, p. 253.

11 Fletcher, *Crosscurrents of Modernism*, p. 233.

12 O. Ford, *Towards a New Subject in Painting*, San Francisco: San Francisco Museum of Art, 1948, p. 11, quoted in Smith, "Crushed Jewels," p. 12.

13 Fletcher, *Crosscurrents of Modernism*, p. 239.

14 M. Gale, *Dada and Surrealism*, London: Phaidon, 1997, p. 352.

15 Matta, quoted in Swain, *Roberto Matta*, p. 4.

16 Carasco, *Matta*, pp. 59–60, quoted in Fletcher, *Crosscurrents of Modernism*, p. 253.

17 Sawin, *Roberto Matta*, p. 3.

18 Sawin, *Roberto Matta*, p. 3.

19 Breton writes in 1927: "Just as contemporary physics tends to be based on non-Euclidian systems, the creation of 'surrealist objects' responds to the necessity of establishing, according to Paul Éluard's decisive expression, a veritable 'physics of poetry,'" Waldberg, op. cit. pp. 38–40.

20 The "great transparents," as vitreurs were also known, showed up heavily in Matta's work by 1944. The paintings *Grave Situation* (1946) and *Wound Interrogation* (1948), completed during the late 1940s, and the drawing *Life Insurance* (1951), best represent the transparent figure.

21 Fletcher, *Crosscurrents of Modernism*, pp. 239–241.

22 Fletcher, *Crosscurrents of Modernism*, pp. 239–241.

23 Fletcher, *Crosscurrents of Modernism*, pp. 239–241.

24 Fletcher, *Crosscurrents of Modernism*, pp. 233 and 241.

25 Fletcher, *Crosscurrents of Modernism*, p. 277.

26 Ferrari, *Matta*, p. 72, quoted in Smith, "Crushed Jewels," p. 13.

27 Fletcher, *Crosscurrents of Modernism*, p. 247.

28 Fletcher, *Crosscurrents of Modernism*, p. 241.

29 Fletcher, *Crosscurrents of Modernism*, p. 241.

30 Sawin, *Roberto Matta*, p. 6.

31 Valerie Fletcher notes that Matta's "images of upheaval, combining destruction with creation, may have served as a personal metaphor for his own situation as a voluntary exile: separated from his old world yet embracing the turmoil of destruction and creativity in his new world" (Fletcher, *Crosscurrents of Modernism*, p. 239).

32 N. Calas, *Art in the Age of Risk and Other Essays*, New York: Dutton, 1968.

33 Fletcher, *Crosscurrents of Modernism*, p. 279.

34 Sawin, *Roberto Matta*, p. 6.

# Chapter 6

# Menace
## Surrealist interference of space

*Silvano Levy*

The destabilization of space was one of the means through which surrealist subversion challenged the architectural paradigm within which reason orders tangible reality. Space, after all, is defined through the architecture that contains it, as well as the architecture that is contained within it.

The significance accorded to de Chirico by the surrealists was in no small way due to the Greek-born painter's capacity to enfeeble spatial mapping by expunging the codified cues that make it comprehensible. Space in de Chirico's work is characterized by a sense of incompleteness: perspectives are deficient, temporal markers are imprecise and the animated occupation of space is never overt. De Chirico's architectural space is expressed in terms of potentialities rather than assertions. It is a diluted space that falls short of the finite and within which possibilities rather than occurrences prevail.

Taking a tack that is encapsulated by the now famous phrase 'ceci n'est pas...', Magritte takes the further step of challenging three-dimensional assertion. He refutes the rational architectural model by blatant negation. In a systematic manner, he engages in a defiance of the conventions through which space has come to be comprehensible. He pictorially subverts the precepts that make up academic painting and then goes on to disrupt their utilization. For Magritte the painting was a 'construction' and, in his view, was capable of being deconstructed. Magritte can be said to have 'dismantled' form and space. As in the case of de Chirico, he renders space

ambiguous. But he also goes on to deform it further by revealing it as para-doxical and fragmentary. Magritte erodes the codification of the 'logical' space that epitomizes the familiar.

Seizing on Magritte's revelation – the tremendous reliance placed on the familiar by the habits of thought – the British surrealist Conroy Maddox set about conducting his own form of challenge to the sense of familiarity and reassurance that we have been conditioned to expect from the architectural environment. Maddox's work deregulates and disrupts space by depriving it of its anchors with the familiar. As does Magritte, Maddox not only forces objects and beings into unlikely juxtapositions but also distorts them and denies them their normal uses. But, for Maddox, such deregulation is by no means conclusive. It is a prerequisite. It sets the stage for what he regards as the surreal 'event'. As well as disrupting contextual space Maddox goes on to allow a particularly uncomfortable form of distur-bance and dislocation to pervade within it. Maddox discards the ordered and structured environment in order to fill the resulting void with very specific subversive forces – those that emanate from menace.

No such sinister and affective undercurrents enter the work of Magritte, however, who is generally content to exploit the rules and conven-tion of spatial depiction in an essentially conjectural iconoclastic manner. From the 1920s he clearly embarks on a systematic and primarily 'intellec-tual' attack on the pictorial tradition that had been drummed into him during his formal art school training. As opposed to what will be shown to be Maddox's disturbingly emotive response to architectural space, Magritte incorporates it into his oeuvre in a manner that, whilst being subversive, remains within the bounds of a detached and impassive form of negation.

By his own account, Magritte considered the academic study of anatomy and of perspective as indispensable.[1] The briefest of surveys of Magritte's production would indeed confirm that he was well versed in and overtly practised the techniques of academic painting. Sylvester points out, for example, that the complicated perspective of *La Géante* (1931) is likely to have been based on diagrams seen in the textbook on perspective used at the Brussels Academy of Arts.[2] It was this in-depth knowledge of the con-ventions of representation that allowed the painter to conduct a poignant subversion of their application; indeed, the rules of traditional painting are flouted in an overt manner throughout his work. But it was particularly from about 1924 to 1930 that this inobservance of the principles of figuration emerges as particularly acute. During that time Magritte undertook methodi-cally to single out and disrupt the precepts laid down by academic painting regarding the formulation of space. He had stated that the painting was 'a constructed object': he clearly considered it capable of being dismantled.[3] In

effect, he 'deconstructed' form and space with the aim of launching a systematic critique of academic pictorial construction.

The origin of the formal principles that had formed the basis of the painter's training at the Academy can be traced back to the fifteenth-century writings of Leon Battista Alberti, who was the first to systematize the stages of construction of a painting or a sculpture. In 1435 (or 1436) Alberti had written:

> youths who first come to painting [should] do as those who are taught to write. We teach the latter by first separating all the forms of the letters which the ancients called elements. Then we teach the syllables; next we teach how to put together all the words. Our pupils ought to follow this rule in painting. First of all they should learn to draw the outlines of the planes well. Here they would be exercised in the elements of painting. They should learn how to join the planes together. Then they should learn each distinct form of each member.[4]

It is through an essentially linguistic taxonomy that Alberti identifies discrete elements within the pictorial construct. He begins by equating the verbal primaries, 'letters', to his concept of pictorial primaries, 'the outlines of planes'. He then advances that in a subsequent stage of pictorial construction these 'elements' join together, just as 'letters' are grouped into 'syllables', to form planes. The linguistic analogy at this point arguably extends to the phonological level since the notion of linguistic constraints acting upon and determining permitted sequences of sounds is itself echoed in Alberti's insistence that there must be a sense of appropriateness in the ways in which planes can be combined. These combinations are, in turn, said to result in the depiction of the 'member'; that is, the smallest part of the image which has an independent semantic value and which could, tenably, be termed a 'pictorial morpheme'.

The analogy between the elements of language and the basic principles of graphic construction is, in fact, quite consistent and Alberti implies that all the 'stages of painting', that he goes on to detail, can be equated with the progressive lexical and syntactical linguistic strata. For instance, the elementary skill that he requires of painters, that 'they should learn each distinct form of each member', clearly involves a selection from the various graphical possibilities and a capacity to give the unitary shape the identity of an isolated symbol. Each shape is regarded as a component of the various classes of concurrent alternatives and it is from these that an appropriate 'kind' of form is deemed to be selectable. The painter, Alberti

insists, should discriminate between 'the rough wool cloak of a soldier' and 'the clothes of a woman'. Should he fail to make such distinctions, and, for example, depict 'a figure whose face is flesh and full' as having 'muscular arms and fleshless hands' he is regarded as having shown an inability accurately to select from categories which themselves are correctly combined.

What Alberti does is to make the fundamentally *linguistic* distinction between selection and combination, which becomes particularly apparent in his definition of the 'three parts' of pictorial construction. Here he expressly distinguishes between the *interrelation* of objects and their faithful representation or *identification*. The text details a first stage of painting, termed 'circumscription', which involves 'the drawing of the outline' and so, the definition, in two-dimensional terms, of the space occupied on the panel. The outline thus acts as a boundary between the internal or 'semantic' description of the object and its external situation or 'syntactic' relations with other objects. Indeed, our primary means of recognizing an object 'involves separating (it) from its background'.[5] Second, Alberti describes graphic concatenation, 'composition', as 'that rule in painting by which the parts fit together in the painted work'. This 'grammar' of the picture predetermines a clear hierarchy of relations. As already mentioned, 'planes are parts of the members': in addition, 'these members are parts of the bodies'. Moreover, the overall regulatory force that orders the arrangement and relations of each object in the composition is 'l'istoria'. This 'greatest work of the painter' is defined by Jean Clair as 'the composition of bodies, their relations, their intervals'.[6] Composition, in Albertian terms, comprises the rules of contiguity, both within objects, and so determining how planes and members are joined, and between them. In this respect, Alberti's perspective construction is clearly central to the determination of spatial sequence. Finally, Alberti treats the plastic representation of the object, which he calls 'reception of light'. By means of this 'stage' the object is given 'light and shade' as well as colour and texture. The reception of light entails the final technical procedures, which turn the various parts of the painting into well-nuanced, or semantically precise, objects.

It is against this background of formal and extremely systematized rules that Magritte formulated his affront on the notion of space and form laid down by formal art. Because of the discrete (compartmentalized) and stratified (hierarchical) nature of the procedures involved in academic painting, that the linguistic comparison has highlighted, it was possible for Magritte to conduct his affront in a focused manner. Not only was he able to subvert individual aspects of the stages of painting, but also he was to do so in a selective manner.

The convention of painting from which Magritte most blatantly diverges, and with which this discussion will concern itself, is that of 'composition'; that is, the 'grammar' of painting. This facet of the painter's contestation is clearly evidenced in *Cinéma Bleu* (1925), which disrupts the relations between the objects that it depicts. The pictorial device of perspective, which normally has the function of unifying the elements of a composition, emerges here as absent or intermittent. The reason why the painting gives an initial impression of random order and lack of co-ordination is that there is imprecision in the chief device by which pictorial context is defined: the illusion of depth and space. The intelligibility of pictorial space, 'composition', is disrupted in such a way that the objects in *Cinéma Bleu* appear impossible to locate accurately in space. In fact, it is the particular technique used by Alberti to define space, and therefore composition, 'dividing the pavement' that is directly contradicted in *Cinéma Bleu*. The most problematical aspect of the painting is the floor area. Although the painting may seem to depict a straightforward theatrical set, there are certain representational inconsistencies which undermine the illusion of a flat, horizontal 'pavement'. For example, in spite of the presence of a high light source originating from the right, confirmed by the skittle and the columns, no shadows are cast and, as a result, the single figure in the painting, that of a slender woman in a model-like pose, does not appear to be standing on the ground but rather to be hovering in the air. Assuming that the 'floor' exists at all, the inconsistency of its relations with the elements of the painting in general makes it an equivocal space with only contingent possibilities of interpretation. Indeed, this floor can be read, at various points in the painting, as any gradation between a horizontal plane perpendicular to the picture surface and a vertical plane parallel to it. As already implied, the general setting (the flanking red curtains, the rudimentary classical scenery, the grimacing, poised figure turning away from a toppled object) conveys the impression of a theatrical situation, and this urges us to understand the lower grey area as a flat stage floor. At the same time the concept of horizontality is contradicted: the lower folds of the curtain on the right, which apparently rests on the floor, are neither vertical nor horizontal but slant down towards the spectator to form a vague slope. Thus the ground area is distorted in such a way that it appears sloped. This reinterpretation of the pavement is itself put into question when we notice that the 'stage floor' appears to be a downward continuation of the bottom riser of the classical façade, and so, far from being construed as a horizontal plane, the so-called 'floor' is upright.

These various readings of the perspective do not, however, abut against one another to produce positive boundaries at which opposing interpretations clash and conflict. The effect is more that of an informal structure

that admits ambivalence. Space in *Cinéma Bleu* is inconsistent and so perspective loses its unifying force. Whereas the exaggeration of perspective in, for example, de Chirico's *Melancholy and Mystery of a Street* (1914) brings pictorial elements into a tense, brooding proximity, *Cinéma Bleu* alienates objects by reconciling incompatible viewpoints. Obviously, Magritte here is ignoring Alberti's insistence on compositional cohesion and instead adopts a somewhat arbitrary pictorial arrangement. It would even be possible to consider the structure of *Cinéma Bleu* as being more akin to that of many shop window displays, with their vague, illusory settings and their deliberately unexpected arrangements of objects, than to formal composition.[7] With this parallel in mind, together with the theatrical undertones of the painting, *Cinéma Bleu* could very well be construed to allude to a 1920s fashion design, with which Magritte, who had prepared advertisements and catalogue covers for the fashion house Norine, was familiar. It may not be incidental that the slim, fluid figure in *Cinéma Bleu* closely resembles Norine (Honorine Deschrijuer) herself, with her slight build and bobbed hairstyle. Certainly the rolling skittle is clearly related to the stylized tailor's mannequin that appeared in one of Magritte's numerous advertisements designed for Norine. What is significant about *Cinéma Bleu*'s similarity with commercial advertisements or fashion displays is that it reinforces the view that the painting rests on principles that are independent of formal composition.

An example of this pictorial inconsistency would be, say, the foreground skittle. On the one hand, its highly polished surface, its highlights and shading make it a solidly modelled object in the round, but it also casts shadows neither on the floor nor on the curtain and so its position in relation to these two elements remains unclear. It is not possible to deduce whether the skittle is on the floor or on the curtain, or indeed whether it is on both or neither. Certainly it is situated behind the post of the 'Cinéma Bleu' sign, but we have no idea about how far. According to José Vovelle, perspective here has been abandoned to such an extent that the links between objects, or rather their relative positions, are only definable as 'la simple succession de plans' and not as sequences in space.[8] In fact, Magritte goes further and does not permit even this tenuous method of situating objects. Evidently, if each object is gauged by the one that precedes it, then the intelligibility of the structure of the whole painting relies on the situation of the foremost element. Since this foreground object, the signpost, is rooted below the lower edge of the painting there is no fixed point of reference at all. So the positional 'composition' is disrupted. The 'Cinéma Bleu' sign, in itself, stresses the overall disruption of the concept of a unified, self-regulated composition. The effect, for example, of the arrow is to turn an otherwise

affirmative label into a pointer to a context beyond the picture boundary. The arrow indicates that the words 'Cinéma Bleu' have nothing to do with what is represented in the painting. The arrow is, in fact, a digressive device which is in keeping with a bias in *Cinéma Bleu* towards compositional disassembly: in opposition to the arrow pointing to a centre of interest on the right, the woman glances to the left and, similarly, the implied rising motion of the balloon opposes the tumbling down of the skittle. The painting displays a lack of compositional control: objects are grouped without achieving the concatenating correlation prescribed by Alberti. *Cinéma Bleu* is a defiance of the 'grammar' of pictorial space. It takes a step away from compositional clarity and towards spatial imprecision.

While in *Cinéma Bleu* the plastic representation of objects is sometimes inconsistent, it is uniform and explicit in *La Fenêtre* (1924 or 1925). Here physical shape is immediately conveyed and objects are clear and simplified. Moreover, the spatial setting appears to be as well defined as the objects. For instance, in conformity with the rules of perspective, the pyramid sharply recedes into space, as does the top of the rectangular block, which slopes towards the vanishing point. In the landscape outside the window, the path bordered by diminishing posts, leads towards, and so establishes, a horizon. A clear distinction appears to be made between the distant external scene and what is inside. The landscape could even be said to show signs of aerial perspective or that, as Alberti put it, 'as the distance becomes greater, so the plane seen appears more hazy'. Yet, on closer inspection the impression of a well-defined space soon crumbles. The inconsistency in the reception of light between the pyramid, illuminated from the right, and the rectangle, illuminated from the left, is indicative of a fundamental disruption of the spatial composition. Magritte places an insubstantial form between the horizontal plane that supports the pyramid and the supposed vertical edge of the window. This form simultaneously lies on both surfaces and consequently puts into doubt their mutual perpendicularity. This creates uncertainty about what is close and what is far away. The hand, obviously inside the room is about to grasp a bird which perspective should have put out of its reach.

This confusion of relative distances is characteristic of Magritte's questioning of the way in which perception makes sense of the visible world. He also uses this particular device in *Une Panique au Moyen Âge* (1927), where the foreground figure is vertically connected to a smaller, more distant figure partially outside a window. As in William Hogarth's *Whoever makes a Design without the Knowledge of Perspective*, which deliberately confuses planar proximity with distance constructed by perspective, *La Fenêtre* and *Une Panique au Moyen Âge* create a compositional confusion between two

otherwise distinct spatial settings, inside and outside. The phenomenon is further demonstrated in Magritte's *A la suite de l'eau, les nuages* (1926), in which the distant clouds *outside* are shown to continue into the foreground *inside* space through a window. Furthermore, the suggestion of what can be called a reversed perspective construction occurs in other paintings of this period, such as *La Fatigue de vivre*, in which an obverse vanishing point is indicated

But it is particularly in *L'Oasis* (1925–27) that a 'Chinese perspective' is evident. In opposition to Alberti's concept of the painting as 'an open window through which I see what I want to paint' and a 'cross-section of a visual pyramid', and so as an illusory space in which scale decreases as the distance from the viewer increases, the table in *L'Oasis* sharply diminishes towards the foreground and thus disrupts the conventional systematization of space. Instead of controlling the representational context, perspective here confuses the expected sequences in depth and relations of scale. The clouds in this work, generally depicted as the most distant and largest elements in a landscape, are reduced in size, and some of them even appear in front of the three trees in the foreground. The painting as a whole shows a progressive contraction in scale and a corresponding reduction in the distances between objects as the foreground is approached. The impression of infinite space and size in the distance contrasts with the proximity of various foreground elements, since not only are the clouds brought down to meet the trees, but also the blue sky is not fully extended upwards. As though the Albertian perspective construction had been totally inverted, the viewpoint seems to be from the opposite end of the perspective pyramid. The impression is that of seeing the whole scene 'from behind', with all the expected sequences in space and scale reversed. Moreover, at the point of the perspective pyramid where the theoretical orthogonals would approach their point of intersection the represented space diminishes and positional relations become indistinguishable. Accordingly, at this hypothetical 'focus' of *L'Oasis*, the table and the trees merge together, as objects are seen to do on the horizon of a 'conventional' painting, where the reducing transversals are finally superimposed.

Another implication of this subversion of Alberti's pictorial control is the disaffirmation of the very basis on which perspective is constructed: the assumed position of the observer. An important concept for Alberti is that 'both the beholder and the things he sees will appear to be on the same plane' – in other words, that the spectator should be assumed to be directly in front of the painting. What Magritte's disruption of pictorial space does is to put into question this traditionally fixed relationship between the observer and the painting. It is true that, already in the sixteenth century, Erhard Schön

had drastically modified the frontality of the spectator's viewpoint, but Magritte goes further by actually reversing this viewpoint and perhaps dispensing with it altogether.

To return to the former consideration of the pictorial pavement, we have so far noted that whereas for Alberti the intelligibility of the ground area is a prerequisite for the 'composition', the floor spaces in *La Fenêtre* and *L'Oasis*, as well as in *Cinéma Bleu*, are incoherent and thus bring about a degree of ambiguity in the space depicted. Basically, the confused state of the pavement in these paintings arises from the inadequacy and absence of perspective cues. But in a small number of paintings of 1926 which contain crossed lines on the ground, perspective can be seen to become positively contradictory. Far from alluding to the 'converging tramlines' of perspective, these intersecting lines establish an irresolvable polyvalency of the ground. Although the lines in the lower half of *Georgette* (1926) appear to designate a surface of shallow pyramids, it is impossible to interpret the pavement as a consistent alternation of peaks and hollows. Due to a lack of shading, each 'pyramid' has two alternative readings, and so the way in which we perceive the polygons is subject to continual reappraisal. The uppermost part of each pyramid can also be interpreted as the base of another. Furthermore, if we consider the various undulations as a continuum, the overall sequence becomes problematical. Pictorial space in *Georgette* is also confused by the unclear sequential relations of the objects depicted. As in the case of *Cinéma Bleu* it is not possible to establish 'a succession of planes'. But in *Georgette* this results from conflicting rather than inconclusive compositional ties. The skittle, for example, could be positioned behind a framed picture of Georgette, which depicts the portion of the skittle which it hides, a situation similar to that in the much later *La Condition humaine* (1933). Consequently, the continuous blue background and the shadow cast on the skittle would indicate that we are looking at an empty frame through which the skittle and Georgette are visible. However, in this instance, Georgette's shoulders would not overlap the edge of the red surface and so, as with the polygons, either interpretation is eventually perceived as untenable. The observer is confounded by the mistaken assumption that the pictorial cues indicate alternative readings: if one option is not admissible the other one(s) will be considered to be correct. As Judith Greene observes in a general sense:

> In a binary situation to affirm one possibility is the same as denying the other possibility. Similarly, a negative statement that one event is not the case amounts to an assertion that the other event is the case.[9]

In *Georgette* neither alternative is plastically valid. The negation of one possibility is accompanied not by the affirmation of the other but by a further negation. The arrangement of objects differs from the ambiguous illusion in that the suggested interpretations are equally unlikely rather than being equally probable.

Magritte's defiance of Albertian pictorial syntactics has thus far been seen either to deny the painted object a precise locational resolution or to place it in a paradoxical situation. In the paintings of the 1920s there is a third type of decontextualization in which the lack of definition in the relationships between objects arises from another state – that of *isolation*. Composition is not determined by an incomplete or polyvalent grammar but by what could effectively be termed pictorial 'agrammaticality'. In certain works there emerges a discontinuity between meaningful units that is comparable to the medical condition of aphasia. As in this linguistic defect, there are interruptions of the contextual continuum: the potential interrelation of semantic units would be evidenced but frustrated. In opposition to Alberti's caveat that the parts of the painting should 'fit together', pictorial elements are kept apart. Such is the situation in *Le Dormeur téméraire*, in which a sleeper is confined in a wooden box and six objects are set into a slab made of concrete or lead. As opposed to the suggested movement of the swirling clouds in the background, each of these objects is frozen in a fixed position. They rest in tightly-fitting recesses outside of which they have no significance or influence. The mirror does not reflect its surroundings and the candle casts no light. No compositional concatenation bridges the spaces between the objects to give them relational ties and, instead, each niche is a self-sufficient, insulated space. The static, quasi-ornamental arrangement of the objects denies them all semblance of potential activity. The rigidity of the candle's niche, for instance, seems to remove the possibility that the wax may be consumed. The objects are permanently inert and out of context. Just like the objects below him, from which he is compositionally distinct, the figure is firmly encased. The box in which he lies is just long enough to accommodate him, and his body is almost totally enveloped in a blanket. This immobile pose is further emphasized by the fact that the sleeper's face sinks deeply into the pillow, echoing the way in which the objects are pressed into their niches. Furthermore, each element in *Le Dormeur téméraire* is not only confined laterally and in depth but it is also intercepted frontally by the picture plane. Both the edge of the box and the bottom of the slab touch the picture edge and thus 'press' the objects against the foreground plane that acts as a transparent surface, hermetically sealing each encasement. As opposed to Alberti's requirement that 'both the beholder and the painted things he sees will appear to be on the same plane', Magritte paints the

sleeper's box in such perspective that the viewpoint is above the top edge of the canvas and therefore removes any direct correlation between the observer's space and the painted space. Equally, the painting itself is not like 'an open window' giving onto an illusory, extended space. Beyond the 'cross-section of [the] visual pyramid' that separates the observer's space from the painted space, *Le Dormeur téméraire* evidences only spatial occlusion. As opposed to the dissipation of a common setting in *Cinéma Bleu*, brought about by an inconsistency of spatial relations, *Le Dormeur téméraire* presents an inventory of elements in a clear, voluminous setting which itself inhibits compositional ties. Although the implied dynamic divergence of objects in *Cinéma Bleu* contrasts with the rigid inertia of *Le Dormeur téméraire*, in both paintings individual objects are effectively alienated from one another. Whether objects have an indeterminate area between them or whether they are deprived of peripheral space, the overall effect in these early paintings is that of spatial fragmentation.

Magritte's disruption of academic composition can be seen to occur on three levels. Pictorial space is first rendered ambiguous, then paradoxical and, finally, it is fragmented. In all of these cases the result, and probably the intention, is a mitigation and counteraction of the dominance of formal artistic practice in figuration. By painting in direct defiance of received convention, Magritte effectively dismisses the supposed supremacy of Albertian precepts in the pictorial depiction visible phenomena.

Such formalistic subversion was not, however, the only use to which the surrealists put the notion of architectural space. They also saw it as a privileged setting where surreality, in its widest sense, was thought most likely to arise. This was particularly true of the spaces and streets created by the architecture of the city. It was among anonymous streets, nameless buildings, roadside hoardings, monuments, shop window displays and street signs that chance encounters and meaningful coincidences were, according to the surrealists, ready to spring into existence. The cityscape was seen as a place pregnant with unrecognized potential. The adventures in Breton's novel-diary *Nadja* (1928) and the enigmatic aimless wanderings recounted in Aragon's *Le Paysan de Paris* (1926) all occurred in the streets, cafés and arcades of Paris. Both poets believed that surrealist revelation was most attainable in such public 'elective places'. For them the street represented a place of anonymity, inactivity and aimlessness, where the conditions were right for arbitrary and accidental events to take place. It was where rationalism and volition were dethroned in favour of the incomprehensible and the marvellous.

The intrigue with what Aragon termed this 'modern mythology' of the city environment was shared in a significant way by Conroy Maddox,

much of whose work dwelt on the enigmatic potential of place. Maddox repeatedly painted settings that, whilst being grounded in commonplace urban reality, simultaneously revealed a vision far removed from the mundane. His unremarkable pavements, streets, walls, passages, squares, arcades and courtyards served as stages on which ambiguous and paradoxical dramas were acted out. What is significant about the civic environment is that it is regulated, banal and unchanging, making it the perfect symbol for all that is knowable and dependable in reality. In undermining its certitude Maddox engages in a fundamentally surrealist endeavour. His way of challenging the sense of familiarity and reassurance that we derive from an environment to which we have become accustomed creates a sense of disquiet and calls into question all habitual convictions and expectations. In this way the entire civic fabric and, by extension, objective reality itself, begins to be distrusted. Maddox deregulates and disrupts the architecture of public space by depriving it of all that is familiar. Within it he not only forces objects and beings into unlikely juxtapositions but also distorts them and deprives them of their normal uses. For him, the city, its streets and its architecture become vehicles for inscrutable mysteries and unconscious discoveries. As in *Nadja* and *Le Paysan de Paris*, the surreal event in Maddox's paintings is often accommodated within and generated by the apparently innocuous, reassuring man-made public environment which has come to be regarded as benign, stable and inoffensive. As if to jolt us from a complacent view of our surroundings, it is from within the known and the familiar that Maddox allows a disturbing and dislocated world to erupt. In his work the ordered and structured urban environment is opened up to forces and mutations that, in the prosaic sense, would normally be alien to it.

Clearly, such subversion can only arise within the confines of the known and the familiar, and indeed, just as Breton and Aragon had identified and even named the streets and buildings that provided the settings for their startling narratives, so Maddox goes to great lengths to depict real and recognizable locations for his derangements of civic tranquillity. In this way he was in a position to defy certainty and reason: he provided just the conditions for an interference with an extant normality. For instance, the location in *Lancaster Arcade* (1984) is not only identified with its official name but is also faithfully based on a well-known wooden arcade with iron railings built in 1873 which ran between Todd Street and Fennel Street in Manchester, England. It is within this factual setting that Maddox proceeds with his subversion – by placing two prowling tigers on the upper gallery he totally perturbed the usual ambience of the secure enclosed space of the arcade. In Maddox's rendering of this normally innocuous constituent of the urban infrastructure those that happen to be

passing by, unsuspecting shoppers and shop assistant, are transformed into potential victims of a grisly end. Similarly, *The Secluded Station (Richmond Station Yorkshire)* (1973) faithfully depicts a real British provincial railway station in North Yorkshire that appears to have stopped functioning normally. Not only is there no sign of human presence, but also the entire public space appears in the process of being invaded by a mass of monstrous plants that threaten to take over.

House of Dreams I (1976), portrays another real building – this time in the United States, according to Maddox – that is surrounded by cryptic events (Figure 6.1). As in the case of the provincial railway station, where intimidating vegetation was seen spreading over the station platform, extraneous elements destabilize the changelessness and stability of the public setting – a burning curtain, complete with rail, flutters down from the sky with the menace of arson, a log fire burns ominously in the foreground as though poised to kindle a more devastating conflagration, and a clutch of sinister large eggs lies dormant, possibly on the verge of hatching into horrific avians or reptiles, that would put an end to the uneasy tranquillity.

6.1
**Conroy Maddox,**
*House of Dreams I,*
**1976, oil,**
**30 in × 38 in**
**(76.5 cm × 96.5 cm)**
Collection Katherine Emma Jones, Cheshire

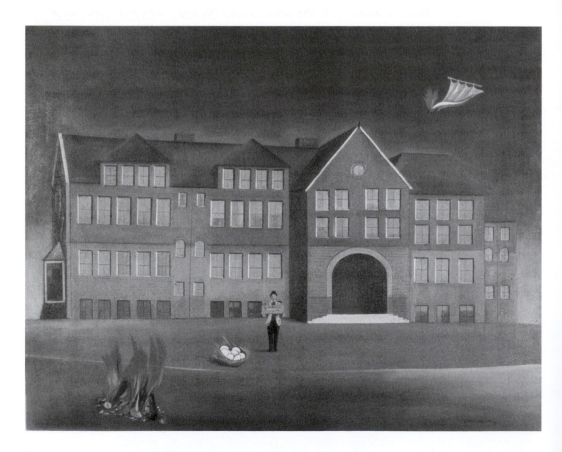

Moreover, the peril posed by each of these peripheral elements is a material one. In the case of the solitary figure that stands motionless in the middle distance, the 'threat' occurs on the psychological level. In a gesture of explication and clarification, the smartly dressed man stands to face the spectator and holds up a plaque for him or her to decipher. But the symbolic message, a dead fish, remains unintelligible. The sign that beckons from the mysterious 'house of dreams', and possibly provides the key to its essence, is impossible to interpret. Maddox confronts us with the unknowable. Despite its communal, 'civic' appearance and its large unbarred doorway, the building assumes an incomprehensibility which turns it into an inhospitable, disconcerting place. In no uncertain terms Maddox defamiliarizes the public space.

The same is true of *The Lesson* (1938) in which an ordinary street becomes the stage for a perturbed, nightmarish spectacle (Figure 6.2). Four windows in the façade of an apparently ordinary house allow the spectator to look into various rooms, where it would have been reasonable to expect homely scenes of suburban domesticity. But what Maddox presents could not be further from the everyday. He brings together four unrelated and incongruous situations that conjure up a sense of tense co-existence. At one of the upper floor windows a woman appears to be on the verge of jumping

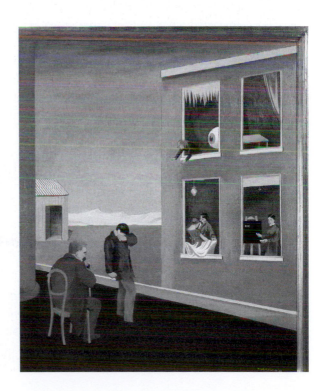

6.2
**Conroy Maddox, *The Lesson*, 1938, oil,
31.5 in × 28 in (80.5 cm × 70.2 cm)**
Collection Jeffrey Sherwin, Leeds

out: overcome with panic and terror as a huge eyeball approaches her, she calls out in a crazed frenzy. Her alarm and helplessness is made all the more intense by the apparent nonchalant indifference of an elegantly dressed couple calmly dancing in the room immediately below. This discordance between the two settings creates a sense of estrangement. The same is true of the activities in the lower two rooms – the light-hearted diversion in which the dancers are engrossed is, in turn, opposed by the formal setting of the adjacent school classroom. There, a mistress is beginning her lesson and appears to be waiting for an answer from her unseen pupils. Totally oblivious to either the joviality close by or of the disquiet overhead, the teacher conducts her lesson with a stern sobriety. The sense of disjunction is intensified still further by the view into the fourth window that, in contrast to the activities and sounds that emanate from the other rooms, reveals a total lack of animation. We see an unoccupied dining table and vacant space – a scene of inactivity, absence and silence. The nature of the disjunction goes further than simply synchrony, however. The contradictions and inconsistencies between the four scenes make it impossible for the composition to be read literally: the activities presented in the various rooms could hardly be construed as simultaneous events. Maddox here could well be recalling a scene from a film with which he was familiar and admired: Cocteau's *Le Sang d'un poète*. In this surrealist work of 1930 numerous rooms of the so-called *Hôtel des folies dramatiques* are presented not so much as material spaces but as 'compartments' of the unconscious. In the same manner, Maddox's compartmentalized, ostensibly 'domestic', scenes could well allude to episodes in a dream: as in a dream, they are both disjointed whilst remaining continuous. That we may not be seeing a representation of the material world is further suggested by the fact that the house, together with its contents, is placed within a type of theatrical setting. Two onlookers, one of whom is seated, appear to be watching the entire spectacle as though it were on a stage. Their reactions to the scene in front of them are, however, totally opposed. The older, seated man is unperturbed by the turbulent events, whilst the younger figure reacts emotionally, shielding his eyes in horror or shame. It is as though the older man is imposing a 'lesson' by exposing the youth to a psychological revelation. The young man shuns the evidence that is being presented to him, just as, according to Freud, we all would fear a confrontation with the contents of our own unconscious.

On some occasions such digressions into the psychological domain were brought about by Maddox's actual experiences. In one work he depicts what was, in effect, a shift from physical reality to the realm of desire. As he had recounted, this occurred after a trip abroad when a mundane event had undergone a startling transformation:

Whilst motoring in the South of France with a friend, I stopped near what turned out to be a railway station. I was so fascinated with the station building that I took a photograph. Some years later I decided to paint that station, but in the process a certain trans- formation took place, which I was not completely conscious of.[10]

The painting in question, *Gare St. Rambert d'Albon* (1972), reveals the extent to which unconscious motives had mingled with the direct recol- lections of that day in France to produce a recast reality. In the deserted street in front of the meticulously painted railway building, complete with its name sign, power cables and glimpse of a waiting train carriage (Figure 6.3), Maddox placed a lion prowling ominously towards some open doorways. What he painted was not so much a recreated holiday photograph as a memento of a state of mind. At the time of the trip he had a close friendship with Pauline Drayson, the woman with whom he was to share twenty years of his life, and it is possible that his 'creature' passions were not far from his thoughts. It may have been those passions that subsequently determined the final format of the painting: the allusions conjured up by a male lion homing in on the 'female' apertures of the doorways are transparently sexual. Also, the absence of other people, the inevitable result of the sudden appearance of a lion, may not have been an altogether undesired state of affairs for Maddox at the time. Given the romantic situation from which it arose, *Gare St. Rambert d'Albon* can be seen as an expression of affection towards a loved one. It is a work in which commonplace reality gives way to

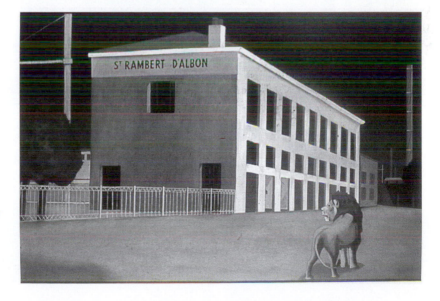

6.3
**Conroy Maddox,**
***Gare St. Rambert***
***d'Albon II*, 1980,**
**oil, 27½ in × 35½ in**
**(70 cm × 90 cm)**
Collection Pauline
Drayson, London

unconscious motivations. Significantly, a second version was painted as a gift for Pauline herself.

A very different motive underlies the modification dramatized in *Winchester Walk* (1973) (Figure 6.4). Again, as Maddox explained, the source of his setting was that of a known urban location. 'The full title of that painting', he pointed out, 'is *Winchester Walk S.E.1.*, a real place.' It is within that benign and, to a Londoner, familiar reality that the estrangement takes place. The assurance and security, represented by the beckoning mother at the window, are overridden by a much more prominent peril:

> In the painting there is a young girl, who could be Alice, who is particularly vulnerable. She is threatened by something she is unaware of.

The threat is certainly extreme. Maddox disrupts the ostensibly tranquil street scene, as it is perceived by the unsuspecting young girl, with the

6.4
**Conroy Maddox,
*Winchester Walk
S.E.1.*, 1973, oil,
25½ in × 30¼ in
(65 cm × 77 cm)**
Private collection,
Cheshire

imminent mortal danger of a large bear on the loose. He paints the moment before a bloody calamity. In an extreme way, he undermines the assurance and reliance that is normally invested in the supposedly tried and tested world of normality where we ought to feel safe. Often in Maddox's work, such alarming dramas and deformations, which suggest that street life is laden with uncertainties and insecurities, are coupled with a generalized feeling of desolation. Michel Remy has written that 'Maddox's city is an anonymous city since its constituent elements, be they architectural or human, take away all its authority and identity'.[11] Maddox's urban space disintegrates into unapproachable voids, into crumbling masonry, into meaningless forms, into indistinct items neglected under dust covers. He creates a sense of emptiness and abandonment. From the scenes he depicts, it would seem not only that most of the ordinary inhabitants had departed long ago but also, judging from the lawlessness of those who are left behind, that the guardians of the peace had deserted their posts as well. Nothing is left of normal civic life. The metropolis that Maddox portrays is one that has ceased to function normally.

This state of debilitation has the effect of accentuating the dangers that Maddox places in the city. The threats appear all the more destructive and potent when nothing remains to thwart them. What he does is to show not so much that order and control are being opposed but that they have already been overrun and invalidated by converse pressures. The 'derangements' of security that Maddox invents appear more as inevitable outcomes of an already anarchic and menacing order of things. Instead of being places where individuals can have at least some expectation of being free to come and go with assurance, the streets depicted in certain of Maddox's works are laden with extreme threats, traps and mortal perils. In some extreme cases, civic space is seen to be disrupted by fierce bestial forces drawn from the most chaotic and disturbing facets of a very different and unfamiliar realm – that of the natural world.

In one painting this threat takes the form of a giant wasp, which visibly gnaws at the stones of buildings. In other works the relative safety of interior settings is seen to be penetrated by devastating elemental forces: rocks fall in avalanches, fires spontaneously erupt, fierce animals run wild and cause havoc. Maddox depicts a chaotic world that has been confounded and disorganized. At times the city in Maddox's work ceases to offer any type of control and protection. It becomes a place where order and security have been totally overruled by tumult and destruction. It is not infrequent, in this phase of paintings, that Maddox evokes explicit acts of violence and ferocity. If we do not actually see the bloodstained victim or the fatal catastrophe, we certainly see the protagonists who are likely to bring about an

assault, molestation or a cataclysmic event. In one painting a wild elephant charges towards an otherwise innocuous covered walkway. In another, a road turns into sea and swallows up an ocean liner. In what is often regarded as Maddox's foremost depiction of urban estrangement, *Passage de l'Opéra* (1970), a lion uncloaks itself as it prepares to pounce on some unsuspecting office clerks, those ultimate representatives of discipline and decorum, who are seen taking their midday stroll in the ostensibly reassuring setting of a Parisian covered arcade.[12] Any sense of civic security and tranquillity becomes irrelevant when conflict and agitation are seen to prevail. Outlandish events and horrifying protagonists become the norm in certain paintings.

At times Maddox does not stop at merely giving the suggestion of impending danger. He transforms mere *feelings* of anxiety and of imminent threat into *actual* conflict. In the ironically titled *A Quiet Street* (1978) he paints a girl being savaged by a pack of four dogs at the corner of a deserted street in broad daylight. It is not difficult to imagine the atrocious mixture of howling and screaming. The total absence of passers-by makes the victim helpless, particularly since a sinister, gigantic face is impassively watching the girl's molestation from an opening in a shop façade. It is as though the only witness condones the carnage taking place. *Rue de Seine* (1944) shows another public setting where rational control and decorum disappear in a similar manner. The painting not only dispels all sense of tranquillity, but does so in a multiple manner: a demented man throws himself out of a window, hysterical women are violated and forcibly dragged out of their homes and an unconscious victim lies supine on a sacrificial pedestal. All restraint is abandoned in this work and the dignified bowler-hatted men seen in *Passage de l'Opéra* reappear in a different guise: totally devoid of their prior confident, self-satisfied air, they now obey a new bestial order that appears to be dictated by an anthropomorphic bull who presides with fists defiantly placed on his hips. Symbolic of the beast within us all, he orchestrates a nightmare of abduction, terror and violence. Public places and their civic buildings are, in no uncertain terms, overrun by the dictates of desire, even when that desire culminates in torment, savagery and death.

*Communal Living* demonstrates just this. Ostensibly, the work depicts the very bland and impersonal vista that Maddox observed day after day from his office window, while he was working for Tate Advertising in Crystal House, Luton. The façade that was so familiar to him, with its unremarkable windows and regular architecture, is painted in a monotonous deadpan manner – Maddox even picks out a long, drab drainpipe running down one wall. But the triteness of the setting is disrupted in a multitude of ways. In a sensational suicide, a young woman leaps from the rooftop. At the

same time a curtain has begun to burn at one window, posing the threat of general conflagration. At another window, wooden boarding has been smashed open, possibly indicating a prior fatal plunge. Moreover, even the other, seemingly vacant, rooms conform to the disruptive ferocity of the rest of the painting. Although, apart from tables and curtains, these scenes appear unoccupied, infrared photography has revealed that Maddox had originally filled them with scenes of extreme violence, which he subsequently painted out in an act of self-censorship. In these, women are gagged and bound and diverse forms of sadism are depicted.

According to George Melly, even when run-of-the-mill reality is depicted in Maddox's work, it serves as a springboard for a conspiracy against mundane existence:

> Each picture is a statement provoked by some 'event' of no didactic or symbolic importance, but suggestive of an order of poetic necessity in direct opposition to the precedence insisted on by the pushers of reality.[13]

It is in opposition to its essentially regulatory and restrictive nature that the urban space and its buildings are forced into a deranged form of transformation. What is immediately dispensed with is the purely matter-of-fact picture of reality to which conventional art has clung for centuries in favour of dialectical distance. Magritte had sought to destroy the stability of the constructed environment in a cerebral manner, by taking away its logic. Maddox, on the other hand, shows that the architecture of space, particularly that of the urban setting, can become the stage for mental convulsion. As Michel Remy writes, 'Conroy Maddox's whole oeuvre is obsessed by the unveiling of the city's other side, the city's dual reality'.[14] The civic construct and the psychological constraints that are coupled to it are challenged by Maddox to the extent of being negated. Common sense and all the barriers to free thought that the conscious mind imposes are discarded so as to unleash the primordial, darker forces that constantly threaten reason. It is through his assault on architecture that Maddox nullifies the logic and rationality that, as surrealism insists, sets boundaries around our conception of reality.

## Notes

1   D. Sylvester, *Magritte*, London: Thames & Hudson, 1992, p. 32.

2   Sylvester directs us to A. Cassagne, *Traité pratique de perspective*, Paris, 1873.

3   R. Magritte, *Ecrits Complets*, Paris: Flammarion, 1979, p. 19.

4   Leon Battista Alberti, *Della Pittura* (1435/6).

5   R.L. Gregory, 'The Confounded Eye', in R.L. Gregory and E.H. Gombrich (eds) *Illusion in Art and Nature*, London: Duckworth, 1973, p. 89.

6   Jean Clair in the catalogue of exhibition *Rétrospective Magritte*, Brussels: Palais des Beaux-Arts, 1978, p. 39.

7   S. Levy, 'René Magritte and Window Display', in *Artscribe*, no. 28, March 1981, pp. 24–28.

8   J. Vovelle, *Le Surréalisme en Belgique*, Brussels: De Rache, 1972, p. 67.

9   J. Greene, *Psycholinguistics, Chomsky and Psychology*, Harmondsworth: Penguin, 1972, pp. 123–24.

10  Conroy Maddox in *Conroy Maddox. Surreal Enigmas*, film, 16 minutes, written and directed by Silvano Levy, 1995.

11  M. Remy, 'La ville déplacée du surréalisme anglais', in *Les Mots la vie*, 1989, no. 6, p. 98.

12  The Passage de l'Opéra was demolished in 1928 by the civic authorities to make way for a new boulevard, but Maddox had seen a photograph of it.

13  G. Melly, catalogue of the exhibition *Conroy Maddox. Recent Paintings*, London: John Whibley Gallery, 1967.

14  M. Remy, 'British Surrealism: Disqualifying Cities', in G. Bonifas (ed.) *Lectures de la ville. The City as Text*, Nice: Faculté des Lettres, 1999, p. 75.

Chapter 7

# Daphne's legacy

## Architecture, psychoanalysis and petrification in Lacan and Dalí

*Spyros Papapetros*

Why can't architectural history be more like one of the issues of *Minotaure*? One page-spread displays the Renaissance forests of "Ucello, lunar painter" and the next the winter trees of Brassaï's photograph of Place Dauphine at night. One issue shows the crystals, coral and aragonites of Breton's "convulsive beauty" and the next unveils the naked nymphs of Paul Eluard's "most beautiful *cartes postales*." Moving in similar diagonal lines, the architecture of this chapter is equally divided between the forest and the metropolis, the nymph and the crystal, psychoanalysis and building. This is the double frame through which the ancient figure of Daphne reappears in the modern landscape. Daphne is the arboreal figure we know from old-fashioned engravings of Ovid's *Metamorphoses* – the forest nymph, who while fleeing from Apollo's amorous pursuit was transformed into a tree (Figure 7.1).[1]

Daphne's vegetal spine endlessly bifurcates. She has two psychological moods, two types of movement, two trees and two bodies. Each of her bodies can be disassembled: Daphne's spine, Daphne's back, Daphne's treehead and vegetal fingers. Daphne roams inside the wood and scatters her fragments in a forest of discourses. There is the Lacanian Daphne and the Dalínian Daphne, yet deep inside the painted background hides the

***Daphne and Apollo*, C. Monnet, engraving by Baquoy in the edition of Ovid's *Metamorphoses* by Banier, Paris, Pissot, 1767**

Daphne of Bernini and the Daphne of Ovid. Enduring from antiquity to the Middle Ages and from the Renaissance to the Baroque – an era when her fame spiraled in a vertiginous peak – Daphne resurfaces in the literature, painting, sculpture and opera of the first decades of the twentieth-century.

In 1931, Picasso created a series of drawings for a new French edition of Ovid's *Metamorphoses* for the publishing house of Albert Skira. The book was advertised in the first issue of the *Minotaure*, next to Lautrea-mont's *Maldoror* illustrated by Dalí and above Matisse's drawings for a col-lection of poems by Mallarmé.[2] The modern Daphne sprouts from the poetic fusion of pastoral harmony and decadent horror unfolding in the pages of *Minotaure*. It was perhaps in this momentous publishing coincidence that the surrealists rediscovered Daphne and developed a veritable infatuation with her architectural attributes, which they extensively manipulated both in image and text. Along with that other famed female relic of antiquity, Freud's and Jensen's *Gradiva*, Daphne entered modernity as one of surrealism's "marvelous anachronisms" – her hair having turned into Rococo stucco dec-oration, her spine into an Art Nouveau iron gate.

Oscillating between the organic and the inorganic, the animate

and the inanimate, frenzied movement and ecstatic paralysis, Daphne became an exemplary figure for Surrealist artistic practices during the petrifying political climate of the late 1930s. On the original cover of Salvador Dalí's novel *Hidden Faces*, written in America in 1943, Daphne is pictured next to a rock marked by a bleeding swastika – she turns both into a tree and an architectural blueprint for the novel's central heroine Solange de Cléda, a veritable "tree lady" whose arboreal figure is consumed inside the burning forest of the Second World War (Figure 7.2).[3] Chased by ruthless new Apollos and haunted by the ravages of war, the surrealist Daphne becomes ultimately hysteric, bipolar, mad. Oscillating between reality and fiction, the Arcadia of her origins and the hubbub of her metropolitan investment, Daphne's tree figure embodies the schizoid constitution of the artistic sensibility of the mid-1930s: half the spirituality of Mondrianian rectangles and half the frenzy of Dalínian putrefieds. Half tree and half woman, half this and half that, yet there is always an implicit "imbalance" spoiling Daphne's classical proportions. It then comes as no surprise that the person who offered us the most discerning diagnosis regarding Daphne's architectural pathology was *not* an architectural historian but a psychoanalyst – a psychoanalyst who was well informed both by the Freudian and the surrealist project; that is, Jacques Lacan.

7.2
**S. Dalí, monumental shield for *Hidden Faces*, Dial Press, New York, 1944**

The Lacanian Daphne

During a lecture of his seventh seminar in The Ethics of Psychoanalysis of 1959, Lacan made a brief "digression" into the myth of Daphne. The nymph's petrification presented the psychoanalyst with an example of human behavior in moments of inescapable, mortifying pain. In an agonizing gesture, the human body instantly freezes, inanimates itself from within into a monument of stone, erect and fixed, reminiscent of the "tortured" forms of Baroque buildings:

> Isn't something of this suggested to us by the insight of the poets in that myth of Daphne transformed into a tree under the pressure of a pain from which she cannot flee? Isn't it true that the living being who has no possibility of escape suggests in its very form the presence of what one might call petrified pain? Doesn't what we do in the realm of stone suggest this? To the extent that we don't let it roll, but erect it, and make of it something fixed, isn't there in architecture itself a kind of actualization of pain – n'y a-t-il pas dans l'architecture elle-même la présentification dela douleur?[4]

Notice that the word "architecture" appears only in the last of Lacan's four consecutive questions. Architecture is the convulsive form produced by the temporary arrest of the psychoanalyst's spiraling questionnaire. Lacan's speech appears to be in empathy with his anxious subject. Like Daphne, he meanders from one question to another; his discourse emulates the Solomonic columns of Baroque buildings which Lacan will discuss immediately after his "digression" on Daphne. On top of that twisted column appears Daphne and the capital of architecture. Daphne is then both the end or crowning of a discourse, but also the introduction, the frame through which one may view architecture from the inside.

What Lacan describes as the "actualization" or "presencing" of pain is in fact an externalization. Daphne does nothing other than to objectify the arborescent diagram of her nervous system, the gradual bifurcation of her psychological pathways. In his Project for a scientific psychoanalysis, written in 1895, Freud had described this bifurcating pattern of neurological excitation as die Bahnung, rendered in English by Strachey as facilitation.[5] In the earlier part of his lecture leading to the example of Daphne, Lacan refers precisely to the cyclical trajectory of these conducting channels, which circle around an object that is no longer present.[6] When they exceed the limits of their diameter or when they are confronted by an obstacle, the channels of die Bahnung "branch off laterally"; they shoot new offsprings in order to

accommodate further excitation. This is the tree growing inside Daphne's psyche, which under intense pressure sprouts out of her skin and spreads into her hair, fingers, toes and finally the torso of her rapidly changing frame.

If this is correct, then Daphne has at least two trees: one growing inside her psyche and a second tree growing out of her skin. In fact, from the moment she is born, the modern Daphne is institutionalized inside a forest – the cluster of arboreal diagrams of nineteenth-century psychopathological discourse. And yet the Freudian tree, especially in its Lacanian species, can ultimately be liberating. The tree becomes the apparatus through which Daphne moves beyond her confinement and grows on another level, that is, architecture – a second fabric enveloping the tree.

Daphne is both figure and background, object and space. As Ovid tells us, Daphne is already inside a forest before she becomes part of it. While running inside the forest, Daphne is devoured by her sister trees. If we pay attention to her behavior, we could diagnose Daphne's affliction as "legendary psychasthenia," the fear of being eaten up by space, first exposed by Roger Caillois in *Minotaure* in 1938.[7] Daphne's metamorphosis is a form of mimicry, where the subject makes a lethal turn to the enclosure that inhibits its progression. Yet the loss of her movement in space, ultimately facilitates another mode of progression.

Daphne, in fact, has two movements: while she flees from Apollo, she meanders across the trees. When she is immobilized, her body spirals across the axis of her own tree. The first movement is horizontal, the second vertical. The first form of agitation is an externalized dynamic animation based on continuous progress in space. The second type of animation, occurring after Daphne's vegetal metamorphosis is *static*. Daphne's body instantly freezes, while her psyche continues to palpitate with utter excitement. As Ovid tells us, when Apollo kisses the bark, he can still hear Daphne's heartbeat. Like *fin-de-siècle* agoraphobics, Daphne embodies life inside paralysis, the frenzy of inertia, inanimate animation. Daphne is the animation of the inorganic – an inorganic that grows roots like a tree.

Notice that Lacan uses the word *douleur* for Daphne's pain. *Douleur* does not mean an occasional discomfort but a permanent residue of grief coming from inside.[8] It would be a mistake to perceive Daphne's reaction as an attempt to ward off or escape pain. According to Lacan, the nymph's petrification does not reveal a termination of her pain but a topological arrest, a fixation in place of her excitation evolving to a building site. Only while fleeing from Apollo, Daphne *avoids* pain; when she turns into a tree she in fact *accepts* it, she prolongs her pain indefinitely into the mineral depths of a monument.

We should not conceive of Daphne's tree as a system of defense. Her building is not a castle or a fortress. It is not an edifice of power but one of frailty. Daphne's monolith is not a statue of narcissism and self-complacency, but the "void shape" of self-shattering. It does not repel pain but absorbs it. In other words, Daphne's monument is not a building *against* pain but a building *of* pain or, as Anthony Vidler would put it, "*in* pain."[9]

The Lacanian Daphne opposes Enlightenment presuppositions regarding the functionalist origins of architecture. The primary aim of building is not to protect us from discomfort – rain, cold and other adverse climatic conditions, as Laugier's "primitive hut" would have us believe – but to pre-serve and elaborate pain, to make the subject vulnerable to it, to "build" the body while opening holes in it – perforations of pain and desire that act as windows to the external world. Translating Lacanian terminology into archi-tecture, this would be a form of "full speech" architecture as opposed to the "empty speech" and yet verbose buildings we are surrounded by.[10] Daphne's Baroque tree is an architecture *silencieuse* as opposed to an *archi-tecture parlante* which says nothing.

Based on the fact that the seminar in which Daphne intervened was devoted by Lacan to ethics and also that in medieval traditions Daphne appears as an ethical allegory, I would also like to employ Daphne's psycho-analytic framing to propose an alternative ethics for architecture. Following both Lacan and the Surrealists this would be an architectural *ethics of desire* and not of prohibition, as both ethics and architecture are normatively under-stood. More specifically, I will talk about desire the way it is *facilitated* (to use Freud's term) and set in movement by the original "foreclosure" imposed by Daphne's virginal resistance – the "unyielding corset" (to use Dalí's term) of her bark.

Let me illustrate this with a representation of Daphne from a fifteenth-century manuscript by Christine de Pisan, whose marvelous qual-ities would have appealed to the Surrealists (Figure 7.3).[11] Stunned by Daphne's transformation, Apollo appears blocked, petrified between two types of architecture: the castle in the background and Daphne's skirted tree in the foreground. The skirted tree is a fortress just as inaccessible as the palace in the background. The castle inscribes a type of enclosure, the skirted tree a foreclosure. Here, we realize that the con-genital relationship between architecture and the tree is precisely in Daphne's "opaque" geni-tals, her heavily clad flesh, the impenetrably shielded "castle" of the nymph's virginity, where architecture is immaculately conceived and (re)born. Semper's *Bekleidung*, the principle of *cladding* as the vertical foundation of architecture meets here its gendered vegetal root.

7.3
*Apollo and
Daphne*, from an
illustrated
manuscript of
Christine de
Pisan's *Epître
d'Othéa* (circa
1460) in W.
Stechow, *Apollo
und Daphne*,
Leipzig 1932

This medieval drawing corroborates Daphne's links with the history (and the historiography) of architecture. According to nineteenth-century architectural historians and theorists such as Carl Bötticher, clad trees were the first "built" monuments in the history of architecture.[12] From Vitruvius's enslaved columns and his vegetal Corinthian capitals to the structural linkages between tree worship and the origins of building, what we call "history of architecture" is in fact a form of modern mythology. Architectural history unfolds as the painted backdrop of a mythic grove peopled by clothed trees, petrified women and other fossilized relics. This is further evidence that Lacan's impromptu, theoretical remark about Daphne's links with the origins of architecture stands upon a well-established ground – Lacan's Daphne stands on a historical pedestal.

No matter in what period style Daphne's tree monument is garnished, the basic pattern of her architectural typology stays the same. Her floor-plan is circular – it replicates the ring of Apollo's empty embrace, the void of his frustrated amorous pursuit. "My bride, he said, if you can never be, at least sweet laurel, you will be my tree!"[13] Even before Daphne turns into laurel, Apollo's open arms create a circular void that presages the nymph's metamorphosis. After Daphne is transformed, Apollo cries, the poets tell us, and his tears make the laurel grow; pain, tears and laurel, all grow in a vegetal cycle – a circle consolidated into the rotund floor-plan of Daphne's temple.[14] Daphne's monument is both a solid column and an

empty ring – a circular emptiness that triggers an incomparable creative activity in its periphery.

Daphne's temple presents a fragment of the primordial psychological technique of building *around* impossible objects of desire whose voids become structuring absences. Like the maternal metaphor in psychoanalysis, Daphne is the primary object that has to be given up, in order for the architect Apollo to keep loving and rebuilding after wrecking and demolishing. Daphne's "*amor crudel*" shows that the reason we restore pain and decorate it with laurels, the reason that as Lacan would say we "actualize" and re-"present" it in stone, is ultimately to keep psychic anguish in movement, to transform the static monument of grief into the moving armature of pain.

There is no "reparation process" to be fulfilled, no sublimated tower to be raised on Daphne's grave. On the contrary, void, pain, lack or any other existing "damage" is further facilitated to continue its base work in art and architecture. The void is built around, not covered. The cavity is further deepened, not built upon. The laurel's compensation is never a full one; her building always creates a vacant circle. This architecturally *active* type of mourning, potent in both Freud and Lacan, is in deep contrast to the historicist melancholia of Dalí's neo-classical pavilions erected after the Second World War.

The Dalínian Daphne

Let us now pass from the Lacanian to the Dalínian Daphne. The artist and the psychoanalyst shared an implicit correspondence which lasted over forty years – from the early writings on the critical use of paranoia in the 1930s to the abstract diagrams of Borromean islands in the 1970s.[15] Daphne is another common subject between these two authoritative Apollos – somewhere between paranoia and the Borromean diagram. The discussion of Daphne is, in fact, one of the very few points where Dalí precedes Lacan and does not copy him.

Recall one of the early portraits Dalí did of his wife in 1932, where Gala's head blossoms with tree branches (Figure 7.4). This fragment was later inserted with Dalí's own "soft portrait" in the monumental shield the painter did for his 1942 autobiography, where the imperial couple is immortalized as Nero and Poppea (Figure 7.5).[16] The Dalínian Daphne turns into a monument long before she dies. Dalí's Daphne portrays the split between the tree woman's primitive sexual origins and the sublime iconography of her classical investment. She remains chaste as a Raphaelesque Madonna and yet she is repeatedly sodomized in public like Millet's praying mantis fieldworker.

7.4

**Salvador Dalí, *Commencement
automatique d'un portrait de Gala*
(unfinished) 1932**

7.5

**Color plate for *The Secret Life of
Salvador Dalí, New York:* Dial Press,
1942, including Dalí's "Soft Self
Portrait"**

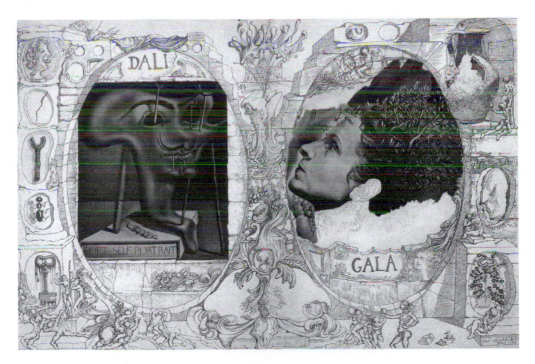

See, for example, the tree lady that Dalí did in 1944 for the fron-tispiece of his novel *Hidden Faces* (in which Lacan makes an "objective chance" cameo appearance anagrammatized as Dr Alcan) (Figure 7.6). In contrast to the fully covered Daphne we just saw, the bust of Dalí's tree woman is thoroughly exposed. In between a Northern Baroque Judith and a wooden doll by Bellmer, this Daphne turns from the virginal priestess of Ovid to a modern stripper in bondage.[17] Her hands and legs are anchored to the tree while her torso is bared ready to be whipped, penetrated by arrows like Saint Sebastian – Dalí's male model of "exquisite agony." In her beatific St Teresa-like smile, this Daphne prolongs her pain with rapturous endurance.

The Dalínian Daphne is neither masochist nor sadist; she is in between. As Dalí would say, she combines "pleasure and pain sublimated in an all-transcending identification with the object," – which in this case is a tree with an ambiguous gender, phallic and female at the same time.[18] By shifting the focus away from the subjectified origins of art and architecture in

7.6

**S. Dalí, Frontispiece for *Hidden Faces*, "Je suis la Dame," New York: Dial Press, 1944**

the direction of the object, Daphne's architectural tree is set on a different pedestal. Here Dalí's Daphne appears to run further away than Lacan's.

However voluptuous she may be, the Dalínian Daphne remains sublimely architectural. In a similar fashion to Lacan's comments on the "architecture of pain," in *Hidden Faces* Dalí writes about an "architecture of passion," buildings with "stairs of pain, gates of desire, columns of anguish and capitals of jealousy."[19] Dalí envisions the marvelous tree woman of his novel as a crystalline Louis XIV fountain where the female's "personality attributes" would be "architecturally transformed" into pedestals and ornaments made out of precious metals.[20] Dalí in fact materialized his female cathedral imagery one year later in an architectural portrait of Gala. The painting made in 1945 had the elaborate title "*My wife, nude, contemplating her own body becoming stairs, three vertebrae of a column, sky and architecture*" (Figure 7.7) and it was later used as the color frontispiece for Dalí's treatise *50 Secrets of Magic Craftsmanship* of 1948.[21]

Where is Daphne in this picture? She could be the little weed next to Gala's back with Apollo's head stuck gazing from a wall. But is not Gala's temple the living memorial of Daphne's tree? Like Daphne and the laurel tree, Gala and her temple appear as two separate objects mirroring each other's legacy. Daphne is pursued (and arrested at a distance) by her building; architecture is her new Apollo.

7.7
**Salvador Dalí, *Ma femme nue, regardant son propre corps devenir marches, trois vertèbres d'un colonne, ciel et architecture* (1945), San Francisco Museum of Modern Art**

Opposing modernism's renunciation of ornament, Dalí presents an antimodernist classicism made up of nothing *but* ornaments. The body disappears, replaced by its accessories. Gala's comb turns into pedimented Palladian windows, her coiffeur into marble scrolls. Notice also the white sheets around Gala's buttocks over her turquoise nightgown. The sheets exude a hospital fragrance. Gala's building means *convalescence* – a momentous tempering of extremes, a prodigious exemption to deviant rules.

Like Daphne's tree, Gala's temple is both columnar and circular, solid and void; in fact she is more void than solid, more "sky" than "temple." Here Lacan would have a suggestion for Dalí and the rest of the Surrealist architects. Despite formal resemblances, Dalí's anthropomorphous buildings and his Palladian corridors have finally little to do with Vitruvian proportions or classical theories of physiognomy and *caractère*; his architectures describe another type of proximity between the human, the built and the vegetal. Lacan would admonish Dalí that the buildings which bear man's image should not be called *anthropomorphic* but rather *egomorphic*. The *ego* here should be understood as the delineation of "man's image," which for Lacan is none other than the "wandering shadow of death."[22] The Albertian notion of the *lineament* as constitutive element of building opens up into a dark perspective. Surrealist "biomorphic" architecture and Tzara's "intrauterine" buildings ultimately turn funereal. Both Tzara's uterus and Dalí's anus (markedly shadowed in both Gala's body and the "rear exit" of her temple) transform into a skull – a proof that the rectum, as Leo Bersani would say, has indeed the tendency to become a grave. This is the dark side of Gala's architecturally splendid and "beautiful behind."

Now that we have met both sides of the Lacanian and the Dalínian Daphne let us compare them. How can we combine Dalí's view of architecture as "the realization of solidified desires" with Lacan's, that is, architecture as "an actualization of pain"? How is Dalí's "continuous transformation of liquid forms" compatible with Lacan's "fixity" of stone monuments?

According to Lacan, Daphne's rigidified skin acts as the very threshold between pleasure and unpleasure (Freud's *Lust/Unlust*) marked by the "limit" of pain which is infinitely expandable. Recall what Lacan had said about Baroque architecture: "something was aimed towards *pleasure* . . . which gave us forms which in a metaphorical language we call *tortured*."[23] Consider also the fact that Daphne intruded into Lacan's seminar right after a physiological remark on the human spine as the bodily axis where motility and sensation coexist.

Daphne's spine as it appears in Bernini's famous Baroque statue (which is, perhaps, Lacan's ostensible model for Daphne) is markedly

twisted; it has nothing to do with the quiescent composure of Gala's back and her columnar vertebrae. While Gala's temple meant convalescence, the Berninian Daphne means disorder and sublime hysteria. One can imagine that both Charcot and Freud would most likely classify Daphne as a hysteric. Freud would certainly attribute her affliction to her apparent sexual frigidity. The transition from the delirium of her frenzied flight to her ecstatic tree posture would represent the two alternating phases of her bipolar behavior.

The nymph's inflected spine traces the secret alignment between Lacan's Daphne and Dalí's well known 1933 *Minotaure* article on "the terrifying and edible beauty of modern style architecture."[24] The Art Nouveau imagery of vegetal nymphs and ecstatic sculptures was replete with the contorted spines and convulsive gestures that Dalí would later call the veering "seraglio of the hystericoepileptics." Despite its rehearsed performance, the body of the female hysteric presents an architecture which could pose as what Lacan would call the "presencing of pain" in all its disparaging permanency. However smiling or serene, Guimard's ecstatic nymphs and masochist columns *prolong* their pain into vegetative amnesia; they turn their torture into pleasure and cling to it with mineral endurance.

However, there are no hysterical bodily convulsions, intense gesticulations or rigid contortions in the famous collage that Dalí made to illustrate the architecture of sexual ecstasy in *Minotaure*. There are only a series of cut-off heads with open mouths (Figure 7.8). The epileptic *seraglio* had become cerebral. The architecture of hysteria is all in the head. With mouth agape and eyes wide shut, Dalí reminds us that architecture is *not* about the reality of the external world but about the interiorized space of fantasy. As opposed to an architecture of erecting and "filling in," Dalí presents an architecture of emptying out and unearthing. It would perhaps be wrong to search for Daphne's architecture in the external forms of a building; she is more of an "interior design."

In medieval illustrations, Daphne appears as a marvelous monster with a female human body and a bulbous bush or an entire tree on her shoulders instead of a head – a figure that art historians have compared to the well-known figure of Mandragora (Figure 7.9).[25] Similarly, the archetype of Daphne's architecture is indeed a "tree-head," that is, a tree that does not simply grow like a pole inside the house but a tree that has *become* the house. The wooden enclosure around Daphne's head projects an internal model of her mind as in a cinematic apparatus or a television. It would be wrong to imagine Daphne's architecture as statuary, solid and fixed. On the contrary, it is a cluster of filmic projections. Daphne's tree bark acts as the projection screen of her fears – a mental inorganic shield engraving the ornamental scribbles of her anxiety.

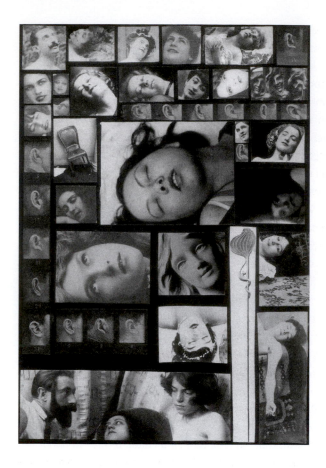

7.8
Salvador Dalí, *Le phénomène de l'extase,* photo-collage, *Minotaure* 3–4, 1933

7.9
Mandragora, and representations of Daphne with a tree-head in Wolfgang Stechow, *Apollo und Daphne*, Leipzig 1932

Daphne's myth presents an alternative explanation of the quick demise of Art Nouveau as a movement in art and architecture. Like Daphne, Art Nouveau's frenzied flight, its avoidance of pain and intensification of excitation leads unavoidably to the style's *petrification*, the eternal arrest of its circular psychogrammes into the white walls of modern architecture. Although Art Nouveau's "hystericoepileptic seraglio" may have calmed down, something of its convulsive ambience remains.

It would be wrong to associate Daphne's architecture only with the vegetal nymphs of Jugendstil or the anthropomorphism of Dalí's neoclassical pavilions. Even normative architectural modernism, what Dalí (after Tristan Tzara) calls "the architecture of self punishment," is saturated with Daphne's baroque prolongation of pain. Although totally transformed morphologically, Daphne's *anima vegetativa*, Art Nouveau's vegetal soul, still vibrates inside the bark of modernist environments. The crystal of purism is perhaps more alive than the biological fossils of the Surrealists. Although mute and ineffable, Daphne's glass tree reverberates with the violently erogenous cries of the architecture of self-punishment *punishing itself*.

Does not in fact Daphne's ecstatic schism between torment and exuberance characterize the bipolar, essentially hysteric constitution of the architectural modernism of the 1930s internally split – *arrested* like Daphne – between the spiritual flatness of *Abstraction-création* and the "salivating muscles" of streamlined modernism?

How does Daphne "actualize" her presence in this modern streamlined architecture? Recall at this point the branches, hands and other forms projecting from Dalí's plaster façade in his infamous pavilion of the "Dream of Venus" made for the 1939 World Fair in New York (Figure 7.10). These arboreal excrescences show that Daphne's main architectural attribute is the element of *protrusion*. The nymph's petrified posture accumulates an excess of energy which is externalized as an "aerodynamic" protuberance jutting out from the flatness of her wooden frame.

As Dalí describes in his theory of "aerodynamic forms," modern artifacts are also the products of such intense pressure from their environment. Like "blackheads squeezed out from an oily nose," streamlined cars and buildings strive to escape from the asphyxiating pressure of modern space, which both hinders and facilitates their production.[26] Like Daphne's virginal bark, modernist artifacts are the products of a stringent resistance formation; they are produced *not* by the flowing function of desire but from its blockage – something like a reaction force steered by the motor brake of an automobile.

Daphne's aerodynamic cover justifies her presence in the technological extravaganza of the 1939 World Fair in New York where she is placed between the joyride of Dalí's *Dream of Venus* and the automobile platform of

7.10
**Salvador Dalí, Façade of *The Dream of Venus* pavilion (New York, 1939)**
Photo by Eric Schaal

the Ford Pavilion. Daphne has transformed into a motor-tree. Notice how Dalí's fossilized automobiles emulate Daphne's petrified leap – both arrested apparatuses standing on one "wheel" (Figures 7.11 and 7.12).

Finally, does not Daphne's arrested flight remind us of *Minotaure's* emblematic photograph of "the speeding locomotive abandoned for years to the delirium of the virgin forest," first presented in an article by Benjamin Péret? (Figure 7.13). Arrested by her sister trees, Daphne turns into a Duchampian vegetobiomorphic bride-machine, equally virginal and equally delirious with the surrealist forest. Daphne could perfectly embody Duchamp's "tree-type" bride, a female nymph whose "blossoming" is exactly as Duschamp wants it to be, "cinematic."[27]

Daphne also perfectly fulfills Breton's first principle of *convulsive beauty* as articulated in his famous article in *Minotaure*, that is, an object "linking motion with repose." Oscillating between the woman, the tree and the stone, Daphne fulfills Breton's second principle too, that of the paranoid mimicry between organic and inorganic materials.[28] Via Daphne's tree, Breton's crystal returns full circle to Eluard's fossilized nymphs.

Not only does Daphne offer an alternative illustration for Breton's theory, but also one of the original illustrations of Breton's article offers an

7.11
**Salvador Dalí, detail from**
***Apparition de la ville de Delft,***
**1935–1936**

7.12
**Detail from *Apollo and***
***Daphne*, W. Baur (1639),**
**engraving Augsburg, M.**
**Küsel, 1681, in Wolfgang**
**Stechow, *Apollo und***
***Daphne*, Leipzig 1932**

7.13
**Photograph of abandoned**
**locomotive in *Minotaure* (10), 1937**

alternative illustration of Daphne, in a surrealist version. I refer to Breton's illustration of "automatic writing" depicting an x-ray of radioactivity simulating the branches of an illuminated tree seen from above (Figure 7.14).[29] This is what remains after all of Daphne's leaves have fallen down – a naked diagram, a cluster of nerves, a network of psychic channels (Freud's *Bahnung*), a fulcrum of luminous pathways spinning like the amoebic arms of a galaxy inside the darkness of a hollow tree.

Daphne Female

And yet it would perhaps be anti-surrealist in spirit if we abandoned Daphne in such a state of abstract disarray. There has to be an alternate pathway leading from the naked diagram back to something that could suggest the bodily figure of the nymph.

All of the authors we have seen thus far – Ovid, Bernini, Lacan, Dalí and Breton – are male. Can there ever be a Daphne re-created by a female? Claude Cahun's 1931 photographic self-portrait titled "*Je tends les bras*" of 1931 perhaps gives a viable answer (Figure 7.15).[30]

The tree, here, has now turned into a stone wall. Cahun presents a woman that is literally petrified. But notice that in this case we see a female not turning into or getting inside a wall or a tree, but struggling to "come out" of it (which may also remind us that Cahun was lesbian). This Daphne does not obediently comply with her architecture. Her arms perform a demonstration. Although her mouth is fully covered, this Daphne *speaks* for her desire. From the tense elbow to the open palm, the arm struggles to

7.15
**Claude Cahun, self-portrait *Je tends les bras* (1931)**

communicate where this body wants to be. Cahun's arms do not stretch hor-
izontally, but slightly bend in the elbows as if they embrace something. They
almost form a circle, as if the female embraces her own dis/appearance.
Even the circular accessories, the colorful bracelets around Cahun's wrist,
echo the greater circle formed by her arms. It is as if the original *Thing* of
Daphne's absence has here been scattered into these little *things*, the circu-
lar accessories adorning her arms. This cluster of visible and invisible rings is
the active diagrammatic circuitry of Daphne's *static* animation.

Although enveloped by the inorganic, this Daphne has infinite
animate extensions. Each finger of Cahun's hands shows a new direction.
Her arms wave like animal tentacles, that is semi-functioning appendages,
not fully functioning branches or organs. Cahun's figure is like a petrified
tadpole – her arms breaking for the first time into the limits of the real world.

Cahun's dynamic gesturing is important because it shows that
Lacan's "presencing of pain" can have a meaning which is not only symbolic
and passive, but also real and potent. This Daphne has not just an elegiac
past but also an active future.[31] One more proof that, however terminal,
Daphne's metamorphosis is not *final*. There are still several menacing
Apollos inside the disenchanted forests of the modern world.

The branches sprouting from Daphne's fingertips show that even when
organisms resist and close their boundaries to a hostile external environ-
ment, their extremities automatically explode and blossom with new mani-
fold extensions. The body reflexively opens up and greets the outer world
that has previously assailed it and triggered its resistance. Daphne attests to
the infinite extensibility afforded by resistance. The vegetal blossoming of
this resilient extensibility portrays the animation of the inorganic. The anima-
tion of the inorganic is the continuous enlargement of an organism held back
by an arrested development. It is an architecture that becomes vibrantly con-
vulsive while trying to outgrow its own petrification.

Daphne's architectures, classical, baroque, art nouveau, stream-
lined and surrealist, exhibit the solid proof of what bodies have learned to do
with their fears, the miraculous plasticity of their desires. The nymph's built
legacy displays the way modern subjects have managed to transform their
masochism into a house of pain using their inorganic resistances to engage
into a trans-species communication with other forms of matter: vegetal,
animal, mineral – anything that can take them away from what we call
human.

## Notes

1 For an analytic survey of the myth of Daphne in literature and art from antiquity until the end of the seventeenth century (and beyond) see the voluminous study by Y. Giraud, *La Fable de Daphné Essai sur un type de métamorphose végétale dans la littérature et dans les arts jusqu'a la fin du XVIIe siècle*, Geneva: Librarie Droz, 1969. For an iconographic analysis of the representation of Apollo and Daphne, see the classic study by W. Stechow, *Apollo und Daphne* (Studien der Bibliothek Warburg herausgegeben von Fritz Saxl, Vol. XXIII) Leipzig and Berlin: B.G. Teubner 1932, reprinted in 1965.

2 *Minotaure* inaugural (double) issue No. 1–2, December 1933, Paris: Skira.

3 S. Dalí, *Hidden Faces* (trans. H. Chevalier), New York: Dial Press, 1944. Later reprints included additional artwork by Dalí.

4 J.-A. Miller (ed.) *The Seminar of Jacques Lacan, Book VII, The Ethics of Psychoanalysis 1959–1960* (trans. D. Porter), New York: W.W. Norton 1992, p. 60. For the original text see Jacques Lacan, *Le Séminaire livre VII, L'éthique de la psychanalyse*, Paris: éditions du Seuil, p. 74.

5 Included in S. Freud, *The Origins of Psychoanalysis, Letters to Wilhelm Fliess, drafts and notes: 1887–1900* (eds M. Bonaparte and E. Kris, trans. J. Strachey), New York: Basic Books, 1954, pp. 347–446. See especially paragraphs 10 and 12 titled "The paths of conduction" and "The experience of pain," pp. 376–383.

6 Lacan, *Le Séminaire livre VII*, pp. 57–59. For a fascinating revision of the concept of *die Bahnung* as the "pathway of unconscious desire," see K. Silverman, *World Spectators*, Stanford University Press, 2000, p. 111. My own pathway on Daphne is heavily indebted to the pathway opened up by Silverman, who proved ingeniously how Freud's original pathway might still creatively bifurcate.

7 R. Caillois, "Mimetisme et psychasthénie légendaire" in *Minotaure*, No. 7, 1935, Paris: Skira, pp. 4–10. For an English translation see R. Caillois, "Mimicry and Legendary Psychasthenia" (trans. J. Shepley), in A. Michelson, R. Krauss, D. Crimp, and J. Copjec (eds.) *October: The First Decade, 1976–1986*, Cambridge, Mass.: MIT Press, 1987.

8 The last part of Lacan's seventh seminar on ethics was dedicated to the figure of Antigone. In his French translation of Kierkegaard's *Antigone*, Pierre Klossowski uses the word *douleur* to translate Kierkegaard's *smerte*. In a translator's note, Klossowski contrasts *"suffrance* implying endurance of pain imposed on the subject by the force of external things" with *"douleur*, suffering the subject imposes on himself through his own reflection." Lacan indicates that the pain he refers to comes from *inside* and that is why it is "inescapable." Klossowski first published his translation of Kierkegaard's *Antigone* in two French literary reviews in 1938. Denis Hollier reprinted part of it in D. Hollier, *The College of Sociology, 1937–39*, Minneapolis: University of Minessota Press 1988, p. 173.

9 A. Vidler, "The Building in Pain," in *AA Files* No 19, Spring 1990, pp. 3–11.

10 On full and empty speech, see J.-A. Miller (ed.) *The Seminar of Jacques Lacan, Book I: Freud's Papers on Technique, 1953–1954* (trans. J. Forrester), New York: W.W. Norton 1988, p. 244.

11 From an illustrated manuscript of Christine de Pisan's *Epître d'Othéa* dated circa 1460, reprinted in Stechow, *Apollo und Daphne*, ibid., figure 6.

12 See the chapter "Bekleidung des Baumes in Weise eines anthropomorphoschen Bildes" (dressing of the tree in the manner of an anthropomorphic image) in C. Bötticher, *Der Baumkultus der Hellenen: nach den gottensdienstlichen Gebräuchen und den überlieferten Bildwerken*, Berlin, 1856, pp. 101–107. Bötticher's study also has a section on the laurel: *"Lorberbäume vor Gebäude gepflanzt* (laurel trees planted in front of buildings), pp. 377–381.

13   Ovid, *Metamorphoses* (trans. A. Melville), Oxford: Oxford University Press, 1986, p. 17.

14   This description is from the version of Daphne's myth by the medieval Spanish poet Gar-cilaso. See M. Barnand, *The Myth of Apollo and Daphne from Ovid to Quevedo*, Durham, North Carolina: Duke University Press, 1987, p. 112.

15   Dalí had praised Lacan's thesis in his first article in the *Minotaure* on *L'Angélus* as "giving for the first time a global and homogeneous idea of the [paranoid] phenomenon, beyond any of the abject notions in which psychiatry at present is mired" (*Minotaure*, 1, January 1933, Paris: Skira, p. 10). In this first issue Lacan had contributed a small essay on style and para-noia (pp. 68–69). The two men had met to discuss paranoia in 1932, but then did not meet again for forty years until Lacan's trip to America in 1975. See E. Roudinesco, *Jacques Lacan & Co.: A History of Psychoanalysis in France, 1925–1985* (trans. Jeffrey Mehlman), Chicago: Chicago University Press, pp. 110–112. On their common discussion regarding the Borromean islands, see E. Roudinesco, *Jacques Lacan*, New York: Columbia University Press, 1997, pp. 377–378.

16   See *Commencement automatique d'un portrait de Gala* (unfinished) 1932, inserted in the monumental shield for S. Dalí, *The Secret Life of Salvador Dalí* (trans. Haakon Chevalier), New York: Dover, [1942] 1993.

17   Neither here nor in his earlier portraits of Gala does Dalí refer to his tree-woman as Daphne or laurel (on the contrary, Dalí used to call Gala his *Olive* or *Olivette* because of the olive shape of her face). Only in a series of drawings made by Dalí in 1977, is there a watercolor depicting a tree woman, which is explicitly titled *Daphne: La femme arbre*. It took forty years for Daphne's name to be recovered.

18   "Because since the eighteenth century the passional trilogy inaugurated by the divine Marquis de Sade has remained incomplete: Sadism, Masochism ... It was necessary to invent the third term of the problem, that of synthesis and sublimation: Clédalism, derived from the name of the protagonist of my novel, Solange de Cléda. Sadism may be defined as pleasure experienced through pain inflicted on the object; Masochism, as pleasure experi-enced through pain submitted to by the object. Clédalism is pleasure and pain sublimated in an all-transcending identification with the object." Dalí, *Hidden Faces*, p. xii.

19   "I want to build a passion like a true architecture in which the hardness of each rib shall sing with the precision of the stone-angles in each of the moldings of the sonnets of the Palla-dian windows – a passion with stairs of pain leading to landings of the expectation of uncer-tainty, with benches on which to sit and wait at the threshold of the gate of desire, columns of anguish, capitals of jealousy carved with acanthus leaves, reticences in the form of broken pediments, round, calm smiles like balustrades, vaults and cupolas of enchanted ecstasy." Dalí, *Hidden Faces*, pp. 134–135.

20   "Solange de Cléda! He visualized her now as perfect, as a transparent Louis XIV fountain, in which all the attributes of her personality were architecturally transformed into the precious metals on which her spirit was 'mounted' and which served her as an accessory and a pedestal. He would look at her and not see her: carved in celestial geometry, only the 'silks' of the rock-crystal of her soul were visible in her limpidness. But if Solange's spirit because of its translucent purity seemed to him more and more inaccessible to the senses, all that might be called the ornamentation of 'her fountain' now no longer appeared to him as light and virtual attributes. On the contrary each leaf of her modesty and each garland of her grace was chiselled with a minute detail and a refined art, as in a rare masterpiece of jewelry, so that the sculptured motifs, elaborately executed in the opaque metal of the border, only set off the smooth and unclouded diaphanousness of the receptacle that stood in the center of her deep being." Dalí, *Hidden Faces*, p. 207.

21   *Ma femme nue, regardant son propre corps devenir marches, trois vertèbres d'un colonne, ciel et architecture*, dated 1945. Dalí's later treatise included a drawing of the same

anthropomorphic building in reverse. See S. Dalí, *50 Secrets of Magic Craftsmanship*, New York: Dover 1992 [1948], p. 172. The similar image of Gala seen from behind without her building, appears in *Gala nue de dos* (1960).

22 "Because of this double relation which he has with himself, all the objects of his world are always structured around the wandering shadow of his own ego. They will all have a fundamentally anthropomorphic character, even egomorphic we could say." J.-A. Miller (ed.) *The Seminar of Jacques Lacan, Book II: The Ego in Freud's Theory and in the Technique of Psychoanalysis, 1954–1955* (trans S. Tomaselli), New York: W.W. Norton, 1988, p. 166.

23 "Something was attempted then [in the Baroque] to make architecture itself aim at pleasure, to give it a form of liberation, which, in effect, made it blaze up so as to constitute a paradox in the history of masonry and building. And that goal of pleasure gave us forms, which, in a metaphorical language that in itself take us a long way, we call *tortured*." J.-A. Miller, *The Seminar of Jacques Lacan, Book VII*, p. 60.

24 The original article titled *De la beauté terrifiante et comestible de l'architecture modern style*, including Man Ray's photographs of Gaudí's buildings in Barcelona and Brassaï's photographs of Parisian metro entrances, was first published in *Minotaure*, no. 3–4, December 1933, Paris: Skira, pp. 69–77. Dalí included part of the same article in his bilingual anti-modernist manifesto of 1957: *Dalí on Modern Art* (*The Cuckolds of Antiquated Modern Art*), (trans. Haakon M. Chevalier, *c*.1957, in French and English), reprinted by Dover (English text only), New York 1996, pp. 31–45. For a more recent English translation, see H. Finkelstein (ed.) *The Collected Writings of Salvador Dalí*, Cambridge: Cambridge University Press, 1998, pp. 193–200.

25 See Stechow, *Apollo und Daphne*, pp. 14–15.

26 S. Dalí "Apparitions aérodynamiques des 'Êtres-Objets'" in *Minotaure*, 6, Winter 1935, pp. 33–34, translated as "Aerodynamic apparitions of 'beings-objects'" in Finkelstein, *Collected Writings*, p. 209.

27 Nevertheless, Daphne seems to have additional roots in pre-surrealist imagery. Her spectacular vegetal blossoming is close to the "cinematic blossoming" of Duchamp's "arbre-type," in his *Large Glass* of 1912, tracing a tree formation, which also evolves as a network of stoppages, similar to Freud's *Bahnung*. See the thorough account of the *Large Glass* by L. Henderson, *Duchamp in Context: Science and Technology in the Large Glass and related Works*, Princeton, New Jersey: Princeton University Press, 1998.

28 André Breton, "La beauté sera convulsive," first published in *Minotaure* 5, Paris: Skira, 1934, pp. 8–15, and later as the first part of A. Breton, *L'amour fou*, Paris: Gallimard, 1937; English edition A. Breton, *Mad Love* (trans. Mary Ann Caws), University of Nebraska Press 1987, p. 10.

29 Breton describes the picture as "*L'image, telle qu'elle se produit dans l'écriture automatique*" in A. Breton "La beauté sera convulsive" p. 10.

30 Claude Cahun, self-portrait, *Je tends les bras*, 1931 in F. Leperlier, *L'écart et la metamorphose*, Paris: Jean-Michel Place, 1992, p. 114.

31 If this "active" reading is correct, then Cahun's image shows that the English translation of Lacan's "*presentification* (*de la douleur*)" as "actualization" was correct from a certain perspective.

Chapter 8

# The ghost in the machine

*Alexander Gorlin*

A strong surrealist element exists in the architecture of Le Corbusier, although he never explicitly acknowledged its presence. Le Corbusier's review of a "madman's" drawings in the Surrealists' *Minotaure* magazine attests to his intimate knowledge of their work.[1] It was not Le Corbusier's intention to relate directly to the decadence of surrealism, as he described it, in *When the Cathedrals Were White*, but the coincidence of imagery is too close to be accidental.[2] For although Le Corbusier's early work appeared to be the triumph of rationality, a white architecture of "sunlight, space, and greenery," it is pervaded by a slightly sinister atmosphere in contrast to and commenting on the major themes of the work. This dialogue between the rational and the surreally anti-rational creates an ironic tone, a questioning, even in his most self-assured modern statement, the Villa Savoye. In Le Corbusier's later work the surrealist themes of the ambiguity between inside and outside, ghostly presences, ruins, petrification, and the occult become more prominent, dominating, for example, the chapel at Ronchamp.

Le Corbusier and the surrealists alike sought to jolt man's perception of the world through the deliberate reversal of the expected, and the juxtaposition of the banal with the extraordinary. For the surrealists, the goal was the transcendence of everyday reality. For Le Corbusier, it was ostensibly the promulgation of his social program, itself an "extraordinary" imposition and transformation of the existing societal and architectural order of the day.

Giorgio de Chirico, the surrealists' most important precursor, had a profound effect on Le Corbusier's early drawings. One of the themes of de Chirico's metaphysical interiors and his series of empty plazas is the exploration of the ambiguous relationship between interior and exterior space. His painting, *Man Seated Before a Window*, is a series of frames within frames: that of the painting itself, an empty canvas within the distorted perspective of the room, and a window framing the distant shutters of a villa. The viewer is included in the spaces as he is contrasted to the white stone bust in the painting, the abstracted black manikin mediating the transition between the live observer and the man of stone inside. Space extends both in front of the canvas and beyond the open window to the space outside.

The view from a metaphysical interior could be the plaza in de Chirico's *Lassitude of the Infinite* (Figure 8.1). Space is defined by intensely lit arcaded buildings, distorted in perspective like the walls of the interior, and defining a void in which are placed strangely isolated objects. A small figure in black turns the viewer to a white statute of Ariadne, the goddess of sleep. They stand alone in the plaza, defined on two sides by the works of man and on the horizon by a wall of mountains.

Le Corbusier's travel sketches of Pisa and Hadrian's Villa, published in *Towards a New Architecture*, are similar to de Chirico's *Joys and Enigmas of a Strange Hour*. In the sketch of Pisa, tiny figures and the huge cylinder of the Baptistery stand between visually skewed walls (Figure 8.2). In one of Le Corbusier's sketches of Hadrian's Villa, the wall defining the de Chiricoesque plaza is marked A, while the horizontal wall of mountains is marked B, diagrammatically contrasting man and nature. Small sentinel-like poplars recall the lonely figures of the painting.

8.1
**Giorgio de Chirico, *Lassitude of the Infinite*, 1913**

8.2
**Le Corbusier, travel sketch of Pisa**

8.3
**René Magritte, *Human Condition III*, 1933**

For Le Corbusier, as he plainly stated, "the exterior is always an interior," in that the natural elements of sky, earth and horizon were to be treated mythologically, as the elements of a vast outdoor room, an extension of the single room shelter.[3] Conversely, the interior was always an exterior, as in his drawings of ruined rooms from Hadrian's Villa and Pompeii which emphasized missing walls of ceilings allowing nature to define the space normally enclosed by man. They recall René Magritte's *Anxious Journey*, where a room opens onto either the reality or the painting of a shipwreck in a storm. *Human Condition III* is Magritte's clearest exposition of the theme of ambiguous interior–exterior space, where a painting of a landscape reproduces the actual scene from the window (Figure 8.3). Since both the "real" landscape and the painting of the landscape are, in fact, mere two-dimensional depictions, our entire perception of reality is questioned, as it is now possible that the view from any window could be real or illusory.

In painting, three-dimensional space must be created before it can be questioned, whereas in architecture, already in the third dimension, the reverse procedure occurs. In Le Corbusier's Pavilion de l'Esprit Nouveau, one wall of the outdoor terrace has been opened to the foliage, the scene flattened and stretched like a painting across the frame of the two-story opening (Figure 8.4). Before this enormous "painting," a table is set for tea. Tiny, wiry chairs are strangely out of place in this surreally overscaled outdoor room, reminiscent of the space in Magritte's *The Childhood of Icarus*. In this gargantuan room to the open forest, stacked with paintings of windows and the sky, a diminutive jockey on a horse gallops toward the outside (Figure 8.5).

Similar themes inform the design of the Villa Stein at Garches. Early sketches reveal that the Villa was a series of promenades and stairs, semi-enclosed by walls, a stage set of architectural elements, balanced between the inside and outside. As constructed, the elaborate promenades were drawn into a compact prism. As opposed to the flat plane of the entry façade, a two-story void is carved out in the back, opening onto and framing the garden, recalling the cavernous hollow of the Pavilion de l'Esprit Nouveau. The same wiry chairs reappear, discordantly out of proportion to the scale of the terrace.

The idea of the frame, the grid ordering the view of nature, was used by Le Corbusier at immensely different scales: at the domestic scale in the lakeside outdoor window of his mother's house; at the urban scale of the multi-story resident apartment block; and at the scale of the landscape in the undulating wall of the Algiers apartments under the highway, where the opening forms a giant gate between the mountains and the Mediterranean sea.

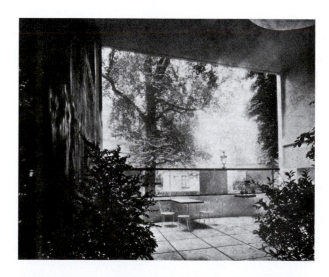

8.4
**Le Corbusier, Pavilion de l'Esprit Nouveau, Paris, 1925**

8.5
**René Magritte, *The Childhood of
Icarus***

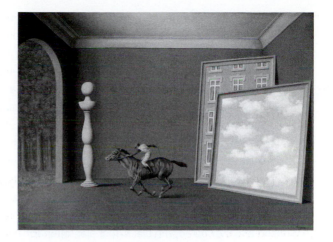

In the Villa Savoie, a window in the roof garden wall frames the view, but here the emphasis is vertical as the walls enclose a space open primarily to the sky (Figure 8.6). The entire villa is virtually a roof garden, enclosed on four sides, open to the landscape only through narrow strip windows, like the eyes of a Kachina doll. In one drawing, the horizon line stretches across the window boundary, connecting the outside with the gridded roof terrace where a table is set for tea. A vertical line divides the scene in two, the landscape of nature on one side, and on the other the artefacts of "civilized" man, a bentwood chair and teacup. This duality recalls Magritte's *The Voice of Silence*, where a bourgeois living room, furnished with the same chairs but empty of people, is juxtaposed to the menacing black void on the other side of the wall.

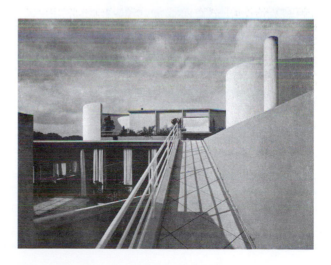

8.6
**Le Corbusier, roof garden, Villa Savoie,
Poissy, 1929–31**

In both these images there is a strong contrast between the otherwise normal setting and an image of disorder or chaos, the emptiness of either the void or wild nature. There is also a feeling that human beings are absent from a place that they had just occupied, a theme previously noted in the work of Le Corbusier by Kenneth Frampton as he explored "the visible/invisible which seems to have been the phenomenological touchstone of his [Le Corbusier's] metaphysical sensibility."[4]

The presence of these human ghosts is evident in Magritte's *Man Reading a Newspaper*, where within a grid a man sits uneventfully by the window only to disappear, his conspicuous absence repeated in each of the remaining three frames (Figure 8.7). A similar feeling pervades Le Corbusier's photographs of the kitchen of Villa Savoie, the table set with a teapot and a loaf of bread, the black door ajar, open for the one who has just left or will soon arrive (Figure 8.8). The scene recalls the painting by de Chirico, *The Philosopher*, where artichokes and a stone bust share a table: one is alive and one frozen, petrified by a Medusa-like vision. The two objects cast shadows from a glaring light, not unlike that in certain surrealist photographs in *Minotaure*.[5] In one, the intense light almost obliterates the silhouettes of the identically aligned sewing machines, their machine-like repetition recalling Le Corbusier's photograph of his floating Salvation Army Hospital. The beds are in a room distorted in perspective and illuminated from behind by a sinister, antiseptic light from an unshaded window.

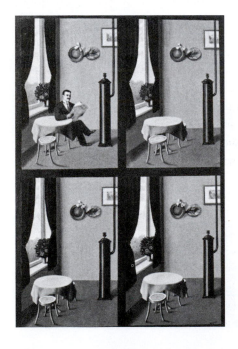

8.7
**René Magritte, *Man Reading a Newspaper*, 1928**

8.8
**Le Corbusier, kitchen, Villa Savoie**

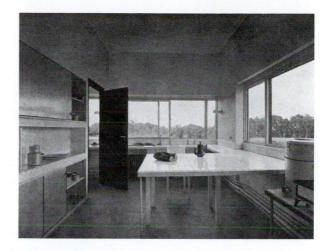

Le Corbusier's photographs of his architecture are highly intentional – not passive recordings, but an active commentary on his world. In the interior photographs there is meaning in whether a room is empty or not, what furniture is inside and where it is placed, and the size and position of the human figures. Like the plan and elevations, the photographs are an integral part of the presentation of Le Corbusier's architecture. In a way, the photographs in the *Complete Works* are as important as the buildings they represent.

In the early work of the 1920s human beings are noticeably absent; only the forms intimately related to their physical form and scale (i.e., chairs, tables, cups) are retained as evidence of their presence. The appearance of people, and their size and place, forms a continuous theme developed in Le Corbusier's interior photography, beginning with the La Roche-Jeanneret house. In a stark, white room, two empty chairs sit in conversation with each other, as in de Chirico's *Furniture in a Valley*. An intermediated stage between the absence of figures and their materialization occurs with the presence, seven years apart, of the same marionette puppet in the Villa Cook of 1926 and in Port Molitor, 1933. This small, articulated doll is a strangely anonymous human, a person once removed. Dolls were a surrealist obsession, evident in the *Minotaure* presentation of disembodied, grotesquely contorted *poupée*, contemporary with the Le Corbusier photographs of 1933.[6]

At first, people in this set of photographs appear facing away from the camera, as the female model does in Le Corbusier's chaise lounge, her face anonymous like the draped couple in Magritte's *The Lovers* (Figures 8.9 and 8.10). In the houses, the figures are initially tiny, on the same scale as the dolls, mass-produced humanoids taking their place alongside the other machined object-types. Alienated, these figures turn away, as in a de Chirico painting.

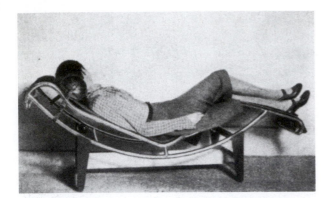

8.9
**Le Corbusier, chaise longue, 1929**

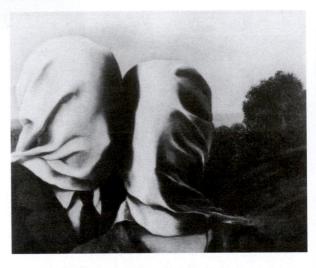

8.10
**René Magritte, *The Lovers*, 1928**

At the height of Le Corbusier's interest in the machine, in photographs of Port Molitor and the Salvation Army, a chilling sequence can be constructed portraying his view of the relationship between people and architecture. Although not adjacent to each other, the following photographs can be grouped together and assembled as a series. In one, a lone figure, probably Le Corbusier himself, stands in the background of a room grossly distorted in the perspective of a wide-angle lens (Figure 8.11). In another photograph, the semblance of a family appears, still doll-like in size and posture. There, a mother and child are shown at play, while two men stand outside, partial obscured by the glare. Finally, the children are gone, only their toys remain under a broken window as a strange man stares into their playroom at the Salvation Army (Figure 8.12). These human dramas occur within the shifting framework of an architecture of neutral walls and thin, wiry furniture, the forms suffused by not entirely beneficent light, and dislocated by the wide angle lens.

8.11
**Le Corbusier, Port Molitor**

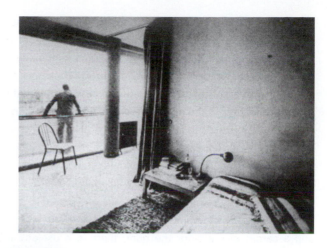

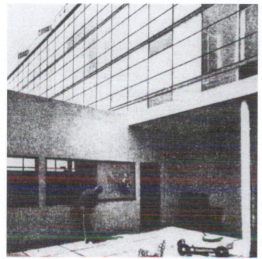

8.12
**Le Corbusier, Salvation Army, Paris, 1929–33**

Another theme that recurs in Le Corbusier's work is his use of the roof garden (one of his five points of the new architecture) as an outdoor room, and ambiguous place between inside and outside. This idea is handled in a similar way in certain paintings of de Chirico and Magritte. In Le Corbusier's stated purpose for the roof garden – to introduce "sunlight, air and greenery" into the house – there is an uneasy opposition between architecture as shelter and its exposure to nature, the garden often becoming an overgrown ruin as implicitly intended. And human beings, the supposed beneficiaries of these healthful elements, are often absent, although their ghosts are implied.

These surrealistic tendencies in Le Corbusier's work reach a culmination in the Beistegui apartment of 1930. This roof garden is the clearest

statement of the outdoor room, a sparsely furnished living room enclosed by four walls – only the ceiling is missing. As in the roof garden of the Villa Savoie, designed at the same time, there is a shift away from the horizontal view of the landscape to the framing of the emptiness of the sky. It recalls the setting of Magritte's *Birth of an Idol*, in which an anthropomorphic form, the bibloquet, stands on a table atop a cut-out of a person, adjacent to a platform of stairs surrounded by a raging sea. It could almost serve as a model for the Beistegui, especially in the photograph in Hitchock and Johnson's *The International Style*. A bibloquet-like tower stands next to a stair leading to the platform of the outdoor enclosure, an island of order above what Le Corbusier considered to be the urban chaos of Paris, and, therefore, the equivalent of Magritte's stormy sea. In this outdoor room, with the sky for a ceiling and a carpet of grass for the door, there is a useless fireplace much like Magritte's hearth with the locomotive steaming out, frozen in its tracks (Figures 8.13, 8.14).

Visible above the walls of the garden are only the great monuments of Paris – the Arc de Triomphe, the Eiffel Tower, and Notre Dame. It is like Le Corbusier's drawing of the *View from Behind a Cemetery Wall*, where the different architectural styles of the mausoleums rise above the horizon of the wall. They are decapitated monuments, severed from the past and their context in the city, standing in isolation like temples in an English romantic garden.

The outdoor room of the Beistegui is implied by the interiors of Le Corbusier's houses of this period. Many are drawn as if outside, for the ceilings are not graphically indicated. The rounded volumes of the rooms stand against what could be the sky. In plan the Beistegui is similar to the Cook House, organized by two framing walls. The sliding doors between the walls

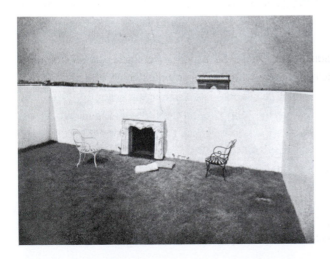

8.13
**Le Corbusier, fireplace and Arc de Triomphe, Beistegui**

8.14
**René Magritte, *Time Transfixed*, 1928**

of the Beistegui, though, are of natural materials, hedges set into electrically controlled slots that part to reveal a vista of Paris.

The meaning of the Beistegui is clear as a model apartment of Le Corbusier's Radiant City, where one sees Paris according to his vision of the future. For in Le Corbusier's plans for Paris, the low-rise urban fabric was to be demolished, replaced by a garden park. Only the great monuments were to remain, with the addition of a new one, Le Corbusier's immense glass apartment towers on the scale of Notre Dame and the Eiffel Tower. From the summit of the Beistegui all these monuments are visible except one: the glass towers; therefore, this would be the view from atop one of the radiant apartments.

The Radiant City would be a garden of historical monuments, each tower a temple in the park. Le Corbusier writes, in an often-overlooked chapter in his book *Urbanism*, that not just the major monuments would be preserved but on a smaller scale, historical fragments of the city:

> the Voisin plan shows, still standing among the masses of foliage of the new parks, certain historical monuments, arcades, doorways, carefully preserved, it safeguards the relics of the past and enshrines them harmoniously in a framework of trees and woods ... these green parks with their relics are in some sort of cemetery, carefully tended in which people may breathe, dream and learn.[7]

Supporting the theory of the Beistegui as a paradigm of the future is a photograph of it where the rooftop topiary statue (recalling a primitive fertility figure) stands sentinel-like opposite the glass wall of the apartment with the Arc de Triomphe in the distance. It is very much like a drawing of the Radiant City where the glass wall of the apartment tower defines one side of the central plaza framing the monument of the same Arc de Triomphe.

The glass towers were to be set amidst a park of trees, not carefully manicured, but a wild and romantic garden reminiscent of a Caspar Freidrich painting, evocative of nature's unrestrained moods. An unnamed roof garden, probably the Beistegui, is presented in 1932, showing the effects of time and vegetation on the once well-maintained garden. Completely overgrown with vines and weeds, the garden has become an abandoned ruin, to the obvious delight of Le Corbusier.

The fascination of the surrealists by ruins and vegetative decay is well known. Specifically linking them to the outdoor room of the Beistegui in its forgotten state is the bedroom at the Surrealists Exposition of 1938 where the bed lies entangled in a swamp. *Minotaure* also published Benjamin Peret's photograph of the locomotive, powerful symbol of the machine

8.15
**Benjamin Péret, "La Nature Devore, Le Progrès et le dépassé"**

age, immobilized by the jungle, entitled "La Nature Devore, Le Progrès et le dépassé" (Figure 8.15).[8] The ruins of the Beistegui contain the memory not only of its former state but also relates to the cycle of creation and destruction admired by Le Corbusier. He even saw the effects of war as an opportunity and a "proof" of the major steps necessary to reconstruct the overcrowded and chaotic cities. The final incarnation of the image of the Beistegui is in Magritte's cover for *Minotaure*, where various impossible magical objects, a black-shrouded cow skeleton, a flaming tuba, and the boot feet stand on the charred remains of a roof garden overlooking Paris, the Eiffel Tower in the distance.

The dark vision of the future in both Magritte's and Le Corbusier's portrayal of the outdoor room could have occurred partly from Le Corbusier's disillusionment at the continuous rejection of his plans for Paris and from the imminence of the Second World War. In both artists, a similar, literally petrifying reaction resulted after the war. Magritte embarked on a series of "stone age" paintings, such as *Remembrance of a Journey*, in which everyday objects, a bowl of fruit, the table, even the table cloth have fossilized into solid rock. The table stands before an open window, threatened by an avalanche of boulders, seemingly frozen in place (Figure 8.16).

The image recalls the outside altar of Le Corbusier's chapel at Ronchamp, especially as transformation of his earlier conceptions of the outdoor room. Situated on the summit of a mountain, the wall of the chapel opening to the landscape is the archaized open-air roof garden, its mythological

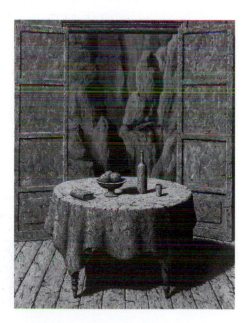

8.16
**René Magritte, *Remembrance of a Journey III*, 1951**

realization as a transcendent place, an "acropolis" atop the roof of a house, an apartment, or a mountain. The walls of Ronchamp are covered with a sprayed on, rough cement coating giving the appearance of stone. Gone is the wiry, movable furniture of the early work; in their place is the table-like altar, a massive and blocky form.

The inside–outside ambiguity is clearly stated in the placement of the two altars, one facing the landscape and the other the interior, each a mirror image of the other, identical in elements and their relation to the curved wall and mysterious balcony. In these drawings, people are again small or absent, the forms of meaning; the table, balcony, window, and cross are themselves called "witnesses" to the religious events. The surreal implications of the opposite side of the chapel (the solid as opposed to the hollow of the altar) are evident in the relation between the bull-nose water spout and the jagged forms of the pool below to Magritte's *Promenade of a Monster*, in which a tentacled, amoebic shape is attached to a wall, poised above the same sharp, pyramidal forms as at Ronchamp (Figure 8.17).

Specifically uniting the Beistegui and Ronchamp is the image of Le Corbusier as the black raven. Le Corbusier's nickname, "Corbu," from *corbeau*, means raven, and he often portrayed himself as such – sometimes humorously, as with a menagerie of his co-workers at Chandigarh, at other times mysteriously, as on the roof garden of the Governor's Palace or in the stained glass of Ronchamp where the raven is linked to the howling man in the moon. Le Corbusier, the bird as silent witness, is placed atop a column adjacent to the ziggurat memorial to the war dead at Ronchamp, the hard-

8.17
**Le Corbusier, waterspout and pool, Ronchamp**

8.18
**Le Corbusier, memorial to the fallen war dead, Ronchamp**

8.19
**René Magritte, *Le Fanatiques*, 1955**

edged square of the stepped pyramid in contrast to the fluid curves of the main chapel. Surprisingly, the same relationship exists in a photograph of the Beistegui twenty years before, where a topiary bird similar in shape and stance to the raven at Ronchamp is silhouetted against the city of Paris. It is atop a platform of steps, like the altar to the fallen dead at Ronchamp (Figure 8.18).

The moon and the raven as the witness appear in two Magritte paintings, the first contemporary with the construction of Ronchamp in 1955. Called *Les Fanatiques*, a raven circles above a mysterious fire within a Stonehenge-like enclosure of boulders (Figure 8.19). In *Gasparade de la Nuit*,

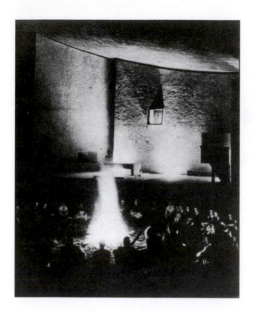

8.20
**Le Corbusier, bonfire, Ronchamp**

the raven looks on as a house burns under a crescent moon. It recalls Le Corbusier's conclusion to his book on Ronchamp: a photograph of a bonfire in front of the cavernous wall of the outside altar, surrounded by a ring of people, while in the night the black raven of Le Corbusier and the howling moon behold an unknowable and primitive ritual (Figure 8.20).

## Notes

1   Le Corbusier, in L. Sutter, "L'Inconnu de la Soixantaine," in *Minotaure* 9, pp. 62–65.
2   Le Corbusier, *When the Cathedrals Were White*, New York: McGraw-Hill, 1964, pp. 147–148.
3   Le Corbusier, *Towards a New Architecture*, New York: Praeger 1972, p. 177.
4   K. Frampton, *Oppositions* 15/16, p. 10; also see K. Frampton, "Has the Proletariat No Use for a Glider?," in *AD Profiles, Surrealism and Architecture* (Volume 48, Number 2–3, 1978).
5   A. Breton, "Souvenir du Mexique," in *Minotaure* 6.
6   H. Bellmer, "Poupee, Variations sur le montage d'une mineure articulee," in *Minotaure* 6.
7   Le Corbusier, *The City of Tomorrow and Its Planning*, Cambridge, Mass.: MIT Press, 1975, p. 287.
8   B. Peret, "La Nature Devore, Le Progrès et le dépassé," in *Minotaure* 10, p. 21.

# Chapter 9

# "...The gift of time"
## Le Corbusier reading Bataille[1]

*Nadir Lahiji*

Sometime between 1949 and 1953 Georges Bataille gave Le Corbusier a copy of his most celebrated book, *La Part Maudite, essai d'economie general* (*The Accursed Share*).[2] The title page bears this inscription, in Bataille's hand: "à Monsieur Le Corbusier, en témoignage d'admiration et de sympathie."[3] On the last page of this copy, Le Corbusier wrote "19 Nov. 1953," which indicates the date he finished reading the book. Le Corbusier marked the text, underlined passages, and wrote commentaries on its two flyleaves. In spring 1988, the Centre Georges Pompidou in Paris exhibited Le Corbusier's copy of *La Part Maudite* for the first time. To my knowledge, Le Corbusier never read Marcel Mauss's monumental work, *The Gift*;[4] but here is a gift he received from Georges Bataille, who at the instigation of Alfred Metraux became acquainted with the theory of *potlatch* outlined by Mauss in *Essai sur le don, forme archaique de l'échange*, which Mauss published in the 1925.[5] Bataille's argument in *La Part Maudite* owes a debt to Mauss's work.

Le Corbusier was fascinated by the chapter "Le don de rivalite (le 'potlatch'")" ["The Gift of Rivalry: 'Potlatch'"] in *La Part Maudite*, where Bataille discussed the idea of the "gift." In his "overview" of Bataille's text, written on the flyleaf, Le Corbusier made these remarks about the section "Theorie du 'potlatch': l'acquisition du 'rang'" ["Theory of 'Potlatch,' The Acquisition of Rank"], with reference to page 92 of his copy of *La Part Maudite*:

Les 5 volumes oeuvres complètes Corbu offrent, proposent et imposent par adhésion enthousiaste les idées Corbu. D'un côté Corbu est assumé par les salauds, de l'autre il est roi. La pratique desintéressée de la peinture est un inlassable sacrifice, un don du temp, de patience, d'amour, sans aucune contrepartie d'argent (sauf les modernes marchands). C'est semer à tout vent pour inconnus. Un jour avant ou aprés la mort, on nous dira merci. C'est trop tard pour tant de traverses vécues. Mais qu'importe; ce qui importe est la clef du bonheur.

[In offering the five volumes of *Complete Works*, Corbu has put forward and has asserted enthusiastic ideas to which Corbu himself is an adherent. From one side, Corbu is taken for granted, and from the other side he is a king. The unselfish practice of painting is an untiring sacrifice; it is a gift of time, patience, and love, expecting no material reward (save the modern merchants). All these spendings have remained *unrecognized*. One day, before or after my death, they will say "thank you." This will come late, after many setbacks that I have lived through in my life. But what does it matter; what *matters* is the secret to happiness.][6]

Phillip Duboy cites this passage in his article for *Le Corbusier, Une Encylopedie*. Duboy writes that Le Corbusier penned this commentary on a flight to the new capital of Punjab, Chandigarh.[7] He suggests that "this brief reflection" by Le Corbusier is the source for the "Open Hand" at Chandigarh. Duboy asserts that these remarks signify the definition of Le Corbusier as a modern hero, the true subject of modernity that owes its definition to Walter Benjamin, who, by the way, Bataille was the first to welcome in Paris and held in highest esteem as German émigré. On the basis of Le Corbusier's reading of Bataille, Duboy offers that one might be tempted to define the modern heroes with what Jacques Lacan would characterize as "qu'illustrent des exploits dérisoires dans une situation d'égarement."[8] Whatever definition of the modern hero we might employ, we would do well to remember what Walter Benjamin, who read Le Corbusier's *Urbanisme*, wrote in "Convolute N" of his monumental work, *The Arcades Project*, about the essence of modernity in the twentieth century: "To encompass both Breton and Le Corbusier – that would mean drawing the spirit of contemporary France like a bow, with which knowledge shoots the moment in the heart."[9] If we replace Breton with the "dissident" surrealist Georges Bataille, we have the dialectical opposites of modernity: the modernity of *discipline* versus the modernity

of *desire*.[10] In his modernity of discipline, Le Corbusier made The Sun and The Body stand on their vertical axes, whereas Georges Bataille, the philosopher of transgression, spent his life subverting this vertical axis, collapsing it into horizontality. Yet why should Bataille, in an act of verbal potlatch and expenditure of words, give a "gift" of his "d'admiration et de sympathie" to Le Corbusier? To which Le Corbusier does Bataille issue this gift: the architect, the painter, the planner, the fellow traveler, or the political comrade? I shall come back to this later in the chapter. Let me state here that an unbridgeable abyss would seem to separate Le Corbusier and Georges Bataille; they are two different thinkers. Yet I am tempted to suggest that we should take "Bataille with Le Corbusier" as twentieth-century "contemporaries," in the sense that Jacques Lacan takes "Kant with Sade."[11]

Bataille reserved enough admiration for Le Corbusier to give him a copy of his *La Part Maudite* as a "gift." Le Corbusier was the first architect to read Georges Bataille's most important work. In fact, Le Corbusier was one of the very few intellectuals who read Bataille's *La Part Maudite* in its first printing, which sold only fifty copies and did not find a wider audience at the time of its publication.[12] In this respect, one might admit Le Corbusier into the circle of Bataille's associates: Michel Leiris, André Masson, Antoine Artaud, Maurice Blanchot, Roger Caillois, and Jacques Lacan, to name only a few. One can speculate that in his reading of Bataille's *La Part Maudite*, Le Corbusier found a confirmation of his reading of Nietzsche's *Thus Spoke Zarathustra* some fifty years earlier: he perceived himself in strife as a tragic hero, whose life was spent as a sacrificial "gift" to humanity. Compared with his reading of Nietzsche, Le Corbusier's reading of Bataille, when he was in his early sixties, may seem to be an incidental event in his later life and works; perhaps one can call this reading posthumous. But, following Duboy, I want to argue that the sources behind the idea of the "Open Hand" might be found in Le Corbusier's reading of Bataille. But I would go further and claim that a reading of Bataille's idea of *dépense* might shed further light on our interpretation of Le Corbusier's later work. I would suggest that *La Part Maudite* strongly influenced Le Corbusier's Plan of Chandigarh. Particularly I will argue that besides the Nietzschean connection in the *main ouverte*, which has aptly been brought up by Manfredo Tafuri, one should think of the Open Hand in the light of Bataille's notion of "Sacrifice."[13] Le Corbusier's reading of Georges Bataille's work was an "autobiographical" one, not unlike his reading of a new translation of Homer's *The Iliad* some years later, which he attempted to illustrate.[14]

How did Bataille know Le Corbusier? Where did his "sympathy and admiration" for Le Corbusier lie? Why did Le Corbusier take an interest in ideas exercised by Bataille in *La Part Maudite*? Until more archival

documents surface, any definitive answer to these questions must be post-poned. Nevertheless, we can speculate on a convergence of ideas that brought these two thinkers together in the complex years of the 1930s in France.[15] Part of the answer must be sought in the similarities between Le Corbusier's and Bataille's politics during the 1930s.[16] One could presume that Bataille came to know Le Corbusier through the magazine *L'Esprit nouveau*, and especially later through the journal *Minotaure*, which was founded in 1933 by Georges Bataille and André Masson, dissident surrealists who gathered together other artists who became disillusioned with André Breton. Strictly speaking, *Minotaure*, along with the journal *Documents*, was not a "surrealist" journal, or, better, it was not just surrealist to the extent that other non-surrealist writers contributed to it.[17] Le Corbusier contributed the article "Loius Soutter, L'inconnue de la soixantaine," to issue no. 9 of *Minotaure* in 1936. As Anthony Vidler incisively observes, the Surrealists' antipathy to modernism reflected itself in the quarrels between André Breton and Le Corbusier.[18] For Breton, "Modernist functionalism was 'the most unhappy dream of the collective unconscious.' "[19] Le Corbusier took exactly the opposite position, as he expressed in his article in *Minotaure*.

Bataille's inscription in Le Corbusier's copy of *La Part Maudite* bears no date, so it is difficult to determine exactly when Bataille gave his book to Le Corbusier. But we can speculate with some certainty that Le Corbusier dealt with the book around and during the time that he began to get involved in the Chandigarh project in India. Albert Mayer and Matthew Nowiki had already established master plan and sketches of the Capitol area of Chandigarh around 1950. In late 1950 Le Corbusier took over the job after the sudden death of Nowicki while flying over Egypt. Le Corbusier flew to India in February 1951.[20] As I mentioned above, according to Duboy, Le Corbusier wrote his "overview" of Bataille's work on this flight.

In the 1930s Le Corbusier was preoccupied with the idea of *planisme*, which explains his interest in the section "The Marshall Plan" in the last part (Part Five, Volume I) of *La Part Maudite*.[21] As Allan Stoekl informs us, Bataille's *planiste* tendency comes to the surface after the war in *La Part Maudite*.[22] At the beginning of the 1950s, Le Corbusier realized in the Chandigarh Plan the ideas of planning that he had put forward in the 1930s. But clearly the conception of planning in Chandigarh is radically different from that of planning in the 1930s. To demonstrate this, we might turn to two chapters in the first volume of *La Part Maudite*: "The Gift of Rivalry: 'Potlatch' " and "The Marshall Plan."

Le Corbusier paid special attention to these chapters, heavily marking paragraphs and making commentaries.[23] Bataille's thoughts on "Potlatch" and the Marshall Plan enabled Le Corbusier to see his role in the

Chandigarh Plan. The nature of this plan was different from that of *Ville Radieuse* in its fundamental philosophical premises, also different in its architectural concept. Le Corbusier's reading of the idea of *potlatch* in *La Part Maudite* reinforced his philosophical conviction about his gigantic, humanistic mission in the Chandigarh project: a plan for the newly born nation of India in need of its own singular transition to a modern state.[24] Let us not forget that Le Corbusier conceived of the plan for Chandigarh in the aftermath of his frustrated attempts at urban planning for the major cities in the West, which forever remained unrealized.

In the 1930s Le Corbusier was intensely, aggressively, and internationally involved in putting forward his urbanistic ideas. In the center of all these projects was a fundamental ideology of central economic planning with authoritarian political control. In addition to his ongoing design and projects, his major activities during this period included publishing *Précision sur un état présent de l'architecture et de l'urbanisme* in 1930; launching a number of studies of town-planning for cities, including Algiers (Plan Obus, A, B, C, D, E), Paris, Barcelona, and Stockholm; proposing the *Ville Radieuse* in 1933; becoming an active member of CIAM; paying his last visit to USSR in 1930; publishing his *Quands les cathédrales étaient Blanches* in 1937; and organizing his exhibitions in the United States and Europe.[25]

The term *planisme*, or "technocratism," refers to the main line of debate in France during the 1930s. The figures debating this notion contributed to the review *Plans*, a short-lived journal founded by Philip Lamour in 1931 to which two contemporaries of Bataille, Robert Aron and Arnold Dandieu, contributed. They were connected to the Ordre Nouveau, and their political positions had much in common with what Bataille expounded in his brilliant and influential 1933 essay, "The Notion of Expenditure."[26] Bataille wrote this essay for the journal *La Critique sociale* at the age of thirty-five.[27] He was fifty-two when he published *La Part Maudite*, which he described in the preface as the fruit of eighteen years of work. Both texts proceed from his discovery of Marcel Mauss's *The Gift* around the end of 1920s.[28]

Le Corbusier was on the editorial board of *Plans* in 1931 and 1932. He regularly participated and actively contributed to this journal.[29] He wrote and published eighteen articles on urbanism between January 1931 and July 1932, many of which he later collected and reprinted in section four of *La Ville Radieuse*.[30] The ideas expounded by Arnaud Dandieu, the leader of Ordre Nouveau and a librarian, like Bataille at the Bibliotheque National in Paris, influenced Bataille.[31] Dandieu published *La Révolution nécessaire* in collaboration with Robert Aron in late 1933, the same year Bataille published "The Psychological Structure of Fascism" in *La Critique sociale*. Dandieu was also a contributor to Bataille's review *Documents*.[32] During 1933 Bataille had

episodic relations with Ordre Nouveau. He anonymously collaborated with Dandieu and Aron on the chapter "Echanges et Crédits" of their *Révolution nécessaire*.[33] The 1930s in France were times of complex political movements and debates on Syndicalism, Communism, Americanism, and Fascism. The Ordre Nouveau movement, headed by Dandieu, joined with the participants of *Plans* in the Fall of 1931 to establish a "genuine European federation." It is possible that through this collaboration, Le Corbusier and Dandieu came to know of each other's ideas; and, through Dandieu and *Plans*, that Bataille could have come to know Le Corbusier. In any case, we can conclude that Bataille's admiration for Le Corbusier in 1949 is rooted in this period, when Le Corbusier's ideas on urbanism and planning might have found a sympathetic ear in Bataille. Bataille's *planisme* later bears similarities to Le Corbusier's. This helps explain why Le Corbusier took a special interest in *La Part Maudite*'s last chapter on the Marshall Plan. The argument advanced by Bataille, and the question he confronted, were of the same nature as the ones that Dandieu and Aron dealt with between the years 1931 and 1933.[34]

In *La Part Maudite*, Bataille attempts to subvert the existing political economy, which was grounded in rationality and utility, and replace it with a "general economy."[35] In this "general economy," unproductive expenditure – sacrifice, luxury, war, games, and monuments – determines social life. As one commentator notes, this notion of general economy

> is not the store and the workshop, the bank and the factory, which hold the key from which the principles of the economy can be deduced. In the blood that spurts from the open chest of victims sacrificed to the sun in an Aztec ritual, in the sumptuous and ruinous feasts offered to the courtiers of Versailles by the monarch of divine right, in all these mad dissipations is found a secret that our restricted economics has covered up and caused to be forgotten.[36]

In the thesis of the "general economy," social wealth is not a utilitarian vision, the parsimonious viewpoint of an ascetic bourgeoisie, which spends only when it expects return. Rather, society itself is formed in

> the *mode of expenditure* of the excess, the consumption of the superfluous, this accursed share ... The dominant prosaic vision may be only a recently formed prejudice contemporaneous with the reign of the bourgeoisie, ushered in by the Reformation, and unable to account for the real and ineluctable movement of

wealth in a society, a movement that sovereignty engages human beings: their relationship to the sacred through religion, mysticism, art, eroticism.[37]

Some of the themes in *La Part Maudite* had already been anticipated in "The Notion of Expenditure": "Human activity is not entirely reducible to processes of production and conservation, and consumption must be divided into two distinct parts." The first part, he writes, is represented by the minimum productive activity necessary for the conservation of life in a given society; the second part is represented "by so-called unproductive expenditure: luxury, mourning, war, cults, the construction of sumptuary monuments, games, spectacles, arts, perverse sexual activity (i.e., deflected from genital finality) – all these represent activities which, at least in primitive circumstances, have no end beyond themselves."[38]

In part two of *La Part Maudite*, in the chapter "Sacrifice or Consumption," the following passage was marked and underlined by Le Corbusier:

> Cette consumation inutile est *ce qui m'agrée*, aussitôt levé le souci du lendemain. Et si je consume ainsi sans mesure, je révèle à mes semblables ce que je suis *intimement*: la consumation est la voie par je où communiquent des êtres *séparés*. Tout transparaît, tout est ouvert et tout est infini, entre ceux qui consument intensément. Mais rien ne compt dès lors, la violence se libère et elle se déchaîne sans limites, dans la mesure où la chaleur s'accroît.

> [This useless consumption is *what suits me*, once my concern for the morrow is removed. And if I thus consume immoderately, I reveal to my fellow beings that which I am *intimately*. Consumption is the way in which *separate* beings communicate. Everything shows through, everything is open and infinite between those who consume intensely. But nothing counts then; violence is released and it breaks forth without limits, as the heat increases].[39]

In the left margin of this passage Le Corbusier wrote the word "fusion," which I take to be a reference to the section, "fusion," in "The Poem of the Right Angle." In "The Marshall Plan," Bataille returns to an affirmation of certain *planisme* that during the 1930s had associations with forms of authoritarianism, proto-fascism, and Marxism.[40] *Planisme* was the very essence of

a centrally organized society with a political leader. During the *Acéphale* period in the 1930s, Bataille was critical of *planisme*. As Stoekl observes, *Acéphale*, a 1936 drawing by André Masson,

> is a figure that bears death, but at the same time "he" is a perfectly coherent and traditional "sacred figure" around which a society, albeit one of conspirators, can be established ... While the head is clearly missing, the stars (nipples), bowels and death's head (genital) only go to create another face, another "figure humaine." Further, the death's head itself has a miniature face ... The "acéphale," in other words, has lost a head, a principle of organization and order, only to mutate and develop another, more hypnotic, doubled and doubling (replicating) face.[41]

In Le Corbusier's idea of *Ville Radieuse*, there was no "acéphalic head" as (dis)organizing principle, but rather it was the very "head" at the top of a hierarchy that was the organizing principle. This plan was compatible with Dandieu and Aron's authoritarianism and the imperative of a center.

Bataille in the chapter "Soviet Industrialization," of *The Accursed Share* wrote:

> Rein n'est fermé à qui reconnaît simplement les conditions matérielles de la pensée. Et c'est de toutes partes et de toutes façons que le monde invite l'homme à le changer. Sans doute l'homme de ce côté-ci n'est pas nécessairement appelé à suivre les voies impérieuses de l'U.R.S.S. Dans la plus grande mesure il se consume aujourd'hui dans la stérilité d'un anticommunisme effrayé. Mais s'il a ses problèmes propres à résoudre, il a mieux à faire qu'à maudire aveuglément, au'à crier une détresse que commandent ses contradictions multipliées. Qu'il s'efforce de comprendre ou mieux qu'il admire la cruelle énergie de ceux qui défoncèrent le sol russe, il sera plus proche des tâches quil'attendent. Car *c'est de toutes parts et de toutes façons qu'un monde en movement veut être changé.*

> [Nothing is closed to anyone who simply recognizes the material conditions of thought. On all sides and in every way, the world invites man to change it. Doubtless man on this side is not necessarily bound to follow the imperious ways of the USSR. For the most part, he is exhausting himself in the sterility of a fearful anti-communism. But if he has his own problem to solve, he has

more important things to do than blindly to anathematize, than to complain of a distress caused by his manifold contradictions. Let him try to understand, or better, let him admire the cruel energy of those who broke the Russian ground; he will be closer to the tasks that await him. For, *on all sides and in every way, a world in motion wants to be changed.*][42]

Le Corbusier circled this paragraph and wrote below it: "Dupius 35 années je fais Des Plans ... car c'est la précisément, mon rôle et mon devoir" ("For 35 years I have made plans ... because this is precisely my role and my duty"). Later, I will come back to the significance of this remark.

Bataille begins "The Marshall Plan" by saying:

Outside of the Soviet world, there is nothing that has the value of an ascendant movement, nothing advances with any vigor. There persists a powerless dissonance of moans, of things already heard, of bold testimony to resolute incomprehension. This disorder is more favorable no doubt to the birth of an authentic *self-consciousness* than is its opposite, and one might even say that without this powerlessness – and without the tension that is maintained by communism's aggressiveness – consciousness would not be free, would not be *alert*.[43]

This passage was underlined by Le Corbusier. The Marshall Plan responded to the threat of Soviet hegemony in an impoverished Europe. It was a plan by which the United States could peacefully enter into competition with the Soviets. After all, "a *plan* must be evolved through which a military confrontation is avoided."[44] The Marshall Plan, according to Bataille, "is the solution to the problem. It is the only way to transfer to Europe the products without which the world's fever would rise."[45] (This passage was also underlined by Le Corbusier.) The Marshall Plan was different from the *planisme* of Dandieu and Aron, and from the *Ville Radieuse*. The end of this plan is a potlatch, a "spending without return" already put forward by Bataille in "The Notion of Expenditure." As opposed to socialist state planning, controlled by an authoritarian "head," The Marshall Plan was "headless" planning. Truman, after Roosevelt, was the "acéphalic head." Stoekl points out that this is

"planning without a head" in another sense as well: the "end" of planning is planlessness ... Just as the most elaborately conceived planning is inseparable from potlatch, so too the most

integrated, nonindividuated consciousness (the consciousness that arises at the end of history, through the an impossible "awareness" of the [non] "objective" of the Marshall Plan) is indissociable from the nothingness it "knows." At this point one can see how Bataille's economic project folds back into the secular mystical experience of the *Somme athéologique*.[46]

Le Corbusier's careful reading of this chapter in marking every page clearly indicates his affirmation of Bataille's thesis. But it is more than an affirmation; I would argue that Le Corbusier found his "headless" Truman in the "acéphalic head" of Nehru. At Chandigarh, Le Corbusier transcends the *planisme* of the 1930s and the authoritarianism of *Ville Radieuse*. The Chandigarh plan is clearly a plan without a head, and free of a hierarchical distribution. It is a potlatch of an "excessive" expenditure of space; its structure is a disarticulated and disjunctive (de)composition. In this plan Le Corbusier frees himself from the anthropomorphic body of *Ville Radieuse* and authoritarian control and achieves a body (dis)organization akin to André Masson's *Acéphale*. In regarding the Chandigarh plan it would be instructive to read Bataille's article "Architecture," published in *Documents* in 1929. This was the first article that Bataille published in *Documents'* dictionary, which was devoted to architecture. The first paragraph states:

> Architecture is the expression of the true nature of societies, as physiognomy is the expression of the nature of individuals. However, this comparison is applicable, above all, to the physiognomy of officials (prelates, magistrates, admirals). In fact, only society's ideal nature – that of authoritative command and prohibition – expresses itself in actual architectural constructions. Thus the great monuments rise up like dams, opposing a logic of majesty and authority to all unquiet elements; it is in the form of cathedrals and palaces that church and state speak to and impose silence upon the crowds. Indeed, monuments obviously inspire good social behavior and often even genuine fear. The fall of the Bastille is symbolic of this state of things. This mass movement is difficult to explain otherwise than by popular hostility towards monuments which are their veritable masters.[47]

According to Bataille, architecture starts as the soul of the society, a neutral image that later will intervene in the very social order that it symbolizes. In this reversal, to follow Hollier's comments, the relationship between architecture and the society that it expresses is analogically similar to the

relationship between Inca civilization and its imperialistic system of state control, also the pre-Colombian Mexicans or Aztecs and their sacrifices atop pyramids, which Bataille discussed in "Sacrifices and Wars of the Aztecs."[48] In *La Part Maudite*, Bataille wrote that all important undertakings of the Aztecs were useless: "Their science of architecture enabled them to construct pyramids on top of which they immolated human beings."[49] He further writes:

> The priests killed their victims on top of the pyramids. They would stretch them over a stone altar and strike them in the chest with an obsidian knife. They would tear out the still-beating heart and raise it thus to the sun. Most of the victims were prisoners of war, which justified the idea of wars as necessary to the life of the sun: Wars meant consumption, not conquest, and the Mexicans thought that if they ceased the sun would cease to give life.[50]

Le Corbusier's Chandigarh plan projects an image of expenditure and distribution of wealth and space for a new India by precisely suspending and disrupting the physiognomy of a hierarchical body, which is based not on consumption but rather on utility and production, such as Le Corbusier symbolized in *Ville Radieuse*. The expenditure of space in Chandigarh knows no boundary; it is a sacrificial giving of space, returning to the sun its gift of accursed energy.

Manfredo Tafuri, the only historian who has drawn on Bataille's writing to interpret Le Corbusier's late work, aptly captured the spirit of the Chandigarh plan. He wrote:

> Nothing in fact joins together the gigantic volume of the Secretariat, the Parliament, and the High Court of Justice: nothing – neither roads, perspectival allusions, nor formal triangulations – helps the eye to situate itself with respect to these three "characters," which weave among themselves a discussion from which the human ear is able to gather only weak and distorted echoes. Indeed, the modeling of the terrain, the dislocation of level, the mirrors of water, especially the Pool of Reflection, are all there to accentuate discontinuities and ruptures.[51]

Tafuri also points out that:

> Interruptions, slippings, and distortions indeed pervade the language of the later Le Corbusier: at Chandigarh they are essential

to the dramatization of the forms. The three great "desiring objects" seek to shatter their own solitude: the Secretariat through its inclined ramp and the broken meshes of its facade gradations; the Parliament through the distortion of the geometric solids that dominate it like hermetic totems; the high Court of Justice through the bending of the brise-soleil and the giant entrance stairway. But the interchange takes place only at a distance: tension informs this dialogue among symbols that have lost the codes that once gave them the value of names.[52]

The economy of this plan is analogous to the "solar economy" in squandering its energy for total *dépense*. In this plan the culture of Schure's "great initiates" comes to meet the secular mysticism of Bataille's *Somme athéologique*. This vision of potlatch culminates in the *main ouverte*. This will lead us to the significance of the idea of the "gift." With the idea of the gift let us return to the notion of an "autobiographical reading" of Bataille's book by Le Corbusier that I suggested at the beginning of this essay.

In *La Part Maudite* Bataille discussed the idea of the gift in a chapter titled "The Gift of Rivalry: 'Potlatch.'" Le Corbusier made some commentaries and remarks on this chapter. I mentioned above Le Corbusier's "overview" of Bataille's text written on the flyleaf, to which I want to return here. Let me draw attention to the key statement in this "overview." Le Corbusier wrote: "La pratique desintéressée de la peinture est un inlassable sacrifice, un don du temp de patience, d'amour, sans acune contrepartie d'argent" ["the disinterested practice of painting is unflagging sacrifice, a gift of the time, of patience, of love, with no restitution"]. In this remark Le Corbusier draws a parallel between Bataille's notion of *dépense* and the identity of his own work. Through Bataille's writing he sees the truth in his paintings as a token of the sacrifice of himself. He appropriates Bataille's argument as his own and sees himself in its mirror. When Le Corbusier writes "a gift of the time of patience ... with no restitution": "time" and "the time of patience" equals the "gift" itself. Before I reflect further, let us see how the idea of the *gift* entered Bataille's thinking. In "The Notion of Expenditure" Bataille quoted Marcel Mauss: "The ideal would be to give a *potlatch* and not have it returned."[53] His reading of Mauss's *The Gift* enabled Bataille to formulate his notion of the "general economy," as he admits in *The Accursed Share*. In *The Gift*, Mauss wrote: "If one gives things and returns them, it is because one is giving and returning 'respect' – we still say 'courtesies'. Yet, it is also by giving that one is giving *oneself*, and if one gives *oneself*, it is because one 'owes' *oneself* – one's person and one's goods – to others."[54] This remark would have appealed to Le Corbusier had he read it.

Mauss explored the institution of "potlatch" in the Pacific Northwest in his elaboration of the theory of gift in archaic societies. He wrote *"the obligation to give is the essence of the potlatch."*[55] The word "potlatch" comes from Nootka Indian *potatsh*, or *patlatsh*, as a noun and a verb meaning "gift" and "giving." Among some North American Indians of the Pacific coast the word means "a gift, a present"; and "a tribal feast at which presents are given and received, given by an aspirant to chiefship." It also means "an extravagant giving away or throwing away of possessions to enhance one's prestige or establish one's position."[56] But we have to go to Mauss for the sociological and ethnographical signification of the idea of *potlatch*. Mauss in the introduction to *The Gift* writes:

> Within these two tribes of the American Northwest and throughout this region there appears what is certainly a type of these "total services," rare but highly developed. We propose to call this form the "potlatch," as moreover, do American authors using the Chinook term, which become part of the everyday language of Whites and Indians from Vancouver to Alaska. The word potlatch essentially means "to feed," to "consume" . . .
>
> Yet what is noteworthy about these tribes is the principle of rivalry and hostility that prevails in all these practices. They go as far as to fight and kill chiefs and nobles. Moreover, they even go as far as the purely sumptuary destruction of wealth that has been accumulated in order to outdo the rival chief as well as his associates (normally a grandfather, father-in-law, or son-in-law). There is total service in the sense that it is indeed the whole clan that contracts on behalf of all, for all that it possesses and for all that it does, through the person of its chief. But this act of "service" on the part of the chief takes on an extremely marked agonistic character. It is essentially usurious and sumptuary. It is a struggle between nobles to establish a hierarchy amongst themselves from which their clan will benefit at a later date. We propose to reserve the term potlatch for this kind of institution that, with less risk and more accuracy, but also at a greater length, we might call: *total service of an agonistic type.*[57]

Further, Mauss gives an exact definition for potlatch: "*The obligation to give is the essence of the potlatch.*"[58] The etymological root for the word "gift" is more complex. Mauss, in a footnote, goes into the meanings of that word in detail. The word "gift," he says "is the translation of the Latin

*dosis*, itself a transcription of the Greek 'dose, dose of poison.' "[59] He goes on:

> This etymology presumes that High and Low German dialectics would have preserved a learned name for a thing in common use . . . One would need to explain the choice of the word *gift* for this translation, as well as the converse linguistic taboo that has hung over the meaning of *gift* for this word in certain Germanic languages. Finally, the Latin, and above all the Greek use of the word *dosis*, with the meaning of poison, proves that, with the Ancients, too, there was an association of ideas and moral rules of the kind that we are describing.[60]

Furthermore, Mauss says: "We have compared the uncertain meaning of *gift* with that of the Latin word *venenum* . . . To this must be added the comparison . . . of *venia*, *venenum*, from *vanati* (Sanskrit, 'to give pleasure'), and *gewinnuen*, 'to win.' "[61] Remarkably, this description of the uncertain meaning of the word "gift" brings it into the association with another equally ambiguous Greek word, *pharmakon*.[62] This ambiguity in the meaning of "gift" is the subject of Jacques Derrida's remarkable essays in *Given Time: I. Counterfeit Money*.[63] In this work, Derrida has taken up the question of the economic reasoning in the idea of gift, or "present," and its relationship to the philosophical category of time in Marcel Mauss's *The Gift*. In his analysis, Derrida remarks on the "madness" of the giving without restitution in the face of which the economic reasoning of the gift falters. The passage in support of Derrida's reflection on the "madness" of gift in Mauss reads as follow:

> No less important in the transaction of the Indians is the role played by honor. Nowhere is the individual prestige of a chief and that of his clan so closely linked to what is spent and to the meticulous repayment with interest of gifts that have been accepted, so as to transform those who have obligated you into the obligated ones. Consumption and destruction are here really without limits. In certain kinds of potlatch, one must expend all that one has, keeping nothing back. It is a competition to see who is the richest and also the most madly extravagant. Everything is based upon the principle of antagonism and of rivalry. The political status of individuals in the brotherhoods and clans, and ranks of all kinds are gained in a "war of property," just as they are in real war, or through chance, inheritance, alliance, and marriage. Yet every-

thing is conceived of as if it were a "struggle of wealth." marriages for one's children and places in the brotherhoods are only won during the potlatch exchanged and returned. They are lost at the potlatch as they are lost in war, by gambling or in running and wrestling. In a certain number of cases, it is not even a question of giving and returning, but of destroying, so as not to want even to appear to desire repayment. Whole boxes of olachen (candlefish) oil or whale oil are burnt, as are houses and thousands of blankets. The most valuable copper objects are broken and thrown into the water, in order to crush and to "flatten" one's rival ... In this way one not only promotes oneself, but also one's family, up the social scale. It is therefore a system of law and economics in which considerable wealth is constantly being expended and transformed. One may, if one so desires, call these transfer acts by the name of exchange or even trade and sale; but such trade is noble, replete with etiquette and generosity. At least, when it is carried on in another spirit, with a view to immediate gain, it is the object of very marked scorn.[64]

The economic reasoning in the notion of the gift lies in its vicious circularity. Derrida writes: "For there to be a gift, there must be no reciprocity, return, exchange, countergift, or debt. If the other *gives* me *back* or *owes* me or has to give me back what I give him or her, there will not have been a gift, whether this restitution is immediate or whether it is programmed by a complex calculation of a long-term deferral or difference."[65] Further, Derrida writes:

> If the gift is annulled in the economic odyssey of the circle as soon as it appears *as* gift or as soon as it signifies *itself as* gift, there is no longer any "logic of the gift," and one may safely say that a consistent discourse on the gift becomes impossible: It misses its object and always speaks, finally, of something else. One can go so far as to say that a work as monumental as Marcel Mauss's *The Gift* speaks of everything but the gift: It deals with economy, exchange, contract (*do ut des*), it speaks of raising the stakes, sacrifice, gift *and* countergift – in short, everything that in the thing itself impels the gift *and* the annulment of the gift. All the gift supplements (potlatch, transgression and excess, surplus values, the necessity to give or give back more, returns with interest – in short, the whole sacrificial bidding war) are destined to bring about once again the circle in which they are annulled.[66]

Derrida then concludes:

> The gift is not a gift, the gift only gives to the extent it *gives time*.
> The difference between a gift and every other operation of pure
> and simple exchange is that the gift gives time. *There where
> there is gift, there is time*. What it gives, the gift is time, but this
> gift of time is also a demand of time. The thing must not be resti-
> tuted *immediately and right away*. There must be time, it must
> last, there must be waiting – without forgetting.[67]

Now, the gift of time and the patience *in* or *of* time, is what Le Corbusier
claims that he has given in his paintings. This given time is the gift, precisely
because it cannot be restituted immediately, in spite of the fact that Le Cor-
busier waited for its restitution.

In the section "The Theory of Potlatch," Bataille inscribes the
idea of the gift in the context of "general economy." "We need to give
away, or lose or destroy," he says. "But the gift would be senseless (and
so we would never decide to give) if it did not take on the meaning of an
acquisition. Hence *giving* must become *acquiring a power*. Gift-giving has
the virtue of a surpassing of the subject who gives, but in exchange for the
object given, the subject appropriates the surpassing. He regards his
virtue, that which he had the capacity for, as an asset, as a *power* that he
now possesses."[68] Le Corbusier paid special attention to the section "The
Acquisition of Rank," which starts with this passage: "*Doubtless potlatch
is not reducible to the desire to lose, but what it brings to the giver is not
the inevitable increase of return gifts; it is the* rank *which it confers on the
one who has the last word*"[69] (Bataille's italics). Le Corbusier marked
the words "rank" and "inevitable" in this passage and marked the rest of
the section with numerous underlinings. In this section Bataille defines
"power" as distinct from "prestige" and "glory," and says: "It must be
said, further, that the identity of the *power and the ability to lose is funda-
mental*"[70] (Le Corbusier's emphasis). Bataille continues by saying: "As the
surviving practices make clear, *rank* varies decisively *according to an indi-
vidual's capacity for giving*"[71] (Le Corbusier's emphasis). Towards the end
of the section Bataille wrote: "Combat is glorious in that it is always
beyond calculation at some moment. But the meaning of warfare and glory
is poorly grasped if it is not related in part to the *acquisition of rank through
a reckless expenditure of vital resources, of which potlach is the most
legible form*"[72] (Le Corbusier's emphasis). Thus, potlatch is a struggle for
pure prestige, which is achieved through the generation of what Bataille
calls the "propiete positive de perte" through which, as Suzanne Guerlac

informs us, non-utilitarian values such as honor, rank, or glory are acquired.[73]

In this regard, the anguish and suffering of Le Corbusier, portrayed in his self-image, lie in the fact that his act of giving has not been restituted, or so he believes. Thus, he acquires rank and pure prestige by the act of potlatch. It is in this belief that he could remark: "C'est semer à tout vent pour inconnus. Un jour avant ou après la mort, on nous dira merci." ("This sowing to the wind is for unknown people. One day, before or after my death, they will say thank you.") Perhaps it is in this context that one should judge all the episodes of post-war writings by Le Corbusier, in which we find statements of self-deprecation, self-portrayal as a tragic hero, which oftentimes verges on the border of the quixotic comic and risible, autobiographical identification with tragic heroes, self-delusion, and repeated references to himself as a figure unappreciated by the public, all of which have not been missed by his critics. To this repertoire one should add this lamenting statement: "Un jour avant ou après la mort, on nous dira merci."

In the light of this reading, all the elements in Le Corbusier's flyleaf commentary cited at the beginning come together. Thus we begin to understand the meaning and character of his autobiographical reading. Le Corbusier saw in his own humanity, art, and mission nothing short of self-sacrifice – that is, he saw his life as potlatch and as a gift to humanity with no return whatsoever. When Le Corbusier later reflected on Homer's *The Iliad* through his twenty-four drawings, in precisely the same fashion he identified himself with the heroes Hector and Paris, combative figures who suffered the violence of life in the face of its abject injustice. He saw in them his own image. Perhaps this is sufficient to advance the claim that Le Corbusier's ultimate self-sacrifice culminated in his idea of the Open Hand.

We might conclude that Bataille's admiration for Le Corbusier is returned to him by Le Corbusier's fascination with *La Part Maudite*. Le Corbusier, a thinker, dazzled by the Sun, would affirm what Georges Bataille said:

> I will speak briefly about the most general condition of life, dwelling on one crucially important fact: Solar energy is the source of life's exuberant development. The origin and essence of our wealth are given in the radiation of the sun, which dispenses energy – wealth – without any return. The sun gives without ever receiving. Men were conscious of this long before astrophysics measured the ceaseless prodigality; they saw it ripen the harvests and they associated its splendor with the act of someone who gives without receiving.[74]

Bataille gave a gift to Le Corbusier; Le Corbusier never gave anything back; instead, in this gift, he found himself in the orbit of solar energy with Bataille.

## Notes

1 A different version of this essay was first published in *Journal of Architectural Education* (September 1997). In this new shorter version I have made some revisions. The research for the original essay was completed at the Fondation Le Corbusier in Paris in Summer 1991. I would like to thank Mme Evelyn Trehin, Director of the Fondation, who kindly facilitated my research by making the documents available to me. I would also thank Daniel Friedman for his intellectual support throughout the writing of this essay and for the painful task of reading early drafts with an editor's eye. I dedicate this essay to the memory of Manfredo Tafuri, whose reading of Le Corbusier's life and work influenced it.

2 G. Bataille, *La Part Maudite, essai d'economi general, la consumation*, Paris: Les Editions de Minuit, 1949. This volume, which is on "Consumption," is the first of a three-volume work on the general economy which has been translated into English by R. Hurley as *The Accursed Share*, 2 vols., New York: Zone Books, 1991. In the 1976 French edition of the first volume, Bataille's essay, "La notion de dépense," has been included. The English translation of this essay, "The Notion of Expenditure," appears in A. Stoekl (ed.) *Visions of Excess, Selected Writings, 1927–1939*, Minneapolis: University of Minnesota Press, 1985.

3 The dedication bears no date and therefore makes it difficult to determine the exact date when Bataille offered his book to Le Corbusier. The only reference that I have come across regarding the offering of the book to Le Corbusier is the short commentary by P. Duboy in *Le Corbusier, Une Encylopedie*, Paris: Centre Georges Pompidou, 1987, p. 67. Le Corbusier's copy of the book is kept in Fondation Le Corbusier in Paris.

4 M. Mauss, *The Gift. The Form and Reason for Exchange in Archaic Societies* (trans. W. Halls), New York: W.W. Norton, 1990.

5 See J. Piel, "Bataille and the World: From 'The Notion of Expenditure' to *The Accursed Share*," in L. Boldt-Irons (ed.) *On Bataille, Critical Essays*, Albany: State University of New York Press, 1995.

6 This commentary appears on the second flyleaf of his copy and is preceded by the mark "P 92" which is the reference to page 92, Les Edition Minuit, 1949. Phillip Duboy cites the passage by suggesting that Le Corbusier wrote this commentary while he was reading the book on the flight to Punjab, Chandigarh (see Phillip Duboy, *Le Corbusier*).

7 Duboy, *Le Corbusier*, p. 67.

8 Duboy writes: "Cette 'petit réflection' " de L.C. Devient alors une source evident de la *Main Ouverte* de Chandigarh, en même temps qu'elle le définit comme héro moderne. "Le vrai sujet de la modernité. Cela signifie que pour vivre la modernité, il faut une nature héroique": voilà une bonne definition de Le Courbusier, que l'on doit á Walter Benjamin enter les deux querres. Mais á la lecture de Bataille et aux reflections qu'en tire Le Courbusier on serait plutôt tenté de le définir, avec Jacques Lacan, comme un de ces héro moderns "qu'illustrent des exploits dérisoires dan une situation d'égarement" (ibid.).

9 W. Benjamin, *The Arcades Project* (trans. H. Eiland and K. McLaughlin), Cambridge, Mass.: Belknap Press/Harvard University Press, 1999, p. 459.

10 I owe this categorization of modernity to H. Foster in *Compulsive Beauty*, Cambridge, Mass.: The MIT Press, 1993. See chapter 6.

11 See J. Lacan, "Kant avec Sade," in *Écrits*, Paris: Editions du Seuil, 1966, vol. 2. The English translation, J. Lacan, *Écrits, A Selection* (trans. Alan Sheridan), New York: W.W. Norton,

1977, did not include this essay. For an English translation of this essay see J. Lacan, "Kant with Sade," trans. by J. Swenson, Jr., with extensive annotations, in *October*, no. 51, Winter 1989.

12  For this information see A. Stoekl (ed.) special issue of *Yale French Studies*, "On Bataille," 1990, p. 2.

13  See M. Tafuri, " '*Machine et memoire*': The City in the Work of Le Corbusier," in H. Brooks (ed.) *Le Corbusier*, Princeton, New Jersey: Princeton University Press, 1987.

14  The reading of *The Iliad* preoccupied Le Corbusier until his death. He had planned to re-illustrate his newly translated copy, which contained the drawings of Flaxman, the eighteenth-century draftsman, but time did not allow him and he completed no more than twenty-four drawings. For the analysis of these drawings see M. Krustrup, *Le Corbusier, L'Iliade Dessins*, Borgen Copenhague, 1986.

15  For Bataille's relation to the 1930s, see J.-M. Besnier, "Georges Bataille in the 1930s: A Politics of the Impossible," in *Yale French Studies*, Paris: Libraire Seguier, 1987. Also see M. Surya, *Georges Bataille, la mort a l'oeuvre*.

16  See F. Marmande, *Georges Bataille politique*, Lyon: Presses Universitaires de Lyon, 1985.

17  For more see M. Surya, *Georges Bataille, An Intellectual Biography*, London and New York: Verso, 2002.

18  A, Vidler, "Homes for Cyborgs," in *The Architectural Uncanny: Essays in the Modern Unhomely*, Cambridge, Mass.: MIT Press, 1992.

19  Cited by Vidler, ibid., p. 150.

20  For more details of Le Corbusier's involvement in Chandigarh see S. von Moos, "The Politics of the Open Hand: Notes on Le Corbusier and Nehru at Chandigarh," in R. Walden (ed.) *The Open Hand, Essays on Le Corbusier*, Cambridge, Mass.: MIT Press, 1977.

21  For my reflection on "*planisme*" and the Marshall Plan I have benefited from the illuminating article by A. Stoekl, "Truman's Apotheosis: Bataille, '*Planisme*,' and Headlessness," in A. Stoekl (ed.) *Visions of Excess*. In discussing *planisme*, Stoekl makes references to Le Corbusier in two passages on which I have based my conjecture in tracing the origin of Bataille's acquaintance with Le Corbusier's activities in the 1930s.

22  Stoekl, *Yale French Studies*.

23  In the handwritten commentaries on the flyleaf of Le Corbusier's copy of the book we see references to the chapter on "Potlatch." In the chapter on "The Marshall Plan," Le Corbusier marked and underlined numerous passages.

24  See S. von Moos, "The Politics of the Open hand," in Walden (ed.) *The Open Hand*, pp. 412–457.

25  For a summary of Le Corbusier's urban planning see T. Benton, "Urbanism" in *Le Corbusier, Architect of Century*, Exhibition Catalogue, England: Art Council of Great Britain, 1987.

26  Stoekl, *Yale French Studies*, p. 182. For an extended discussion on the "Ordre Nouveau," see J.-L. Loubet del Bayle, *Les Non-Conformistes des Années* 30, Paris: Seuil, 1969.

27  For the journal *La Critique sociale* and Bataille's connection, see Suyra, *Georges Bataille*.

28  Piel, "Bataille and the World," in Boldt-Irons, *On Bataille*.

29  See M. McLeod, "Bibliography: *Plans*, 1–3 (1931–1932); *Plans* (bi-monthly), 1–8 (1932); *Bulletin des groups Plans*, 1–4 (1930)," in *Oppositions* 19/20, Winter/Spring 1980, pp. 185–206. As McLeod informs us, Le Corbusier also participated in another syndicalist journal, *Prelude* (1933–1935). Both of these journals significantly contributed to the propagation of the ideas on urbanism that were a continuation of the earlier *L'Esprit nouveau*. "Le Corbusier himself was anxious to pursue the urban studies that he had commenced in *L'Esprit nouveau*. In fact, he proposed that *Plans* assume the remaining financial holdings of the earlier journal" (p. 186).

30  McLeod, "Bibliography," p. 185.

31  Stoekl, *Yale French Studies*, p. 183.

32  Ibid.

33  See Surya, *Georges Bataille, la mort a oeuvre*, p. 486. Surya further informs us that "Bataille ne fit cependent pas parti d'*Ordre Nouveau*. La seule collaboration qui ait été évoquée (par Pierre Prévost. Entretiens) est anonyme: Bataille aurait fourni les éléments d'élaboration du chapitre "Echanges et Crédits" du ivre manifeste d'Arnaud Dandieu et Robert Aron, *La Révolution nécessaire*. Ce qui, à lire ce chapitre, paraaît en effet éviodent: la plupart des thèmes d'analyse de "La notion de dépense" s'y retrouveent. Il ne semble cependant pas que Bataille ait redigé ce chapitre. De même qu'il ne semble pas, pour singulièr que soit cette collaboration anonyme et totalement desintéressée, qu'elle ait eu de suit. Bataille ne fit en tout cas jamais mention de tout cela" (p. 183).

34  Ibid., p. 198.

35  See J. Goux, "General Economics and Postmodern Capitalism," in *Yale French Studies*. For my summary of *The Accursed Share* I have followed Goux's essay. For a philosophical discussion of the idea of "general economy" in Bataille, see J. Derrida, "From Restricted to General Economy: A Hegelianism without Reserve," in J. Derrida, *Writing and Difference* (trans. A. Bass), Chicago: University of Chicago Press, 1978.

36  Goux, "General Economics," p. 207.

37  Ibid.

38  Bataille, "The Notion of Expenditure," reprinted in Stoekl (ed.) *Visions of Excess*, p. 118.

39  Bataille, *La Part Maudite*, pp. 75–76; *The Accursed Share*, pp. 58–59. Le Corbusier marked the footnote related to the passage after the word *séparés*, which reads: "J'insiste sur une donnée fondamentale: la séparation des êtres est limitée à l'ordre réel. C'est seulement si j'en reste à l'ordre des *choses* que la séparation *est réele*. Elle *est* en effet *réele*, mais ce qui est réel est *extérieur*. 'Tous les hommes, intimement, n'en sont qu'un.' "

40  See Stoekl, *Yale French Studies*.

41  Ibid., p. 198. Also, for the "Acéphale" figure in Bataille, see A. Stoekl, "The Death of Acéphale and the Will to Change: Nietzsche in the Text of Bataille," in *Glyph*, no. 6, 1979.

42  Bataille, *La Part Maudite*, p. 222; *The Accursed Share*, p. 168.

43  Stoekl, *Yale French Studies*, p. 169.

44  Ibid., p. 201.

45  Bataille, *The Accursed Share*, p. 175.

46  Stoekl, *Yale French Studies*, p. 203.

47  See the English translation by D. Faccini in *October*, no. 60, Spring 1992, p. 25.

48  I have followed Hollier's interpretation of this passage in his *Against Architecture: The Writings of Georges Bataille* (trans. B. Wing), Cambridge, Mass.: MIT Press, 1995, pp. 47–58.

49  Bataille, *The Accursed Share*, p. 46.

50  Ibid., p. 49.

51  Tafuri, *Le Corbusier*, p. 213.

52  Ibid., pp. 213–214.

53  G. Bataille, "The Notion of Expenditure," in Stoekl (ed.) *Visions of Excess*, p. 122.

54  Mauss, *The Gift*, p. 46.

55  Ibid., p. 39.

56  All etymologies are from *The Oxford English Dictionary* unless otherwise indicated.

57  Mauss, *The Gift*, pp. 6–7.

58  Ibid., p. 39.

59  Ibid., p. 152.

60  Ibid., pp. 151–152.

61  Ibid., p. 152.

62 See J. Derrida, *Dissemination*, Chicago: University of Chicago Press, 1981. Derrida, in the chapter on "Plato's Pharmacy," reads in the *Oeuvres* of Marcel Mauss, published in 1969, the entry "Gift-gift" and quotes: "Moreover, all these ideas are double-faced. In other Indo-European languages, it is the notion of poison which is not certain. Kluge and the etymologists are right in comparing the *potio*, "Poison," series with *gift, gift* ["gift," which means "present" in English, means "poison" or "married" in other German languages – trans.]. One can also read with interest the lively discussion by Aulus-Gellius ... on the ambiguity of the Greek pharmakon and the Latin *venenum* (p. 133). Derrida relates the meaning of *pharmakon* (poison and remedy) to scapegoat and sacrifice, which comes close to Bataille's interpretation of "gift" related to his notion of sacrifice.

63 See J. Derrida, *Given Time: I. Counterfeit Money* (trans. by P. Kamuf), Chicago: University of Chicago Press, 1992.

64 Mauss, *The Gift*, p. 37.

65 Derrida, *Given Time*, p. 12.

66 Ibid., p. 24.

67 Ibid., p. 41.

68 Bataille, *The Accursed Share*, p. 69.

69 Ibid., p. 71.

70 Ibid.

71 Ibid.

72 Ibid.

73 See Suzanne Guerlac, "Recognition 'by a Woman!: A Reading of Bataille's L'Eroticism,' " in "On Bataille," in Stoekl (ed.) *Yale French Studies*.

74 Bataille, *The Accursed Share*, p. 28.

Chapter 10

# Introjection and projection

## Frederick Kiesler and his dream machine

*Stephen Phillips*

> The difficulty in reflecting on dwelling on the one hand, there is
> something age-old – perhaps eternal – to be investigated here, the
> image of the abode of the human being in the maternal womb . . .
> [O]n the other hand . . . we must understand dwelling in its most
> extreme form . . . The original form of all dwelling is existence not in
> the house but in the shell. The shell bears the impression of its occu-
> pant. In the most extreme instance, the dwelling becomes a shell.
>
> Walter Benjamin

The surrealists were positioned in opposition to modern architecture, as
reflected in well-known public disagreements between André Breton and Le
Corbusier. As Anthony Vidler explains in *The Architectural Uncanny*, the sur-
realists had argued against the sterile "overrationalized technological
realism" of modern building.[1] Breton instead envisioned more habitable
architecture, one which surrealist members Tristan Tzara and Matta Eschaur-
ren elaborated and described in the eclectic journal *Minotaure* during the
1930s. In 1933 Tzara wrote against modern aesthetics that deny human

dwelling in favor of architecture with intrauterine appeal.[2] He called for a new serenity of "prenatal comfort" ushered in by the qualities of "soft tactile depths" experienced inside "circular, spherical, and irregular houses."[3] From a "cave" or "tomb" in the "hollows of the earth," Tzara believed "health" could be restored in the realm of "luxury, calm and voluptuousness."[4] Similarly, in 1938 Matta argued for a folded body wrapping architecture of "wet walls" and "appetizing" "furniture" that fit with "molded profile" our "infinite motions" according to "life intensity" as "umbilical cords" "like plastic psychoanalytic mirrors."[5] He envisioned architecture that could "get out of shape" to "fit our psychological fears," and relieve "the body of all the weight of . . . [its] right-angle past."[6] Matta had described a provocative surrealist project, which sought to create *alloplastic* architecture modulating to the infinite transformations of the body in motion.[7] Unconscious sensual desires could be forever satiated with flexible architectural skins moving in response to our every need. For Tzara and Matta non-rectilinear houses embodied surrealist architecture – one which the Austrian-American architect Frederick Kiesler had been well on the way to developing.[8] Kiesler's now well-known Endless project, since its inception between 1924 and 1926, served to nurture the dweller inside an embryonic casing of eggshell construction, and eventually, as the design developed, inside the cave-like bodily expression of intrauterine digestion. As the surrealist artist Hans Arp describes, "in [Kiesler's] egg, in these spheroid egg-shaped structures, a human being can now take shelter and live as in his mother's womb."[9]

## The egg

Kiesler presented the first model of his egg-shaped concept at the New York International Theater Exposition held at Steinway Hall in 1926. He had already become well known for his successful European avant-garde theater exhibitions in Vienna and Paris in 1924 and 1925. And upon invitation by Jean Heap of the *Little Review*, Kiesler had moved to New York with his wife Steffi to coordinate and present European avant-garde theater to America.

At the exhibition Kiesler unveiled his Endless Theater project designed to accommodate various sporting, parking, and theater facilities for up to 100,000 people.[10] His plans showed multiple open platforms suspended with elastic cables encased within a double shell, glass and steel, spheroid-matrix shaped structure upon which images and films could be projected.[11] The theater was to be built without columns using glassy balloon materials so that interaction between actors and spectators could circulate freely – almost automatically – along spiral ramps and stairs.[12] Kiesler presented his vision for

mobile-flexible architecture designed to respond to the drama of the event – the motion of the crowd. "We must have organic building," Kiesler describes, "elasticity of building adequate to the elasticity of living."[13]

Unable to realize his theater project, Kiesler developed varied architectural interests for several years, but chose to return to his egg-shaped concept in the 1930s. In 1933 Kiesler exhibited a full-scale prototype of his egg-shaped structure called the Space House for the Modernage Furniture Company in New York. Kiesler's Space House emphasized the use of a new structural principle – continuous tension shell construction.[14] Kiesler published his description of the house in *Hounds & Horn* magazine in March 1934. He divided the article into three parts: the social requirements of the house, the tectonic solutions to achieve those requirements, and the structural technology used for building the exterior shell.

In the social realm Kiesler insists housing should support relationships between family and groups, but must also provide for "complete seclusion," "physical separation," "privacy," and even "semi-seclusion."[15] The Space House ideally provides introverted living for every member of the household, and, as Kiesler remarks, it

> must act as a generator for the individual. His generated forces are to be discharged to the outer world. The outer world: his own family or any outer group. The house is built on this two-way principle: charging and discharging through a flexibility that is contracting and expanding.[16]

10.1
**Painted collage by Frederick Kiesler over images of Space House (1933) and Endless Theater (1924–1926)**
From "Frederick Kiesler, Architecture as Biotechnique," *Architectural Record*, September 1939, p. 67 (1940)

*In attitudes toward the technological environment, we observe three tendencies as to morphological principle: (a) the functional or synthetic, (b) the formal or transcendental, (c) the mechanical-materialist or disintegrative. The mechanical-materialist attitude is not distinctively biological, but is common to nearly all fields of thought. (It dates back to the Greek atomists. The self-deceiving triumph of mechanistic science in the nineteenth century led many to accept mechanical materialism as the only possible scientific method.) Even ... especially in design, it is more akin to the ... attitude.

cell division with the aim of continuity; man can only build by joining parts together into a unique structure without continuity. Nevertheless, man-made joinings are ultimately controlled not by man but by nature. The process of disruption through natural forces becomes imminent from the very moment of joining parts. Building design must, therefore, aim ... f joints, making for higher resistance, ... intenance, lower costs. Such con- ... p Continuous Construction.**

ourtesy Columbia U. Library Photo. Div.

hnique" appeared first in my treatise on "Vitalbau" in "De Stijl" No. 10/11, Paris, ... first in "Hound and Horn," May 1934. ... biotechnics" appeared in writings of other ... n biotechnique. See also Arch. Forum, ... chnical design of my plans for a Com- ... stock, N. Y. ... ited until my plans of The Endless were ... 25, and New York, 1933 (left). View of ... New York, 1933) showing first continuous ... lter design and also continuous window fram- ... e Architectural Record 1930 and 1934.

SEPTEMBER 1939

DESIGN TRENDS

67

DO NOT BLOCK
UNTIE YOU SEE S.
Mr. Kiesler

For Kiesler the house serves to charge the individuals energy forces for discharge back into the external world. As Kiesler represents in a series of unpublished notes and sketches on the Space House, his concept of contraction converts the house over time to provide a sense of security through individual space enclosures that then can expand to provide for group interactions and ultimately outer world experiences. He anticipates time can be a factor in the use of the house, where the building can transform in accord to the needs of varied events.[17]

Kiesler argues the house functions through an organic machination of metabolic processes where the "individual passing through time" is "subjected to two forces; Anabolism: building up; Catabolism: breaking down."[18] Kiesler believes that within all objects, whether animate or inanimate, there is a constant exchange of these two categories of mutating forces integrating and disintegrating at low rates of speed.[19] His architecture

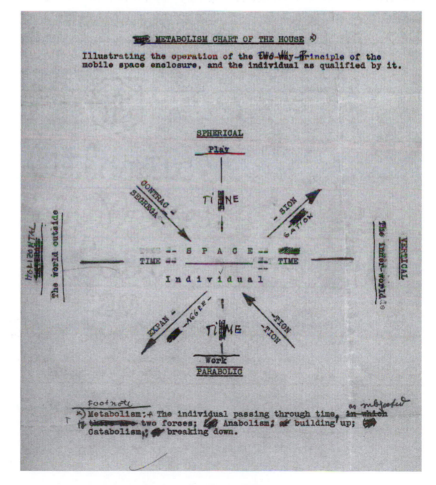

10.2
**Frederick Kiesler, diagram of metabolic processes within his Space House project, 1933**

is modeled on molecular processes he describes as "nuclear-multiple forces," which fuse together and pull apart subjects and objects in time.[20] As the individual, he suggests, passes horizontally to the world outside, vertically into the inner-world, parabolically to work, and spherically for play, the house interacts and exchanges forces with the dweller. This is achieved, he says, through the "*the mobile space enclosure, and the individual as qualified by it.*"[21] "This expansion and contraction is the propensity of the house," he argues, and "it is achieved" tectonically through a series of movable partitions, rubber curtains, varying floor-levels, and rolling and sliding walls.[22] Kiesler intends the "whole house to be one living room" of "static-flexibility" that can adjust as needed.[23] The house is not to be fixed in time but is intended to transform to the needs of human dwelling keyed to the changing and evolving necessities of the inhabitant.

Kiesler's design for his Space House project sought to envelop dwelling within a mobile-flexible architecture that served to cultivate the body in coordination to daily habits. It could charge and discharge one's energy forces geared to interactions of work, rest, or play. The house engaged the body physically – tactilely, and its form took shape in correlation to everyday use. The house was intended to move in response to the body with seamless organic expression. "Stream-lining becomes here an organic force," Kiesler describes, "as it relates the dynamic equilibrium of body-motion within encompassed space."[24] The "proprio-spatial dynamic" function of the house, he argues, is its ability to seam together complex components into one physically and visually elastic space.[25]

Touch and vision are essential to the dynamic function of the house. Published in a series of images in *Architectural Record*, Kiesler presents a shoe subtly applying pressure to an elastic sponge rubber carpet or a scissor tearing through the veil of a net fabric ceiling.[26] William Braham suggests in his article "What's Hecuba to Him? On Kiesler and the Knot," that these fabrics are "the most architectural realization of the surrealist project into which Kiesler, the traveler, was about to be initiated."[27] In the Space House Kiesler uses materials to envelop the habitant in tactile protective layers, which provide varied function to facilitate "sound proofing," "isolation," and "vision."[28] Kiesler's materials serve as screens that could be drawn to veil or be pulled back to reveal the outside world. Kiesler recognizes that materials have "psycho-functions" that can be utilized to stimulate the psyche.[29] As Beatriz Colomina presents in her article, "De psyche van het bouwen: Frederick Kiesler's *Space House*," the erotic "sensuality of Kiesler's house extends from touch into the visual freedom the design affords and beyond into the psyche."[30] As Kiesler's sketch of this concept expresses, the sensing terrestrial body is surrounded in a world of objects with arrows and lines that all inter-

relate and establish a perceptual boundary of the "stellar spectra."[31] Kiesler's architecture attempts to entice perception to pass through the tactile senses through the psyche and then beyond to outer space.

The Space House provides a perceptual boundary or semi-permeable shell that can respond to inner needs while at the same time resist external pressures. The structural "outer shell" of the house is intended to facilitate the flux and flow of physical and psychical force. It acts like a cellular membrane that provides "*flexible* division between outdoor and indoor."[32] It is "not a wall," Kiesler remarks, but instead provides glass panels for optic contact, movable-glass for physical contact and terraces for extensity.[33] Its overall structure is modeled on the concept of an eggshell, which Kiesler argues is the most "exquisite example we know of utmost resistance to *outer* and *inner* stress with a minimum of strength."[34] The house is to be unified into one viable protective tensile skin that can provide shelter, enclosure, and floor without conflict of interaction or use between parts. Continuous tension shell structures would not have joints that are subject to dis-joint. Instead their elastic nature and cellular structure would resist fracture or decay. Kiesler was well aware, however, that the technology to construct his vision was not yet available: "There is no question: a new construction method has not yet been reached. We are in transition," he said, "from conglomeration to simplification."[35]

Correalism and biotechnique

In 1936 Kiesler received an appointment as an associate professor at Columbia University School of Architecture and established his Laboratory for Design-Correlation. In the laboratory Kiesler and his students researched elasticity as a spatial and technological building concept through the design of home furniture. They advanced an interest in time and motion and developed a theory of Biotechnique as inspired by the work of Sir Patrick Geddes. Kiesler published his findings in a series of articles in *Architectural Record* in the 1930s.

Kiesler founded his theory of biotechnique based on architecture of environmental technology that sought to incorporate human needs into flexible built form for the benefit of human health. Health is central to Kiesler's discourse as it had been for Tzara. In 1939 Kiesler declared that

> Architecture . . . can only be judged by its power to maintain and enhance man's well being – physical and mental. *Architecture thus becomes a tool for the control of man's health, its degeneration and re-generation.*[36]

For Kiesler, architecture is a tool for *controlling* the de-generation and re-generation of man's physical and psychical being. As Kiesler describes, architecture provides a physical environment that can adapt to mitigate "maladjustments by *protection against fatigue* (preventive) and by *relief of fatigue* (curative)."[37] It is Kiesler's intention to create architecture that will bring the body into harmony with the technological environment in order "*to maintain the equilibrium of its health.*"[38]

In designing this new architecture of biotechnique his students made extensive observations of the body in its relation to objects of everyday use. They relied on time-motion studies similar in intent to those invented by Eadweard Muybridge and Etienne-Jules Marey, which were then later advanced by Frederick Taylor and Henry Ford. Seeking a "*proper balance*" between the forces of expending and replacing energy Kiesler aims to achieve "*optimum efficiency.*"[39] However, unlike Fordist practice that attempts to mold the body to the demands of an efficient technological mechanized work force, Kiesler searched to develop a technology that might adapt to the needs of an evolutionary process of socio-economic changes.[40] From "deficiency" to "efficiency" Kiesler charts how "actual needs are not the direct incentive to technological and socio-economic changes," instead he argues that "*needs are not static: they evolve.*"[41] Kiesler sought to develop a typology of organic architecture – a living machine – designed to *modulate* to man's motion in time counter to Le Corbusier's vision of the home as a machine for living.[42]

Kiesler believed architecture could be built organically in contradistinction to techniques used to construct the modern box. He resisted machine-fastened panel and frame construction represented by the work of Mies van der Rohe and Le Corbusier. And he wildly departed from the International Style with his spheroid-shaped eggshell structures and palpable-tactile interiors that stimulated psychical experiences. In support of biomorphic architecture, Kiesler idealized elastic spaces held together in continuous tension and found inspiration for his structural concept in Marcel Duchamp's "Big Glass."

In his essay on glass pictures published in *Architectural Record* in 1937, Kiesler argues that Duchamp's sculpture appears structurally similar to a leaf; it holds together varied suspended elements floating within a framework of tensional fillings, both elastic and interdependent.[43] The glass provides porosity and protection; it is visually transparent while at the same time appearing to resist fracture and decomposition – without relying on typical joinery techniques. Kiesler's interpretation of the "Big Glass" was regarded highly by Duchamp, who facilitated Kiesler's association with the official surrealist group.

Surrealist galleries

Receiving respect and understanding from within the surrealist circle, Kiesler was invited to design the 1942 Art of This Century Gallery exhibition in New York for Peggy Guggenheim. He designed displays, lighting, and furniture for four different gallery exhibitions. Kiesler's chairs designed for the varied spaces exemplified ideas explored in the Design-Correlation laboratory. His chairs made of plywood and linoleum transform to the evolving body in motion; they are manufactured for several different seating or standing poses and bear striking similarity to the surrealist sketch of Matta Echaurren's chairs published in *Minotaure*, 1938. Movement – the body in motion – is a central theme explored throughout Kiesler's work. And while Kiesler's chairs attempt to pre-figure and inspire possible gesture and movement, modulated to future conditions, his exhibition designs used imagery and lighting effects to consciously stimulate and unconsciously motivate the body and mind to wander. As Edgar Kaufmann Jr. remarks in his review of The Art of This Century Surrealist Gallery, the "viewer . . . [is] led around the room by the eye, and shown objects singly, but in no special sequence."[44] The viewer passes through the space between two continuously curved plywood shells over and under the looming plywood ceiling and sinuous linoleum floor. Pulsating lights are intended to move in rhythmic distracting succession to focus concentrated attention upon the individual images while a roaring sound of an approaching train is heard in the background. "It's dynamic, it pulsates like your blood," Kiesler describes.[45] "Geometrically severe" art is often displayed in Kiesler's post impressionist exhibition designs with a "distracting jumble of effects," Kaufmann explains.[46] And the flickering movement imposed by "the lights going on and off automatically" in the Surrealist Gallery, Kaufmann suggests, creates an equally complicated effect.[47] Too shocking, the automatic feature had to be permanently switched off.

Kiesler uses techniques of distraction to focus attention on disparate foreground images amid a sinuous spatial field in varying ways in all of his 1940s exhibition designs. In dynamic asymmetric rhythm, individual images catch one's focused conscious attention, and a path, delineated as a mobius strip (an endless strip), throughout the space invites the eye and in turn the body to unconsciously move about the room within a labyrinthine maze. With the eye set to distracting images of wonder, the body moves habitually – autonomically – about the galleries. Moving from image to image, from moment to moment, time merges into an expansive space. Kiesler created environments of contraction through image and of expansion through undulating surface. Individual works of art are seamed together by

the *a*conscious autonomic motion of the viewer moving along the path of exhibition. Content of fantastic imagery alongside the surging darkness of the room serve to support a *virtual* dreamlike state of surrealist awakening, where the dreaming self becomes a relaxed self, open to suggestion, among a flow of internal *remembrances*.

In his catalogue review of the Blood Flames Gallery exhibition, Nicholas Calas claims that both the art works and spectators become "monads in a continuum whose lines have been traced by Kiesler's magic wand. Pictures, statues, [and] spectators are carried by a colorbow into new situations which are to serve as starting point for . . . personal metamorpho-sis."[48] Kiesler constructs his galleries as an array of part objects seamed together in continuum. In this continuum subjects and objects meld together. As T.J. Demos argues in his article "Duchamp's Labyrinth," Kiesler explicitly intends these gallery spaces to achieve a pre-linguistic unity that invokes fusion between vision and reality in order to simulate the aura of the primal maternal relationship.[49]

Kiesler's galleries were the idealizations of the confines of his continuous embryonic eggshell structures designed to recreate the sensual environment of continuity with the mother. As Kiesler noted and sketched often, these galleries were conceptually intended to be the interior of his egg that encased surreal habitation within a spheroid-matrix shell. Surrounding the inhabitant in soft palpable curvilinear walls saturated with a full spectrum of lighting effects, Kiesler's Endless House presented at the Kootz Gallery in New York, 1950, exemplifies this extreme form of surrealist dwelling.

The Endless House

In the Endless House, Kiesler's exhibition gallery effects became psychologi-cal lighting effects, which dominate the interior atmosphere. Psychic projec-tion is delineated through a series of colored lines enveloping and generating from within the Endless House. Kiesler suggests lighting is the means to "push back the physical boundaries" of architecture while at the same time surround the inhabitant with distracting "color and brilliance" to inspire expansive rumination secure in remote havens of rest.[50]

Featured during the daytime in the "Endless House," Kiesler describes, is a large crystal that filters the sun into a prismatic kaleidoscope using "convex mirror reflex devices" to translate light – "to diffuse it" – into rays that transform into a series of three colors from dusk until dawn, marking the passage of daily habits in "continuity of time" and "dynamic integration with natural forces."[51] Time is introduced into Kiesler's architec-ture to demarcate habitation – to codify the body's actions in relation to

spatial conditions. As time passes, the room systematically changes color. Daytime lighting provides periodic riotous colors whose patterns record the passing of daily habits, diffused on surfaces and inscribed in personal memory.

Night-time lighting provides similar effect, with "exhilarating" "double-direct-indirect" lighting, remarks Kiesler, which reflects off woolen white carpeting and then bounces back onto the walls and ceiling – "diffused" endlessly.[52] Night lighting being theatrical and motion-sensitive it moves with the inhabitant and provides a variety of experiences marked by "vast succession of shadows beyond shadows."[53] Spotlights focus upon objects and habitants. Diffuse light radiates upon curvilinear walls. Kiesler transforms the habits of everyday life into the auratic traces of surface memory dispersed as colorful illusory affects timed to the movement of the body and rhythms of sun and moon.

Dwelling no longer leaves traces in the physical markings upon material surfaces of the architectural body. It becomes dispersed as sensational images marked through time as fantastic illusory colors and shadows recorded in memory. Kiesler believed twentieth-century man could dwell in multi-media, and he designed his architecture to envelop habitation within a casing of illusory projection. The house forms a virtual environment that becomes an effervescent halo surrounding the habitant, constructed as a seemingly elusive surface of "continuous tension" eggshell construction. The Endless House is a complex matrix or shell that encases, prefigures, adapts, and controls the parameters of dwelling inside its virtual elastic skin.

"The Endless House is called 'Endless' because all ends meet, and meet continuously," Kiesler remarks in response to his final version of the project modeled in 1959 (Figure 10.3).[54] The final form of the house undulates with shapes and volumes that Kiesler demands were not "amorphous, not a free-for-all form. On the contrary, its construction has strict boundaries according to the scale of your living. Its shape and form are determined by inherent life processes."[55] The form of the house is shaped in accord to daily events of family and guests – and not only guests of the conscious world, but those from the unconscious realm. For as Kiesler contends:

> the "Endless" cannot be only a home for the family, but must definitely make room and comfort for those "visitors" from your own inner world. Communion with yourself. The ritual of meditation inspired.[56]

The Endless House ideally provides comforting rooms to inspire meditation for inner communion. The home is "no longer a single block with either flat, curved, or zigzag walls,"[57] Kiesler argues, for it has become a softer, gentler

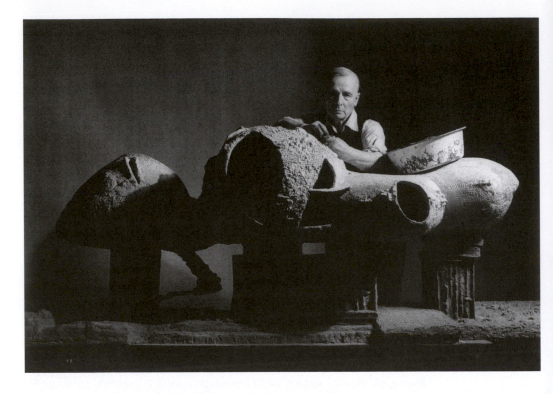

space of reclusion; it "is rather sensuous, more like the female body in contrast to sharp-angled male architecture," he muses. Inside the Endless House, "you could womb yourself into happy solitude."[58] For Kiesler, the house is a sensual body that one desires to inhabit; it is organic and non-rectilinear that provides for mental hygiene through re-creating an environment that simulates the nurturing peace and comfort ideally experienced inside the womb.

Kiesler's architecture, however, is not a simplistic return to intrauterine fantasy for regressive eternal bliss as a means to completely avoid existence in the external world. For within Kiesler's Endless House, at the darkest moment of solitude, sheltered in the warm palpable depths of intrauterine dwelling, Kiesler hoped to provide a fantastic dream world that can reach out to the cosmos and expand. He attempted to rely on the technology of magic illusion – theatrical projection, cinema, and even television as "Broadcasted Decoration" – to achieve expansive space.[59] Though he recognizes that "[w]e *want* to live in a confined space, we want to be protected, so to say, from the outer world. What is important is the necessity of *temporary* confinement."[60] *Temporality* for Kiesler, however, cannot happen within the shape of a box; it has to be formed biotechnologically in the shape of a shell, for, as he states:

10.3
**Frederick Kiesler, the Endless House, 1959**
Photograph by Irving Penn

10.4
**Frederick Kiesler:
inside his
Bucephalus
sculpture, 1965**

When the moment comes when we want to move a wall way
out, to breathe more fully – yes, when we want the ceiling to be
higher, or the whole area to change into another shape – that is
where the Endless House comes in. Because it has a twofold
expression: first, it has the reality of the walls and the ceiling and
the floor as they are . . . but also a lighting system . . . so that by
changing the lights . . . one can expand or contract the interior in
an illusionary way. You can't do that with boxes.[61]

At the heart of Kiesler's interest in the Endless is the promise of the "illu-sionary way." The Endless House provides no sense of boundary, but is still able to shelter.

Kiesler created a machine for dreaming, as a living organism that can be inhabited and engaged by the body. Kiesler's Dream Machine was designed for curative effect, to strengthen the body and psyche for discharg-ing individuals back into the sensual world of men – digested, regenerated, and redeemed. As the editors of *L'Architecture d'Ajourd'hui* once said, "but does it not seem that Kiesler pursues one goal only: to reach Man, to destroy him in some fashion to re-create him, and to let him eject a new 'elan' of imagination and liberty?"[62]

Kiesler's Endless House performs to stimulate an idealized paradisiacal life inside an ergonomically designed illusionary cinematic spatial experience that can expand and contract to engage one's every motion and desire. It is geared to rebuild both the physis and the psyche of the dweller – tailored to mediate the flux and flow of the evolving demands of daily existence. Designed to adapt to constantly changing parameters, the house is built of materials that on a molecular level can absorb and resist shock. Fluctuating between reparation (building up) and destruction (breaking down), the house is ideally porous and protective, enveloping the body in a fantastic elastic skin. This architecture of eternal contraction and expansion (*détente*) assimilates the perceiving body within the total artwork [*Gesamtkunstwerk*] of effects. Surface boundaries become diffuse and elusive, yet remain immanently maintained through organic creation. Its transmutable shape characterizes the disposition of its inhabitants stretched between introjected perceptions and projected actions. Dwelling finds its home between illusion and reality, continuity and individuality, vision and fact.

## Notes

1  A. Vidler, *The Architectural Uncanny: Essays in the Modern Unhomely* (Cambridge, Mass.: MIT Press, 1992), p. 150.

2  T. Tzara, "D'un certain automatisme du goût," *Minotaure*, nos. 3–4, 1933, pp. 81–84 (p. 84), as translated in M. Jean (ed.) *Autobiography of Surrealism*, New York: Viking Press, 1980, p. 337.

3  Ibid.

4  Ibid.

5  Matta Eschaurren, "Sensitive Mathematics – Architecture of Time," *Minotaure*, no. 11, May 1938, p. 43, as translated in Jean, *Autobiography of Surrealism*, p. 339.

6  Ibid.

7  For more on alloplasticity (to change or mold the external world to reflect the unconscious)

versus autoplasticity (to change one's body), see O. Rank, *The Trauma of Birth*, New York: Dover, 1993, p. 101, originally published as O. Rank, *Trauma der Geburt*, London: Kegan Paul, Trench, Turbner and Co., 1929.

8  Tzara and Kiesler had been friends since 1924. They were in close contact between 1925 and 1931; Tzara had received several letters from Kiesler. See research conducted by V. Sonzogni, "Correspondence Frederick Kiesler–Tristan Tzara in the Bibliotheque Littéraire Jacques Doucet," in the Austrian Frederick and Lillian Kiesler Private Foundation Archive, Vienna. Matta and Kiesler became friends in the 1940s.

9  Cited in Vidler, *The Architectural Uncanny*, p. 153. Originally cited by D. Vesely, "Surrealism and Architecture," in *Architectural Design* 48, 1978, nos. 2–3, p. 94.

10  F. Kiesler, "Project for a 'Space-Theatre' Seating 100,000 People," in *Architectural Record*, May 1930, p. 495.

11  Ibid.

12  The concept for Kiesler's Endless Theater was originally described in the exhibition catalogue for the International Music and Theater Festival of the city of Vienna in 1924. Kiesler explained that his theater would have "plastic forms . . . created from glassy balloon materials . . . [where] atmosphere is invoked by means of film projection." F. Kiesler, "Das Railway-Theater," in *Katalog der Internationalen Ausstellung neuer Theatertechnik*, Vienna, 1924, Austrian Frederick and Lillian Kiesler Private Foundation, Vienna. "*Milieu-Suggestion schafft die Filmprojecktion. Plastische Formen entstehen aus glasartigem Ballonstoff.*"

13  F. Kiesler, "Manifesto of Tensionism," in *Contemporary Art Applied to the Store and its Display*, New York: Bretano's Publishers Inc., 1930, p. 49. Originally published in German: F. Kiesler, "Ausstellungssystem Leger und Trager," De Stijl Serie XII, nos. 10 and 11, 6 Jaar 1924–1925, p. 146. Translated by Frederick and Stoffi Kiesler in varying versions from 1925–1930 (see Austrian Frederick and Lillian Kiesler Private Foundation, Vienna).

14  Shell structures using steel reinforced concrete in tension were developed by the Swiss bridge builder Robert Maillart in 1930.

15  F. Kiesler, "Notes on Architecture: The Space-House," in *Hound & Horn*, January–March 1934, p. 294.

16  Ibid.

17  Ibid.; see also B. Colomina, "De psyche van het bouwen: Frederick Kiesler's *Space House*," in *Archis*, November 1996, p. 74.

18  F. Kiesler, "Metabolism Chart of the House" (1933). Unpublished miscellaneous sketches, notes, and drafts, Space House Folder, Austrian Frederick and Lillian Kiesler Private Foundation Archives, Vienna.

19  See F. Kiesler, "On Correalism and Biotechnique: a definition and the new approach to building design," in *Architectural Record*, September 1939, p. 61.

20  Ibid., p. 70.

21  Kiesler, "Metabolism chart of the house" (my emphasis).

22  F. Kiesler, "Architectural Solution" (1933), p. 1. Unpublished miscellaneous sketches, notes, and drafts, Space House Folder, Austrian Frederick and Lillian Kiesler Private Foundation Archives, Vienna.

23  F. Kiesler, "Notes on Architecture: The Space House – Draft" (1933), p. 1. Unpublished miscellaneous sketches, notes, and drafts, Space House Folder, Austrian Frederick and Lillian Kiesler Private Foundation Archives, Vienna.

24  Kiesler, "Notes on Architecture: The Space-House," p. 296.

25  Ibid.

26  F. Kiesler, "Space house," in *Architectural Record*, vol. 75, January, 1934, pp. 44–61.

27  W. Braham, "What's Hecuba to Him? On Kiesler and the Knot," in *Assemblage* 36, August 1998, p. 20.

28  Kiesler, "Notes on Architecture: The Space House," p. 295.

29  See Kiesler, *Contemporary Art Applied to the Store and its Display*.

30  Colomina, "De psyche van het bouwen," p. 77.

31  Ibid., p. 76.

32  Kiesler, "Architectural Solution" (1933), p. 2.

33  Ibid.; see also Kiesler, "Notes on Architecture" (1933), p. 2.

34  Kiesler, "Notes on Architecture: The Space House," p. 296 (my emphasis).

35  Ibid., p. 295.

36  Kiesler, "On Correalism and Biotechnique," p. 66 (emphasis in the original).

37  Ibid., p. 65 (emphasis in the original).

38  Ibid. (emphasis in the original).

39  Ibid.

40  Ibid., p. 64.

41  Ibid. (emphasis in the original).

42  Ibid. (see charts on pages 64 and 71).

43  F. Kiesler, "Design-Correlation, Marcel Duchamp's 'Big Glass,'" in S. Gohr and G. Luyken (eds) *Frederick J. Kiesler: Selected Writing*, Stuttgart: Verglag Gerd Hatje, Ostifildern, 1996, p. 40. See also F. Kiesler, "Design-Correlation: from brush-painted glass pictures of the Middle Ages to [the] 1920s," in *Architectural Record*, vol. 81, May 1937, pp. 53–59.

44  E. Kaufmann, Jr., "The Violent Art of Hanging Pictures," in *Magazine of Art*, March 1946, p. 109.

45  "Isms Rampant: Peggy Guggenheim's Dream World Goes Abstract, Cubist, and Generally Non-Real," in *Newsweek*, November 2, 1942, p. 66, as held in the Frederick Kiesler Papers, Archives of American Art/Smithsonian Institution, Reel 127.

46  Kaufmann, "The Violent Art of Hanging Pictures," p. 109.

47  Ibid.

48  N. Calas, *Bloodflames 1947*, exhibition catalogue, New York: Hugo Gallery, 1947, p. 16, as held in the Austrian Frederick and Lillian Kiesler Private Foundation Archives, Vienna.

49  T. Demos, "Duchamp's Labyrinth: First Papers of Surrealism, 1942," in *October* 97, Summer 2001, p. 105.

50  F. Kiesler, "Frederick Kiesler's Endless House and its Psychological Lighting," in *Interiors*, November 1950, p. 125.

51  Ibid., p. 122.

52  Ibid., p. 126.

53  Ibid.

54  F. Kiesler, "The 'Endless House': A Man-Built Cosmos," in *The "Endless House": Inside the Endless House: Art, People and Architecture: A Journal*, New York: Simon and Schuster, 1966, p. 566.

55  Ibid., p. 568.

56  Ibid., p. 567.

57  F. Kiesler, "The Endless House," in Gohr and Luyken, *Frederick J. Kiesler: Selected Writings*, p. 130.

58  Ibid., pp. 126–127.

59  F. Kiesler, "The Broadcasted Decoration," in Gohr and Luyken, *Frederick J. Kiesler: Selected Writings*, p. 19.

60  F. Kiesler, "Kiesler's Pursuit of an Idea," in *Progressive Architecture*, July 1961, p. 116 (emphasis in the original).

61  Ibid., p. 117. Sylvia Lavin's reading of the Austrian-American architect Richard Neutra's post-war houses contends with Kiesler's observations; she argues illusionary psychical space

can be achieved inside boxed-shaped houses. See S. Lavin, "Open the Box: Richard Neutra and the Psychologizing of Modernity," in *Assemblage*, no. 40, Cambridge, Mass.: MIT Press, 1999, pp. 6–25.

62  The editors, "Translation from the French of the Editorial of *L'Architecture D'Aujourd'hui*," June 1949, as held in the Frederick Kiesler Papers, Archives of American Art/Smithsonian Institution, Reel 127.

## Chapter 11

# Invernizzi's exquisite corpse

## The Villa Girasole: an architecture of surrationalism

*David J. Lewis, Marc Tsurumaki, and Paul Lewis*

In 1935, Angelo Invernizzi, an engineer from Genoa who had previously experimented with reinforced concrete parking structures, completed work on his own vacation house outside Verona. Named il Girasole (the sunflower), Invernizzi's home is an attempt to mitigate the consequences of the rotation of the earth. The top portion of this house was constructed so that it could, with the aid of two motors, spin to follow the arc of the sun. Like the natural twisting motion of the sunflower through the course of a day, il Girasole can continually maximize a frontal exposure to the sun, thus minimizing shadows, to specific portions of the home. To produce the villa, Invernizzi worked with three other men: the mechanical engineer Romolo Carapacchi, the interior decorator Fausto Saccorotti, and the architect Ettore Fagiuoli. None of these men were particularly avant-garde, with Fagiuoli now considered the "most representative exponent of official Veronese architecture at the time."[1] The style of the villa is seemingly unremarkable and decidedly Novecento in its base and interior, with the rotating top portion demonstrating tendencies of the machine age: clean lines, industrial railings, and stretched-skin walls. The villa's immediate yard is, at first glance, nothing

more than a stripped-down version of a formal garden, orchestrated by the dictates of geometry. Aside from a few brief articles, and passing mention in collections of Italian twentieth-century architecture, il Girasole has remained insignificant to the discourse of twentieth-century architecture. When mentioned, the villa is a technological feat or an example of the Fascists' cult of the sun translated into architecture.[2]

Yet, there is something quite strange with this villa. As the direct product of rational engineers solving a clearly defined problem, il Girasole is today more than a mechanical curiosity in its landscape. We will argue here that il Girasole offers an exceptional text-case for understanding architecture and the constructed landscape as a particular type of surrealist act. Driven by a speculative proposal, a sequence of rational decisions culminates in the villa as not just a surreal object but rather a surrational object, the product of an excess of rationality, or logic. Whereas surrealism, or more precisely Breton's surrealists, struggled with producing an architecture of surrealism, surrationalism, as articulated by Gaston Bachelard, offers a means to rethink the inherent perversity of architectural and landscape production.

A seemingly simple question drives the design of this project: "What if a dwelling could maximize the health properties of the sun by rotating to follow it?" To answer this question, Invernizzi divided the villa into two portions: one fixed, the other mobile (Figure 11.1). Situated on the side of a hill in the wine country outside Verona, il Girasole is a rotating top set into a base. Similar to a military bunker, a circular masonry base is buried into the hillside, anchoring the villa (Figure 11.2). Entrance to the base is through the lowest portion of this base, decorated in a rusticated, modernist style fashionable at the time.[3] An entrance vestibule, rooms for servants, bathrooms, garages, and an expansive semi-circular terrace, complete with a colonnade framing the landscape beyond, compose the primary areas of the base. The rotating top portion of the villa sits in direct contrast to the base. Made from a structural frame of reinforced eraclit (a lightweight concrete made with wood chips),[4] mounted on a platform of wheels, and wrapped in a thin coat of aluminum, this chevron-shaped rotating top portion is organized around, and structurally linked to, a spinning central cylindrical core (Figure 11.3). A concrete spiral stair in this core extends 42.35 meters from a trust block at the base to an illuminated cupola at the top. Glowing in stark contrast to the traditional Veronese homes of the countryside, the shimmering metal villa looks out of place, even before it begins to rotate. The top of the core is glazed at the top, filtering sunlight down the circulation shaft of the building during the day and radiating electric light at night, turning the villa into a landlocked lighthouse beckoning, perhaps, an inevitable future flood.[5]

**11.1**

**Villa Girasole: diagram showing structural frame and solid base**

11.2
**Villa Girasole:
view of entrance
and masonry base
with top portion
shown under
renovation**

Following the dictates of the double-winged plan – designed for reasons of rotational balance around a single pivot – Invernizzi's villa makes odd the bourgeois dwelling. The two-story rotating top holds the primary living space. The first level contains the formal garden and public areas, with the two wings marking a division between work and eating – in one wing a living room, two studies and a bathroom, and in the other a formal dining

11.3
**Villa Girasole:
upper mobile
portion of villa**

room, breakfast room, and kitchen. Abiding by the conventions of a villa, the top floor is private. However, following the symmetrical configuration of the plan, one wing identically mirrors the layout of the other, producing a villa with two master bedrooms, two master baths, and two sets of bedrooms, complete with four built-in sinks. Sewer and water connections are made through pipes, leading down from the mobile core to collection containers

hung off the underside of the house – the architectural equivalent of colostomy bags. The rotating portion of the house contains in excess all the standard elements of a home, yet is nearly functionally independent from the base into which it is intimately coupled.

While not the intention of its designers, in its final realization il Girasole is the Surrealists' game of the exquisite corpse, drawn in stone, steel, glass and metal. As is well known, the exquisite corpse was one of the means by which the Surrealists sought to unite the world of dream with the lived world of reality through structured play.[6] As André Breton describes in the "Second Manifesto of Surrealism" of 1930:

> In the course of various experiments conceived as "parlor games" whose value as entertainment, or even as recreation, does not to my mind in any way affect their importance: Surrealist texts obtained simultaneously by several people writing from such to such a time in the same room, collaborative efforts intended to result in the creation of a unique sentence or drawing, only one of whose elements (subject, verb, or predicate adjective – head, belly, or legs) was supplied by each person, in the definition of something not given, in the forecasting of events which would bring about some completely unsuspected situation, etc., we think we have brought out into the pen a strange possibility of thought, which is that of its *pooling*. The fact remains that very striking relationships are established in this manner, that remark-able analogies appear, that an inexplicable factor of irrefutability most often intervenes, and that, in a nutshell this is one of the most extraordinary *meeting grounds*.[7]

Whether done through written text or drawing, the game rests on the logic of the fold or crease of paper, through which associations of dif-ference between individual players can join in the making of a singular monster. The end result is more than the cumulative product of individual contributions. The unanticipated whole exceeded the powers of the indi-vidual imagination and validated the Surrealist's belief in the transformative power of the unconscious, unleashed through games with rules of engage-ment. Unlike the Surrealists' earlier attempts at accessing the unconscious through unstructured automatic writing – which tended to form new patterns of habit and routine[8] – the exquisite corpse was predicated on a clearly defined logic of operation. Where Breton had privileged automatism – espe-cially writing and dreams – as the very definition of Surrealism in the first manifesto of 1924, by 1930 he defends Surrealists games, and only the rare

tour by a disciplined practitioner of automatic writing into "interior fairyland" against the majority of such writing which digressed into "obvious clichés" and "rampant carelessness."[9]

In the exquisite corpse of il Girasole, the fold-lines are clearly marked as the divisions of influence between the engineer's top (that of Invernizzi), the architect's base (that of Fagiuoli), and the interior of the decorator (that of Saccorotti). These three areas of the villa never coalesce into a proper singular aesthetic pronouncement. Upon first glance, the villa gives the appearance of a new building built upon the foundations of an existing ruin still partially buried by time. While this ancient-looking base remains traditional and solid, with structural columns and masonry bearing walls, the top is ephemeral and light, constructed through an open concrete frame, clad in thin metal. While the base exemplifies the stripped-down modernized Novecento classicism echoing the history of Italian architecture, the rotating portion personifies the aesthetics of a future machine for living. Because the top portion of the house is a well-defined object, a clear division is made between the inside world and outside skin. This fold-line between interior and exterior allows the house to be smooth, light and shiny on the outside, while remaining domestic, dark, ornamented and typically bourgeois on the inside.

The top of the architect's portion, the constructed roof garden of the fixed building, is the ground upon which the engineer's house rotates. Like lines extended across the folds of paper, the circular form of the architect's base is predetermined by the outline carved by the rectilinear top as it rotates 360 degrees around a fixed point to follow the sun – the engineer's machine for living as the world's largest landscape compass (Figure 11.4). A formal garden covers this crease, but a garden that only grows grass. The slicing effect of the house in rotation prohibits the planting of anything taller (Figure 11.5). Unfortunately, the garden of the machine il Girasole can't sustain sunflowers. The layout of this grass garden is dictated by the circular paths etched by the fifteen massive wheels upon which the house rotates, and the four exit landings that cantilever down to the ground. Garden doors on the yard side always lead to sidewalks that terminate back into the villa. Thus it is nearly impossible to leave the house directly from the back door. Like the inscriptions onto the condemned man's back in Kafka's *In the Penal Colony*, il Girasole is a writing apparatus, continually transcribing the movements of the sun, through a skin of landscape, onto the shoulders of architecture.

Because of the logic of the inquiry – make architecture move – inversions of the norm occur. The assumed fixed relationship between architecture and landscape, building and ground, critical to identity of each

11.4
**Villa Girasole:
space between
rotating top and
fixed base**

discipline, is destabilized. From a position within the rotating top, the tradi-
tional distinctions of front, back and side yards typical in domestic settings no
longer apply. Landscape's claims for offering measure to the cycles of a day
must now compete with a mechanical sundial, clearly visible on the hillside.
By tethering architecture to the rotation of the sun, the adjacent vineyard
landscape moves around architecture. The sun is constrained to only a verti-
cal rise and fall within a single slot of a window frame during the course of a
day. The mobile house transforms the surrounding landscape from the pictur-
esque to the panoramic, albeit one in slow motion.

  Even though the base abides by all the rules of proper domestic
architecture the living spaces have been evacuated to the ephemeral top,
relegating the spaces of architectural stability to the position of storage and
service. The proper formal entrance is through the grotto-like basement,
which directly leads to a passage terminating into a caged elevator located
within the center of a spiral staircase. Primary access to the *piano nobile* is
thus made through a caged lift, typically found only in larger apartments.
Paradoxically, the vibrations of the rotating crown prevented the extensive

11.5
**Villa Girasole:
circular garden
drawn by path of
rotating house**

wine cellar in the base from functioning, despite its ideal submerged location[10] – the workings of the collective exquisite corpse disrupting individual contributions.

Invernizzi's seemingly rational decision to make architecture follow the sun, renders il Girasole part of a larger history of bachelor machines – attempts to harness through man-made devices the reproductive, regenerative, and transformative energy of nature – that fascinated and

engaged the Surrealists.[11] Even at a weight of 1,500 tons, the mechanics of il Girasole is ingeniously designed so that only two motors, totaling three horsepower, are needed to move the crown at 4 millimeters a second. A full rotation is thus possible in nine hours and twenty minutes with the push of a single button. Designed to facilitate necessary repairs, the wheels are clearly visible in the space between the garden roof and the concrete underside of the rotating villa. Like the wheels of Duchamp's "The Chocolate Grinder" which activates the "Large Glass," the movement of the house enacts an autoerotic repetition of the machine on a perpetually endless route. Over time, the grinding movement of the vertical shaft, penetrating into the earth-bound architecture, has begun to wear away the building.[12] Each turn of il Girasole brings the machine to life and, at the same time, closer to its demise. When activated, the movement of shadows across an interior room or courtyard is eliminated. By constructing a "machine-for-living" that arrests the temporal cycle of a day, Invernizzi's villa is, in effect, a time machine in the process of destroying itself.

Is it possible to extract from this mechanical villa and its resultant landscape a productive way of considering the relationship between surrealism, architecture and landscape? Even though il Girasole may demonstrate aspects of a Surrealists' game, the villa certainly does not reflect any of the aesthetic marks typically associated with an architecture or landscape of surrealism. Indeed, Invernizzi was not a member of a Surrealist group and il Girasole is not mentioned in texts on or by Surrealists, who prefer to cite the more obvious examples: Hector Guimard, Antoni Gaudi, Ferdinand Cheval, Roberto Matta, and Frederick Kiesler – the latter two by party affiliation, the former by stylistic affinity.[13] Yet the relentless set of rational logical decisions involved in the production of il Girasole, initiated by the heliotropic speculation and relentlessly carried through into its technical realization, concludes in a villa on the edge of the irrational. As such, il Girasole exemplifies a line of thought that paralleled Breton's conception of surrealism after 1929 – that of Bachelard's surrationalism.

In 1936, the philosopher-scientist Gaston Bachelard wrote a short essay entitled "Surrationalism," published in Julien Levy's important catalogue to the surrealism show in New York, in which Bachelard called for the radical reconfiguration of the boundaries of rationalism:

> The decisive action of reason is almost always confused with monotonous recourse to the certitudes of memory. That which is well known, which has often been experienced, that which one faithfully repeats, easily, vehemently, gives the impression of objective and rational coherence ... By subtle endeavor reason

must be brought to the point of not only doubting its own works, but of systematically subdividing itself once more in all of its activities. Briefly, human reason must be restored to its function of turbulent aggression.[14]

Surrationalism was to rationalism, what surrealism was to realism.[15] Whereas Breton was interested in the critique of daily and artistic experience, clouded by habit and burdened by civilization, Bachelard sought to combine the flexibility of science with a philosophy freed from *a priori*, binary, or dialectical categories in the production of a surrational mindset. Four years after writing the essay, Bachelard extended his inquiry into surrationalism in his publication *The Philosophy of No: A Philosophy of the New Scientific Mind*, arguing explicitly for the expanded possibilities of the surrational thought-processes that accompanies a "philosophy of no."[16] Instead of accepting the conventional philosophy that assumes a dialectic process, in which newer theories supersede older models, Bachelard's "Philosophy of No" seeks to retain the antithesis with the thesis. The coupling of the two is a productive broadening of the base of philosophical inquiry, necessitated by parallel developments in the sciences in which Bachelard saw increasingly complex and even contradictory concepts at play (notably Einstein's Theory of Relativity and Newtonian Physics).[17] Surrationalism is thus the active solicitation of an excess of rational thought, seeking to hold in a similar creative tension seemingly incompatible inquiries, in order to break with established conventions and habits of thought. This is rational thought actively brought to the point of the irrational, turbulently reclaiming reason from the vicissitudes of memory.

It is here, in the possibility of an architecture of surrationalism, that il Girasole exemplifies a parallel, if not identical, and certainly more productive line of inquiry, than with surrealism. Fixated as surrealism is on questions of the real, inquiries of architecture and surrealism inevitably seem to fall short. Architecture is the difficult object of the real, *par excellence*, for once constructed it is the physical manifestation of desire into fact. It is no wonder that Breton's primary engagement with architecture occurs at the level of re-assembling or destroying known monuments of the city – as the partial ghosts of Paris in *Nadja*, or as the standards of stupefying reality, ripe for *Experimental Researches (On the Irrational Embellishment of a City)*.[18]

Perhaps persuaded by the success of the visual arts of surrealism, designers, historians and critics have usually sought surrealism in architecture in the wrong place. Looking for visual and formal oddities alone misses a more creative way of seeking the extra-ordinary at the heart of surrealism. As this chapter has attempted to illuminate, il Girasole stands and

rotates as a surrational object, making strange its site. Its mechanical opera-
tions providing transparency to the logical sequence of its construction and
operation. Begun by Invernizzi as a seemingly rational desire, the uncanny
aspects of its conclusion form a testament to the surrational capacity of an
architecture, unhinged from its conventional relationship to ground, sun, and
landscape.

## Notes

1   L. Bisi, "The Rotary House," in *Lotus International* 40, 1983, p. 115.
2   See Bisi, "The Rotary House," pp. 112–128; L. Bisi, "il 'Girasole' " in *Abitare*, July–August
    1979, pp. 8–21.
3   S. Polano, "Verona – Marcellis, Villa Il Girasole," in *Guide all'architettura italiano del Nove-
    cento*, Milano: Electa, 1991, p. 237.
4   Bisi, "The Rotary House," p. 115.
5   While discussion of Invernizzi's childhood in Genoa might offer a rationale for the lighthouse
    form at the center of the building, it does not diminish the strangeness of this illuminated
    tower in the landscape. See T. Williams, "The House that Turns to the Sun," in *House and
    Garden*, February 1987, pp. 150–157.
6   Breton defined surrealism as "the future resolution of these two states, dream and reality,
    which are seemingly so contradictory, into a kind of absolute reality, a *surreality*, if one may
    so speak." A. Breton, *Manifestoes of Surrealism*, Ann Arbor: University of Michigan Press,
    1969, p. 14. For description of the Exquisite Corpse, see A. Breton, "Le cadavre exquis," in
    *La Révolution surréaliste* 9, 1929, p. 10; A. Brotchie (ed.) *Surrealist Games*, Boston: Shamb-
    hala Redstone Editions, 1993, pp. 25 and 143–144; and A. Breton, "The Exquisite Corpse,"
    in P. Waldberg, *Surrealism*, London: Thames and Hudson, 1965, pp. 93–95.
7   A. Breton, "Second Manifesto of Surrealism," in *Manifestoes of Surrealism*, pp. 178–179.
8   For a description of the failings of automatism slipping into habit, see M. Nadeau, *The
    History of Surrealism*, New York: The Macmillan Company, 1968, pp. 161–165.
9   Breton, *Manifestoes of Surrealism*, pp. 157, 162.
10  For further discussion of the dilemma of living in il Girasole, the house without shadows,
    exemplified by the problem of storing wine, see M. Frascari, "A Secret Semiotic Skiagra-
    phy: The Corporal Theatre of Meanings in Vincenzo Scamozzi's Idea of Architecture," in *VIA*
    11, 1990, p. 49.
11  J. Clair, H. Szeemann, and C. Marche (eds) *The Bachelor Machines*, Venice: Alfieri, 1975.
12  "In the quiet afternoon hours, as it silently turns, the sound of a pebble dropping may be
    heard. It echoes upward through the central drum. We are told there is a slow disinteg-
    ration, a grinding down, of the great base. Later this loss is evidenced by a powdery sub-
    stance, granules of dust, on the polished entry floor far below." Williams, "The House that
    Turns to the Sun," p. 198.
13  See S. Alexandrian, "Chapter Ten: Surrealist Architecture," in *Surrealist Art*, New York:
    Praeger Publishers, 1969: pp. 177–189; J. Levy (ed.) *Surrealism*, New York: Da Capo Press
    Ltd, 1936, p. 57; and D. Vesely, "Surrealism, Myth & Modernity," *Architectural Design* 48,
    no. 2–3, 1978, pp. 87–95.
14  G. Bachelard, "Surrationalism," in *Inquisitions* 1 (1936), reprinted and translated in Levy,
    *Surrealism*, pp. 186–189.
15  For further comparison of Breton and Bachelard, see M. Caws, *Surrealism and the Literary
    Imagination*, The Hague: Mouton & Co., 1966.

16  G. Bachelard, *The Philosophy of No: A Philosophy of the New Scientific Mind*, New York: Orion Press, 1968.

17  For another discussion, see R. Smith, *Gaston Bachelard*, Boston, Mass.: Twayne Publishers, 1982.

18  A. Breton, "*What is Surrealism?*" (ed. F. Rosemont), New York: Monad Press, 1978. See also R. Spiteri, "Surrealism and the Irrational Embellishment of Paris," Chapter 14 in this volume.

Chapter 12

# The tangency of the world to itself

## The Casa Malaparte and the metaphysical tradition

*Jacqueline Gargus*

The Casa Malaparte is the best-known example of a building designed in the ambit of the original group of Surrealists, those established in France by André Breton in the 1920s. During the villa's inception and construction, client/architect Curzio Malaparte edited an issue of an avant-garde journal on the topic of Surrealism. Included were works by French Surrealists, like Breton and Paul Éluard, as well as works by members of the Italian Meta-physical School such as Giorgio de Chirico and Alberto Savinio.[1] Images and ideas of the Surrealists must have commingled in Malaparte's mind with his vision of the house. He probably even discussed the project with Surrealist artists featured in the journal. Not only do paintings by Savinio hang in the Casa Malaparte, but Savinio even designed ceramic tiles for the floor. Thus immersed in the culture of Surrealism, Malaparte absorbed, transformed and adumbrated a kindred sensibility in his house.

Like a distorted image from a de Chirico painting, the pure, red, trapezoidal block of the Casa Malaparte is set into the rugged cliffs of Capri, a slab of marooned geometry cast onto rocky, alien shores (Figure 12.1). Like the Surrealist operation of "objective chance," in which strange new

**12.1**
**Casa Malaparte,**
**Capri, 1938–43**

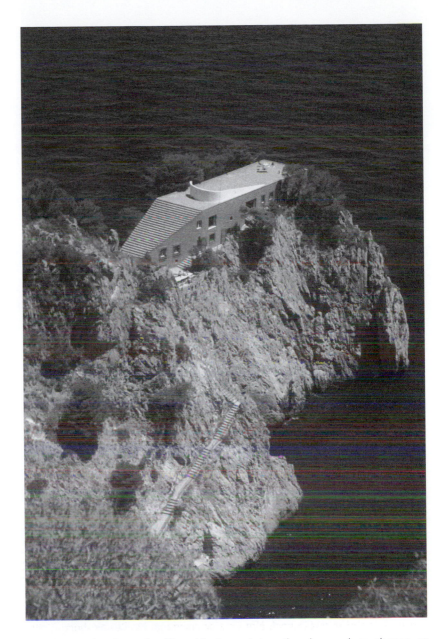

meanings arise from familiar objects cast together by random chance or revealed by *frottage* or erasure, the Casa Malaparte recontextualizes simple, familiar forms to startling effect. A wall, a stair, a door, a sail, the color red – elements familiar in the vernacular landscape of Italy – are wrenched out of context in the Casa Malaparte. Indeed, the Casa Malaparte almost seems to quote de Chirico's works. In de Chirico's *The Enigma of the Arrival and the Afternoon*, 1912, a red wall cuts horizontally across the canvas, collecting

difference and contradictions along its edge. The frozen immobility of the stark foreground abuts a tumultuous sea, and a wraith-like sail emerges above the wall. Likewise in the Casa Malaparte, the curving, white solarium screen rises up anomalously from the incessant, red geometry of the roof terrace; likewise, the Casa Malaparte uses familiar forms, recast in exaggerated color and skewed perspective.

Yet the effect of the Casa Malaparte is more potent than that of the paintings. While Surrealist painting can only constantively represent images of dreams, hallucinations or visions beyond conscious reality, the Casa Malaparte presents an unsettling stage and instigates action in which the viewer is forced to participate. A bodily sense of disequilibrium and a direct, visceral, non-linguistic response is thereby instigated. Even the most ambitious and ambiguous of de Chirico's paintings rely on vision alone, and are thereby bracketed away from "the real" by artifice, paint and frame. The Casa Malaparte, on the other hand, works on the body itself.

Malaparte observed in *Prospettive* that de Chirico's work succeeded because it did not rely on idiosyncratic imagery and intellectual or linguistic games, but that it tapped into memory. Playing on the edges of half-remembered, mythic space and real, embodied, lived space, the Casa Malaparte exploits the clash between landscape and geometry, the domesticated and the wild. An unstable, *informe* order is established between figure and ground, object and cliff, subject and object.

"*Informe*" is a term invented by the sometime Surrealist writer Georges Bataille to describe the delicate, oscillating interplay between opposite conditions that undermines clarity and erodes or contaminates status. For Bataille, the *informe* is at the center of the Surrealist project. As in a dream, no dominant reading coalesces, no singular meaning nor formal quality is stipulated, attempts at classification are thwarted, and signified is wrenched away from signifier. In his *Critical Dictionary*, Bataille refuses to define "*informe*," arguing that his task is "not to give the meaning of words, but their jobs . . . [*informe*] is not only an adjective having a given meaning, but a term that serves to bring things down in the world [*déclasser*]."[2]

Surrealist writer Michel Leiris began his essay "The Bullfight as Mirror"[3] by thinking about how *informal* oppositional structures work in relationship to each other, and his description of the bullfight seems especially useful in explaining the Casa Malaparte:

> God – the coincidence of contraries, according to Nicholas of Cusa (which is to say: point where two lines come together or one track bifurcates) – has been defined pataphysically as "the point of tangence between zero and infinity." Likewise, there are

among the countless elements composing our universe certain nodes or critical points that might be represented geometrically as *the places where one feels the tangency of the world to itself.*

Indeed, certain sites, events, objects, certain very rare circumstances give us the feeling that they are presenting themselves before us or that we have a stake in them, that their role in the general scheme of things is to put us in contact with the most deeply intimate elements that, on ordinary occasions, are the most murky, if not totally obscured. It would seem that such sites, events, objects, circumstances have the power to bring very briefly to the uniformly flat surface of the world where we normally find ourselves some elements that most properly belong in our deep inner life, before allowing them to sink back – subsiding along their other slope of the curve – towards the cloudy obscurity from which they arose.[4]

Just as the lurid, ritualistic dance of the bullfight arranges oppositions sequentially in time and space, so too does the stiff, relentlessly hieratic architecture of the Casa Malaparte unfold processionally, calling forth an ever-changing relationship between landscape and viewer, whose bodily presence activates the event. John Hejduk has noted how the procession to and through the Casa Malaparte seems to rehearse an ancient ritual.

Malaparte's house . . . is a house of rituals and rites, it is a house of mysteries, it at once brings forth the chill of the Aegean on the horn head of past sacrifices, it is an ancient play in Italian light. It has to do with the primitive gods and their unrelenting demands. It has to do with the suction of the leaves and stone and the expulsions of sea and sky. It has to do with the choice of good and evil and the inevitable pathos when a wrong choice is made. It has to do with the hollowness of caves and the inaccessibility of the sun. It has to do with the abandonment of abstraction and the seduction of the lyrical . . .[5]

Hejduk recognized the doubleness of meaning that attached itself to the house in his recitation of opposites: good/bad; stone/sky, caves/sun, abstraction/lyricism. Malaparte too recognized the villa to possess simultaneously opposite, contradictory qualities. His nicknames for the villa were *Kasematte*, German for "bunker," which suggests that the house serves to keep malefactors out, and the homophonic *casa matta*, Italian for "mad house," which suggests the very opposite. The Casa Malaparte collects images and shifts

meaning, thus establishing an unstable network of affinities and differentiation.

The Casa Malaparte cannot be understood without some discussion of its owner, Curzio Malaparte, born in 1898, in Prato, to a German textile worker and a Milanese mother. As a young man, Kurt Suckert (Malaparte's original name) interrupted his career in journalism to join the Italian army and fight in the First World War. Half German, Malaparte considered himself to be "different from other Italians – more romantic and more barbarian."[6] After the First World War Malaparte joined the Fascist party and took part in the infamous March on Rome. In the climate of extreme nationalism fostered by the Fascist state, Suckert adopted the Italian-sounding pseudonym "Curzio Malaparte." While "Curzio" is a rather uncommon, Italianized version of "Kurt," he chose the surname "Malaparte" believing that it was the original family name of Napoleon Bonaparte, discarded by the general because of its negative connotations. Like *Kasematte/casa matta*, the name "Malaparte" fuses together references to a thing and its opposite: *mal/bon*, bad/good.

As a journalist, Malaparte wrote on every imaginable topic, sometimes finding favor with Mussolini, and sometimes irritating the regime. He also ran the cultural journal *Prospettive*, authorized by Mussolini and financed by the Ministry of Culture.[7] Each issue was devoted to a special topic. In its early years, the journal dealt with propagandistic themes, such as "Fascist Youth" or "Heroism of Textile Workers." After October 1939 the journal developed a different focus and Malaparte cast his eye exclusively on progressive developments in the arts and culture. The format grew smaller and the graphic layout became more stylish and more pointedly avant-garde. After Malaparte redefined the journal, he lost state sponsorship and circulation fell from over 100,000 issues to around 3,000. It was in the new *Prospettive* that Malaparte explored themes like "Surrealism," "Existentialism," and "Architecture."

In 1933, Malaparte published a pamphlet on how to pull off a *coup d'état*. Not surprisingly, the publication was not well received by the Fascist government and Malaparte was sentenced to a five-year period of internal confinement on Lipari, an isolated volcanic island off the coast of Sicily. During this period he saw the rocky outcropping of Punto Massulo and decided to build a villa on the site. Italian architects Adalberto Libera and Luigi Moretti had collaborated with Malaparte on the architecture issue of *Prospettive*. Hence, for the construction of the villa, Malaparte turned to Libera, requesting a plan of the building, for "without it, [he] cannot do anything."[8] Libera had impeccable modernist credentials: his drawings were displayed with the brightest avant-garde architectural luminaries at the

Weissenhof Siedlung in 1927, and he was a member of the avant-garde Milanese architectural group, *Gruppo Sette*. In spite of this, Libera's plan for the villa was remarkably unambitious, showing a simple two-story box, structured by ponderous bearing-walls, and organized by a single-loaded corridor.

It is likely that Libera's drawing was for the sole purpose of securing building permits and had little to do with the actual design of the house. Indeed, Libera never included the villa in his catalog of collected works. Furthermore, the final version of the Casa Malaparte differs greatly from Libera's drawing. The rectilinear block in the drawing gave way to a canted trapezoid, and the image of the truncated stair on the roof came out of nowhere, or perhaps out of the vernacular landscape of Malaparte's place of exile, Lipari, where a rural church features a similar triangular flight of stairs. However, in Capri there is no building atop the stairs, only absence. Like de Chirico's headless *mannequin écephale*, the house had been decapitated, leaving only a blood-red crypt or blood-soaked cyclopean altar in its place.

Rather than the work of a rationalist modern master like Libera, the Casa Malaparte appears to be the product of Malaparte's extraordinary imagination, in collaboration with a skillful Caprese mason who was able to translate Malaparte's idiosyncratic, imagistic sense of the house into stone and mortar. Rather than pursue modernist objectives of rational construction, the exploitation of new materials, and the liberation of pure space, the house reveals Malaparte's close association with the very different objectives of Surrealist thought.

It was in 1940, the very period of the villa's development and construction, that Malaparte produced his issue of *Prospettive* on Surrealism. When conservative Fascist authorities attacked Surrealism as frivolous and decadent, Malaparte countered that "decadence begins exactly at the moment when one loses the magical sense of a magical interpretation in reality, which is the intimate, natural, spontaneous, element of our creative power."[9] In the issue, Malaparte especially praised the Italian metaphysical painters over northern Surrealist artists, emphasizing the importance of transforming the familiar in their work, versus the celebration of purely subjective, personal images in the works of the latter.

The Italian Metaphysical School provides a more illuminating context for Malaparte's work than contemporary avant-garde architecture or even work by members of the Surrealist inner circle. De Chirico's paintings of the 1910s and early 1920s routinely involve the radical juxtaposition of nature and artifice in strategic ways, very close to that of Malaparte. Tense, alienating spatial incongruities arise as angular, geometric objects awkwardly struggle to inhabit the same space with natural, organic form. In de Chirico's *The Sacred Fish*, 1919 (Figure 12.2), an ordinary still life is transformed

through the introduction of sharply chiseled geometric objects. The trapezoidal platter is ambiguous, suggesting at once a cipher for a static, hieratic altar, and at the same time the mad, improbable, rushing convergence of space. Scale is awry, and innocent elements in the composition, like the fish, are charged with menacing intimations of the uncanny. Likewise in *Gare Montparnasse* (*The Melancholy of Departure*), 1914, an alien element (an enormous, abandoned bunch of bananas) functions as a normalizing datum, which registers all particularities and idiosyncrasies of space, scale, and human presence. Foreground and background fold in upon one another across a luminous diagonal, and notations of perspective space only belie the impossibility of coherence and legibility.

After four years of construction the Casa Malaparte was finished, a severe block made of local stone, 33 feet wide by 178 feet long, roofed by a trapezoidal stair to a terrace. Designed in a pared-down architectural language, its smooth, pure, geometric clarity contrasts to the rough irregularity of its natural setting. Indeed, the relationship of the villa to its landscape is at once surreal (*sur + real*) in its juxtaposition, yet hyper-real in its ability to bring into focus, or unveil, hidden truths about the landscape. Like the temple described by Martin Heidegger in his essay "Origin of the Work of Art," "the steadfastness of the building contrasts with the surge of the surf, and its own repose brings out the raging of the sea."[10]

For Heidegger, the truth of the site is not revealed by duplicating and extending existing conditions but by introducing difference. Likewise, the Casa Malaparte gains its power not through the isolated success of its

12.2
**Giorgio de Chirico (1888–1978) © ARS, New York, *The Sacred Fish*, 1919. Oil on canvas, 29$\frac{1}{2}$ in × 24$\frac{3}{8}$ in**
Acquired through the Lillie P. Bliss Bequest (333.1949),
The Museum of Modern Art, New York

form or features, but through the nexus of contradictory, oscillating opposi-tional relationships it establishes. A stark red geometric block, it re-forms the top of the craggy rock cliff into a severe, horizontal plane. In so doing, the essential irregularity and roughness of rock comes into focus with new power. Moreover, by making the rough hill as flat as the sea, the horizontal table of the sea is recreated high above the water. Foreground and back-ground come together; the middle ground is erased. The solarium screen, a kind of white sail, displaced from ship and sea, further enforces the connec-tion between terrace and water. Paradoxically, by inserting a prismatic paral-lelepiped into an uneven terrain, Malaparte has destabilized conventional understandings of both the sea and the cliff.

As in a de Chirico painting, the geometry of the Casa Malaparte stair is warped, and the perspective is thereby exaggerated and accelerated. The body is thrown off center by the expansion of space as one ascends. Originally, a rude, primitive entrance was cut into the middle of the monu-mental stair. By removing the central entrance, Malaparte assured that no orthogonal opening could disturb the vertiginous play of perspective caused by the steeply converging sides of the stair.

Malaparte plays Surrealist games of quotation, dismemberment, and displacement in the development of interior spaces. The living room of the house is vast – eight by fifteen meters – with four enormous plate glass windows framed by curved, black tufa braids. The furniture, designed by Malaparte, is comprised of unrelated fragments of truncated columns, pristine planes of glass, gnarled, warped tree trunks and massive planks of undressed wood. The collection of *objects trouvés* suggests an archeology, laying bare a concealed history and bringing into juxtaposed relationship disparate elements from culture and nature. The solid itself is inwardly focused and introverted – a kind of apteral or "intrapteral"[11] temple, a temple turned inside out, fragmented columns within bearing witness to this violence.

The interior of the house is focused, axial and linear while the roof is open to infinite space. Spatially, the evacuated void of the living room is starkly contrasted with the extreme, claustrophobic compression of the adja-cent part of the house. The interior of the *piano nobile* opposes two paradig-matic types: a cave-like megaron (the living room), and a densely packed maze (the bedrooms and the dead-end corridors). The opposition of elemen-tal qualities is brought to a head in the design of the massive fireplace. Bor-dered by a tufa frame, the fireplace has a back surface of glass, revealing a view of the sea and the cliffs below. To the admixture of earth, air and water, the fourth Platonic element, fire, has been added, with the spectator caught between the image and the frame.

Framing is thematic throughout the house. Four over-scaled windows symmetrically flank the living room, their thick, exaggerated moldings making them seem more like picture frames. The conflation of natural landscape with painted artefact was an effect Malaparte deliberately strove to achieve. The window frames were only added as an afterthought, more than a year after the house was completed.[12] In his novel *The Skin*, Malaparte explains his villa to a guest, Field Marshal Rommel:

> before leaving, he asked me whether I had bought my house as it stood or whether I had designed and built it myself. I replied – and it was not true – that I had bought the house as it stood. And with a sweeping gesture, indicating the sheer cliffs of the Faraglioni, the peninsula of Sorrento, the islands of the Sirens, the far-away blue coastline of Amalfi, and the golden sands of Paestum, shimmering in the distance, I said to him: "I designed the scenery."[13]

Malaparte's association with the Italian Metaphysical School helps to explain the villa's uncomfortable, uncategorizable place in architectural history. The villa has nothing in common with Libera's other designs, such as the Palazzo dei Congressi or Post Offices in Rome, nor with anything else produced by the *Gruppo Sette*, the Italian Rationalists, nor, for that matter, anything produced by anyone in any architectural avant-garde. In its stark, severe, simplicity, the Casa Malaparte seems to transcend style and time. It is a provocative, one-of-a-kind phenomenon, a beloved monument sitting somehow, outside of history, or at least outside the historical narrative that is commonly used to explain the development of modernist art and architecture. Indeed, it is difficult to discuss the villa in a historical sense, in the same way that Surrealist painting is difficult to discuss in the context of modernist painting.

A progressive model of the course and development of artistic production emerged in the late eighteenth century and dominated the way in which the twentieth century defined the discourse. Influenced by Kantian critical philosophy, which aimed at uncovering essences, the object of art became involuted and self-referential. From thenceforth, art, in a proper avant-gardist sense, tended toward abstraction. Art was for art's sake, and the means of criticism became the subject of the critique. Architecture, likewise, could only be about architecture. In painting, the progressive development of modern art favored the simplification and reification of artworks based on the expression of the intrinsic, telling qualities of the medium and the suppression of extrinsic elements, or features which belong more properly to another medium. Art critic Clement Greenberg identifies modernist

painting as involving a "shift from mimetic to non-mimetic features in paint-ing" – that is, an emphasis on "flatness, consciousness of paint and brush stroke, the rectangular shape"[14] at the expense of traditional tasks of paint-ing, such as naturalistic representation and storytelling. In the words of the monochrome painter Ad Reinhardt: "the one object of fifty years of abstract art is to present art-as-art and as nothing else ... making it purer and emptier, more absolute and more exclusive..."[15] Architecture was not immune to such ambitions towards purity. The essentialist meta-narrative of modernist architecture, as set forth by Siegfried Giedion, celebrated the most abstract, essential value of all: pure space.

Surrealist painting, with its obsessive emphasis on representa-tional subject matter, the evocation and description of psychic states, dreams, and extra-pictorial effects, falls outside of the clean history of twentieth-century modernist abstract painting. So too does the Casa Malaparte fall outside Giedion's modernist narrative. The villa is not about materials, technology, space, space/time, or even architecture, in the grand sense of the word. It has more to do with architecture's uncanny ability to act on the psyche, to jar memory, to shape's one's engagement with the world or force confrontations with its elements. It functions, in the words of Yves-Alain Bois, as a "privileged metaphor of metaphysics."[16]

Like the Surrealists, Malaparte was not interested in abstract values or the positivistic celebration of the scientific method, technical systems, or new materials. Like the Surrealists, he aimed at provoking and exacerbating the doubleness of meaning that lay just beneath the surface of rational discourse. The house was conceived as a social stage for ritual inter-action, and can be read as a kind of *unheimlich* psychoanalysis of the conven-tional home. Even the form is blurred – is it a perfect geometrical wedge, or a distorted rectangle? A pristine, a-historical, geometric block, a violently marred, decapitated plinth, lacking a temple, or a fragment of a ruined theater? A violent eruption of the chthonic forces of the earth, or a colossal stairway to the sky?

One almost might say that Surrealist painting is a doomed enter-prise, unable to attack reality as insidiously as other media, such as sculp-ture, which makes use of real, three-dimensional things, or photography, which captures an indexical trace of the real world. In spite of ambitions to achieve immediacy by tapping into the unconscious mind, repressed thought and the super-rational, the paintings of many Surrealists suffer because they rely too heavily on straightforward techniques of naturalistic representa-tion. While their imagery may provoke shock, interest or amusement, the imagery is often so patently fantastic and bizarre that it does little to push at the boundary of "real." The extreme subjectivity of such work limits its

accessibility and interest because of the impossibility of fixing reference and controlling readings. The framing of the object as a two-dimensional representation lets the spectator domesticate its subversiveness and rele- gate it into the category of comfortable fictions, thereby canceling both the reality of the work and its potential surreality. Yet even more than photo- graphy or sculpture, architecture fully confronts and situates an embodied viewer. Because it is most profoundly embedded in the world, architecture may be the most apt medium for the Surrealist project, and Casa Malaparte the most powerful essay on the theme.

## Notes

1   Savinio adopted the pseudonym to distinguish himself from his famous older brother, Giorgio de Chirico.
2   G. Bataille, in the *"architecture"* and *"informe"* entries to his *Critical Dictionary*, published in *Documents* 2, Paris, 1929, p. 117, reprinted in G. Bataille, *October* 60, Spring 1992.
3   M. Leiris, "The Bullfight as Mirror," in *October* 63, Winter 1993 (trans. A. Smock), p. 21.
4   Ibid.
5   J. Hejduk, "Cable from Milan," in *Domus*, Milan, April 1980, pp. 8–13.
6   G. Guerri, *Arcitaliano: vita di Curzio Malaparte*, Milan 1980, pp. 179ff.
7   Ibid.
8   Quoted by M. Talamona, *Casa Malaparte*, New York, 1992, attached as Document 9.
9   Guerri states this was the Éluard poem "Morire" (Death), in Guerri, *Arcitaliano*, p. 185.
10  M. Heidegger, "Origin of the Work of Art," in *Poetry, Language, Thought* (trans. A. Hofstadter), New York: Harper, 1975, pp. 41–42.
11  "Apteral" means "without columns"; "intrapteral" is my own neologism to mean "columns on the inside."
12  Talamona, *Casa Malaparta*, Document 38, p. 111.
13  C. Malaparte, *The Skin*, cited by W. Arets and W. van den Bergh, "Casa come me – a sublime alienation," *AA Files* 18, p. 9.
14  Quoted by A. Danto, *After the End of Art, Contemporary Art and the Pale of History*, Prince- ton, New Jersey: Princeton University Press, 1999, pp. 7–8.
15  A. Reinhardt, *Art-as-Art: The Selected Writings of Ad Reinhardt* (ed. Barbara Rose) Berkeley and Los Angeles: University of California Press, 1991, p. 53.
16  Yves Alain Bois's definition of *informe* in his essay in Y.-A. Bois, *The Informe: A User's Guide*, Paris, 1996.

Chapter 13

# Modernist urbanism and its monsters

*David Pinder*

### Arriving in the city

In March 1935 André Breton travels east from Paris to Prague. He is drawn by his interest in the Czech surrealist group, which was founded the previous year and is enjoying close ties with the Czech Communist Party. It is his first visit to the city, for a lecture tour. On his third day he delivers his lecture "Surrealist situation of the object" at the Mánes Union of Fine Arts. He begins by referring to the "legendary delights" of Prague, describing it as "one of those cities that electively pin down poetic thought, which is always more or less adrift in space". With its "towers that bristle like no others", when viewed from afar he suggests that it seems to be "the magic capital of old Europe". He states that of all the cities he had not yet visited it "was by far the least foreign to me", and adds: "By the very fact that it carefully incubates all the delights of the past for the imagination, it seems to me that it would be less difficult for me to make myself understood in this corner of the world than in any other."[1]

Among Breton's references in the lecture is one to the Palais Idéal, located in the village of Hauterives in south-east France. The structure was built single-handedly by the postman Ferdinand Cheval, out of rocks and stones gathered from the region, over a period of thirty-three years between 1879 and 1912. Cheval had no training in architecture or construction, but he worked on what he called his "fairy palace" in the evenings and at night by

candlelight after his postal rounds. The result is an extraordinary hybrid of sculpture and architecture that teems with figures, animals, organic forms, as well as pillars, columns, grottoes, galleries, temples, and representations of different places and fragments of text. The profusion of forms and elisions between them overloads attempts to catalogue, register and locate references as they enter into an apparent process of exchange, metamorphosis, even flux, with the permeability of inside and outside conveying an impression of in-betweenness and flow. For Breton it is a "marvellous construction" with its dream-like qualities and its passionate expression of an individual's untutored and imaginative vision. He takes particular delight in its lack of utility for, as he notes, it has "no place for anything except the wheelbarrow that [Cheval] had used to transport his materials".[2]

Seven months later, Le Corbusier travels west from Paris to New York. Manhattan has long fascinated him, its vertical structures an obvious reference point for his own plans for constructing a new city for the "machine age". This is his first visit, for a lecture tour. On his third day in the city he gives a talk at Radio City in the Rockefeller Center, broadcast to more than fifty stations in the United States, in which he describes his feelings on arriving. From the deck of the *Normandie* at quarantine he sees "in the morning mists a city which was fantastic and almost mystical". It appears to him to be "the temple of the new world". As the ship moves forward, "the apparition in the mist was transformed into an image of brutality and savagery". But, he adds: "This brutality and savagery do not necessarily displease me. For it is thus that all great work must begin – by strength."[3] He claims to be greeted relatively coolly, but newspapers and magazines show considerable interest in his arrival. A number latch on to an initial comment he makes about the skyscrapers. "Too small? – Yes, says Le Corbusier; too narrow for free, efficient circulation."[4] Headlines in the *New York Evening Post* announce the arrival of the French architect with "plans to rebuild city", and note: "Le Corbusier moans over waste of ground – calls skyscrapers spiny needles."[5]

Over the two months of his visit Le Corbusier will in fact be continually torn, assailed by a stormy debate in his mind involving "hate and love". He despairs about the state of the city of New York, its distances, uproar and slums. But he is also enthused and optimistic at what he calls its "fairy splendour".[6] Inspired by New York's sense of promise, his initial impressions confirm his belief that "[t]oday, at last, a new type of city can be born, the city of our modern times, filled with happiness, radiant with the essential joys"; and in the United States, so he tells his radio audience, he has found "the very country most capable of realizing first and with extraordinary perfection this great task of our day".[7]

This chapter is located between these two journeys; or, rather, it is located in tensions that can be traced between the spaces and geographical imaginations here invoked. My concern is less with addressing their respective positions than with working with these tensions to explore troubled dreams of modernist urbanism. In particular, I am concerned with Le Corbusier's visions of urbanism promoted in the 1930s that underpin his perspectives on New York. These visions have occupied a central place within historical accounts of modernist urbanism and planning, being a by-word for rationalist enterprises seeking to remake the city in the name of universal, geometric and pure concepts of urban order. However, by returning to tensions with contemporaneous thinking, and specifically surrealism, I want to interrogate aspects of Le Corbusier's conceptualisation of urban order, in effect disturbing that which has so often been projected in pristine and soundly formed terms. This is part of a wider argument about the need for critical and multidisciplinary perspectives to address what Leonie Sandercock calls a "noir" side of modernist urban planning, and to bring together forces, figures and debates in ways that destabilise forms and open space for different imaginings of architecture and urbanism.[8]

Monsters in the city

In making his assessments of New York in 1935, Le Corbusier refers repeatedly to his vision of the Radiant City, published in book form that same year and first exhibited in Brussels in 1930. While this vision marked both a development and departure from his writings and urban planning projects from the early to mid-1920s, at its core remained demands to clean up, re-order, purify: themes that had famously run through his earlier schemes and sense of the "modern". Urban order is conceived of here as a task. It is a matter of design and action, a struggle against its "other", which is defined as chaos and disorder. It is an attempt to eradicate forms of under-determination and ambivalence. The focus is on what Michel de Certeau calls the "Concept-city", on the development of an urbanistic discourse concerned with the production of its own space, a regulated, structured and "proper" space that is rationally ordered and "pure".[9] Elements and functions are to be differentiated, classified and redistributed, and there is to be an expulsion of all that does not fit in with this ordering and that is now constructed as "waste". Practices of administration and elimination go hand in hand, as classification and ordering entail the repression of "pollutions" that would compromise the properness of the produced space.

Le Corbusier had in fact been confronting New York at a textual level for some years. He typically presented it as non-modern or not-yet modern, contrasting it with his alternative: the Cartesian city, harmonious and lyrical. When he finally comes face to face with New York in 1935 he is caught up in the power and energy of the scenes. He also despairs. Catastrophic, in his view, is the disorder of the city that is most clearly laid out when he flies overhead in an aeroplane. Against this he sets his own proposals. They are based on his assertion that the "true image of architecture" is *"a materially and spiritually superior putting in order"*, and that urban planning is inseparable from this architecture, involving a putting-in-order as "the social organiser par excellence".[10] In making his case about the disorder of New York, Le Corbusier retains a sense of detachment. He stands back or rises above the tumult in order to pass judgement. But what particularly interests me here are the moments when the detachment breaks down, when he becomes embroiled in the materials that he is seeking to distance and compose. There is a continual struggle between order and chaos in his account. New York, he writes, is a "titanic effort of organisation and discipline in the midst of chaos brought about by the speed of accelerated times". It is "a kind of snorting monster, bursting with health, sprawled out at ease".[11] The monstrous is a term that recurs in his account of his visit. Urban sprawl is denounced as a monstrous and disruptive growth, while the Manhattan skyscraper is depicted as a "man-eating monster", sucking the life out of neighbouring areas. Elsewhere the skyscraper is likened to "a man undergoing a mysterious disturbance of his organic life: the torso remains normal, but his legs become ten or twenty times too long".[12]

The rhetoric was part of Le Corbusier's wider use of organic and biological metaphors. It continued his earlier critiques of cities as "sick" and "diseased", and his claims that the unorganised growth of the city was causing its body to lose its true nature and degenerate. Notions of organic growth and generation had become especially important in Le Corbusier's work from the end of the 1920s as he reassessed his previous purist-machinic vision, and sought a new dialogical play and balance between the geometrical and the natural, and the machinic and the organic.[13] Such a play is apparent in his "ideal type" plans for the Radiant City, which have an openness and fluidity oriented on a heliothermic axis that allow both change and potentially indefinite growth, and also a formal basis on an articulation between a mechanical grid and a natural order. The natural order is suggested by an analogy with the human body, with the business and administration centre as the head, the cultural centre as the heart, the residential zones as the lungs, industry and warehouses as the legs and feet, and highways and railways as arteries.

One of the consequences of the use of organic concepts is that it enables Le Corbusier to naturalise his urban projects, to present them as being for the good of the whole. Urban problems are depicted in terms of a disturbance to the balance of the organism and planning schemes are then presented as forms of medicine or restorative surgery, aiming to "cure" the organism and restore the city's health. It is a means of depoliticisation whereby problems rooted in the social production of urban space are dissimulated to appear as ailments that require the judicious hand of the architect and planner to be resolved, with planners themselves being presented as "doctors of space". The language about monsters emerges out of these concerns. "Paris has become a monster crouching over an entire region", he writes in the *Radiant City*. It is a "monster of the most primitive sort: a protoplasm, a puddle". Buenos Aires, too, has become "gigantic, protoplasmic".[14] His fears about degeneration are made clear in his attack on the becoming-monstrous of Buenos Aires where he argues that the city was once organic, having a spirit of order meaning that it "*could be policed*", but it has become "perfectly amorphous, a primitive system of aggregation. It is no longer an organism, *it is no more than a protoplasm.*"[15]

The references to monsters are freighted with powerful associations and work in a variety of ways. They are connected with Le Corbusier's biological conceptions of the urban and his drive to create a well-structured city form. The notion of the protoplasm works here as a negative other to his interest in the "classical" body, from the analogy for the spatial form of the Radiant City to its use as an architectural measure. Underpinning Le Corbusier's appeals to such regulating devices are assumptions about ideal body types, which demand further critical scrutiny as influencing social constructions of the dis/abled body within architecture and urbanism.[16] What especially concerns me here, though, are how the invocations of the protoplasmic and becoming-monstrous work within spatial-social ordering. Of key significance is a concern with *formlessness*: the monstrous city arises out of a confrontation with that which supposedly defies definition, regulation and form. The use of the term monstrous, which is itself one of ambiguity and mixing according to its Greek etymology, and which has classically been depicted as involving the blurring of genres, stems from an urge to separate categories and to reject the unstructured and under-determined. The threatening coding of the protoplasmic relates to anxieties surrounding a failure to make clear definitions in the face of spatial disorder and the formless. As Jeffrey Jerome Cohen writes: "In the face of the monster, scientific inquiry and its ordered rationality collapse. The monstrous is a genus too large to be encapsulated in any conceptual system ... Full of rebuke to traditional methods of organising

knowledge and human experience, the geography of the monster is an imperilling expanse, and therefore always a contested cultural space".[17]

At the same time there is a fascination apparent with the body of the city and its excess. This is in keeping with the idea of the monster as a figure of contradictory signification, something that is suggested by the Greek root *teras/teratos*, which, as Rosi Braidotti notes, is simultaneously holy and hellish, evoking both horror and fascination.[18] Hence the way Le Corbusier's writings on cities reveal a revulsion to, as well as fascination with, interminglings, ambivalences, violations of boundaries; things that stagnate or rot, where decay presages an inversion of hierarchies; the mass, the swarm, the "primitive cell"; and undifferentiated matter or unchanneled flow that threatens to swamp, to sweep away, to bring about the dissolution of the individual. Hence, too, his obsession with establishing classifications, boundaries and hierarchies, and with zoning functions to ensure "non-contaminating" land uses.

Faced with the city's supposedly amorphous and inorganic mass, the task becomes how to construct an organism with a proper biological structure. "How then", Le Corbusier asks, "insert in this protoplasm a cardiac system (aorta, arteries, and arterioles) indispensable to the circulation and the organisation of a modern city?"[19] In relation to the "protoplasmic" city of Buenos Aires, he turns to these questions of circulation and flow: "must open the channels vital to urgent urbanisation: waterway, railway; must reshape its cellular condition".[20] Behind his vision of a healthily circulating space is a desire for wholeness, harmony and the regeneration of the body, both that of the city and of the human subject. If the human subject has been disturbed by the first machine age, so Le Corbusier claims, then the rationally planned era to follow will see its rebirth with "*the formation of a serene soul in a healthy body*".[21] His writings connect here with the wider discourse around a "return to man" that was being developed during the early 1930s, especially in French syndicalist journals with which Le Corbusier became associated.[22] Much could be said about the politically troubling aspects of this theme in the context of debates around eugenics and concepts of "biological man", as well as the authoritarian and oppressive side of Le Corbusier's own pathologising rhetoric and construction of biological "norms". In the rest of the chapter, however, I want to explore other sides of this endeavour through returning to contemporaneous activities of the surrealists.

Disrupting form/lessness

The urban dreams of Le Corbusier may appear antithetical to those being evoked around the same time by the surrealists. This is certainly the case with Breton's references to Cheval's Palais Idéal in his lecture in Prague, with which I began this chapter. Breton started to eulogise this now well-known palace after visiting it in 1931, and he and other surrealists were among the first to proclaim its wider artistic significance. Jacques Brunius shared the enthusiasm for its "feverish creations", and posited that Cheval had established "a monstrous system of imagined memories", with the palace itself being "a monument to the imagination".[23] Breton meanwhile included a photograph of himself standing at one of its entrances in his book *Les Vases communicants*, and praised the palace's creator a year later as "the undisputed master of mediumistic architecture and sculpture".[24] The result represented for Breton the passionate expression of an individual's dream, an example of creativity that had little to do with the protocols of formal artistic or architectural training. This of course connected with the surrealists' wider interest in the work of marginalised figures and those situated outside the institutionalised spaces of art.

In his lecture in Prague, Breton sets this interest in a "concrete irrationality" in architecture, as breaking through the field's limits, against a modernist conception: specifically, his target is the Pavillon Suisse of the Cité Universitaire in Paris, designed by Le Corbusier and constructed in the period 1930–32. The building, which has often been regarded as a prospective fragment of Le Corbusier's Radiant City, is described by Breton as one that "outwardly answers all the conditions of rationality and coldness that anyone could want in recent years". He further relates how, only the day before his talk, there had been news of a plan to decorate an "irrationally undulating" wall in the Pavilion with photographic enlargements from the fields of microbiology and micro-mineralogy, something that suggests to him the conclusion that: "the irrepressible human need, coming to light in our era as in no other, to extend what was long held to be the prerogative of poetry to other arts will soon get the better of certain routine resistances seeking to hide themselves behind the pretended demands that a building be useful".[25] Breton was far from being alone in his attitudes among the surrealists, with many other critical engagements with modernist architecture and urbanism emerging among those associated with the group that included Salvador Dalí's enthusiastic embracing of art nouveau's "delirious" and "extra-plastic" character, as cited by Breton in his lecture, and Tristan Tzara's arguments for an "interuterine" architecture.[26] Where the monstrous emerges in this context, it does so as a quite different force. It involves the undermining of

hierarchies and the transgression of norms, with surrealist teratology being concerned with what Elza Adamowicz calls "excentricity, working at the frontier of linguistic, pictorial and rhetorical spaces, at the limits of mental space rather than in the oppositional space traditionally occupied by the monster".[27]

Yet, if this indicates a clash of perspectives, Le Corbusier for his part has also been seen as employing surrealist elements in his work. These are especially apparent in his paintings with their evocative juxtapositions of natural objects and in his references to "objets à reaction poétique".[28] They are also suggested by the oneiric qualities of certain of his architectural promenades, and the extraordinary entertainment spaces and contraptions of the penthouse that he designed for Charles de Beistégui in Paris from 1930 to 1931. While Le Corbusier appears to have shown only sporadic interest in surrealist journals,[29] and rarely confronted the group's ideas and positions directly, he did nonetheless engage in direct polemics. Early in his career he criticised the surrealists' approach to the object, arguing that they had failed to acknowledge the dependence of their poetic flights and dreams upon real objects produced through conscious effort, objects with a *function*, and hence upon a *realism* that was a product of the machine age.[30] Later, in his account of his journey to the United States in 1935, he described surrealism as "a noble, elegant, artistic, funereal institution", before launching into a dense attack that demanded: "What liturgy is this? What refined, moving, spectral ceremony? What appeal to the past?"[31]

Beyond direct clashes, however, there are senses in which Le Corbusier's dreams of urban order remain entangled with, and haunted by, matters that are confronted explicitly by the surrealists. Interminglings, metamorphoses, the monstrous: themes that run through surrealist experiments also shadow Le Corbusier's dreams in different ways. This may be explored further by following to the side of surrealism that term that so troubles Le Corbusier, the *formless*. Here differentiation, purification and systems of ordering are refused, and the formless itself is valorised. The vertical that is central to Le Corbusier's urban projects, its lines a regulating principle, its mark that of a morally upright stance, is brought down through a process of horizontalisation. The sun inscribing its arc through the sky, the "sun our dictator" as Le Corbusier called it, an ennobling symbol of reason marking out the rhythm of the day, becomes also a "rotten sun", one linked to self-destruction and sacrifice, a blinding presence for those who stare at it, its two sides indicated by the myth of Icarus where it not only illuminates his flight as an elevated goal but also destroys his passage through melting the wax on his wings. In this line of thinking – which is associated especially with Georges Bataille, who himself had a tense and at times antagonistic relationship with Breton, and whose connection with Le Corbusier, especially in the

post-war period, is a matter of interesting discussion[32] – there is a vigorous repudiation of ideal schemes of ordering, one that embraces a materialism that resists the distinction between form and matter and its attendant hierarchy of things.

Bataille stresses that the word *informe* or "formless" is not only an adjective with a particular meaning but a term that performs a task: it declassifies, brings things down in the world. "What it designates has no rights in any sense and gets itself squashed everywhere, like a spider or earthworm", he writes. To affirm that the universe is formless "amounts to saying that the universe is something like a spider or spit".[33] His words bring us back to that which so horrified Le Corbusier – the "protoplasmic", the "puddle" – but in a way that, instead of demanding the institution of order, interrupts dreams of pure form and wholeness. The matter of which they speak is heterogeneous and refuses to be tamed or elevated through the use of concepts and categories. The concern with base matter is characterised by a mistrust of the conventions of visual experience and optical clarity that have long been linked to notions of form. It also heralds a return to the body. This is a body, however, that contrasts with Le Corbusier's ideal conceptions and contemporaneous discussions of a "new man", being open, with porous boundaries, and – after the image of man adopted as the symbol for the Acéphale secret society later established by Bataille – headless.[34] It was in the name of such an assault on the "common cause" between human and architectural orders that Bataille commended the work of modernist painters in challenging the elegance of the human figure and in tracing a path that "opens toward bestial monstrosity, as if there were no other way of escaping the architectural straitjacket".[35]

## Conclusions

Interruption is the note on which I want to conclude. Interruption, that is, of heroic narratives and geographical imaginings of modernist urbanism that would write out their monsters and downplay their contested and fraught formation. The specific challenge of thinking "Bataille with Le Corbusier" as twentieth-century contemporaries, especially for the latter's conception of the Open Hand in his project at Chandigarh, is explored by Nadir Lahiji elsewhere in this book.[36] The interrelationships between that pairing, and the pairing with which I began of Breton and Le Corbusier, invites further speculation. However, my concern to reconnect Le Corbusier's urban visions, which have played such a central role in mainstream histories of modernist urbanism, with the contemporaneous activities of the surrealists, which have

not, is part of an attempt to draw out further how such visions were struggled over, how they were forged through debate and opposition. The defence of the formless, for example, can here be seen as part of a wider tradition that includes a range of oppositions to formal purity, one that represents what Martin Jay identifies as "a subordinate tendency in aesthetic modernism, which challenged the apotheosis and purification of form".[37]

At the same time, such a move can serve to destabilise the lofty claims and ambitions of ideal urban plans. In my account the figure of the "monstrous" has emerged as being of particular significance in this regard. This is not only in relation to the entangled nature of Le Corbusier's confrontations with the modern city – in this chapter specifically New York – but also to the ways in which surrealist concerns continue to shadow his plans and his writings. Out of these encounters and confrontations, questions about the formation of modernist spaces return with particular force. Issues about the conceptualisation of order and chaos are shown to be in high tension and sites of active struggle. Whatever the supposed purity of the planned urban spaces, then, presented as they are through a rhetoric of establishing order and making a proper organism out of a chaotic mass or protoplasm, there is always the threat of disruptions from within. Monsters, writes Jeffrey Jerome Cohen, "can be pushed to the farthest margins of geography and discourse, hidden away at the edges of the world and in the forbidden recesses of our mind". But, he adds, "they always return".[38]

## Acknowledgements

I would like to thank those who discussed earlier versions of this chapter at conferences and seminars, especially Steve Pile and Jenny Robinson for inviting the initial paper in which they were tried out, and Elza Adamowicz and Peter Dunwoodie for facilitating an opportunity to develop it.

## Notes

1  A. Breton, "Surrealist situation of the object", in his *Manifestoes of Surrealism*, Ann Arbor: University of Michigan Press, 1972, pp. 255–78; citations from p. 255.

2  Ibid., p. 261.

3  Le Corbusier, "La ville radieuse", speech originally given on The Women's Radio Review on WEAF-NBC, 24 October 1935, from a transcript issued as a press release by The Museum of Modern Art, New York.

4  H. Brock, "Le Corbusier scans Gotham's towers", in *New York Times Magazine*, 3 November 1935, p. 10.

5  J. Klein, "French architect arrives with plans to rebuild city", in *New York Evening Post*, 23 October 1935.

6   Le Corbusier, *Quand les cathédrals étaient blanches: voyage au pays des timides*, Paris: Plon, 1937, translated by F. Hyslop; *As When the Cathedrals Were White: A Journey to the Country of Timid People*, New York: Reynal & Hitchcock, 1947, p. 40.

7   Le Corbusier, transcript of "La ville radieuse".

8   L. Sandercock, *Towards Cosmopolis: Planning for Multicultural Cities*, London: Wiley, 1998, pp. 34–37. The arguments and materials of this chapter are developed in my forthcoming book *Visions of the City* (Edinburgh: Edinburgh University Press, 2005).

9   M. de Certeau, *The Practice of Everyday Life* (trans. Steven Randall), Berkeley: University of California Press, 1984, pp. 94–95. The book was first published in France in 1974.

10  Le Corbusier, *When the Cathedrals Were White*, pp. xix, 210 (emphasis in the original).

11  Ibid., p. 111.

12  For a vivid account of Le Corbusier's attempts to "conquer" New York, see R. Koolhaas, *Delirious New York: A Retroactive Manifesto for Manhattan*, New York: The Monacelli Press, 1994.

13  See also D. Pinder, "Meanders", in S. Harrison, S. Pile and N. Thrift (eds) *Patterned Ground: Entanglements of Nature and Culture*, London: Reaktion, 2004, pp. 82–84.

14  Le Corbusier, *La Ville radieuse*, Boulogne-sur-Seine: Editions de l'Architecture d'Aujourd'hui, 1935, translated by P. Knight, E. Levieux and D. Coltman as *The Radiant City: Elements of a Doctrine of Urbanism to be Used as the Basis of our Machine-Age Civilization*, London: Faber and Faber, 1967, pp. 202, 221.

15  Le Corbusier, *Précisions sur un état présent de l'architecture et de l'urbanisme*, Paris: Crès et Cie, 1930, translated by E. Aujame as *Precisions on the Present State of Architecture and City Planning*, Cambridge, Mass.: MIT Press, 1991, pp. 210, 212 (emphases in the original).

16  Cf. R. Imrie, "The body, disability, and Le Corbusier's conception of the radiant environment", paper presented at the Annual Conference of the Royal Geographical Society with the Institute of British Geographers, University of Exeter, 8 January 1997.

17  J. Cohen, "Monster culture (seven theses)", in J. Cohen (ed.) *Monster Theory: Reading Culture*, Minneapolis: University of Minnesota Press, 1996, pp. 3–25; citation from p. 7.

18  R. Braidotti, "Signs of wonder and traces of doubt: on teratology and embodied differences", in N. Lykke and R. Braidotti (eds) *Between Monsters, Goddesses and Cyborgs: Feminist Confrontations with Science, Medicine and Cyberspace*, London and New Jersey: Zed Books, 1996, pp. 135–52.

19  Le Corbusier, *Precisions*, p. 212.

20  Le Corbusier, *The Radiant City*, p. 221.

21  Ibid., p. 143 (emphasis in the original).

22  These journals included *Plans*, *Préludes* and *L'Homme réel*; see M. McLeod, "Urbanism and Utopia: Le Corbusier from Regional Syndicalism to Vichy" (Unpublished Ph.D. dissertation, Princeton University, 1985), Chapter 3.

23  J. Brunius, "Palais idéal" (trans. J.M. Richards), in *The Architectural Review* LXXX (October 1936), pp. 147–50; citations from p. 150.

24  A. Breton, "Le message automatique", in *Minotaure* (1933), translated as "The automatic message", in his *What is Surrealism? Selected Writings* (ed. Franklin Rosemont), New York: Pathfinder, 1978, pp. 97–109; citation from p. 103. The photograph was published in A. Breton, *Les Vases communicants*, Paris: Cahiers Libres, 1932.

25  Breton, "Surrealist situation of the object", pp. 261–62.

26  See, for example, S. Dalí, "L'Âne pourri", *Le Surréalisme au service de la Révolution* 1, July 1930, pp. 9–12; and T. Tzara, "D'un certain automatisme du Goût", *Minotaure* 3–4, December 1933, p. 84.

27  E. Adamowicz, *Surrealist Collage in Text and Image: Dissecting the Exquisite Corpse*, Cambridge: Cambridge University Press, 1998, p. 96.

28  C. Green, "The architect as artist", in M. Raeburn and V. Wilson (eds) *Le Corbusier: Architect of the Century*, London: Arts Council of Great Britain, 1987, pp. 110–30.

29  Ibid., p. 125. Le Corbusier contributed one essay to a surrealist journal, his "Louis Soutter, L'inconnu de la soixante", *Minotaure* 9, October 1936.

30  Le Corbusier, *L'art décoratif d'aujourd'hui*, Paris: Editions Crès, 1925, translated by James L. Dunnett as *The Decorative Art of Today*, London: Architectural Press, 1987, pp. 187–88.

31  Le Corbusier, *When the Cathedrals Were White*, p. 147.

32  See N. Lahiji, "The gift of the Open Hand: Le Corbusier reading George Bataille's *La Part Maudite*", in *Journal of Architectural Education* 50.1, 1996, pp. 50–67. See also the revised version of this essay, N. Lahiji, ". . . The gift of time": Le Corbusier reading Bataille, Chapter 9 in this anthology.

33  G. Bataille, "Informe", *Documents* 1.7, December 1929, p. 382, translated as "Formless", in G. Bataille, *Visions of Excess: Selected Writings, 1927–1939* (ed. and trans. A. Stoekl with C. Lovitt and D. Leslie, Jr.), Minneapolis: University of Minnesota Press, 1985, p. 31.

34  "Man has escaped from his head just as the condemned man has escaped from his prison", writes Bataille in his text "The sacred conspiracy", which was published in the first issue of *Acéphale* (June 1936) and accompanied by a drawing of the symbol by André Masson; translated in *Visions of Excess*, pp. 179–181; quotation from p. 181. On Bataille's critique of ocularcentrism and return to the body, see the discussion in M. Jay, *Downcast Eyes: The Denigration of Vision in Twentieth Century French Thought*, Berkeley: University of California Press, 1993, pp. 211–62; and in his essay "Modernism and the retreat from form", in M. Jay, *Force Fields: Between Intellectual History and Cultural Critique*, London: Routledge, 1993, pp. 147–57.

35  G. Bataille, "Architecture", *Documents* 1.2 (May 1929), p. 117, translated by D. Faccini as "Architecture", *October* 60 (1992), pp. 25–26; quotation from p. 26.

36  See N. Lahiji, ". . . The gift of time", Chapter 9 in this anthology.

37  Jay, "Modernism and the retreat from form", p. 147.

38  Cohen, "Monster culture (seven theses)", p. 20.

Chapter 14

# Surrealism and the irrational embellishment of Paris

*Raymond Spiteri*

Materialistic historiography ... is based on a constructive principle. Thinking involves not only the flow of thoughts, but their arrest as well. Where thinking suddenly stops in a configuration pregnant with tensions, it gives that configuration a shock ... In this structure [the historical materialist] recognizes ... a revolutionary chance in the fight for the oppressed past.

Walter Benjamin, "Theses on the Philosophy of History"[1]

In March 1933 the French surrealists conducted an inquiry on "some possibilities for the irrational embellishment of a city." This inquiry was one of a series of experimental investigations into irrational knowledge conducted during February and March, in which participants were asked to comment on such objects as a clairvoyant's crystal ball, a piece of pink velvet cloth, a painting by Giorgio de Chirico, the year 409 – the date was chosen at random – and the irrational embellishment of a city. These investigations were more than an idle parlor game; despite their innocuous appearance, they employed collective endeavor to reinforce the *esprit de corps* within the surrealist group. Such collective games were an important facet of group activity among the surrealists: one need only recall the pivotal role played by

hypnotic trances and collective automatic writing sessions in the emergence of surrealism in the early 1920s.[2] It is evident the surrealists considered these experimental investigations significant, since they not only kept detailed records of individual sessions, but published these transcripts, with lengthy commentary, in the May 1933 issue of *Le Surréalisme au service de la révolution* (*LSASDLR*).[3]

The format of these investigations was quite straightforward. The participants would first choose an object or theme, then collectively draw up a list of questions; next, the participants would answer each question in turn, writing their response without premeditation or forethought. After each question the responses were read to the group, with a quick summation, before passing to the next question.[4] The game recalled the definition of surrealism in the *Manifesto of Surrealism* as "psychic automatism in its pure state," and its goal was to circumvent the interference of reason in the answers, thus allowing the unconscious free play in the formulation of answers.[5] In the inquiry on the irrational embellishment of a city each participant was asked: "Should one conserver, displace, modify, transform or suppress?" A list of thirty-one Parisian monuments followed, ranging from famous monuments like the Eiffel Tower and the Arc de Triomphe to the more obscure Lion of Belfort and Statue of Claude Chappe (Figure 14.1).

Paris had long represented a recurring theme in the writings and works of the surrealists – Louis Aragon included lengthy descriptions of an aging shopping arcade and an expedition to a Parisian park in *Paysan de Paris* (1926); similarly, André Breton included numerous references to locations like Les Halles, Tuileries Garden, Palais Royal, Porte Saint-Denis, Boulevard Bonne-Nouvelle and Tour Saint-Jacques in his trilogy of autobiographical narratives, *Nadja* (1928), *Les Vases communicants* (1932), and *L'Amour fou* (1937). Paris also featured prominently in the writings of Robert Desnos, Benjamin Péret and Philippe Soupault.[6] Clearly, one preoccupation of the surrealists was a poetics of place, particularly among the writers associated with the movement, and it is through this awareness of place that the Paris of the surrealists intersects with the monumental face of Paris. In this context the inquiry on "some possibilities for the irrational embellishment of a city" presents an opportunity to consider the role of public monuments in the iconography of surrealism. The surrealists exhibited a complex attitude towards these monuments, an attitude that oscillated between celebration and condemnation. On the one hand, they celebrated the imaginative possibilities certain monuments offered for the irrational embellishment of the city; on the other hand, they were critical of the way other monuments reinforced the political hegemony of the Third Republic. Indeed, the surrealists exhibited a keen awareness of the ideological function of monuments: the relation between

14.1

**M. Damé, *Statue of Claude Chappe* (1893), Boulevard Saint-Germain, 7th Arr., Paris; destroyed 1942**

aesthetic experience and politics, particularly the way public monuments were used to construct a representation of French history. The inquiry on the irrational embellishment of a city thus did more than playfully suggest improvements to the urban décor; it intervened in a political topography of Paris to contest the symbolic charge of certain monuments in urban fabric.

In what way does the inquiry on the irrational embellishment of a city func-
tion as a strategy of symbolic contention? To answer this question it will be
necessary to briefly review the history of urban decoration in Paris during the
nineteenth century. Maurice Agulhon has discussed the history of urban dec-
oration since the French Revolution of 1789 , contrasting the limited decor-
ative programs of *ancien régime*, based on the exceptional character of kings
and saints, to the more inclusive decorative programs of the democratic
Third Republic, based on merit rather than birth, that expressed the ideology
of liberal humanism – optimistic, progressive, pedagogical.[7] June Hargrove
builds on this account in "The Statues of Paris," her contribution to Pierre
Nora's *Les Lieux de mémoire*.[8] In keeping with the tenor of *Les Lieux de
mémoire*, Hargrove examines the role of public statues in the construction of
the symbolic identity of France, reading the vicissitudes of Parisian statues –
their commissioning, commemoration and destruction – as an index of the
fortunes of the French state from the *ancien régime* to the present. Accord-
ing to Hargrove, the art of commemoration reached its apogee during the
Third Republic (1870–1940). A number of factors contributed to this situation.
First, the Third Republic inherited a city that had undergone enormous urban
renewal: the plan conceived by Rambuteau and developed by Haussmann
had encircled the city with a ring of large boulevards, creating numerous new
squares and public spaces.[9] Unlike the monumental programs of earlier
regimes, which aimed for a harmony of design and ideological function
between statues and their settings, the Third Republic lacked the ideological
coherence to undertake a program of large-scale monumental decoration.
Indeed, the democratic republic required a less formal monumental program,
one that emerged from the civic initiative of independent committees rather
than state decree.[10]

One effect of this independent patronage was to encourage a
massive increase in the number of statues commissioned. Paris witnessed a
veritable invasion of statues and monuments, leading to the often heard
charge of "statuemania" – a term with strongly pathological connotations. In
the thirty years after 1880, more that 230 new public statues were installed
on the streets of Paris. These statues depicted prominent figures in the
fields of the arts, sciences and politics: there were sixty-seven works dedi-
cated to the letters, sixty-five dedicated to men of progress, fifty-six to
political figures, and forty-five to the arts.[11] The purpose of this commemor-
ation was twofold: it embodied not only the egalitarian attitudes of the
Enlightenment, the belief in merit over birth, but also the belief in the value
of education within democratic society.

The statuemania of the Third Republic differed from monumental
decorative programs of earlier regimes. It did not express the unified political

program of the absolutist state, but rather an arena of shifting political antagonisms. Although civic committees commissioned individual statues, this did not prevent projects becoming the focus of political agitation. Certain statues came to symbolize definite political beliefs. For example, the statue of Etienne Dolet in the Place Maubert became a symbol of religious intolerance, and as such a rallying point for anticlericalism and "free thought." Dolet, who had been executed for writing "prohibited and damned" books in 1546, became a martyr for liberal humanism, an idea conveyed by the statue's inscription: "Victim of religious intolerance and the Royalty." Similarly, the statue of the Chevalier de La Barre erected opposite Sacré-Cœur Basilica in Montmartre was a symbol of religious intolerance: La Barre had been burnt at the stake in 1766 for failing to salute a religious procession. The statue was commissioned in the context of the divisive political debate about the separation of Church and State, its anticlerical symbolism heightened by being placed directly in front of Sacré-Cœur's façade.[12] Not surprisingly, the statue of the Chevalier de la Barre would find particular favor among the surrealists in their investigation on the irrational embellishment of the city.

Daniel Sherman, writing on the commemoration of military fatalities after the First World War, has argued that monuments played an important role in the process of commemoration by giving visual form to the abstract ideas of sacrifice and nationhood. Significantly, the war memorials were not unitary in meaning, but possessed a polyvalence that enabled them to represent the symbolic content of different and sometimes antagonistic interests, such as the experiences of combatants and non-combatants. Through the process of monument building and commemoration these contested meanings were reconciled in the collective memory of the nation.[13] The important point here is that the function of the public monument changes over time. This enables us to understand how the debates that often surrounded the commissioning of monuments could subside as the monument, now part of the city, become woven into the fabric of memory.

In this context the statuemania of the Third Republic represents a point of convergence between history, memory and contemporary experience that gave visual form to the political hegemony of the nascent democracy. The important feature to note here is that this hegemony was not singular but contested, encompassing the ideological divisions of antagonistic social factions – the division between political left and right, clericalism and anticlericalism, republicans and nationalists. In giving expression to these antagonisms, monuments acted to reinforce the fragile political hegemony, since it allowed different social factions to articulate political differences on a symbolic level; it was part of the process of constructing the democratic *polis*, of giving voice to particular interests and incorporating them into the public sphere.

This is not to say, however, that every political tendency could erect a statue. One of the most contested historical legacies was that of the French Revolution, particularly its more extreme manifestations during the Reign of Terror. This is evident in the fate of the statue of Marat, which was shuttled from one location to another; while the extremism of Robespierre was clearly beyond the pale of commemoration. Nor were there plans to commemorate the anarcho-socialism of J.-J. Proudhon (d. 1865) or the communism of Louis Blanqui.[14] Indeed, the weakness of the radical left in the aftermath of the Paris Commune meant that there were no initiatives to commemorate heroes of the revolutionary left – although it could be argued that certain tendencies sought to commemorate the revolutionary tradition more through propaganda of the deed.

The other important role of statuemania was as a representation of historical time. Whereas prior to the Third Republic historical time was closely identified with the major events of the state – the deeds of the monarch and his representatives, great military victories and alliances, etc. – the democracy of the Third Republic was unable to call on such a unified historical narrative.[15] In this context statuemania can be seen as an attempt to fashion a sense of public history appropriate to the new regime through the commemoration of great achievements in the arts, sciences, industry and politics. Public monuments were one way that Paris was constructed as a palimpsest of historical representations, in which the *ancien régime* gave way to the democratic Republic, technological progress improved the welfare of humanity, and the arts and letters improved the moral well-being of the people. Moreover, by giving spectacular form to this process of commemoration, statuemania rapidly constructed a historical pantheon that could be assimilated within the collective memory of the nation. It acted as a salve to the traumatic history of the Third Republic – its origins in humiliating defeat during the Franco-Prussian War, the violent suppression of the Paris Commune, the challenge of General Boulanger, the Dreyfus Affair, the Panama scandal, and the separation of Church and State – while simultaneously articulating differences within the democratic *polis*.[16] Public monuments were one way to give striking visual form to the political aspirations of the democratic Republic, a role that was later eclipsed by the emergence of mass media during the twentieth century.

I now want to look more closely at the experimental investigations into irrational knowledge. The result of five inquiries held during 5 February and 12 March were published in *LSASDLR*. Broadly speaking, they were part of the surrealists' interest in the creation and significance of symbolic objects first documented by Salvador Dalí, Alberto Giacometti and André Breton in

the December 1931 issue of *LSASDLR*.[17] However, as M. Stone-Richards has noted, the impetus behind the codification of the surrealist object was the crisis engendered in the group by the Aragon affair – Aragon's recent defection from surrealism to the Parti communiste français (PCF); thus, for Stone-Richards, the rationale was "to formulate a plan of action which would involve the whole group in common activity" that "would have for con-sequence the emphasis on the affective dimensions of collective experience."[18] The key point here is that the surrealist object was part of a collective *experience* that affirmed the identity of the group qua *group*. This dimension of collective identity is also evident in the investigations on irra-tional knowledge, which are contemporary with another period of crisis in the surrealist movement related to their membership of the communist domi-nated Association des Artistes et Écrivains Révolutionnaire (AEAR).

The AEAR had been established in January 1932 under the control of the PCF as a forum in which to bring together left-wing intellectuals. It was modeled on a similar organization that the surrealists had attempted to establish in 1931, an initiative that had been scuttled through hostility from the PCF. This hostility continued in the new organization, and it was only after ten months of lobbying, and a policy change in Moscow, that the sur-realists were admitted into the AEAR in October 1932, and Breton appointed to the board of directors. Despite this apparent thaw in relations, the surreal-ists still felt frustrated within the organization.[19] Although the surrealists recognized a revolutionary possibility in communism, the legacy of the Russian Revolution did not blind them to the totalitarian nature of Stalin's regime – a tendency already revealed through the Aragon Affair. The experience of freedom actualized through creative endeavor and embodied in surrealism was ultimately incommensurable with Stalinism, and this concern with the radical dimension of freedom would not only distance the surrealists from Stalinism but lead to their rapprochement with Trotsky in the late-1930s (and anarchist groups during the 1950s). In this context the investigations into irrational knowledge acted to reinforce the collective purpose of the sur-realist group at a time when political engagement with the AEAR threatened to dilute its communal identity and purpose.

There is also a definite movement in the five inquiries published in *LSASDLR*: only the first two were based on irrational knowledge of actual physical objects (a clairvoyant's crystal ball and a piece of pink velvet); the third was based on a painting by Giorgio de Chirico, *The Enigma of Day*, while the fourth and fifth investigations addressed the dimensions of time (the year 409) and space (the irrational embellishment of a city). In other words, there is a progressive enlargement of the investigation from the irra-tional knowledge of specific objects to the irrational embellishment of urban

spaces; that is, a movement from the private to the public, indeed political, realm.[20] The experimental investigations thus provide evidence of an effort among the surrealists to affirm their collective identity as a group through the imagined reconfiguration of the symbolic fabric of the city. Whereas the statuemania of the Third Republic gave spectacular form to the contested political hegemony of the parliamentary democracy, the surrealists attempted to develop a mode of symbolic contention that not only subverted the political imaginary of the Third Republic, but created through this act of subversion an opening for the spontaneous appearance of a new political space that would be an alternative to both the democratic Republic and the Stalinism of the PCF.

At this point it is useful to distinguish between the politics of surrealism and that of the French state. Here Claude Lefort's distinction between "politics" and "the political" is useful.[21] According to Lefort, the *polis* is constituted through the repression of "the political" to create the institutional space of "politics" – in the case of the Third Republic, the system of parliamentary democracy. In so far as statuemania expressed the political hegemony of the Third Republic, it sought to articulate political antagonisms in the form of public symbolic discourses and rituals, and thus pacify the transgressive "political" character of revolutionary action. Surrealism, however, sought to constitute a new political space that would open up the democratic *polis* to the revolutionary political possibilities repressed in the constitution of the Third Republic.[22] If the surrealists were to intervene in this space, it would be through a strategy of symbolic disruption or transgression – strategies already developed through the theory of the surrealist image and technique of collage.[23] Their strategy was not to call upon an alternative or repressed history but to articulate a moment of political possibility that had been foreclosed in political discourse during the Third Republic.[24]

The inquiry addressed thirty-one monuments and was divided almost evenly between architectural monuments and figurative statues; of the fifteen statues included, only two dated from before the Third Republic (the statues of Henri IV and Louis XIV). The legacy of the *ancien régime* and Napoleonic Empire was represented through monuments such as Notre-Dame, the Invalides, Arc de Triomphe, Vendôme Column and Palais de Justice; but even here, many of these monuments continued to figure in the political imaginary of the Third Republic. For instance, the Arc de Triomphe, which housed the Tomb of the Unknown Soldier since 1920, was the center of military commemoration after the Great War, while the Palais de Justice was the heart of the French legal system.

The geographic distribution of the monuments was focused on central Paris, with the majority of monuments located in the first and eighth

arrondissements. Twenty-two monuments were located on the Right Bank of the Seine, four on the Ile de la Cité, while only five were located on the Left Bank. Similarly, the bulk of the monuments were located in western or central Paris. Indeed, at first sight the selection of monuments reflect a concern with sites that not only commemorated the official history of France but also were still used in official ceremonies of state. Monuments that commemorated heroes of the left were almost totally absent: apart from Camille Desmoulins, no heroes of the 1789 Revolution like Danton or Marat were included; also absent were sites like the Bastille or Column of 14 July, as well as sites related to the subsequent revolutions, such as the Mur des Fédérés at Père Lachaise (where the Communards were executed in 1871). Nor were the Enlightenment precursors of the Revolution such as Diderot, Voltaire or Rousseau commemorated. In fact, apart from a small number of idiosyncratic choices, the vast majority of the monuments selected for the inquiry would be comfortable in an official tour of Paris.

Indeed, it is unlikely that the monuments chosen for the inquiry reflect a conscious political program. It seems more plausible that the choice was governed by more immediate emotional considerations, either feelings of disgust (Arc de Triomphe, Palais de Justice) or favor (Chevalier de la Barre, Tour Saint-Jacques, Chappe). Negative feelings towards the idea represented in a monument appeared a more powerful motive for selection than positive feelings: it was sufficient to hate what a monument represented for it to be included, whereas monuments that represented less detestable figures also had to possess a peculiarity that invited an imaginative reconfiguration of the monument. This partially explains why certain statues and monuments were excluded, particularly those figures towards whom the surrealists would have felt a degree of sympathy.[25]

Given this context, what sense can we make of the inquiry on some possibilities for the irrational embellishment of a city. Seven surrealists participated in the inquiry: André Breton, Paul Éluard, Arthur Harfaux, Maurice Henry, Benjamin Péret, Tristan Tzara and Georges Wenstein. As noted in Éluard's commentary, certain responses were "clearly dictated by disgust or hate." This is evident in the responses to the Arc de Triomphe, which as the Tomb of the Unknown Soldier became a bellicose monument to militarism after the First World War. Of the four responses given, all suggested its destruction or replacement: Breton wanted to "blow it up after burying it in a mountain of manure," while Éluard wanted to "lay it on its side and transform it into the most beautiful public urinal in France." The Palais de Justice, the central law court and heart of the French legal system, was to suffer a similar fate. All three respondents wanted to destroy it, with Breton wanting to transform the

site into a "magnificent graffiti to be viewed from an airplane," while Éluard and Péret both took advantage of the Ile de la Cité's location in the center of the River Seine to install a swimming pool on the site. The statues of Joan of Arc and Georges Clémenceau were also subjected to mistreatment. Although Joan of Arc had initially been seen as a figure that symbolized national unity after the French defeat in the Franco-Prussian War, with the rise of the nationalistic right in the wake of the Dreyfus affair, she increasingly was celebrated as the figurehead of the extreme right. The surrealists' responses to Frémiet's gilded-bronze equestrian statue of the armor-clad patriot ranged from the suggestion that it be sold by auction (Harfaux), replacing the horse with a pig (Henry), the horse trampling the figure underfoot (Wenstein) to Éluard's suggestion, strongly reminiscent of Dalí, "to place a gilded-bronze turd on her head and a crudely sculpted phallus in her mouth." The recently deceased Clémenceau, who as President led France to victory at the end of the First World War, and whose statue had only been installed on the Champs Élysees the previous year, was victim of the surrealists' antimilitarism; the statue was to be thrown in the rubbish bin (Éluard), camouflaged like a canon (Harfaux), replaced by a gold public urinals (Péret), or surrounded by "thousands of bronze sheep, and one made of camembert" (Tzara).

Other monuments benefited from their "symbolic form." Here the surrealists capitalized on the phallic symbolism of monuments such as the ancient Egyptian obelisk from Luxor in the Place de la Concorde or the Vendôme Column. Breton supplemented these phallic structures with female counterparts: he suggested moving the obelisk to the entrance of the La Villette abattoir when the "immense gloved hand of a woman would hold it," and transforming the Vendôme Column into a "factory chimney being climbed by a nude woman."[26] Éluard proposed inserting the obelisk into the spire of Sainte-Chapelle, while Tzara wanted to crown it with a steel feather of the same height. Harfaux wanted to substitute a flexible column that responded to the wind for the rigid Vendôme Column, while Éluard capitalized on the history of the Paris Commune to restage the ceremony of 1871, during which the Vendôme Column was toppled.

Another monument to benefit from its symbolic form was Auguste Bartholdi's *Defense of Paris in 1870*, which commemorated Léon Gambetta's escape from a besieged Paris in a balloon during the Franco-Prussian War (Figure 14.2). In this case the balloon's spherical form suggested a testicle which was then embellished with additional elements: Harfaux suggested transforming the monument into "an enormous sex, the balloon forming one testicle and the phallus being horizontal," surrounded by a tall grill fence. Breton's response evoked the image of copulating genitals, suggesting the addition of a "twin balloon, slightly flattening the first, and furs [*poils*]."[27]

**14.2**
**Auguste Bartholdi,**
*Defense of Paris in*
*1870* (*c*.1905),
**Porte des Ternes,**
**8th Arr., Paris;**
**destroyed 1942**

*1150    PARIS. — Monument élevé à la Mémoire des Aéronautes*
*morts pendant le Siège de Paris, par Bartholdi (sculpteur-architecte)*

Breton's responses frequently played on the associations of the monuments. For instance, he wanted to replace Sainte-Chapelle with a "rainbow" cocktail of the same height as the original building, a response clearly suggested by Sainte-Chapelle's Gothic stained-glass windows. In another expression of anticlericalism, he suggested replacing the towers of Notre-Dame with an "immense oil and vinegar cruet, one bottle filled with blood, the other with sperm," while the actual cathedral would become a

"school for the sexual education of virgins." In this case the shape of the façade suggested the cruet, the blood and sperm recalled the use of wine and bread in the ritual of the Eucharist, while sexual education of virgins was related to the saint to whom the cathedral was dedicated, the Virgin Mary.

A monument that no longer possessed a practical purpose or charged symbolic meaning could become the object of fanciful embellishment. The Tour Saint-Jacques, for instance, elicited six responses. Péret suggested moving it to the center of Paris, where "beautiful female guards dressed in shifts" would watch over it, while Henry wanted to substitute it for the obelisk in the Place de la Concorde; Wenstein and Breton wanted to demolish the surrounding houses, with Breton also prohibiting all access under penalty of death for one hundred years; Éluard and Tzara suggested less aggressive modifications, the former simply wanting to curve the tower, while Tzara wanted to replace it in rubber.

The slavish realism of some monuments invited imaginative embellishment. The statue of Claude Chappe on the Boulevard Saint-Germain, which commemorated the inventor of a semaphor system that prefigured the telegraph, was to have its realism enhanced by being painted in natural colors (Tzara and Henry), and become a scaffold for the display of meat ham and sausages (Figure 14.1).

Perhaps one of the most interesting responses relates to the statue of Camille Desmoulins in the Palais Royal (Figure 14.3). Desmoulins had participated in the French Revolution, and this statue commemorated the impromptu speech he gave at the Palais Royal after the arrest on Necier in June 1789. Yet the surrealists responded less to his role in the Revolution than to the absurd tension between realism and dramatic immediacy in the statue. Indeed, the surrealists sought to heighten the incongruous absurdity of the statue: Éluard suggested installing the statue as a ticket machine in a métro station; Henry wanted to place one foot in a jar of current jam, and place a can of sardines in his hand; Péret wanted to transplant the statue to the Place de l'Opéra where Desmoulins would squeak his shoes on a rickety footstool; Tzara wanted to supplement the statue with bedroom furniture placed on another, larger pedestal; while Wenstein wanted Desmoulins shown in the act of performing his morning ablutions, holding a teeth-glass in one hand. These responses seem puzzling until one looks at a reproduction of the statue (sadly, no longer extant), in which the sculptor depicted Desmoulins in a moment of great agitation, arms outstretched, next to an overturned chair. Although the statue was meant to commemorate Desmoulins's speech at the Palais Royal, its pose recalls less a rousing oration than the contortions of a hysteric, which no doubt accounts for the statue's attraction for the surrealists.

14.3
**Eugène Jean Boverie,** *Statue of Camille Desmoulins* **(1905), Jardin du Palais-Royal, 1st Arr., Paris; destroyed 1942**

The final point to consider is the relation between the irrational embellishment of the city of the representations of history. Walter Benjamin was one of the first critics to acknowledge the revolutionary dimension of surrealism. In his 1929 essay, "Surrealism: Last Snapshot of the European Intelligentsia," he discussed the way surrealist "profane illumination" intervened

in the circulation of images in modern society, opening an "image-space" (*bildraum*) in which body and image shared the same space.[28] As Benjamin's work on the Arcades Project progressed during the 1930s, his conceptual frame shifted from a spatial to temporal register, from image-space to now-time (*Jetztzeit*). In the "Theses on the Philosophy of History," for instance, he argued that the Revolution required a break with the historicism of bourgeois history to redeem the past: "History is the subject of a structure whose site is not homogeneous, empty time, but time filled by the presence of the now [*Jetztzeit*]."[29] Whereas historicism considered the past as homogeneous, empty time that could be filled with appropriate content – a triumphal narrative of progress, for instance. Benjamin recognized that a revolutionary history is one that not only arrests the flow of time but one that flashes up in a moment of crisis. The task of the historian was "to seize hold of a memory as it flashes up at a moment of danger."[30]

Could the surrealists' inquiry on some possibilities for the irrational embellishment of a city be considered an analogical strategy, an attempt to effect a radical break with the historicism of the Third Republic through a leap into the present? Although the surrealists lacked an explicit theory of revolution comparable to that of Benjamin, the surrealist image had provided Benjamin with a prototype for the "dialectical image." Here due weight must be given to statues and monuments as *lieux de mémoire*, as sites of remembrance – a tendency explicitly embodied in the statuemania of the Third Republic. The inquiry on the irrational embellishment of the city opened an abrupt rupture with the historicism of the Third Republic, rejecting the sense of historical time that the statuemania of the Third Republic was designed to summons through acts of symbolic desecration. Indeed, surrealism's attitude to public monuments was similar to its attitude to historical time: the goal of history was not to recover the past as an object of nostalgia, but to remake the past in the present. The aim of this operation was to disclose the revolutionary potential of the past: to blast public monument out of historical time – the time of the repetition, of aborted revolutions – and open the possibility of revolutionary political change.

Here we must give due weight to the intractable context in which the surrealists worked. The surrealists' efforts to establish some kind of rapprochement with groups on the radical left, notably the PCF, had only resulted in frustration and disappointment, and indeed the revolutionary tradition increasingly appeared foreclosed to the radical experience of freedom – compromised by social democracy, menaced by the totalitarianism of Hitler and Stalin. However, the surrealists did not retreat in the face of failure, but reasserted the first principles of the movement: the spontaneity of poetic thought in the context of group experience. The inquiry on some possibilities

for the irrational embellishment of a city not only transformed public monuments into surrealist images, blasting these monuments out of the continuum of history, but, in a prefiguration of situationist *détournement*, it also reconfigured them as a premonition of revolutionary time that would leave the historicism of the Third Republic in ruins. Although the surrealists never managed to bridge the gap between "politics" and "the political" – that is, between the specific institutional forms of political organization in society and the movement that constitutes the social space of a particular society – surrealism did nonetheless represent a manifestation of the political. As such, surrealist endeavor acted to question the political hegemony of the Third Republic. The political significance of the inquiry on some possibility for the irrational embellishment of a city was thus twofold: it not only attempted to reconfigure the relation between specific monuments and the representation of history but it thus enlarged the compass of surrealist endeavor to establish an articulation between other, more conventional types of creative endeavor (painting or writing, for instance) and the irrational embellishment of Paris.

However, I shall leave the last word to Paul Éluard, who noted in his commentary to the investigation on some possibilities for the irrational embellishment of a city:

> For too long cities have suffered from the horror of emptiness. To combat agoraphobia their inhabitants have erected monuments and statues everywhere, without any consideration of their interaction with the actual, everyday life of men. The monuments are ... stupid, useless or dedicated to the most infamous superstitions, to the worst desires. Apart from the rare exception, their ugliness irritates, cretinizes, and disfigures those who contemplate them. The statues, almost always of despicable individuals, are placed on pedestals, which elevate them above any possibility of intervention in human affairs. They should be overturned.
>
> Wishing only the best, we have attempted to embellish slightly, physically and morally, the physiognomy of Paris, on which so many corpses have left their mark ... Let us welcome the excellent transformation thus preformed. Some could be, without any false modesty, given as examples to well-intentioned architects and sculptors. For them the smallest city in the world would become a perpetual construction site.[31]

## Notes

1 Epigraph from W. Benjamin, "Theses on the Philosophy of History," in *Illuminations: Essays and Reflections* (ed. H. Arendt, trans. H. Zohn), New York: Schocken, 1969, pp. 262–63. A version of this paper was presented as a guest lecture organized by the Department of History of the Australian National University in May 1999. I would like to thank Christopher Forth for inviting me to speak at ANU. I would also like to thank Don LaCoss for his comments on an earlier draft of this paper, and Elena Filipovic for conduction image research in Paris.

2 On automatism see J. Chénieux-Gendron, *Surrealism* (trans. V. Folkenflik), New York: Columbia University Press, 1990, pp. 47–60; on the role of games see E. Garrigues (ed.) *Archives du surréalisme*, vol. 5, *Les jeux surréalistes*, Paris: Gallimard, 1995; for a more lighthearted account see A. Brotchie, *A Book of Surrealist Games*, Boston and London: Shambhala Redstone, 1995.

3 *LSASDLR*, no. 6 (15 May 1933), pp. 10–24.

4 According to Arthur Harfaux and Maurice Henry, the method was as follows: "an object – preferably simple, not too fabricated – was chosen and placed on the table. It generally presented an evidently poetic enough character (sea sponge, a piece of pink velvet). A list of questions was established in common, a list which was then used to question the experience of other objects. The participants wrote their responses to each question, which were then read out, with summary comparisons, before passing to the next question." A. Harfaux and M. Henry, "A propos de l'expérience portant sur la connaissance irrationnelle des objets," in *LSASDLR*, no. 6 (15 May 1933), p. 23.

5 A. Breton, *Manifestoes of Surrealism* (trans. R. Seaver and H. Lane), Ann Arbor: University of Michigan Press, 1969, p. 26.

6 For a discussion of the image of Paris in surrealist poems and narratives, see M. C. Bancquart, *Paris des Surréalistes*, Paris: Seghers, 1972.

7 M. Agulhon, "La 'statuomanie' et l'histoire," in *Ethnologie française*, vol. 8 (1978), pp. 145–72.

8 J. Hargrove, "Les statues de Paris," in P. Nora (ed.) *Les Lieux de mémoire*, Paris: Gallimard, 1984–92, vol. 2:3, pp. 243–82.

9 On Haussmannization, see M. Carmona, *Haussmann: His Life and Times, and the Making of Modern Paris* (trans. P. Camiller), Chicago: I. R. Dee, 2002; D. Olsen, *The City as a Work of Art: London, Paris, Vienna*, New Haven: Yale University Press, 1986.

10 Hargrove discusses the process of monument building in J. Hargrove, *The Statues of Paris: An Open Air Pantheon*, New York: Vendome Press, 1990. This book offers a more developed account of the argument presented in her contribution to *Les Lieux de mémoire*.

11 These figures are based on the research of J. Lanfranchi, "Les Statues de Paris," unpublished thesis, Paris I, 1979, cited in Hargrove, "Les Statues de Paris," p. 256.

12 Hargrove discusses both statues in *The Statues of Paris*, pp. 140–42. Also see N. McWilliam, "Monuments, Martyrdom and the Politics of Religion in the French Third Republic," in *Art Bulletin*, vol. 77, no. 2, June 1995, pp. 186–206. Also see Breton's description of the Statue of Etienne Dolet in A. Breton, *Nadja* (trans. R. Howard), New York: Grove, 1962, p. 24.

13 D. Sherman, *The Construction of Memory in Interwar France*, Chicago: University of Chicago Press, 1999.

14 A statue did, however, commemorate the utopian socialist Charles Fourier on the Boulevard Clichy in the 9th arrondissement, commissioned by the Phalanstery he founded in 1899. See Hargrove, *Statues of Paris*, p. 137. Fourier would become a significant figure for surrealism during the 1940s.

15 On the construction of history during the Third Republic, see the illuminating discussion of Ernst Lavisse in P. Nora, "Lavisse, The Nation's Teacher," in P. Nora and L. Kritzman (eds) *Realms of Memory: The Construction of the French Past*, vol. 2, *Traditions* (trans. Arthur Goldhammer), New York: Columbia University Press, 1997, pp. 151–84.

16 Indeed, one of the strengths of the Third Republic was its ability to incorporate antagonistic political groups, often hostile to the idea of the Republic, into the social space. The instability of the ruling parties often obscures the more fundamental strength of the regime and its ability to defuse challenges to its legitimacy.

17 S. Dalí, "Objets surréalistes," in *LSASDLR*, no. 3 (December 1931), pp. 16–17; A. Giacometti, "Objets mobiles et muets," in *LSASDLR*, pp. 18–19; A. Breton, "L'objet fantôme," in *LSASDLR*, pp. 20–22.

18 M. Stone-Richards, "Failure and Community: Preliminary Questions on the Political in the Culture of Surrealism," in R. Spiteri and D. LaCoss (eds) *Surrealism, Politics and Culture*, Aldershot: Ashgate, 2003, p. 312. I am indebted to Stone-Richard's discussion of the role of collective endeavor in the formation of the surrealist group.

19 M. Polizzitti, *Revolution of the Mind: The Life of André Breton*, London: Bloomsbury, 1996, pp. 388–89.

20 It is worth noting in passing that de Chirico's imagery often framed the way the surrealists perceived Paris, and indeed *The Enigma of Day* was a crucial document in this context. On this point see my "Surrealism and the Political Physiognomy of the Marvellous," in Spiteri and LaCoss, *Surrealism, Politics and Culture*, pp. 52–72.

21 C. Lefort, "The Question of Democracy," in *Democracy and Political Theory* (trans. D. Macey), Minneapolis: University of Minnesota Press, 1988, pp. 9–20.

22 For a discussion of the relevance of Lefort's work to an understanding of surrealism, see "Revolution by Night: Surrealism, Politics and Culture," in Spiteri and LaCoss, *Surrealism, Politics and Culture*, pp. 1–17.

23 On the image, see Breton, *Manifestoes*, pp. 37–38; Chénieux-Gendron, *Surrealism*, pp. 60–70.

24 One question often posed in relation to surrealism is the gendered nature of its representations. Although other inquiries on irrational knowledge included female participants, all the participants in the inquiry on the irrational embellishment of a city were male. Thus the responses tend to express heterosexual male desire.

25 Another factor that may have influenced the selection of subjects was that the ideological divisions of the Third Republic already overdetermined the significance of many monuments. The commissioning and placement of statues in Paris was influenced by the division of power between the French State and the City of Paris, so that the municipal government, which was more radical than the national government, repeatedly came into conflict with the State, and sought to commemorate figures who resisted central government like Etienne Marcel, whose statue was erected outside the Hôtel de Ville in 1888 as a symbol of the city's autonomy. On this point, see Hargrove, *Statues of Paris*, p. 106. Although important for understanding the history of the Third Republic, these debates were largely irrelevant to the surrealists, for whom politics assumed a far more radical cast. The only issue upon which surrealist and Republican beliefs coincided was anticlericalism, but even here the surrealist program went further than debates over the separation of Church and State.

26 Breton's strategy here deserves comment: in supplementing phallic monuments with female figures he was not only foregrounding the unconscious symbolism already implicit in the monuments but inscribing it in an image that emancipated desire from the repressive symbolic structures of bourgeois society.

27 There are parallels between the transformation of monuments and the iconography of surrealism: for instance, Harfaux's response to the Defense of Paris in 1870 recalled

Giacometti's sculptures, while Breton's response to the Vendôme Column recalled de Chirico's fondness for factory chimneys.

28  W. Benjamin, "Surrealism: The Last Snapshot of the European Intelligentsia," in *One Way Street and Other Writings* (trans. E. Jephcott and K. Shorter), London: Verso, 1985, p. 239.

29  Benjamin, "Theses," p. 261.

30  Benjamin, "Theses," p. 255.

31  P. Éluard, "Remarques," in *LSASDLR*, no. 6 (15 May 1933), pp. 22–23.

Chapter 15

# Re-enchanting the city

## The utopian practices of the Paris group of the surrealist movement

*Jill Fenton*

Utopia is the magic lamp of those who refuse to leave them-
selves crushed by the night.[1]

René-Guy Doumayrou, *André Breton et l'art magique à
Saint-Cirq-la-Popie*

The architect and surrealist René-Guy Doumayrou cherished an incredible
fantasy of houses of pleasure – 'bedrooms of the delicious'[2] with phallic
images within architectural and decorative designs, effectively symbolist
architecture. Inspired by Sade, he imagined creating a cinema floating
between two volcanic springs in the lake Pavin, and 'the living room at the
bottom of the lake' modelled on Rimbaud's *Une Saison en enfer*[3] – gardens
of the marvellous within a future city that Doumayrou, in refusing to be
crushed by the night, imagined as functioning for desire in order to liberate
the individual. Both Doumayrou and the architect Bernard Roger entered the
surrealist movement in Paris in 1950 and, in their devotion to Fourier's pha-
lanstery, they joined Breton's quest to find the surrealist 'place' whether in
the design of the dreamlike Ideal Palace of the postman Cheval or a property
in the environs of Paris that Breton fantasized renting. Such property would

be composed of thirty rooms with long sombre corridors, hectares of wooded ground, streams, ponds, an underground for entering and leaving without being seen, and accommodation for young girls, mediums and sorcerers. Perhaps inspired by an earlier surrealist game in which players were asked whether they would conserve, displace, modify, transform, or suppress certain aspects of the city,[4] Bernard Roger presented at the Paris Exhibition E.R.O.S., between 1959 and 1960, an architectural project to rehabilitate into a palace of love a disaffected Notre Dame de Paris. Churches and cathedrals have no clerical value to the surrealists, and the exhibition E.R.O.S. illustrated this – not only with Roger's fantastic project but also in exhibiting the paintings of Clovis Trouille in which Eros replaces images of religion. In the same spirit, over forty years later in the café la Tour St Jacques in rue Pernelle, members of the Paris group of the surrealist movement plot on a large map of Paris places they would like to transform or re-enchant in a poetic sense. Irrational embellishment and surrealist subversion of state and religious institutions are evident principles in their play and, in addition, a distinct critique of architects whom surrealists suggest lack imagination and whose creations on the map they propose to demolish and transform (Figure 15.1). Like the Situationist Constant's *New Babylon*, the surrealist perspective and practice discussed in this chapter does not constitute a formal plan or blueprint to be realized in the future, nor a harmonious vision of architecture and space, but desire for a different and better future that seeks to disturb, displace assumptions and to open up ideas on alternative modes of living.

The Paris surrealist movement has continued over four separate historical periods, the most recent – and in spite of a split in 1969 that almost ended the movement – since 1970 under the auspices of Vincent Bounoure. While there are some surrealists who have opted to remain outside of the movement since 1969, there are others, for example Michel Zimbacca, Aurélien Dauguet and Jean Benoît, who frequently attend meetings at the café la Tour St Jacques and participate in the group's activities; indeed, Zimbacca is a key figure within the group. A number of younger members have post-Situationist backgrounds that, combined with their surrealist sensibility, have enhanced their activities and exploration of the city. Some of the membership have lived in Paris for a substantial part of their lives – Zimbacca, who recalls Paris over the period of the Second World War during which he participated in an event that was a precursor for surrealist intervention in the city. With an accomplice he placed a wooden mannequin, that had a wooden egg affixed to its head, on the roof of one of the oldest medieval buildings in Paris, the derelict Hotel de Sens (Figure 15.2). This intervention has preserved for Zimbacca a notion of *possibility* in relation to certain spaces in

15.1
Some further re-
enchantments of a
city (Paris)

**Fig. 1. Some further re-enchantments of a city (Paris)**

*Palais de Justice – Ile de Cité - 1ˢᵗ arrondissement (arrt)*: transform into an incubator for dreams.

*Préfecture de Police – Ile de Cité (1ˢᵗ arrt)*: transform into a museum of social and natural history that exhibits different species of cop.

*Place de l'Hôtel de Ville (4ᵗʰ arrt)*: destroy the 'stupid' fountains built by Chirac; transform the square into a meadow with leaping sheep.

*Université de Paris VII Jussieu (5ᵗʰ arrt)*: destroy the buildings and transform into a wild garden with every kind of wild plant.

*L'Institut de France (6ᵗʰ arrt)*: transform into a place for travelling in kaleidoscope (reference to the famous alchemy novel of Irène Illel Erlanger entitled *Voyage Kaleidoscope*, published in the 1920s).

*The church of St Augustin (8ᵗʰ arrt)*: transform the church into an art gallery consecrated to Clovis Trouille and install palm trees.

*Carrefour (crossroads) Barbès Rochechouart (10ᵗʰ arrt)*: transform into a fish harbour of Brittany – the water will return via a source of the canal St Martin.

*Place du Colonel Fabien (19ᵗʰ arrt)*: destroy the building of the French Communist Party designed by Oscar Niemeyer, the architect of the functionalist town Brasilia; transform the site into a castle of mist and install a ball tango.

*Ministère de Finance, Bercy (12ᵗʰ arrt)*: transform into a pump that pumps out beer, wine and money instead of water and that diverts coinage which no longer has any value – *coins of the ancient times*; install a great statue of Ubu and a statue of Mephistopheles (this statue an allusion to Alfred Jarry's character Ubu who is named *The Great Master of the Phynances*).

*Bibliothèque Nationale de France (13ᵗʰ arrt)*: transform this and the district around into nomad camps with storytellers, readers, orators; as a monument install a gigantic artichoke that illuminates according to the pleasures experienced in the nomad camp; this location to become a departure place for wanderings.

*Boulevard Périphérique*: transform into a huge greenhouse of 36 kilometres around Paris with open air dance halls and cafés and install a ghost train that operates around the entire circumference of the old Périphérique.

*Parc des Expositions (15ᵗʰ arrt)*: transform into a volcanic lake with hot springs that throw up columns of water.

*Parc André Citroën (15ᵗʰ arrt)*: donate for transformation to some mad builders or, alternatively, to the Czech surrealists Eva and Jan Švankmajer.

*Maison de Radio France (16ᵗʰ arrt)*: transform this circular building constructed in the sixties into a giant crystal snail that can be entered.

*Buildings in the north east of Paris near La Villette (19ᵗʰ arrt)*: destroy completely these huge, ugly buildings; install a place for departure of air balloons; position a chocolate grinder according to the plan of Marcel Duchamp.

*Parc de la Villette (19ᵗʰ arrt)*: destroy all buildings except the Géode and transform area into a dense forest of high trees that surround the Géode and can only be approached via the canal.

24 June 2003
The Paris group of the surrealist movement

Paris that are inscribed with a sense that *something will happen* and the nurturing of a feeling of possessing Paris through entry to such spaces. In latter years Zimbacca expresses despondency in noting obsessive gating and CCTV to places that were once accessible for walking. Zimbacca's critique of controlled space extends to a revulsion towards development since the 1970s that has destroyed places formerly stimulating to the imagination – Lunapark in the 17th arrondissement that was immortalized in *Paris la Belle*, a film made by Pierre Prévert and narrated by his brother, the surrealist poet Jacques Prévert. During the war years Lunapark was a highly popular funfair.

15.2
**Postcard of the Hotel de Sens on which Michel Zimbacca has drawn his Second World War intervention of placing a wooden mannequin, with red wooden egg affixed to its head, on the roof**

However, its magic has been lost forever through demolition and subsequent construction of a towering concrete hotel complex. Within the Paris surrealist movement there is copious critique of architects and planners who increasingly impose developments on the city's topography that do away with the city's 'surprises and detours . . . its disturbances and glances'.[5] One redevelopment that has struck a cord of anguish across the entire group is the destruction and reconstruction of the area of Bercy in the 12th arrondissement. Bercy was formerly a small wine-producing village with railway, warehouses, large kegs that furnished cobbled streets, an ancient inn and many Parisians employed in the industry. The village was demolished under the Mitterrand government of the 1980s, erasing its history forever and replacing

it with a sports stadium and the centre for the Ministry of Finance. Joël Gayraud, a member of the surrealist group comments:

> Here the map is the territory, you can immediately perceive the design of the place – square corners, not places of intimacy. The garden is a wide-open space dotted with the old trees of Bercy, huge external stairs and paved walkways of concrete and stone. In the garden you can see a highway along the Seine, part of the towers of the new national library . . . and the awful concrete and glass stadium. Everywhere is dominated by right angles. Here you do not live in landscape but an idea of landscape born of geometry not poetry.[6]

This critique resonates the melancholy of Louis Aragon in *Le Paysan de Paris* in which he immortalizes the outmoded in the form of the Passage de l'Opera that was demolished during the Haussmannization of Paris. Present-day surrealists suggest that Paris is undergoing a 're-Haussmannization' in which decentralization and regeneration are displacing communities and altering urban space, evidently in order to maintain the cycle of capitalism. How then is it possible to preserve surrealist activity in the city – the drifts and games that explore the city and discover the magic of its latent and anodyne spaces? Is it possible for surrealist spirit of place to survive, to experience an *other* city that, in spite of changing architectural, economic, social and cultural conditions, plays a game with such demands and in so doing remains open to possibility?

> We have to discover the city by setting down to work an imaginary architecture in constant outpouring.[7]

> Dream is utterly linked to reality – there is no difference between them just as there is no difference between day and night – they presuppose each other.[8]

Dream is an important element in surrealist engagement with the city; similarly imagination that is able to transform architecture. Several years ago Zimbacca dreamt that Place Clichy in the 17th arrondissement had become a Greek village – the Haussmann buildings on the right had disappeared and in their place were small Greek houses and tavernas that at night were lit with different-coloured lanterns, while the life within the tavernas spilt out onto the streets. Now when Zimbacca passes through this square he sees the place in the transformation of the dream. Another member of the surrealist

group, Guy Girard, most often dreams of Paris by night and he makes comparisons between the dream and reality. Preferring to see certain places in his dreams, he recounts the dream in the present tense, perhaps suggesting that through imagination the dream becomes reality:

> In one dream I am passing the building for special and riot police in Place de la République and I see it has been destroyed – only the façade remains while behind is a large hole in which there are archaeological ruins.[9]

Within the surrealist movement transformation of place is a projected model for a *possible* utopia founded on imagination, dream and fantasy. Gayraud imagines oneiric architecture – the restoration of a building in rue André del Sarte in the 18th arrondissement that was previously occupied by the large department store Dufayel, and has a gigantic arch in the middle. Gayraud suggests that because of the incongruous monumentality of the perspective in very narrow streets, reinstatement of the hollow of the arch and prolongation of the street beneath would create an effect of strangeness. Similarly, Girard imagines diverting the dominant perception of the Arc de Triomphe by incorporating the urbanism of the Romanian surrealist Gherasim Luca, his three-dimensional cubomania,[10] that every year would be changed to ensure a constant transforming of ambience.

In their re-enchantment of Paris, surrealists would destroy the Périphérique and the buildings constructed in the 1930s that encircle Paris. They would create a fortress wall – not a defensive wall – in the design of a castle shaped like a spiral that would measure the perimeter of the Périphérique and have medieval towers. People could live in the wall while a continuous ghost train would run around the circumference:

> This wall could be conceived like an enormous raw art or popular art – made by the people who live inside. It could resemble the Ideal Palace of the postman Cheval – Paris could become like a city of fairy tale.[11]

The recently constructed Charles de Gaulle bridge between the 12th and 13th arrondissements would be remodelled on an ancient bridge such as the Pont Neuf, that would have houses built on both sides in the baroque style, access restricted to pedestrians only, and beneath the bridge, like a Ferris wheel, a mill of love with small benches that would enable people to pass through the water as the wheel turns. Similarly, in order to reinstate the concept of labyrinth, the Ile de Cité in the 1st arrondissement would undergo

medieval restoration, but with all the conveniences of modern sanitation. Gayraud suggests such architectural renovation would facilitate a more communitarian society:

> The cathedral Notre-Dame would be open every night, people could sleep inside, speak loudly, it would be a living place and not as it is now a museum piece for tourists.[12]

Surrealists would transform ugly and industrial suburbs such as Aubervilliers and St Ouen into countryside, forests or woods, while architecturally attractive buildings such as the École Militaire would be joined with the site of the demolished UNESCO building and other sites to form a phalanstery for a collective settlement of people who would have a communal activity of their choice. Gayraud comments:

> The city of Paris has so many possibilities of creating the Fourieriest idea of phalansteries – there are lots of places that are used for military purposes and this utopia could be immediately realized because why, what is the necessity to have a military school?[13]

Surrealists propose that the department stores Galerie Lafayette and La Samaritaine in the 9th arrondissement be transformed in accordance with their architecture to become habitations, theatres or circuses, particularly beneath the dome of the Galerie Lafayette. Marie-Dominque Massoni comments:

> You could take these places and change them into another kind of existence – put people living there, creating there, making theatre instead of being big department stores.[14]

The Piano and Roger's design of the Centre Pompidou is considered by surrealists to be a dystopia that has contributed to the destruction of a once popular and living district of Paris. Gayraud proposes that the building be conserved as a mark of the 'high-tech' phase of architecture. However, the dominant surrealist group view is to remove all artworks cherished by surrealists and allow nature in the form of a forest and animals to invade the interior and exterior, while artworks remaining on the inside would be transformed by nature. In a similar vein, as a memorial to the hole that existed for many years prior to the development of the notorious Forum des Halles in the 1st arrondissement, surrealists propose to transform the entire complex into an initiation labyrinth with quicksands that enable access to the

centre of the earth. People could choose whether or not to enter the labyrinth.

Present-day surrealist disenchantment with functionalist architecture since the 1960s is a prominent perspective in the group's project of mapping attraction and repulsion. The destruction of popular housing on several sites, in order to accommodate tower blocks, has led to the relocation of communities to inferior housing in the suburbs and to a process of gentrification. In their mapping activity, the surrealist group proposes to demolish these tower blocks and re-enchant the affected areas. Thus, following the destruction of the tower blocks in Place des Fêtes in the 19th arrondissement, a large boating lake would be installed, together with open cafés and dance halls, and this more pleasurable ambience, in diverting children from their allegiance to the Play Station, would enchant them towards nature in the form of the simple gardens they create around the lake. Massoni suggests that the name Place des Fêtes indicates how the place should be, one of festivity, but she also believes this area should be transformed in order to reflect its historic link with water – the underground river named le ruisseau de Ménilmontant (the brook of Ménilmontant) flows from this part of Paris and many streets have kept symbolic names – rue des Cascades (street of the waterfalls) and rue de la Mare (street of the pond).

Surrealists propose to demolish the two unsightly tower blocks near the Avenue d'Italie in the 13th arrondissement and to replace them with giant totems between which a King Kong would roam. In order to view this manifestation they would install open-air cafés and dance halls. The Tour Montparnasse in the 6th arrondissement similarly would be demolished, together with the unsightly postmodern Gare Montparnasse. An identical model of the old Montparnasse station would be rebuilt, incorporating the legendary accident in which a locomotive burst through the station's front wall and landed nose-down onto the pavement. Zimbacca suggests that two enormous swan's wings be added to the locomotive engine to give the effect of a big bird (Figure 15.3). Gayraud comments that this reinstatement would serve as a diversion, and a point of contemplation – 'the crystallization of dialectics in terms of the speed of the locomotive and the arrest – the stop with the locomotive suspended in air then falling down onto the pavement'.[15] He associates this with a photograph in Breton's l'Amour fou of a locomotive abandoned in a virgin forest that illustrates a comparable idea of uncontrolled beauty.

Diversion in the city is combined with recreation in an idea of Bruno Montpied who, in daily travelling on line 2 of the métro, where the track runs externally, delights in the sudden and dramatic turns of the tracks that recall to him the childhood experience of being on a roller-coaster. In re-

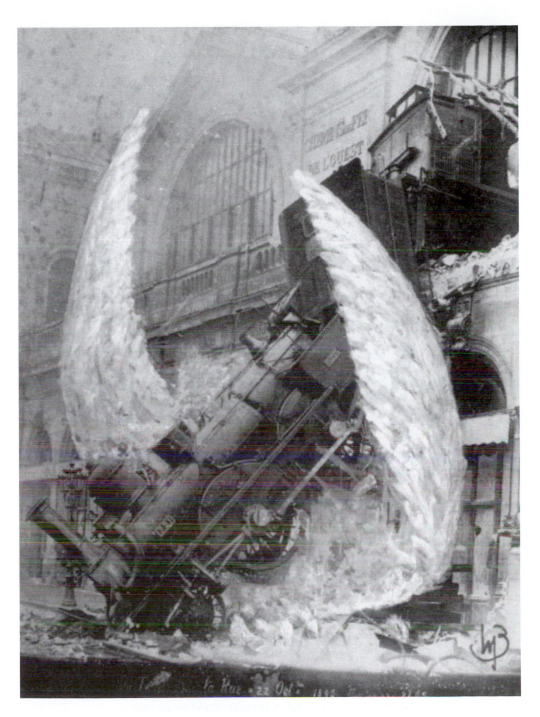

15.3
**Winged locomotive – a perfect illustration of convulsive beauty;
postcard of locomotive accident at Gare Montparnasse, with
addition of swan's wings painted by Michel Zimbacca**

enchanting Paris, he would transform all lines of the métro into roller-coasters adapted to people's pleasures and install ghost trains:

> with optical illusions, skeletons, animated people, the ghosts of public enemies – travellers would wonder if they are dreaming or hallucinating. There would be daily hallucinations created by a whole team of Situationists and the ghost of a naked woman would be in a different place each day – people would be driven to choose alternative routes and never the same route day-in, day-out. There would be community service for everyone who lives in Paris to make animations for the métro, and using the métro would be a happier experience because it would be like a permanent funfair.[16]

Inspired by the layout and diversity of the Jardin des Plantes in the 5th arrondissement, Montpied would also like to see spaces in the centre of Paris conquered by nature and abandoned to wilderness. He refers to this as natural hazard, and he comments:

> In a city like Paris all natural hazard is forbidden – the institutions, people controlling the city, they want to control everything and would not allow a single small plant to grow between two buildings or in the street. I am for the wilderness with the man inside, I do not remove man from the wilderness – I defend hazard or chance.[17]

The mapping activity out of which these re-enchantments of Paris emerge is a critique of uninspiring, functionalist architectural design and a surrealist exploration of space that engages with imagination, dream and fantasy. In projecting a maxim of Henri Lefebvre, the 'possible–impossible' of utopia,[18] the activity also inspires small achievements in everyday life – the centrality of play as the restitution of the city, its times and rhythms. It connects with the Situationist Constant's project of *unitary urbanism* – a desire 'to reclaim social space, to construct cities for pleasure, adventure and a creative unfolding of life',[19] and to open up ways of envisaging an *other* city and *other* life through evoking alternative atmospheres. David Pinder suggests that 'the emphasis is on the possible, on what could be, and on realizing desires through processes of social and spatial change',[20] and he highlights the need for such projects that 'seek to prise open understandings of the present, that offer glimpses of other possibilities, and that maintain a creative game with current conditions in order to figure alternatives'.[21]

During the 1970s a group of unsightly tower blocks were constructed on land fronting the Seine in the 15th arrondissement. The surrealist group proposes to demolish these and transform the area into a beach; they imagine gigantic leather dice cups laid on their sides and huge white dice emerging from these, the black spots to which are entrances to an interior labyrinth. Perhaps it is possible to believe that through installing *Paris Plage* along the banks of the Seine during the summers of 2002 and 2003, the Mayor of Paris, Bertrand de la Noë, demonstrated a similar yearning for restoration of the city's fabric to projects that evoke imagination, fantasy and dream.

## Notes

1   R.-G. Doumayrou, catalogue *André Breton et l'art magique à Saint-Cirq-la-Popie*, 1991, reprinted in J. Vovelle, 'Utopie et Surréalisme: Éros et "Les Architectes"', in R. Barbanti and C. Fagnart (eds) *L'Art au XXe siècle et l'Utopie*, Paris: l'Harmattan, 2000, p. 247.

2   Voyelle, 'Utopie et Surréalisme', p. 247.

3   Paris: Gallimard, collection la Pléiade, 1974 (1st edition 1873).

4   A game entitled 'Certain possibilities relating to the irrational embellishment of a city', printed in *Le Surréalisme au Service de la Révolution*, 15 March 1933, No. 6, pp. 18–23.

5   Breton's statement, in A. Breton, *Les Pas Perdus*, Paris: Gallimard, 1924, p. 12.

6   Interview with Gayraud, 15 December 2001.

7   Interview dated 14 December 2001 with Bertrand Schmitt, member of the Paris group of the surrealist movement.

8   Interview dated 14 September 2002 with Jean-Pierre Le Goff, member of the Paris group of the surrealist movement prior to 1969.

9   Interview with Girard, 13 December 2001.

10  'In his cubomania, Luca, after having cut out an image (generally the reproduction of a celebrated picture) in regular squares, redistributed these fragments to end up in a new composition that would disturb the readability and produce some categorically incongruous comparisons.' G. Durozoi, '1944–1951 "Liberté, mon seul pirate"', *Histoire du mouvement surréaliste*, Paris, Éditions Hazan, 1997, p. 448, translation from French.

11  Interview with Gayraud, 15 June 2002.

12  Ibid.

13  Ibid.

14  Interview with Massoni, 17 December 2001.

15  Interview with Gayraud, 15 June 2002.

16  Interview with Montpied, 14 April 2002.

17  Ibid.

18  E. Kofman and E. Lebas (eds) *Writings on Cities – Henri Lefebvre*, Oxford, UK and Malden, Massachusetts, USA: Blackwell Publishers, 1996, p. 53.

19  D. Pinder, 'Utopian Transfiguration: the other spaces of New Babylon', in I. Borden and S. McCreery (eds) *New Babylonians*, London: John Wiley & Sons Limited, 2001, p. 18.

20  D. Pinder, 'Urban Transfiguration', p. 19.

21  Ibid.

# Chapter 16

# Landscape surrealism

*Fernando Magallanes*

> From this rock where I sit, the river flows only a few feet from my
> feet, silver and dappled with cumulus clouds that are really miles
> above. The effect is surreal, as though I were suspended
> between water and sky, myself another particle of flotsam carried
> seaward from the mountains.[1]
>
> Tim McLaurin, *The River Less Run: A Memoir*

Surrealism, the twentieth-century art movement, has influenced American
landscape architecture and landscape design. From its early French begin-
nings in the 1920s, surrealism survives as poetry, writing, painting, photo-
graphy, cinema, and philosophy for the contemporaries of the twenty-first
century. Landscape historians and critics have failed to narrate in detail the
significant threads of surrealist influence on landscape history. This historical
account establishes some of the known connections with lesser-known con-
nections between landscape and surrealism.

    Beginning with Thomas Church, the earliest recognized landscape
architecture modernist, one sees that surrealist theories were judiciously
applied in the arranging and designing of the landscape. Further study must
focus on early surrealist beginnings to understand how its basic tenets con-
sequently affect design and inquiry from early twentieth-century landscape to
the contemporary landscape. Surrealist theory continues to be fertile for
exploration, and post-surrealist ideas continue to emerge in the writing and
production of landscape architecture.

    In order to discuss and debate landscape surrealist themes and
work critically, examples must be singled out. Surrealist and landscape sur-

realist works often cannot be easily identified. André Breton, the designated leader of the surrealists, officiated the recognition of surreal works during much of surrealism's history. He defined surrealism in 1924, using the definition to help identify works:

> Pure psychic automatism in its pure state, by which one proposes to express – verbally, by means of the written word, or in any other manner – the actual functioning of thought. Dictated by thought, in the absence of any control exercised by reason, exempt from any aesthetic or moral concern.[2]

The problem (or surrealist advantage) with Breton's definition is the conceptual nature of the definition, which was purposefully provocative and attempted to break with traditional ways of looking at the making and understanding of art. This kind of definition allowed for many interpretations by the artists in expression, style, or media. Writers on the subject of surrealism point out that even with this definition the surrealists often contradicted themselves about the specifics of its practice, and even its theory.

Surrealism began as an art form with writing and evolved from painting to photography, cinema, and sculpture. Surrealism entered many realms of the arts and, to its credit, entered the everyday vocabulary of our society. Landscape was never the focus of surrealist theory. Yet, it is clear that landscape was indirectly addressed as a metaphorical, poetic, and inspirational vehicle for surrealist ends. Surrealism's openness to a variety of media expression incited painters to expand into collage, frottage, and decalcomania and opened the door for a sympathetic relationship with the built and natural landscape. As landscape designers curiously glance at surrealism, a closely examined gaze at landscape examples, the painters, and the writers who initiated the surrealist movement is needed.

Landscape and the writers

The surrealist writers and poets were active observers. They turned to the environment in which they lived and mined for images in the landscape that obsessed them.[3] Chance juxtapositions of objects or random events inspired their writing. Louis Aragon (1897–1982), in his book *Paris Peasant* (1924), was inspired by a visit to Parc des Buttes-Chaumont with André Breton (1896–1966) and fellow writer Marcel Noll. The visionaries were seeking a spontaneous adventure and escaping the boredom of an evening party. Why choose this park as the destination? The choice was accidental, as Breton won the attention of the cab driver from Noll and instructed the driver to go

to Buttes-Chaumont, a reclaimed stone quarry and landfill transformed into a nineteenth-century landscape park.[4] The trip to the park was uneventful. However, it was significant in demonstrating how the surrealists played to engage the creative muse and identified the landscape as the place to find that muse. These kinds of playful adventures, like the unplanned visit to Parc des Buttes-Chaumont, were the initial sources that led writers to build a deeper reality of place. For Aragon, Parc des Buttes-Chaumont was a site filled with abstract fictive possibilities and more concrete visible objects, such as oddly placed Greek follies, engineered bridges, and reconfigured artificial landscapes containing magical and psychoanalytical meanings. The animist qualities found in the park objects, the deaths produced from numerous suicide jumps off a bridge in the park, and its tormented quarried past were magical to the writers in reconfiguring a surreal place.

André Breton's book *Nadja* (1928) follows Aragon's direction. In the book, Breton walks the streets of Paris aimlessly seeking to find something but not knowing specifically what. His walking engages both the conscious and the unconscious, as he writes excitedly about his discoveries. He finds that a banal environment can be emotive, that the environment is a paradox, that there is a changing, shifting perception as he walks, and that irritation is the equivalent of delight. Ultimately he realizes that poets and writers, like himself, can point to surreal situations, helping others to see what the unconscious offers. What surreal situations? The situations referred to the arrangements of common everyday things, objects that are cultural, historical, or iconic symbols in society offering new meanings as they are thrown together in various ambiguous relationships achieving a surrealist beauty – which Breton and Aragon identify as the "Marvelous."[5]

These encounters elucidated what Breton understood about humans deriving their identity from their dwelling, habitat, and environment.[6] He discovers that landscape is a familiar fixed point ("*happened to be in the Rue Lafayette...*") from which humans identify and carry out actions ("*buying Trotsky's latest work*") in that world.[7] His observations lead to debates about the clarity and ambiguity in what exists. This epistemological understanding of the world and the psychology of these wanderings led to revelations about how psychological factors affect the perception of the world and its relationships. Breton also applied a hermeneutical approach to seeing and observing the world in hopes that it could lead to interpreting and evaluating in a new way. By studying the landscape, its people, and the effects of these relationships in *Nadja*, Breton brought psychology, philosophy, and anthropology to art and literature.

Surrealist landscape painting

How exciting it must have been for the surrealist painters to read Aragon's and Breton's discoveries, and how challenging to explore Freudian psychology in their paintings. The surrealist painters Ernst, Miró, Dalí, Matta, Masson, Arp, Tanguy, and Magritte followed the writers closely, exploring the visual equivalent of surrealist writing. Why use landscape as the subject for the surrealist dream or vision? Walking the streets of Paris, Breton discovered that landscapes are accepted as familiar to us. Juxtaposing the familiar landscape (earth, horizon, sky, and built form) with unfamiliar objects and relationships yields a tension, an excitement, and an ambiguity in the viewer. In order to realize their dreams, the painters used the "real" landscape as the familiar, adding to it the unfamiliar to advance their painting to the "sur-real" (the dream). This new place was where the conscious and the unconscious could be seen, where the irrational met the rational, and where the familiar and the unfamiliar were made real.

One can see this playfulness in the works of Joan Miró (1893–1983) and Salvador Dalí (1904–1989). Miró explored Barcelona, the Mediterranean coast, and the rural nature of his native Spain in his paintings. Salvador Dalí painted his dreams in the Catalan towns and landscapes of Pubol, Cadaques, and Figueras, Spain. Miró represented his dream landscapes as abstractions of biomorphic forms, words, and color seen in his *Catalan Landscape, The Hunter* (1923–24). Dalí's dream environments were represented through the exactitude of realist painting techniques, like those found in his *Persistence of Memory* (1931). They both explored dreams and automatist methods in the context of their Spanish homeland through two different painting techniques, and both were considered surreal.[8] The use of two different painting techniques points out how surrealism allowed for varied outcomes of surrealist experiments. The depiction of the landscape is important, as it is used to challenge the viewer's perceptions of what is known to be real against the surrealist meaning created by the painter.

The application of Freudian psychology introduced science to painting and gave painting a new reason to exist in addition to the beauty of the painted surface. The fact that landscape was found to be where painters placed their dream vision made apparent how deeply imbedded the landscape is in our conscious and unconscious.[9] Landscapes are symbols imbued with regional and universal societal values. Humans know how to read the everyday landscape, identifying civilization's marks such as territory, pleasure ground, use, or the expression of individuals or its society. Furthermore, landscape is a natural and biological entity in a constant state of flux, offering a

media loaded with possibilities and never boring, this being a surrealist pet peeve.

The importance of landscape in surrealist writing, and later in landscape painting, was its mix of the psychological, philosophical, political, autobiographical, and the aesthetic of surrealism. What happens when surrealism moves from writing and painting to the three-dimensional surreal landscape? In *landscape surrealism*, the placement of objects (object as a symbol, icon, history, culture, and the everyday) in a recognizable landscape creates complexity in its relationship to its context (landscape, architecture, geology, biology). Human activity and perceptions (societal values, morals, and standards) confront the juxtaposition of recognizable things in unexpected relationships, igniting the enigma of clarity and ambiguity. This paradox creates tension, shock, surprise, and beauty is "the marvelous."

Patricia Johanson at Fair Park Lagoon in Dallas, Texas (1982) used surrealist devices to create the qualities of her garden. Placing a larger than life representation of the aquatic plants *Saggitaria platyphylla* and *Pteris multifida* in an existing park pond, she creates the surreal for the visitor (Figure 16.1). The viewer is moved from banal existence into that of a dream. What is the giant contorted reddish concrete object, and what is its purpose? What are paths and bridges doing in the water? Is this a sculpture or a way to

16.1
**Fair Park Lagoon, Dallas, Texas:**
***Pteris multifida* by Patricia Johanson**
Photograph by Fernando Magallanes, 1984

repair the pond's eroded edges? Is the red object alive like the other aquatic plants that surround it? How can concrete be so fluid and expressive? The design is what Breton described as an image with vigorousness that derives its strength from its ambiguous meanings.[10] Johanson's surrealist intervention is a three-dimensional surrealist painting.

American landscape surrealism

Surrealism was well developed by Breton to be consumed by the arts, science, and to engage society's values. Publications and exhibitions had proven examples of the surrealist vision. In the United States surrealism entered first as a European idea. Later, individual surrealists followed, and with them they brought a new philosophical approach and technique to art in America. Paris exhibitions led to American exhibitions of surrealist works at the Museum of Modern Art in New York (1936) and the San Francisco Museum of Art (1937). In architecture and landscape architecture, surrealism arrived in the university programs via the Bauhaus ideals and its former teachers. Walter Gropius arrived at Harvard (1937), while Josef Albers arrived at Black Mountain College (1933), and Laszlo Moholy-Nagy established the New Bauhaus in Chicago (1937). Their "Modernist" ideas included surrealism. It is during the late 1930s that the landscape architects Garret Eckbo, Dan Kiley, and James Rose grew as students, and Thomas Church, along with other practicing landscape architects and architects, applied these Modernist theories in his work.

Thomas Church's Dewey Donnell Garden (1948) in Sonoma, California, was the first recognized example of American landscape surrealism[11] (Figure 16.2). Landscape architecture historians and critics Marc Treib, Melanie Simo, Peter Walker, and Catherine Howett labeled the garden surreal.[12] Their argument highlights Church's use of biomorphic forms (organic forms responding against the static dynamic of the Beaux-Arts) in his work. Certainly the forms in the Donnell Garden were organic and resembled the sculpture of Hans Arp. However, imitating surreal forms does not make the garden surreal. To those who understand surrealism, the garden is surreal for many other reasons. In his book, *Gardens are for People* (1955), Church enlightens us about the surreal influences in his ideas, artefacts he designs, and the meditations of his design philosophy.

The experience and study of place draws Church and surrealists together. Both surrealist and landscape architect searched for revelation by observing their world. Church claimed that he knew and understood California in a similar manner to Dalí's, Miró's, and Breton's understanding of Spain

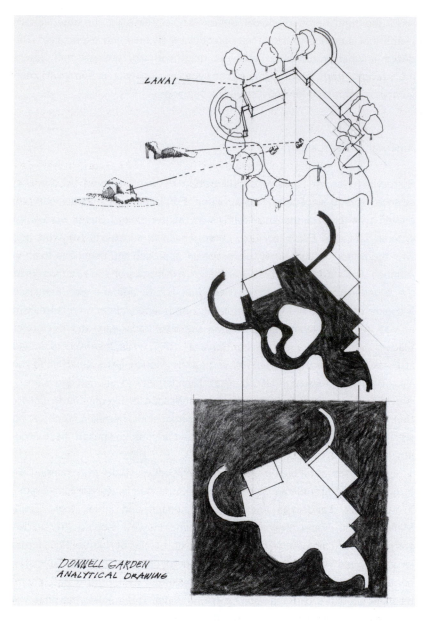

LANAI

DONNELL GARDEN
ANALYTICAL DRAWING

16.2
**Analytical drawing
of Thomas
Church's Donnell
residence**
After original
drawings by
Thomas D. Church

and Paris, respectively. He admitted that he "seems slanted toward the West Coast," because most of his professional "experience [had] been in California."[13] They all knew that the landscape provided humans with a basis for their identity. For the surrealists the landscape educated them on the beauty of the everyday enigma of their environment. For Church the landscape informed him that there had been changes "socially and economically," and

his designs needed to adjust for those changes.[14] Church and the surrealists both drew on their travels for inspiration. The surrealists left Paris every summer to "[travel] to renew their faith in the Marvelous."[15] In Church's book we read that his travel and experiences also influenced his design philosophy. In 1937 he embarked on travel to Europe and was enlightened by the Decorative Arts Exposition in Paris of 1937. Church applauded the Fair's attempt to entertain innovative ideas and break ties to the eclecticism of its day.[16]

The art world contributed its influence on Church and garden. Californian Adaline Kent (1900–57), studied sculpture in Paris in 1924, and worked with Church at the Donnell residence. Kent's previous works were drawn from the organic world through studying rock sedimentation, tree trunks, and fungus.[17] The San Francisco Bay Area of the 1940s saw surrealist works move towards a surrealist biomorphism, an organic abstraction much like the work of Joan Miró and Hans Arp.[18] It is unclear to what extent Kent contributed to the design of the Donnell Garden other than the sculpture, the rock rise and the lanai. However, Church's collaborative effort with Kent was certain to have been influenced by direct contact with surrealist circles and ideas. Adaline Kent's work is described as having "an anthropomorphic inventiveness in sculptures that have a magical aura, touched here by capriciousness, there by enigma."[19] At the Donnell residence her white reclining human-like figure posing in the pool is much like the figures in a Giorgio de Chirico (1888–1978) metaphysical painting (*The Uncertainty of the Poet*, 1913). The white sculpture inhabits the space as it is presented against the sky, ground and horizon. Even when the owners or guests are not present the human-like figure inhabits the space, presenting a melancholic atmosphere.

Infinite surreal space can be seen or experienced when standing or sitting on the pool deck. The view does not end at the edge of the pool. It extends across the existing marsh and beyond to the mountains. Against this natural context, the biomorphic forms of the pool, and the melancholic sculpture by Kent in juxtaposition with the California mountains beyond, create the surreal effect.[20] The garden's southern exposure enhances the surreal with its shadows that create dramatic lights and darks. There is no doubt that the objects in the design are identifiable. The landscape design includes the pool, the sculpture, the trees, the paving patterns, the buildings around the pool, and the landscape beyond the pool's edge. The ambiguous relationships between all these elements create the juxtaposition of clarity and ambiguity. What is the significance of the sculpture? Are the sculpture, pool and deck floating in the air? What is the relationship between the geologic features beyond and the rockery by the pool? How do the people who inhabit the pool relate to this space?

Church and the surrealists were exploring the human wants "desire" and "pleasure." Church contended that the garden must be "determined by the desires of the people who expect to find happiness in their gardens."[21] The images of desire and pleasure explored by the surrealist painters, and by the sadist writer Lautreamont (1846–70) in *Chants de Maldoror*, far outweighed Church's thoughts on the subject. Church's interpretation of desire and eroticism was not as extreme as that of the surrealists. Fulfilling desires for Church meant knowing what his clients desired and expressing those needs for them. In a surrealist painting the painter's desires are fulfilled, while in a landscape the client's desires are realized. Church relates a story about the Don Edwards residence in Woodside, California (1954), another of his designed projects, and explains fulfilling the Edwards's desires to move to the countryside, where horses, paddocks, terraces, and swimming pools could coexist. He produced a garden where they would "never smell freshly cut turf or know the joys of dividing perennials, but they'll have piles of manure to give their friends."[22] Dalí would laugh and support the making of manure. It is the manure (excrement) that would attract flies, creating the kind of environment that fascinated Dalí in many of his paintings.

Both Church and the surrealists concur that designer and artist should remove their preconceptions when beginning a work. Church enters the design process unencumbered, and he explains: "[I]t behooves the designer to listen and observe before getting any preconceived notions about how his client's gardens should be arranged."[23] The surrealists did not want preconceived ideas either. The artists and writers were expected to explore new methods for expressing art, to liberate their rational selves from following tradition or formulaic standards of painting and writing. Was Church surreal? No. The Donnell garden and his book indicate that Church interpreted and was open to surrealist theory for his own application of designed landscapes. It also indicates that there are some natural proclivities between landscape and surrealism.

Landscape surrealism today

The avant-garde landscape designers have played with surrealist ideas and created surrealist works since the late 1960s. Contemporaries interpret, borrow, or reflect on surrealist doctrine, which offers inspiration for rethinking landscape practice, perceptions, values, expression, and experimentation of materials. Theory, imagery, and techniques help birth new ideas that break from the traditional. Contemporary landscape architects are not surrealists, they are designers who seek to mine the surrealist spirit.

Since its early days surrealism has dispersed, morphed, transformed, and evolved into many other forms of art and modes of expression, but the historic legacy of surrealism still survives. Many of the artists are dead, but their works are in museums, and we can still read what was once freshly inked criticism. There exists a rich collection of visual imagery. Teachers continue to present an invitation to landscape surrealism. Today, landscape surrealist visions surface repeatedly in much the same manner and places that the early surrealists' work presented itself: competitions, visionary exhibitions, catalogs, magazines, books, built landscapes, and academic theory. The following examples are landscape surrealist visions that highlight a few prominent designers and their contributions to landscape surrealism.

In the exhibition catalog, *Transforming the American Garden: 12 New Landscape Designs*, Pamela Burton and Katherine Spitz present "Hydrotopia" (1986), an unbuilt project where landscape becomes "more than a pretty garden: it functions like a language, uncovering through its discontinuities deeper meanings within the mind."[24] They describe their continued study of the rational and the irrational, moving from Freudian psychology to Lacanian psychology, allowing the unconscious to inform about the discontinuities in experiences.

Between 1991 and 1995, *Landscape Architecture Magazine* held a yearly "Visionary and Unbuilt Landscapes" competition provoking the profession towards creativity for the new millennium. Many of the designs presented surrealist imagery with rhetoric directly from Breton's writings. The entries expressed subversion, provocativeness, and cleverness, and were hopeful catalysts for other ideas and for further action against the non-acceptance of standards present in landscape architecture. Rebecca Krinke, a competition winner in 1991, played with dreams and found objects in a natural setting to create a landscape of "beauty and fear."[25]

Chip Sullivan, practitioner and teacher, identifies himself as surreal through his teachings. In his book, *Drawing the Landscape* (1997), he informs us that he uses surrealism in its many forms of inspiration. Most notably, travel and automatic drawings allow a non-prejudgmental point of view for his designs. He recommends the *Exquisite Corpse* to students learning to draw.[26]

James Corner and Mira Engler are surrealist-like thinkers and representative of surrealism in academic settings. They both search for far-reaching methods to help students and society rethink its urban landscapes. Jim Corner, like Max Ernst (1891–1976), uses collage and the computer to shape his theoretical images. Corner's works and explorations bespeak his mission, like Ernst, to change the direction of landscape architecture and the department he now chairs at the University of Pennsylvania by aggressively

"[plunging] into the unknown."[27] He has progressively become more blatant about his surrealist affections, allowing them to show in his works at Downsview Park, Toronto (2000). Mira Engler, a professor at Iowa State, researches what she refers to in her lectures as the history of shit.[28] The subject is sanitation, but the depth of her ideas involves how culture deals with its excrement. She reveals the historical perspective of shit, its physical and societal impact affecting how we perceive it and its relationship to the design of landscapes and architecture. She has also discovered that Parc des Buttes-Chaumont was a waste-treating park.[29]

Gross. Max. and Adrian Geuze are the contemporary anarchists of landscape architecture. Gross. Max. a design firm based in Edinburgh, Scotland, defiantly yells out the same phrase of defiance as practiced by the surrealists and uttered by André Breton: "landscape must be convulsive or not at all."[30] Adrian Geuze is a landscape urbanist in the Netherlands who encourages landscape architects to rebel against becoming a victim of "wallpaper" landscapes and cautions against the application of "recipes" from garden history.[31] Both of these designers pose paradoxical surreal questions in their work and use the juxtaposition of carefully selected objects in their landscapes.

Criticism of landscape surrealism

Some surrealist interventions are seen as dangerous and inappropriate, conflicting with landscape architecture's position as society's guardian and steward of the landscape. Surrealism poses a threat to the historical framework of thought and traditional expectations of landscape architecture. Celebrated landscape architect Laurie Olin expresses ambivalence about the use of surrealism for the design of everyday environments, wondering if surreal design can only express "alienation, and a hallucinatory and obsessive preoccupation with loneliness, self, and unfulfilled yearning."[32] Surrealists engaged society in a broader discussion about life that included an alternative view of landscape tradition. How can landscape architecture not be involved with the subjects of alienation, hallucination, and fragmentation if those are the issues present in our society?

Two breakthrough projects of the 1980s were surreal and felt the controversial blade: the Bagel Garden, Boston, Massachusetts (1980), designed by Martha Schwartz, and Harlequin Plaza, Denver, Colorado (1980–82), designed by George Hargreaves when working for the SWA Group. Both created a new vision for landscape environments as a place for experimentation and offered an alternative debate and argument about the

future of landscape architecture. The Bagel Garden was a private curbside garden for a Back Bay townhouse with purple aquarium gravel, 96 weather-proofed bagels, and was visually accessible to pedestrians. It proved to stimulate a physical and mental tension.[33] Hargreaves followed a similar design approach that Church used at the Donnell Garden in designing the roof garden of the Harlequin Plaza office complex by juxtaposing sculpture, painted walls, harlequin paving pattern, and a water element against the earth, horizon, and sky of the Colorado mountains and landscape.[34] Criticism and controversy is nothing new to surrealists, whether in the 1930s or today.

Conclusion

The surrealist spirit is alive in the twenty-first century. From its 1920s beginnings the writers and painters established poetry, writing, psychology, and philosophy as its founding guides. Thomas Church explored and applied those ideas in his works to help us realize that the landscape is well suited for surrealist interventions. The historical connection to surrealism lies in its pertinence to the contemporary landscape architects' mission of experimenting and exploring the future. Breton fashions surrealism's relevance: "The Marvelous is not the same in every period of history..."[35] J.G. Ballard, essayist and cultural critic, agrees about surrealism's relevance: "The techniques of surrealism have a particular relevance at this moment, when the fictional elements in the world around us are multiplying to the point where it is almost impossible to distinguish between the 'real' and the 'false' – the terms no longer have any meaning."[36]

The experiments in landscape surrealism are emerging in imagery, process, text, theory, and construction. More landscape surrealist works must be identified to expand beyond what is documented here and critically assess concepts and experiments. Landscape can now focus on observing, questioning, and exploring the landscape with a surrealist vision. When interviewed in 1952 Breton was asked if he had any regrets about his life. He responded that he had always aimed to be a total poet and not a purist poet. He was referring to his role in society: "not to seek to please and be admired, but to know and to communicate knowledge."[37] As the twenty-first century unfolds, renewed deliberation about life and landscape will continue Breton's commitment to know and to communicate knowledge in the spirit of landscape surrealist possibilities.

## Notes

I am grateful to Lope Max Diaz for discussing the content of this chapter, and to Logan Barber, Johanna Hewlitt Brown, and Stephany Coakley for editorial help in the writing of it.

1 T. McLaurin, *The River Less Run: A Memoir*, Asheboro, North Carolina: Down Home Press, 2000, p. 11.

2 A. Breton, *Manifestoes of Surrealism* (trans. R. Seaver and H. Lane), Ann Arbor: University of Michigan Press, 1969, p. 26.

3 A. Breton, *Nadja* (trans. R. Howard), New York: Grove Press, 1960, p. 27; "The image must obsess you if it is to be surreal."

4 G. Melly, *Paris and the Surrealists*, New York: Thames and Hudson, 1991, pp. 97–103.

5 L. Aragon, *The Libertine* (trans. J. Levy), New York: Riverrun Press, 1993, p. 24.

6 C. Norberg-Schulz, *The Concept of Dwelling: On the Way to Figurative Architecture*, New York: Rizzoli, 1985, p. 9.

7 Breton, *Nadja*, p. 63. This is the datum from which he departs to tell us about meeting Nadja for the first time.

8 W. Rubin, *Dada, Surrealism, and Their Heritage*, New York: The Museum of Modern Art, 1968, p. 40.

9 S. Freud, *The Interpretation of Dreams* (trans. A. Brill), New York: Gramercy Books, 1996, p. 161. Freud discusses what he calls the dream-stimuli: "in their investigation of dreams we can prove that the dream possesses intrinsic value as psychic action, that a wish supplies the motive of its formation, and that the experiences of the previous day furnish the most obvious material of its content . . .".

10 N. Calas, *Art in the Age of Risk*, New York: E.P. Dutton & Co, 1968, p. 93.

11 T. Church, *Gardens Are For People*, New York: Reinhold Publishing Corporation, 1955, pp. 231–235.

12 C. Howett, "Modernism and American Landscape Architecture," pp. 18–35; and M. Treib, "Axiom for a Modern Landscape Architecture," in M. Treib (ed.) *Modern Landscape Architecture: A Critical Review*, Cambridge, Mass.: MIT Press, 1998, pp. 36–67. P. Walker and M. Simo, *Invisible Gardens: The Search for Modernism in the American Landscape*, Cambridge, Mass.: MIT Press, 1994, pp. 108–111.

13 Church, *Gardens Are for People*, preface.

14 Church, *Gardens Are for People*, p. 7.

15 Melly, *Paris and the Surrealists*, p. 75.

16 Church, *Gardens Are for People*, p. 35.

17 S. Ehrlich (ed.) *Pacific Dreams: Currents of Surrealism and Fantasy in California Art, 1934–1957*, Los Angeles: University of California, 1995, p. 130.

18 Ehrlich, *Pacific Dreams*, p. 28.

19 Ehrlich, *Pacific Dreams*, p. 28.

20 R. Arnheim, *Art and Visual Perception: A Psychology of the Creative Eye*, Berkeley, Calif.: University of California Press, 1974, p. 300. "Thus a number of inherent inconsistencies create a world that looks tangible but unreal, and changes shape depending upon where we look and which elements we accept as the basis for judging the rest."

21 Church, *Gardens Are for People*, p. 6.

22 Church, *Gardens Are for People*, p. 6. "You wouldn't like the flies, odors, noises? But you see, you're different. It doesn't matter to someone who loves horses." One person's desires and pleasures may not be another's.

23 Church, *Gardens Are for People*, p. 4.

24   M. van Valkenburgh (ed.) *Transforming the American Garden: 12 New Landscape Designs*, Cambridge, Mass.: Harvard University Graduate School of Design, 1986, p. 48.

25   *Landscape Architecture Magazine*, December 1991, pp. 42–43. CELA 2002, Syracuse, New York. In a conversation with the author she revealed that her idea was derived from one of her dreams.

26   C. Sullivan, *Drawing the Landscape* (2nd edition), New York: John Wiley & Sons, 1997, pp. 15, 29, 59–63.

27   A, Breton, *Surrealism and Painting* (trans. S. Taylor), New York: Icon Editions, 1972, p. 66.

28   M. Engler, *Designing America's Waste Landscapes*, Baltimore, Md.: Johns Hopkins University Press, in press.

29   Conference of Educators in Landscape Architecture, San Luis Obispo, 2001, n.p.

30   T. Schroder, *Changes in Scenery: Contemporary Landscape Architecture in Europe*, Basel: Birkhauser-Publishers for Architecture, 2001, pp. 162–171.

31   Harvard University, Graduate School of Design, lecture, April 20, 2001.

32   L. Olin. "Form, Meaning, and Expression in Landscape Architecture," in *Landscape Journal*, Volume 7, Number 2 (Fall 1988), p. 154.

33   *Landscape Architecture Magazine*, January 1980, pp. 43–46.

34   E. Kassler, *Modern Gardens and the Landscape* (revised edition) New York: Museum of Modern Art, 1986, p. 107. Harlequin Plaza no longer exists in its original state.

35   Breton, *Manifestoes of Surrealism*, p. 16.

36   J.G. Ballard, *A User's Guide to the Millennium: Essays and Reviews*, New York: Picador USA, 1997, p. 88.

37   A. Balakian, *Surrealism: The Road to the Absolute*, Chicago: University of Chicago Press, 1986, p. 239.

# Chapter 17

# Surreal city
## The case of Brasília

*Richard J. Williams*

The surrealists thought little of architecture, and if it was modernist, even less. For all of them, to whichever faction they belonged, architecture was irrevocably associated with order, with affirmation, and with officialdom – in other words, with most of the things that they hoped to subvert. According to Anthony Vidler, Breton thought that modern architecture was 'the most unhappy dream of the collective unconscious', a 'solidification of desire in a most cruel and violent automatism'.[1] Georges Bataille wrote in 1929 that architecture was simply authoritarian, its forms 'now the true masters across the land, gathering the servile multitudes in their shadow, enforcing administration and order and constraint'.[2] Breton, it is true, saw surrealism as a vehicle of political revolution rather than simply internal contemplation, and his stress on the collective rather than the individual has certain parallels with the ambitions of modernist architects. The experience of the *merveilleux* was a step towards making a better society, not just an aesthetic game for privileged players. But there was no surrealist programme for architecture, no material measures that compare with Le Corbusier's imagination of a civilization of the near future in his Plan Voisin, or Ernst May's *Siedlungen* at Frankfurt, or the public housing built in Britain after the Second World War. Where the surrealists showed any interest in the city at all, it was never in the fresh or new, but rather the abandoned, ruined or marginal, the places the modern world invariably overlooked. Hence Bataille's interest in the slaughterhouse[3] – or Breton's in the underbelly of Paris via the novel *Nadja*, a

tale of wandering in pursuit of a psychotic woman with whom the author was enamoured. Illustrated with odd, deadpan photographs by André Boiffard, Paris appears as an arbitrary collection of fringe sites bearing little relation to the official city of monuments.[4] To discuss Brasília in this context might well appear perverse. After all, the post-1960 capital of Brazil is not only modernist in form but monumental in both idea and execution, rigidly geometrical, and much liked by the military.[5] But Oscar Niemeyer, the city's chief architect, wrote of it early on in unmistakably surrealist terms: he hoped it would provide the visitor with 'an indescribable sense of shock' that would lift them out of the everyday.[6] And the many foreign visitors to the inauguration in April 1960 expressed their own anxieties in the same language. Alienation, shock and estrangement are the key terms, whether the writer is favourable or not. As a discursive phenomenon, Brasília is from the start a profoundly surreal place.

More recently I suggest that the surreal has become assimilated. Through certain cultural phenomena, such as the burgeoning religious cults in and around the city, Brasília now actively cultivates the irrational, promoting itself as the new age capital of the Third Millennium.[7] In other words, in Brasília the surreal has become something of an official style. What I provide here is not the first surrealist account of Brasília – David Underwood has already described it in these terms, and James Holston refers to surrealism in his discussion of Brasília and the avant-garde.[8] But what I do here is explore surrealism in relation to Brasília as *discourse*, and in so doing show how pervasive it is. Surrealism is not just expressed in Niemeyer's architecture, but is a basic part of the city's identity.

A new capital

Brasília was and is extraordinary, a fact recognized by UNESCO in 1988 when, after a campaign initiated by the governor of the Federal District, they agreed to declare it a World Heritage Site.[9] It now has, as a result, the same status as the Taj Mahal and the Pyramids. A settlement planned for 500,000 people, it has become a metropolitan region of 2.5 million (if one includes the peripheral areas of the Federal District) in what was until 1960 one of the most remote parts of Brazil. At the time construction was initiated, in 1957, the nearest road was over 100 km distant, and the site lay over 700 km from the nearest large city. Its altitude, 700 m, makes for a notably dry climate. The city was built with astonishing speed, the principal monuments and residential areas having been designed and constructed in a little over three years. It remains by far the largest single project of architectural modernism,

far surpassing Chandigarh in extent, and is one of the largest building projects in history.

Its plan, by the Brazilian urbanist Lúcio Costa, takes the form of a bird or aeroplane, or bow and arrow, depending on one's point of view. Its curving wings, bearing 15 km of low-rise residential blocks or *superquadras*, are bisected by a 5 km monumental axis containing the seat of government, the president's office, the ministries, the national theatre, and the bus station. At the southern end of the plan is an artificial lake, 80 km in perimeter, made by damming the river Paranoá. Costa planned different scales for different parts of the city, and the residential areas have a degree of intimacy about them. But the visitor's impressions are likely to be dominated by the immense size of the monumental axis, the vast spaces between buildings, the hugeness of the sky (Figure 17.1).

Nobody had any idea how much the project would cost, least of all those most closely involved. The city's principal architect, Oscar Niemeyer, once questioned on the subject, simply shrugged his shoulders and asked how he was supposed to know.[10] Israel Pinheiro, the president of the new town corporation, NOVACAP, was more brutal – 'if you criticise me', he once said to parliament when they had the nerve to ask him about money, 'you do not get your town'.[11] The cost, borne by borrowing on the hope that land values would rise, is generally thought to have been the cause of Brazil's economic crisis in the 1970s.

17.1
**Lúcio Costa/Oscar Niemeyer, monumental axis, Brasília, 1959**

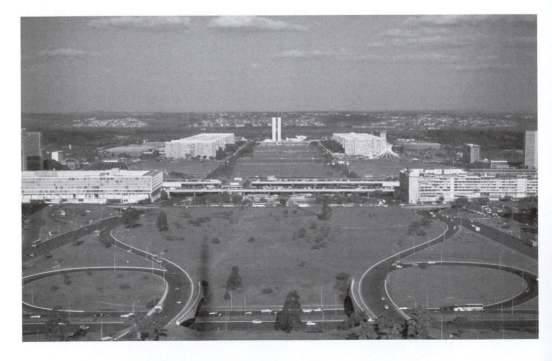

To realize such an unlikely large project as this in a democracy required a convincing rationalization. In fact, provision had been made for a new, geographically central capital in Brazil's first post-independence constitution in 1891, and the geographical state of Goiás was identified shortly afterwards as the most suitable site. The rationale then and henceforth was straightforward: the new city was the means of making a post-colonial Brazil. Rio de Janeiro, the old capital and seat of the Portuguese monarchy from 1808–21, had been long regarded by politicians as an unsuitable place for a capital city. Its climate was thought to be unhealthy, its geography awkward, its population devoted to pleasure rather than work, and its bureaucracy parasitic and lazy.[12] Like Brazil's other big cities, it was essentially colonial, looking across the Atlantic towards Europe. The post-colonial future, so the argument went, lay in the mineral wealth and the space of the vast, unpopulated centre of the country. The state of Goiás, with its high plains, hot and dry climate, and unlimited land, was thought a fine place to start. Its qualities, not to mention its physical resemblance to the western states of North America, had long been appreciated by foreign visitors, including Theodore Roosevelt, who wrote of the place after a visit in 1913 that 'any sound northern race could live here . . . surely in the future this region will be the home of a healthy, highly civilized population'.[13]

A foundation stone for the city was laid in 1922 in what is now one of Brasília's suburbs, but this was a symbolic gesture, no more. No serious thought was given to constructing the new capital until Kubitschek's presidency.[14] Kubitschek himself had apparently not thought about the new capital until 1955, but when challenged on the campaign trail about the new capital he promised to 'implement the constitution', at which point it became the central campaign issue.[15] Once elected the following year, he created an agency to build the city, NOVACAP, whose first act was to launch a design competition for the city plan, for which twenty-six entries were received. The mostly Brazilian jury also included the British planner William Holford, a Greek architectural publisher Stamo Papadaki, and André Sivé of the French government. Niemeyer had already been appointed by his friend Kubitschek to design the presidential palace, and it was his informal influence on the foreign members of the committee that led to the adoption of Costa's entry, a late submission, and no more than a sketch by comparison with the others.

A project of immense symbolic and political importance for Brazil, it not only articulated desire for political consolidation and economic development, but the amelioration of the country's social condition, in particular the deep divisions of class and race that were believed to be a product of the country's colonial history. Costa imagined the housing pattern would work actively to lessen social division.[16] Niemeyer, in public, hoped that it would be a city of 'free, fortunate men without racial or social discrimination'.[17]

Above all it was Kubitschek who rationalized the city in this way. The country was impossible to govern, he stated, with 'one part possessing extraordinary wealth, the other paying richly the price of this mirage'. Brasília was nothing less than a means of 'ensuring the physical and economic consolidation of the country'.[18] In summary, the official presentation of Brasília, its legitimizing narrative, had to do with national development. It was justified rationally in terms of economic progress, and the amelioration of social problems.

A surreal city

For some inside Brazil, Brasília's rationalism was decidedly alien. The sociologist Gilberto Freyre thought it an image picture of American or German bureaucratic efficiency, inappropriate for a developing tropical nation.[19] In place of Brasília's austere spaces organized around work and authority, Freyre imagined a different kind of utopia organized around pleasure, an area in which Brazil was already expert, and which would serve the country dominated by increasing automation. Freyre's critique is useful here because it points up some of the problems with the rational image of Brasília, suggesting that in Brazil at least it could not be straightforwardly accepted. The appearance of authority and regulation might be acceptable in northern Europe or the United States, but was alien here. So in some ways it is not surprising to find that as much as Brasília is represented as a rational project, it is also marked by surrealism. The city, outside of a few political speeches, is always an irrational place that rarely functions in the way that a rational or humane city ought. This begins with Costa's competition entry, which he claimed (with echoes of surrealist automatic writing) appeared as if in a dream: 'I am merely liberating from my mind', he wrote, 'a possible solution which sprang to it as a complete picture, but one which I had not sought'.[20]

Niemeyer meanwhile wrote of the importance of surrealist art for his work. In his memoirs, he recalled meetings in Paris with Breton, Luis Buñuel, Louis Aragon and other surrealists in the Café Cyano, and wrote approvingly of their work. His sketches, he says, have often been 'surrealist' in character, and he cited the formal influence of artists who had assimilated surrealism, including Matisse and Picasso, Henry Moore, Barbara Hepworth and Aristide Malliol.[21] But most specifically he writes of the need for architecture to 'shock' – a typical avant-garde rationale to raise or change consciousness. In Bretonian surrealism, the shock produced by decontextualization, bizarre juxtaposition or dream imagery leads to the positive state of the *merveilleux*. There is something very similar in Niemeyer's work at Brasília. 'I wanted', he wrote in 1960,

the buildings to give future visitors to the capital the sensation of surprise and emotion that moves and uplifts them. I remember St. Mark's Sq., the Doge's Palace, Chartres Cathedral, all those monuments where beauty and daring execution produce an indescribable sense of shock, without which we only have technical and functional reasons to guide the builders.[22]

This 'shock', although not theorized, indicates a desire for the irrational. Niemeyer's reluctance to acknowledge or adapt to the natural conditions of the high plain was much criticized, but there was a surrealist sensibility at work here, one which was little interested in architecture as a means of providing shelter. At Brasília, according to one account, Niemeyer was preoccupied with form alone – anything else was a 'lesser' consideration.[23] Consider, for example, the cathedral, on the monumental axis, a circular, concrete framed building whose sixteen ribs are both structural and symbolic, making a structure that reads unambiguously as a crown of thorns (Figure 17.2). Other symbolic elements include the subterranean entrance, the visitor passing through a deliberately dark passage before emerging in the light of the body of the cathedral. And it is light, shockingly so in comparison with both cathedrals of the Gothic period (Niemeyer occasionally cites Chartres as an influence) or the comparable modern cathedrals at Liverpool and Rio de Janeiro.[24] And being light – this is a mostly glass building in a climate where a typical midday temperature is 35 degrees – it is also very hot; in fact, a 'solar-fuelled hothouse' in one account.[25] It is not a comfortable building, but neither is it ordinary.

The experience of shock continues as one leaves the cathedral – the temperature drops by about ten degrees and you find yourself again on the esplanade of the ministries, in an area of exceedingly hard landscaping. There is no shelter of any kind, the only greenery being the grass poking through the paving stones, while the red dust of the surrounding land blows around. In the middle distance are the ministries themselves, low-rise, green-glass cuboids arranged with perfect regularity end-on to the monumental axis. The severity of both their form and their arrangement is achieved at the expense of functionality, for they proved incapable of maintaining a bearable temperature in the daytime heat. More than one senior official was said to keep two offices on opposite sides of the building for this reason: one for the morning and one for the afternoon.[26] This indifference to function is well represented elsewhere in Niemeyer. The predominance of white as at the Plaza of the Three Powers was explained as a means to 'illuminate the immense darkness of the Highplain', despite this being one of the most consistently sunny places in the world.[27] What matters here is a *metaphorical*

17.2
Oscar Niemeyer,
cathedral, Brasília,
1959

understanding of the site, which has little relation to material reality.
Niemeyer recognized later on that his approach was not necessarily popular,
but that it had its own integrity. What was important to him, he wrote in
2000, was making an architecture above all that was 'different'. This let him
say to contemporary visitors to the capital 'you will see the palaces of

Brasília, which you may like or not, but you will never be able to say you have seen anything like them'.[28]

Niemeyer's lack of concern for function is connected, one senses, to the experience of its building, a terrible but exhilarating period of three years from the competition to inauguration. The first time he went to the site, he recalled in an interview for the BBC, he was frankly 'scared'. It seemed 'too far away, the end of the earth. The loneliness was terrible'.[29] The living conditions were bad too, with only zinc huts for shelter. Like a battlefront, the city demanded sacrifices from its makers, who were unsure when and if they would see their families again. The harshness of the experience was only partly alleviated by *caiparinha* and the dubious pleasures of the Cidade Livre, the *favela* on the outskirts of town. But in Niemeyer's accounts, the experience is redemptive. The trying conditions produce an unprecedented camaraderie amongst those involved, from labourer to project architect, dissolving, albeit temporarily, Brazil's immense social divisions.

But to visitors from outside Brazil, the shock of the city in its early days led to no redemption. It was simply alienating. These accounts fixed on the city's terrifying isolation, the wildness of the surroundings, and, above all, the realization that the civilized life of the modern centre could only be facilitated by the presence of a huge and unruly underclass that threatened the city. Surrealism is at work here too, but not of the Bretonian kind, where alienation is the prelude to enlightenment.

Simone de Beauvoir's account of Brasília in *La force des choses* (1963) falls into this category. It describes a two-month semi-official trip to Brazil made with Sartre in late summer and autumn of 1960, and it is the most sustained literary commentary on the city made by a visitor. Sartre saw himself during the trip as the anti-Malraux, correcting the Gaullist propaganda he felt had been spread the previous year by the French minister of culture.[30] They went everywhere and met everyone, including Niemeyer and the president, Kubitschek. Brasília itself occupies five pages, although it is a sinister presence throughout. The sociologist Gilberto Freyre meets them shortly after arrival in Brazil, and tells them almost immediately that Kubitschek has blown a fortune on 'an abstract city where no-one wants to live'.[31]

Their trip to the city is characterized by foreboding, only partly alleviated with moments of dark comedy. Brasília is only attainable by road, and during their journey their driver, a government employee, takes it upon himself to seize contraband goods along the way from itinerant sellers, to resell at great personal profit in the capital, everything there being very expensive as it is 'cut off from the world'. The drive itself, on infinitely

straight roads through the semi-desert, the *cerrado*, is utterly 'dismal'. Things don't pick up much on arrival – the place is at first glance a life-size architectural model; the scale of everything is 'inhuman'. You can't go anywhere – there's precisely nowhere to go to anyway – and if you do, it's essential to go in a car. Buying a bottle of ink or a lipstick means a punitive expedition because of the heat and the sun, for which the artificial lake provides no respite – the latter merely reflects sky that appears to be on fire. Cidade Livre is the only place you can buy anything, the only place with any life, but it's a wild west town coated in a red soil that reddens the soles of your feet and fills your ears, nose and eyes with red dust.

There is no pleasure to be had anywhere. What fun is there, she writes in a passage that has been often quoted, 'in strolling around the superquadras of 6 to 8 stories, built on pilotis, where superficial variations [in form] don't counteract the elegant monotony'.[32] The street, so captivating whether empty or full, and wherever it is – Chicago, Rome, London, Peking, Bahia, Rio – 'doesn't exist in Brasília and never will'. No opportunity for *flânerie*, then. No fun either for the *candangos*, the labourers from the poor north-east, who are universally miserable and whose only pleasure is watching the wealthy residents of the superquadras, through the all-glass façades of the superquadra blocks, sit down to dinner, the apartment block becoming the *televisão de candango*. But no fun either for those at the other end of the social scale. At the presidential palace, '10 km' from the hotel, there is a statue of Kubitschek's two daughters tearing their hair out because they've been sent to Brasília.[33]

De Beauvoir's reaction is hardly surprising. An upper class Parisienne was unlikely, whatever her politics, to find much to like in the post-inauguration Brasília, a Wild West town at heart, whatever its superficial modernity. But her reactions, which almost entirely concern the city's physical trials, actually centre on the same terms which Niemeyer and others of the city's advocates use to justify the place. Here the city's alienating character is in some way essential, not something to be overcome, but an essential part of its being.

In the early responses to Brasília, the surrealist sensibility is well developed in the early photographs of the city taken by photographers for the Magnum agency, especially those by René Burri and Elliot Erwitt. Burri's pictures taken on or around the day of inauguration in 1960 tend to subvert, intentionally or otherwise, the humanistic rhetoric of the city's authors. Where they speak of the project as a means of making a new, post-colonial state in which social divisions are erased, Burri and his colleagues present a terrifying authoritarian spectacle in which the architecture appears to have come from space. This mode is well in evidence in a slightly later image, published in *L'Architecture d'Aujourd'hui* in 1962 (Figure 17.3). Depicting

17.3
**Oscar Niemeyer,
Congresso
Nacional, Brasília,
1959**

Niemeyer's congress building from the north, the twin towers of the con-
gress members' offices on the right, the dome of the senate on the left, it
shows the public – a handful of tiny figures at the top of the ramp – utterly
dwarfed by their alien surroundings.

The image, with its visible grain and high contrast, emphasizes the abstract geometry of the buildings and tells nothing about the humanistic purpose of the city, Kubitschek's main subject. But it is a powerful image of otherworldliness and authority – very good, in other words, at expressing the sense of shock that runs through so many of the literary accounts. It also belongs to a general history of apocalyptic science fiction images. The 1951 film *The Day the Earth Stood Still*, for example, tells a story of a mysterious saucer that lands on the Mall in Washington, DC. Presently a ramp opens and a giant automaton appears, bearing a message of peace for the world, but under the condition that the earth submits to his authority. Images of the saucer and the ramp are present throughout the film and they are uncannily like these early images of Brasília. I cannot say whether he meant to make specific allusion to this film. But he certainly alludes to popular images of this kind, and the intended affect – a sense of otherworldly authority – is the same in each case.[34]

For Susan Sontag, writing in the essay 'Melancholy Objects', the surreal has the tendency of flattening the world so that everything, however grotesque or bizarre, is legible as an *objet trouvé*.[35] Like the picturesque, this aestheticizing of the world is not value free, but develops explicitly from a bourgeois social position in which the viewer is essentially detached from what he sees, uncommitted and uninvolved. His gaze is that of fascination with the other. Surrealism, she writes, 'is a bourgeois disaffection'. While it appears through its subject matter to support the rights of the 'underdog . . ., the disestablished or unofficial reality', in actual fact it treats its subjects as an 'exotic prize to be tracked down and captured by the diligent hunter with the camera'. And the subjects themselves, 'sex and poverty', are the 'homely mysteries obscured by the bourgeois social order'.[36]

The surrealist mode present in these early representations of the city in fact persists through to the present day. It is no surprise to find this in journalism on the city – see Rolin and Bellos, both of whom focus on the burgeoning new-age cults throughout the Federal District. But it is strongly present too in academic accounts of the place, including James Holston's *The Modernist City: An Anthropological Critique of Brasília*. Still by far the most exhaustive analysis in English, Holston's book makes use of extensive anthropological research done in the early 1980s. Holston aims to describe the city from the point of view of its inhabitants, both the privileged middle class of the Pilot Plan, and the dispossessed on the city's fringes. The thesis is that the city is an alien import, though having increasingly taken on the characteristics of existing cities, but that this process has taken place at the periphery rather than the centre. The Pilot Plan increasingly seems irrelevant, a strange aberration.

More recent research by Brazilians would confirm aspects of this,[37] but unlike them, Holston dramatizes what he finds. Like de Beauvoir, Holston's entry to the city is made to seem extraordinary – after many hours of isolation, driving through the barren, depopulated *cerrado*, the city suddenly appears like a mirage, utterly unreal.[38] And then, once in the city itself, the life of the planned centre. Here there are, we learn, 'no urban crowds, no street corner societies, and no sidewalk sociality, largely because there are no squares, no streets and no street corners'.[39] And the form of the city means that visitors and new residents alike must learn new ways of getting around:

> The discovery that Brasília is a city without street corners produces a profound disorientation. At the very least the realization that utopia lacks intersections means that both pedestrian and driver must learn to re-negotiate urban locomotion.[40]

Elsewhere in the book, the titles of chapters dramatize the city in different ways: 'The City Defamiliarized', 'The Death of the Street', 'Cities of Rebellion'. Here is a very strange place indeed, where everything, it seems, is the opposite of how it should be. These are odd criticisms: the rigidity of the planning apart, the texture of lived existence of central Brasília in its housing density, its orientation around the private car, and its socialization around the suburban shopping mall is really not very different from the American suburb, as Evenson noted as early as 1973. The city lacks the bustle of older Brazilian cities, but there is plenty of life in the entertainment and hotel sectors of the centre, as well as the extraordinary bus station. And the Praça dos Tres Podores is, as Thomas Dekker has noted, a genuinely popular space.[41]

Holston's intention may be, on one level, to demythologize the city, but the resulting book is one that actually confirms the myth. The anthropological method means that Brasília remains the place of fieldwork with all its attendant problems: the author is a privileged outsider on the hunt for exotic human specimens. The city and its inhabitants remain – despite the author's great familiarity with them – resolutely other. The language of surrealism is the means by which this is achieved, the city being persistently represented as alienating, strange, and irrational.

Holston's case tells us a good deal about the surreal mode in operation in the representation of Brasília. The viewer, whether a foreigner like Holston or a non-Brazilian like Niemeyer, remains essentially distanced from the city, and displays a marked tendency towards exoticization. Further, this tendency to exoticize what is found produces an essentially apolitical stance, one that is essentially unconcerned with changing the state of things

as found. Spectacle is all. What matters most is the pleasure that can be given to the absent consumer of images, and in this regard the more disturbing or odd or horrific, the better. In this scheme, Brasília cannot be simply ordinary.

In this Brasília is in some ways no different from countless other cities around the world, doomed to play out its surreal position in the same way that Paris must be romantic, Los Angeles smoggy, or Manchester rain-soaked. But the city itself now seems to have assimilated the surrealist mode, so the tourist literature emphasizes the strange religious cults around the city, from the astonishing Vale do Amanhecer on the northern periphery to the pyramid of the Templo da Boa Vontage on the south wing of the city centre, the latter now Brasília's biggest tourist attraction (Figure 17.4).[42] Brazilians seem proud of these things, and keen to show them off: the visitor

17.4
**Vale do Amanhecer, Distrito Federal, 2001**

can scarcely avoid them. However, Brasília was originally produced as surreal by outsiders without much commitment to the city – a description that even applies to Niemeyer.[43] They stood outside of it, exoticized it, enjoyed its extremes of wealth and poverty, technology and nature, civilization and uncivilization, doing so safe in the knowledge that they would leave. Their apparent concern, as Sontag points out, masks the desire to aestheticize. The reproduction of the surreal mode of perception by Brazilians themselves reiterates a perceptual frame that puts them and their city at some disadvantage.

## Notes

1 A. Vidler, *The Architectural Uncanny*, Cambridge, Mass. and London: MIT Press, 1992, p. 150.

2 G. Bataille, 'Architecture', in N. Leach (ed.) *Rethinking Architecture*, London: Routledge, 1997, p. 21.

3 Bataille, 'Architecture', p. 22.

4 Breton, A., quoted in Vidler, *Architectural Uncanny*, p. 150.

5 J. Holston, *The Modernist City: An Anthropological Critique of Brasília*, Chicago, Ill.: University of Chicago Press, 1989, p. 314.

6 O. Niemeyer, 'Mes Experiénces a Brasília', in *L'Architecture d'Aujourd'hui*, 90, 1960, p. 9.

7 Several hundred religious cults have established themselves in and around Brasília: the number is growing all the time, as Alex Bellos has reported in the *Guardian* (14 August 2001). Much the largest is the Vale do Amanhecer (Valley of the Dawn) on the northern outskirts of the city, a settlement of 30,000, with its own mountain, lake, and elaborate ceremonial buildings.

8 D. Underwood, *Oscar Niemeyer and the Architecture of Brazil*, New York: Rizzoli, 1994, p. 79, Holston, *The Modernist City*, p. 55.

9 C. Wright and B. Turkienicz, 'Brasília and the Ageing of Modernism', in *Cities*, 4, November 1998: 347–64, pp. 347, 362–3.

10 Max Lock, in W. Holford, 'Brasília, A New Capital City For Brazil', in *Architectural Review*, 122 (731), December 1957, p. 157.

11 Holford, 'Brasília', p. 158.

12 Holford, 'Brasília', p. 395.

13 Roosevelt, quoted in N. Evenson, *Two Brazilian Capitals*, New Haven, Conn. and London: Yale University Press, 1973, p. 101.

14 Holston, *The Modernist City*, p. 18; Juscelino Kubitschek was president from 1956–61.

15 V. Fraser, *Building the New World: Studies in the Architecture of Latin America 1930–1960*, London: Verso, 2000, p. 216.

16 Costa, in Holford, 'Brasília', p. 401.

17 Niemeyer, 'Mes Experiénces a Brasília', p. 9; Niemeyer's position has never been exactly consistent. His public statements about the Brazilian social situation, and his membership of the Brazilian Communist Party, contrast with his architectural practice which has been preoccupied with formal invention. At Brasília, his work concentrated on those areas – monumental public buildings – where his formal skills could be most dramatically deployed. He designed none of the superquadras, for example.

18 J. Kubitschek, Interview, *L'Architecture d'Aujourd'hui*, 90, June–July 1960.

19  Gilberto Freyre, *Brasis, Brasil, Brasília*, Lisboa: Libros do Brasil, 1960, pp. 156–7.

20  Costa, in Holford, 'Brasília', p. 399.

21  O. Niemeyer, *Les Courbes du Temps*, Paris: Gallimard, 1999, pp. 126–7.

22  Niemeyer, 'Mes Experiénces a Brasília', p. 9. These views were confirmed in interview with Niemeyer in Rio de Janeiro in September 2001, and in a visit to the Niemeyer Foundation at Canoas at the same time, where the remnants of the architect's library showed an interest in surrealism.

23  R. Harbison and G. Balcombe, 'Conversation in Brasília', *RIBA Journal*, vol. 68, no. 13, November 1961, pp. 481–94.

24  F. Gibberd, Roman Catholic Cathedral, Liverpool, 1960. Nikolaus Pevsner compares this directly with Niemeyer's work. See Pevsner, N., *The Buildings of England: South Lancashire*, London: Penguin Books, 1969, pp. 194–5. The other comparison is the Catedral Metropolitana de São Sebastião do Rio de Janeiro, designed by Edgar de Oliveira da Fonseca in 1964, and constructed between 1965 and 1976. Both these share a conical form with the Brasília cathedral.

25  Wright and Turkienicz, 'Brasília and the Ageing of Modernism', p. 352.

26  D. Crease, 'Progress in Brasília', in *Architectural Review*, 131 (782), 1962, p. 258.

27  Wright and Turkienicz, 'Brasília and the Ageing of Modernism', p. 352.

28  O. Niemeyer, *Minha Arquitectura*, Rio de Janeiro: Revan, 2000, p. 43.

29  O. Niemeyer, Niemeyer habla de Brasília, 41 años despues, 2001, http://news.bbc.co.uk/hi/spanish/misc/newsid_1292000/1292551.stml. Accessed 11 November 2001.

30  André Malraux (1901–76) was French Minister of Information under de Gaulle from 1945–6, and Minister of Cultural Affairs during the period 1960–9.

31  S. de Beauvoir, *La force des choses*, Paris, Gallimard, 1963, p. 535.

32  De Beauvoir, *La force des choses*, p. 577.

33  De Beauvoir, *La force des choses*, pp. 577–8.

34  Niemeyer seems to cultivate the otherworldly aspects of his architecture. Interviewing him in September 2001 in Rio, he showed me a film that had been recently made by a Belgian about his work. It opened with an animated sequence in which a flying saucer was shown flying over Rio, landing on a rocky promontory at Niterói. At this point it became the new art gallery recently designed by Niemeyer, and the architect, superbly performing his role as extraterrestrial visitor, descended the ramp and introduced himself.

35  S. Sontag, *On Photography*, London: Allen Lane, 1978, p. 46.

36  Sontag, *On Photography*, p. 54.

37  Wright and Turkienicz, 'Brasília and the Ageing of Modernism'; F. de Holanda, 'Brasília Beyond Ideology', *DOCOMOMO Journal*, 23, August 2000; T. Dekker (ed.) *The Modern City Revisited*, London: Spon, 2000.

38  Holston, *The Modernist City*, p. 3.

39  Holston, *The Modernist City*, p. 107.

40  Holston, *The Modernist City*, p. 101.

41  Dekker, *The Modern City Revisited*, p. 176.

42  A. Bellos, 'Tomorrow's World', the *Guardian*, 14 August 2001.

43  Niemeyer asked me how long I intended to stay in Brasília: 'two weeks', I ventured. 'Two days would be more than enough' was the retort. (Interview with Niemeyer, September 2001.)

Chapter 18

# Latencies and imago

## Blanchot and the shadow city of surrealism

*M. Stone-Richards*

### Ouverture

> The work holds open the Open of the world.
>
> Martin Heidegger, *The Origin of the Art-Work*

When one considers the main lines of post-Hegelian philosophy in which
questions of negativity, temporality and affect have played determinant roles,
one is not surprised to find, given the role of architecture in Hegel's aes-
thetic, that the European avant-garde, above all Surrealism, should have
become a means for giving historical form and significance to questions
bearing upon the architectural to the extent that the European avant-garde,
mediated by its Symbolist-Hegelian heritage – Villiers de l'Isle-Adam, Mal-
larmé, but also Jarry – was shaped, conditioned by the experience of totality.
On such an account – leaving aside the Cubism of Picasso, Braque, Léger
and Gris as a special case[1] – the historic avant-garde, from Futurism onward,
is to be distinguished from its formalist peers by the articulation of an ethical
experience enjoining a political correlate in the realization of a *project*, a
project in which no art would be self-legitimating, denying, in other words,
autonomy to form or to distinct historicities of form. On such an argument,
Fauvism, for example, like its forebear Impressionism, is but a group of

painters whilst Futurism, like its Symbolist forebears,[2] was a movement in culture. Where it should make no sense to speak of a Fauvist or Impressionist poetry, decorative arts, theatre, still less architecture, in Futurism, based upon a developing *practice*, and not upon a singular commitment to the explicit fiction of the autonomy of form, it is intelligible to speak of Futurist poetry, theatre, dance, music and, indeed, architecture, all the more so where architecture, never to be conflated with building, becomes an image encompassing the form of life to be desired, the city of communal being, whence the requirement that every such ethical vision – or demand – enjoin a political dimension for its articulation. Manfredo Tafuri, in his study *The Sphere and the Labyrinth*, understood that though the historic avant-garde rejected their Symbolist forebears, the essential vision of the city, the form of its affective discourse, was definitively shaped by Symbolist culture.[3] The philosophers of our modernity – Benjamin, Wahl, Croce, Wittgenstein, Heidegger, Sartre, Cavell, Derrida, Arendt – articulate in discursive form the aesthetic intelligence opened by this culture, the fading accomplishment of Romanticism.

Perhaps no philosopher of the twentieth century – not even Wittgenstein, who under the influence of Loos created the beautiful house for his sister Margarete Stoneborough[4] – indeed, since Hegel, has had as much influence on architectural discourse and culture as Martin Heidegger, since his 1935 lecture on "Der Ursprung des Kunstwerkes (The Origin of the Art-Work)," but even more so since the 1951 lecture on "Bauen Wohnen Denken (Building Dwelling Thinking)"[5] which opens, in all modesty: "In what follows we shall try to think about dwelling and building. This thinking about building does not presume to discover architectural ideas, let alone to give rules for building."[6] Rather, says Heidegger, his meditation seeks to trace "building back into that domain to which everything that *is* belongs"; which is to say, Being (p. 145). From the late 1950s onward, beginning with the group of French Marxist-Heideggerians (philosophers and sociologists) gathered in the group and eponymous publishing series *Arguments* – Kostas Axelos, Jean Duvignaud, Edgar Morin and Henri Lefebvre – that dealt with the ecological aspects of Heidegger's thinking – in their language, *la pensée planétaire* – along with the Norwegian Christian Norberg-Schulz, there grew up a veritable industry of phenomenological (almost exclusively Heideggerian) accounts of architectural *experience*: Kenneth Frampton, Karsten Harris, Dalibor Vesely, Robert Mugerauer are, with Norberg-Schulz, amongst the notable names which, on the side of architects, could include Tadao Ando and Daniel Libeskind – the latter having studied with Vesely as a graduate student at the University of Essex in England.[7] With Heidegger, certain luminary names emerge in phenomenological reflection on spatiality and architec-

tural experience: Hans-Georg Gadamer and Gaston Bachelard. (Occasionally commentators might observe that the author of *La Production de l'espace* (1974), Henri Lefebvre, served a very important part of his intellectual life, after finally leaving the Communist Party, as a Marxist-Heideggerian with *Arguments*.) The reasons for this are not, of course, hard to find: other than the key status of "Der Ursprung des Kunstwerkes," which would shape the post-Second World War European mode of philosophical poetics in the interpretation of art,[8] "Building Dwelling Thinking," along with the reflections on the *question* of the status of technology implicated in any historical understanding of (a) Western metaphysics and its relation to (b) violence in modernity, ensured that Heidegger's thinking on the status and nature of dwelling and the architectural would reach an audience beyond professional philosophy. The leading Heideggerian concepts to emerge from this period, "Weltbild" and "Ge-stell," would quickly come to be deployed beyond Heidegger's immediate concerns.

Parages

[Blanchot] que je considère tout simplement comme le chantre de nos lettres . . .

Jacques Lacan, *Séminaire VI* (1961–62), *L'Identification*,
27 juin 1962

The controversies surrounding the nature of Heidegger's National Socialism in no way diminished the importance and reception of his thinking on the architectural, and Jacques Derrida, for his part, has furthered the critical understanding of Heidegger's thinking on the implicit relationship between metaphysics, violence and technology[9] and has himself, in a post-Heideggerian mode, contributed significantly to debates – through Eisenman, Tschumi, Libeskind and others – on the status of the architectural in the experience of modernity.[10] Even if the American reception of this aspect of deconstruction and architecture discourse has downplayed the Hegelianism of Derrida's thought – for which without doubt the determinant work will be seen to be *Glas* in which the architecture of Hegelian experience, which is to say, of modernity, is thought in terms of the rest, remnants and relics[11] – it remains strange, haunting, even, that the name of Maurice Blanchot, at the intersection of all of these debates, has scarcely figured in the architectural discourse *pace* Hegel, Heidegger, Derrida or, indeed, Surrealism, since for each of these moments, Blanchot's thought is determinately present, and through Blanchot the presence of the surreal – over which time *n'a pas de*

*pris(e)*, as Breton expressed this in the prose-poetic *récit* of *Arcane 17*.[12] Derrida, for his part, has never failed to acknowledge the role of Blanchot for the unfolding of his thinking; and no interpretation of Surrealist experience, encompassing Bataille, has approached the subtlety and power of that developed by Blanchot. Bernard Tschumi on Surrealism is but a means to Bataille; Rem Koolhaas on Dalí and delirious New York, no more than a toolbox; whilst Anthony Vidler, so fluent and well-informed that he quotes readily from the unpublished *Séminaire* of Lacan never, to my knowledge, in his many discussions of Surrealism and architecture, approaches Blanchot even when his discussions, such as his essay on Diller and Scofidio, rightly and tellingly stray into the larger culture of Surrealism – especially pertinent here is Vidler's rapprochement of Caillois with the great phenomenological psychiatrist Eugène Minkowski – in order to rearticulate Surrealist experience beyond its immediate chronological confines for a new generation.[13] Glance through any of the standard anthologies on modern architectural discourse and culture and, even where Surrealism is a topic of discussion, Blanchot will not be found.[14]

Consider, though, Mark Wigley's seminal study of *The Architecture of Deconstruction*, tellingly sub-titled "Derrida's Haunt," and we find but occasional references to the name of Blanchot. In what remains by far the most sustained serious book on Derrida and architectural thinking, Blanchot is not discussed by Wigley other than to situate the occasion of an essay by Derrida, to wit, "In 'Title (To be Specified),' a reading of Maurice Blanchot's short story [*sic*] 'La Folie du jour,' Derrida looks at the curious architectonic role of any title."[15] And yet, when we begin to reflect on the elements of Derrida's thinking on architecture undertaken by Wigley – elements such as uncanniness, dislocation of space, the event of taking place – it becomes clear that these elements are fully developed in Blanchot's novels, *récits* and reflection and, furthermore, in such a manner that makes ineluctably evident the dislocating presence of Surrealism in Blanchot's imaginary and, through Blanchot, in Derrida too. Wigley's very sub-title "Derrida's Haunt" is difficult not to think of in relation to the opening of Breton's *Nadja*: "Qui suis-je? Si par exception je m'en rapportais à un adage: en effet pourquoi tout ne reviendrait-il pas à savoir qui je «hante»?"[16] And, linking the inherited Romantic disposition for the particular form of fragment that is the ruin with a Surrealist attention to the aporias of the symbolic, Breton, in his essay on "Limites non-frontières du surréalisme" (1936/37), observes how

> Les ruines n'apparaissent brusquement si chargées de significations que dans la mesure où elles expriment visuellement l'*écroulement* de la période féodale; le *fantôme* inevitable qui les

*hante* marque, avec une intensité particulière, l'appréhension *du retour des puissances du passé*; les souterains *figurent* le cheminement lent, périlleux et obscur de l'individu humain vers le jour.[17]

And finally, when one considers the title of Derrida's collection of essays on Blanchot, namely, *Parages* – a word of some import to Surrealists such as Jules Monnerot, Louis Aragon and Breton[18] – it is quite difficult not to think of the opening of that most enigmatic text "Il y aura une fois" (1930) which concentrates in almost hermetic terms Breton's thinking on architecture and the event of place, a text which opens with a quotation from Huysmans' *En rade* thus:

> Imagination n'est pas don mais par excellence objet de conquête. "Où, se demande Huysmans, dans quel temps, sous quelles latitudes, dans quelles parages pouvait bien se lever ce palais immense, avec ses coupoles elancées dans la nue, ses colonnes phalliques, ses piliers emergés d'un pavé miroitant et dur?"[19]

This emergence of the relations of dream, architecture and the event of place – to which we shall return in more detail – is presented in explicitly philosophical and specifically Hegelian terms by Aragon in the *Paysan de Paris* (1926), and furthermore in a language the terms of which will be both Blanchotian and Surrealist. Quoting the Hegel of *La Philosophie de l'esprit* in Véra's translation on the origin of sexual difference in relation to the capacity of judgment, Aragon turns to the Passage de l'Opéra in which *tant de promeneuses diverses se soumettant au jugement* in such a way that their femininity is *total* in comparison with which a man or a child "qui cherche une image de l'absolu pour ses nuits, n'a rien a faire dans ces parages."[20] Where certain women have made of this *place* – that is, the Passage de l'Opéra – their general ambience (quartier general), "D'autres ne hantent pas les passage que par rencontres: le désoeuvrement, la curiosite, le hasard...,"[21] from which is but a small step to Blanchot's interpretation of Nadja wherein Surrealist experience is such that *la rencontre nous rencontre*,[22] now become part-and-parcel of Blanchot's conception of the experience of thinking marked by encounter, chance (*hasard*) and, to be sure, *désoeuvrement*. *Tout a fait désoeuvrée et très morne*, such was Breton's description of the afternoon as recounted in the second part of *Nadja* when on 4 October 1926 he encountered Nadja for the first time.[23] This experience of *parages*, of indeterminate distance, a nautical term indicating a difficulty of assessment, of measurement of something that cannot

be assessed to be either far or near, is here, in the terms of Surrealist experience, situated within an architecture becoming strange, an architecture in course of being lost, undone: the dismantling of the Passage de l'Opéra which is a condition of its modernity for Aragon, Breton and Benjamin, which is to say, its becoming de-familiarized, open to *désoeuvrement* and de-materialization.[24] Such is the claim for Heidegger's *destruction* of architectural metaphor in philo-sophical thought that Wigley would find in his reading of Derrida.

Question, approach

If, then, "Heidegger's well-known criticism of the traditional philosophy of art in The Origin of the Work of Art ... turns on an architectural example ... [that] disturbs the familiar understanding of building,"[25] we should recognize this as the formality of Heidegger's *modernism*: de-familiarization, making strange, the *insolite*, are the synonymous modes, from Symbolism through Russian Formalism to Surrealism, for the recovery of experience from habit. We should note, too, that in "The Origin of the Art-Work," Heidegger speaks repeatedly of the question [die *Frage*]: the question concerning the origin of the work of art (pp. 17 and 19);[26] the question as to what truth is and how truth can *happen* (p. 41, my emphasis); "We now ask, he says, the question of truth with a view to the work" (p. 41), and underlining that the problematic is as much upon the nature of questioning – i.e., the manner of *approach* to ... – as it is upon the art-work, he notes "But in order to become more familiar with what the question involves, it is necessary to make more visible once more the happening of truth in the work" (p. 41). The visibility in ques-tion here, the manifestation, is such as to foreground the *work* not as object – architecture as thing – but as event or happening: that which works and in working permits relations of visibility to be maintained, sustained, whence:

> The temple, in its standing there, first gives to things their look and to man their outlook on themselves. This view remains open as long as the work is a work, as long as the god has not fled from it.[27]

It is here crucial to appreciate that when Heidegger first intro-duces architecture in "The Origin of the Art-Work," it is *conjointly* introduced with sculpture: "Architectural and sculptural works can be seen installed in public places" (p. 19); in other words, that is how familiar they are, art-works. "The Origin of the Art-Work" sets up architecture as a public spatiality, which, furthermore, can collapse when it ceases to be an event and the

place (*Ort*) for happening, a place for the work of working. The public spatial-
ity of architectural and sculptural works, then, is not separate from another
kind of spatiality whose work is marked by the possibility of collapse, of neg-
ativity. It is with this *other spatiality* that Blanchot and Surrealism are con-
cerned – a spatiality marked by passage and transition – and where
architectural metaphoricity encounters, comes with, the possibilities of de-
familiarization and dislocation of space, that which, following the great study
of Pierre Kaufmann on *L'Expérience émotionnelle de l'espace* (1967), I shall
refer to as the *dessaisissement de l'espace*.[28]

With the rejection by the young Surrealists of Apollinaire's *esprit
nouveau* there goes, too, his conception of modernity and the nature of its
space; in its stead, the reciprocities and aporia between subject and object,
language and experience, the time of the world and the time of the subject,
along with a conception of spatiality *in terms of place*; that is, in terms of
limit and measure. For place is not space, the particularity or instantiation of a
more abstract structure. Common to all accounts of the problem of place, as
distinct from space, is the idea of the negation of geometric space: *Entfer-
nung* (deseverance) is Heidegger's term from *Being and Time*; *dessaisisse-
ment* is the term used by Pierre Kaufmann in his *L'Expérience émotionnelle
de l'espace*, whilst Breton, in *Nadja*, deploys the term *faits-précipices* for this
experience of the negation of space acceding to place, the experience of
finding oneself *hors de son plan organique*. The other telling characteristic
common to accounts of place is the crucial role accorded to passivity (most
tellingly in Plato's account of the *chôra*): within the instant, there obtains a
simultaneity of events (and significations) to which the apprehending con-
sciousness, far from being in a position of mastery, is, instead, subject (psy-
chosis, anguish are but dramatizations of such radical passivity.) Place, thus,
can be characterized as the functional imbrication of different temporalities in
the "rapprochement de deux réalités plus ou moins éloignées"[29] in the same
instant. Amongst the first self-conscious developments of this new concep-
tion of spatiality in terms of place as the experience of limit and measure
were Aragon's *Le Paysan de Paris* (1926) and Breton's *Nadja* (1928).

Transition

Though many have celebrated Surrealism's critique of the architectural avant-
garde, it is by no means clear that the implications of Surrealism's thinking
on the experience of the city and architecture have been fully grasped. From
Baudelaire to Surrealism and the Internationale Situationniste, there is a
common rejection by the poetic avant-garde of the architectural and urbanist

avant-garde: Haussmann, Le Corbusier are equally vilified by the poetic avant-garde for the imposition of quantitative spatial practices that result in a loss of temporality or fluidity (Guy Debord). Instead, for Surrealism there is a valorization of architecture Modern' Style and of the outmoded or the naïve in a manner that calls attention to architecture and the city conceived in terms of latencies and supports for the archaic, leading to a conception of experience marked by interrupted temporalities – caesuras, intervals, voids, negative spaces, absences and uncanny (*insolite*) moods – along with loss within a city-scape marked by indeterminacy, finitude, negativity and anguish, no less, indeed, than boredom. Within this attitude, the architectural sites favored by Surrealism – La Tour Saint-Jacques, La Place Dauphine, etc. – are, it will be argued, (archaic) traces, symptoms within the pathology of the modern city which mark out a negative spatiality where the imaginary encounters and seeks to limit, to distort the boundaries of the Symbolic; they are, above all, these sites, *fragments* within a transformed psychic *envelope* – and it cannot be avoided just how many of the key moments of the Surrealist experience of the city find their realization *at night*, a principal means for the setting into motion of the undoing of space (*dessaisissement*) for the accession of the experience of place. Since 1943, that is, with the publication of *Faux pas*, there is in Blanchot's lifelong meditation on the possibilities of Surrealist experience and a full awareness of the radicality of Surrealist thinking on movement in the city as a movement of absence, un-doing work, of alterity, what Blanchot in his interpretation of *Nadja*, calls the third (*le tiers*), and that, furthermore, the city is the form of this thirdliness – the shadow city, in other words. Lastly, Blanchot deploys a radical conception of the imaginary – something which Lacan appreciated and acknowledged in his *Séminaire* of 1961–62 on *Identification* – and sees in Surrealism a form of experience that enjoins the imaginary in its emphasis upon fragmentation, for the significance of Surrealism on Blanchot's account is that it is an "experience of experience,... [an] experience which dismantles [and] interrupts itself."

Within Surrealism, one emerging practice more than any other captured the varying dimensions of the architectural in a performative mode of construction, interruption and dismantling, and that was the Surrealist exhibition. Here we might foreground the possibilities and scope of Surrealist sensibility in architecture in terms of (a) Surrealist taste: the Palais Idéal of the Facteur Cheval, Gaudí's Sagrada Familia, the organic imagery of Guimard's métro designs, La Tour Saint Jacques, etc.; (b) the use of maps and mapping so important in the iconography of an artist such as de Chirico (such as the painting *La Politique*, 1914, with its depiction of a partial map of Scandinavian/Russian Europe[30]) and in the "imaginary" iconography of the

art of the insane. An especially important example of such an imaginary map is that drawn from Marcel Réja's *L'Art chez les fous* (1907) depicting the plan of an imaginary city *based upon the plan of ancient Babylon* which the Surrealists would use as the basis for their "Ville surréaliste" in the 1938 Exposition internationale du surréalisme, the first authentically *Surrealist* exhibition as installation;[31] (c) within the Surrealist récits of Paris – *Paysan de Paris*, *La liberté ou l'amour!*, *Nadja* going back to *Les champs magnétiques* – there is a developing conception of the city as text to be deciphered, which is to say, the city as enigma, as well as an approach to the city in its urban fabric – which, psychologically, is apprehended as a matricial support – conceived in an iconography of night,[32] of liminal suspension, in which places (La Place Dauphine) and architectural structures (Le Passage de l'Opéra) are eroticized, even though such eroticization is never separate from the work of negativity, or, more specifically, anguish;[33] finally (d) the practice of the city slowly elaborated through the récits, a practice, that is, in the reconception of the imaginary at the collective level, finding its architectural form in the construction of programmatic exhibitions beginning with the 1938 Exposition internationale and continuing with the *First Papers of Surrealism* installation in New York in 1942. Such exhibitions were never Surrealist simply because works by Surrealists were exhibited; rather, the enterprise had to be a collective one. It had also to deploy a theme that responded to the culture and politics of its time – in other words, the exhibition was understood to be a form of intervention – and, finally, a distinct space, and therefore architecture, had to be constructed.[34] (In this light, one can see that the Surrealist exhibition fulfilled the role of the theater for Russian Constructivism in the imagination of cities yet to come.[35]) Finally, the forms of architecture and iconography developed in the Surrealist installation-exhibitions, following on from the practice of the city elaborated through the récits, are such as valorize feminine – I should say, choric – spatiality: the construction of tactile, haptic spatialities with "inner," indistinct sounds which evince forms supportive of experiences of reversibilities. When one considers the architectures of Gaudí, the Facteur Cheval and other Surrealist admirations, it jumps out just how much such works are heavily textured surfaces, and as such not just works of touch and kinesthetic appeal but works which invite loss of sensation, this helping one to understand that, at the unconscious level, the specificity of Surrealist architectural metaphoricity is the approach to a surface that is skin-like. Indeed, Tzara, who, in the 1930s could be quite Jungian, has reflected upon this phenomenon in almost Kleinian terms, noting the satisfaction given by substances for touching, licking, sucking, breaking, eating, when applied against the skin or the eyelid.[36]

Traces, undergrounds and childhood neurosis: the architecture of Surrealism

Though Surrealism's status as the representative European avant-garde movement is more secure than ever, and many in architecture culture, as with the art history of "modernism" from the 1970s, have turned to it as a means of envisioning alternative models of architectural hermeneutics (or semiotics), it remains that its conception of the experience of modernity does not align it with architectural modernism. Colin Rowe and Fred Koetter, in their *Collage City* of 1978, felt able to point out, with scarce concealed astonishment, that it was rarely grasped that the poetic avant-garde was by no means continuous with the architectural avant-garde:

> [Though unobserved and] mostly ignored by the architect, there have long been available two distinct but interrelated formulations of modernity. There is the formulation, dominant for the architect, which might be described by the names: Emile Zola, H.G. Wells, Marinetti, Walter Gropius, Hans Meyer; and there is the alternative formulation which could be identified by the further names: Picasso, Stravinsky, Eliot, Joyce, possibly Proust. So far as we are aware this very obvious comparison of two traditions has never been made.[37]

My concern is not whether this difference had been noticed before – it had – but to point out that, in effect, what Rowe and Koetter had identified is a *technological* avant-garde and what I shall term a non-technicist avant-garde (alone of the great European avant-garde movements Futurism and Russian Constructivism were committed to technology and relatedly to a belief in Progress). I should also argue that within the poetic avant-garde, whose basis in Symbolist thought is here determinant, the city is conceived, fundamentally, in organic terms, which is first to say, in terms of temporality, embodiment and latency, with the question of *identification* between city and body (rather than soul and city) being left open; that is, aporetic, given the role, certainly for Surrealism, of distortion as the inevitable result of dream-work. Tzara, in his study of the component of compulsion in the faculty of taste, has given the sharpest sense of the significance of *identification* in noting that "Ce qui distinguerait l'homme évolué du primitif, serait alors sensiblement développée, *la faculté de transfert* dont le rôle reste à étudier historiquement avant tout dans l'élaboration de la métaphore."[38] Hence the Belgian Symbolist Georges Rodenbach on the city as a living form in the preface to his novel *Bruges-la-morte* (1892): "In this study of the passion I have tried first and foremost to evoke a city as one of the principal

characters . . . Bruges, our elected city, is portrayed in fact, as almost human. [Those who live there] are moulded by the city according to its historical sites and its bells . . . it is the town which directs all that occurs there; the urban landscapes are not mere backdrops." Consistent with this mode of affective transfer worked out in the Symbolist tradition from Baudelaire to Rodenbach, in *Le Paysan de Paris* Aragon rejects the importation through Haussmann of the grid,

> Le grand instinct américain, importé dans le capital par un préfet du Second Empire, qui tend à récouper au cordeau le plan de Paris, [qui] va bientôt rendre impossible le maintien de ces aquariums humains déjà morts à leur vie primitive.[39]

In a telling moment that makes clear the manner in which the city, in Surrealism, is thought of in terms of embodiment, identification and the organic, Aragon would comment upon the penetration, the arrival of the Boulevard Haussmann:

> C'est à peu près au niveau du Café Louis XVI qu'il s'abouchera à cette voie par une espèce singulière de baiser de laquelle on ne peut prévoir les suites ni le retentissement dans le vaste corps de Paris. On peut se demander si une bonne partie du fleuve humain qui transporte journellement de la Bastille à la Madeleine d'incroyables flots de rêverie et du langueur ne vas pas se déverser dans cette échappée nouvelle et modifier ainsi tout le cours des pensées d'un quartier et peut-être d'un monde.[40]

Leaving aside the obvious example of *Nadja* (1928), and turning to the 1930s (that is, the period that sees the definitive *mise-en-forme* of Surrealist thinking), Breton, in his turn, in the lecture "Situation surréaliste de l'objet" (1935), dismisses what he characterizes as the cold rationalism of Le Corbusier's *L'esprit nouveau*, and in its place valorizes the architecture of the Modern' Style 1900. In a strange, beautiful, indeed, *enigmatic* text of 1930, "Il y aura une fois,"[41] as though at the very mention of the word *ennui*, modern architecture will be evoked by association, Breton, in powerfully direct terms, will declare: "On ne peut se defendre de penser ainsi et de prevoir, devant ces aveugles architectures d'aujourd'hui, mille fois plus stupides et plus revoltantes que celles d'autrefois. Comme on va pouvoir s'ennuyer là-dedans! Ah! l'on est bien sûr que rien ne se passera."[42] In very similar terms, Tristan Tzara, realigned with Breton between 1929 and 1935, will articulate an especially crucial aspect of Surrealist architectural sensibility

– namely, the valorization of the maternal and pre-symbolic, the realm of phantasmatic experience, when he observes of so-called "modern" architecture, "aussi hygiénique et depouillée d'ornements qu'elle veuille paraître, n'a aucune chance de vivre . . . car elle est la négation complète de l'image de la *demeure.*"[43] Instead, Tzara, in a manner that echoes Giacometti's récit of the enormous black (feminine) presence (stone) depicted from the perspective of childhood in "Hier, sable mouvants" (1933),[44] evokes the world of "the mother" – the citation marks belong to Tzara – since the cave, the grotte, the igloos of the Esquimaux, even the tent, along with circular, spherical or irregular houses, emergent from and evocative of tactile, haptic depths, the interior at once of childhood and inter-uterine life, a life, that is, which does not know "l'esthétique de castration dite moderne," which aesthetic of castration is at the same time "la voie de l'aggressivité auto-punitive qui caractérise les temps modernes."[45] It is in this context that we find an explicit ennunciation by this former Dadaist of the role of latency in the architectural experience, which must, on this account of the *demeure* – which I here translate provisionally as that which survives, shelters, resides – be proximate to childhood – hence Tzara's allusion to Baudelaire's *luxe, calme et volupte* – for, as though anticipating the argument that his position might be "retrograde," Tzara comments that "Ce sera, en faisant valoir à ces aménagements les acquisitions de la vie actuelle, non pas un retour en arrière, mais un réel progrès sur ce que nous avons pris comme tel, la possibilité qu'on donnera à nos désirs les plus puissants, parce que latents et eternels, de se libérer normalement."[46] When, some five years later, Matta, fresh out of Le Corbusier's studios, will speak of man's longing for his origins *enveloped* in humid walls "où le sang battait tout près de l'oeil avec le bruit de la mère," of walls "comme des draps mouillés qui se déforment et épousent nos peurs psychologiques," of FIXTURES "qui déroulent d'inattendus espaces, cédant, se pliant, s'arrondissant comme une marche dans l'eau [an unformulatable trajectory] qui dessine un espace nouveau, architectural, habitable,"[47] he adds little to Tzara or to the Surrealist conception of a feminine architecture of metaphoricity, what he himself – with the aid of Georges Hugnet – will refer to as "une matrice fondue sur nos mouvements."[48]

In Surrealism, architecture, never separate from the movement of the city, the support of any differential articulation, came to be a privileged form for the exploration of this temporality of the archaic and the matricial continuously available. Hence Breton, in his reflections upon architecture Modern' Style, would observe that though advanced painting had made considerable inroads into the privilege of poetry – Breton's argument is clearly Hegelian – he notes: "Chose remarquable, il semble que l'architecture, c'est-à-dire le plus élémentaire de tous les arts, ait été aussi le premier

à s'orienter vraiment en ce sens,"[49] in overturning the received idea of human construction in space in such a manner as to be able to give expression to repressed desire. Not only does Breton identify the architecture Modern' Style with this movement toward poetry – which for Breton means a movement toward higher intelligibility – he further identifies it with the expressive terrain of latencies and the archaic, the movements of which, potentially automatist, potentially autonomous, may cause surprise or shock. When there is talk of Surrealism and the uncanny, it is often forgotten that for Freud, as also for Breton following Freud, the uncanny must be a function of feeling – for Freud sees himself in the opening lines of the essay on the uncanny as contributing to *an aesthetics of feeling* – as also, in a necessarily related mode, *the repetition of childhood anxiety*, of archaic experiences, in other words. Thus Breton, quoting Dalí, will speak of the forms of architecture Modern' Style as "réalisations de désirs solidifiés, où le plus violent et cruel automatisme trahit douloureusement la haine de la réalité et le besoin de refuge dans un monde idéal, *à la manière de ce qui se passe dans une névrose d'enfance.*"[50] To the extent that archaic experiences remain at work (unconsciously) upon, within and through an individual in shaping his or her experience of embodiment, then we may speak of the form of the archaic experience in terms of the unconscious bodily image called the imago, and on this argument the imago in Surrealist experience encompasses the city, *la forme d'une ville* of Baudelaire's plainte at the fading of Paris, whence the possibility of what Marie-Claire Bancquart, in her beautiful study *Paris des surrealistes*, speaking of the work of automatism on the terrain of the archaic, characterized as a transference at the level of the city, "[un] transfert à une echelle plus grande que celle de l'homme."[51] Indeed, it is the possibility of this transferential work – this *transfert de travail* – this primary act of defamiliarization and *dessaisissement* that opens up all the subsequent possibilities, among which the city approached as dream-scape.[52] Hence, too, the prevalence in Surrealism of a language of experience – whether interior experience or "psychological" experience – as *hors du temps*, such as in Breton's account of the dream of palaces and cupolas in Huysmans' *En rade*.[53] Transferential work, in making available the movement of the unconscious, or moments of the dream, anachronizes time. It is this sense of the anachronic contemporaneity of the city, of the shadow of Paris, in which, as Blanchot famously observed, "Nadja est toujours rencontrée," that is captured in Blanchot's interpretation of the radicality of Surrealist thinking on movement in the city as a movement of alterity, what Blanchot in his interpretation of *Nadja* calls the third (*le tiers*), and that, furthermore, the city is the form of this thirdliness, the shadow city, in other words.

Far from it being the case, as Bernard Tschumi once argued, that Surrealism neglected architectural spaces – the void, emptiness – that for Surrealism "[r]eal spaces were less important than the symbolic images they contained,"[54] there is in Surrealism a radical rethinking of spatiality which is part of (a) a critique of modernity, (b) an understanding of inner space as imaginary and archaic, and (c) as implicating an experience conceived in terms of transition and passage, as, indeed, part-and-parcel of a temporalized psychic envelope. Against Apollinaire's celebration of technological modernity, the Surrealist *approach* to the city – from *Les Champs magnétiques*, to *La liberté ou l'amour*, in *Le Paysan de Paris*, in Breton's *Nadja*, no less than in certain paintings by Magritte (*L'assassin menacé*, 1927) or the collage novels by Ernst – is concerned with the city as a support for latent desires, the latencies of which can only be uncovered if the normal libidinal attachments governed by habituation are un-done, hence the cultivation in Surrealism of collective practices, and techniques of passivity such as *disponibilité*, free-floating attention, aleatory walking, boredom and other modes which result in an "informe" relation to the socially given and habitual. This uncovers a city-scape marked by absences, non-time (what *is*, what happens, what works *hors du temps*), of rests, remnants, residues and relics for which architectural forms become means of articulating the muted shapes of an inner experience that is not a *personal property*, and not separate from the spatiality of city forms and supports.

Shadows

Le monde d'ombres nouvelles connu sous le nom de surréalisme.[55]

André Breton

Where architectural modernism is preoccupied with air, circulation, clarity (of vision, line and form), with light as transparency, Surrealism's approach to the city, coming out of Symbolism, Atget and de Chirico (*L'Enigme d'une journée*, 1914), begins with the possibilities of silence – "Nous courons dans les villes sans bruit," says the inaugural prose-poetic text of Surrealism, "La glace sans tain" – and of movement in the city in terms of affect – and thus necessarily in terms of relations of projection and introjection, the phenomenological texture of proximity and distance[56] – in a medium infused with night, become an intermediate or transitional state (consider La Tour Saint Jacques in *L'Amour fou*), that quality of suffusion and nascent, proleptic de-materialization characterized by Aragon as "La lumière moderne de l'inso-

lite," where *insolite* is the early Surrealist term for *Unheimlich*. A singular consequence of this absorption and assimilation through night and textured movement is (a) the separation and isolation of parts from the whole, and (b) the creation of a sense of envelopment for these newly charged, that is, cathected parts which, through collective endeavor, may come to play a role at the level of the imaginary in the re-organization of the form of the city.

It cannot be underestimated just how many of the key moments of the Surrealist experience of the city are situated and conceived through night and where night is both celebratory and a function of negativity: the scenes of the Tuileries (*Nadja*), the Buttes-Chaumont (*Paysan de Paris*), the Marché aux fleurs, 1935 (*L'Amour fou*); it is the joyous *dérive* of the *Paysan de Paris* which culminates nevertheless in the sentiment of being "tout enveloppé par la mort"; it is, as Jean Gaulmier long ago observed of the theme of nocturnal Paris in Breton, the anguishing night of *Nadja* and *Vases communicants* where "la nuit se charge d'inquiétude, l'obscurité efface les limites entre les choses, l'espace, devenu indéfini, suscite la sensation pénible d'une *existence sans existant.*"[57]

The function of night, here, facilitates what Pierre Kaufmann, terms the *dessaisissement de l'espace*, that is, the sensation of losing one's relation to and situatedness within the frames of space, the un-doing of space – Heidegger in his account of place in *Sein und Zeit* had called this same phenomenon *Ent-fernung*, that is, de-severance. Such an experience diminishes the ego at the same time that it permits the presencing of alterity. When in "Il y aura une fois" Breton interrogates Huysmans on the nature of the dream-space event in which palaces and cupolas may emerge – Huysmans' question to himself, which is also Breton's question, is "dans quel parages pouvait bien se lever ce palais immense, etc" – it is the phenomenon of *dessaisissement* that is in play leading to the dislocation of the spatial community[58] as socially constituted. It remains that, in "Il y aura une fois," Breton desires such a dream palace or castle wherein an elect of friendship can take place. What it is that is made possible by this dessaisissement/de-severance is precisely what Blanchot's account of Surrealist experience foregrounds; namely, the radical experience of *place* that makes possible the embodied experience of space. This is the experience of place as liminal suspension. The significance of the movement from space to place is most famously captured in the philosophical-hermetic formulation of the motivation of Surrealism in the *Second Manifeste* (1929) as the attainment of *le point suprême*, that point (clearly, that fiction) where above and below, before and after, life and death cease to be apprehended as contradictories. In his novel *Thomas l'obscur*, Blanchot explores the impossible predication implied in such a spatiality where there is no longer any "arrière et plus d'avant. [A situation for Thomas in which] L'espace qui

l'entourait était le contraire de l'espace."[59] Far from it being the case, as some have argued, that Surrealism is an idealism that does not address material, architectural space – as Tschumi, following Denis Hollier puts it, "Breton tries to reconcile opposites" whilst "Bataille concerns himself less with 'mind' or 'perception', than with *space* and *relations*, in very material terms"[60] – Surrealism is concerned with the conditions for the possibility of spatiality. It is, by the way, absurd to speak of mind and perception in this way (in inverted commas) since as Blanchot (and even a critic such as Sartre) realized, Surrealism's concerns are anti-psychological and share with Freud's metapsychology a beyond of the philosophical concept – the Concept of experience in Surrealism is not the philosophical Concept, hence the supreme point as something not space, as something which, when thought in terms of place, is a condition for the accession to space, that is, a directedness (the *hither* of Heidegger's analytic of *Raumlichkeit*) opened up in the violence of the movement of transcendence (de-severance) by a moving body.[61] The aporetic relations between body and city in terms of place as liminal suspension, so important to Surrealism, is given stunning form in Blanchot's *Thomas l'obscur* (1950) in the depiction of the experience of radical passivity in the loss of boundaries between Ann and Thomas, in which Anne penetrates into Thomas, and in so doing – and how redolent is the imagery here of the iconography of paintings such as Tanguy's *Il vient* (1927) or Ernst's *La ville entière* (1935–36):

> Elle passa par d'étranges cités mortes ou, au lieu de formes pétrifiées, de circonstances momifiées, elle recontra une nécropole de mouvements, de silences, de vides.[62]

The archeological metaphor "d'étranges cités mortes" refuses the ready association of dead cities – formes pétrifiées, circonstances momifiées – in favor of movements with silences and emptinesses: the movement, in other words, of absence. Indeed, it should be clear that one function of the archeological metaphor, doubling for a future but latent architectural metaphor, is to suggest an originary city; indeed, an archaic city whose form – whose shadow and latency – is ever present in the contemporaneity of the city where there is experienced "La lumière moderne de l'insolite," which, it should be noted, is a "Lueur glauque, en quelque manière abyssal."[63] Hence Aragon, playing upon a similar paradox between the contemporary and the archaic, the animate and the inanimate, says in *Paysan de Paris*:

> Là ou se poursuit l'activité la plus équivoque des vivants, l'inanimé prend parfois un reflet de leurs plus secrets mobiles: nos cités sont ainsi peuplées de sphinx méconnus.[64]

The enclosing proximity of body and city, the middle term of which relationship is the archaic, is most fully developed in *Thomas l'obscur* in Anne's movement toward death – and again one notes the powerful parallel with the depth atmosphere of Tanguy's acoustic silence such as we find in *Le jardin sombre* (1928) and *Untitled* (*Les profondeurs tacites*) (1928):

> Durant les instants qui suivirent, une étrange cité s'éleva autour d'Anne. Elle ne resembla pas à une ville. Il n'y avait là ni maison, ni palais, ni construction d'aucune sorte; c'était plutôt une immense mer, bien que les eaux en fussent invisible et le rivage évanoui. Dans cette ville, établie loin de toutes choses, triste et dernier rêve égaré au milieu des ténèbres, tandis que le jour baissait, que s'élevaient doucement les sanglots, dans les perspectives d'un étrange horizon, comme quelque chose qui ne pouvait pas se représenter, non plus être humain, mais seulement être, parmi les éphémères et les soleils déclinants..., Anne remontait le cours des eaux où se débattaient d'obscurs germes.[65]

What is this "étrange cité" which does not resemble "une ville"? It is, in one sense, a movement back in time – *Anne remontait le cours des eaux* – yet is not strictly of time. Here we should think of Breton's *hors du temps* – since it is something "qui ne pouvait pas se représenter," and so as something that marks the limit of representation it is a condition of possibility. This particular feature of temporality has been termed by the psychoanalyst Pierre Fédida the *passé anachronique*: the anachronic pass, his translation of Freud's *zeitlos*, that the unconscious is without time, is timeless, or, in Fédida's terms, that there is no syntactic governance of time in the unconscious, which is precisely the condition for its simultaneous contemporaneity and its archaic permanence. Fragmentation is the form for the articulation of what is without time: simultaneity, multiplicity, reversibility: the collage, the *cadavre exquis*, the many games of chance and aleatory movements in the city are some of the Surrealist instances of this time which is not time, in an experience of place that is not-space, where reciprocity is but the manifestation of a fundamental movement which defies conventional causality, temporality and meaning permitting of interpenetration, passage and transition; namely, analogy: in his theoretical reflections Blanchot terms this a non-dialectical temporality.[66]

There can be no clearer example of this transition, this inter-passage of imaginary (archeology, say) and physical supports than the role in the conception of the city than the use of de Chirico's painting *L'énigme d'une journée* in Surrealist affective bonding. Here, indeed, following Heidegger,

one sees the ordinariness of architecture – l'Hôtel des grands hommes from which Breton begins the narration of *Nadja* – and sculptural works: the statue of Rousseau near the Hôtel des grands hommes. Consider the photograph by Man Ray (1924/25) of Breton in trance-like condition in front of (but also within, in terms of depiction) *L'énigme d'une journée* the sense of which pose, and the meaning of the canvas for Breton, is confirmed by a drawing of *L'énigme d'une journée* reproduced in *Le Surréalisme au service de la révolution* in the context of a collective experiment "Sur les possibilités irrationnelles de pénétration et d'orientation dans un tableau *Giorgio de Chirico: L'Énigme d'une journée* (11 feverier 1933)." The framework of questions for this collective experiment in the context of a group identification (for which the drawing is but a stand-in for publication) assumed both the possibility of projection through this canvas onto an imagined city and that there was a close relation between this projective dimension and still life, object elements and affective city-scape into which one may be lost. Hence Éluard, summarizing the results of this experiment for the group, could say:

> On a eu en établissant le questionnaire [for the enquête], le désir de rendre fantastique l'atmosphère de cette place sur laquelle il semblait ne jamais rien devoir se passer ... On a vu par les réponses que l'aventure fut dramatique et quel cauchemar ce fût pour ceux qui voyagèrent dans ce pays interdit. Toutes les apparences du monde leur étaient pourtant laissés: l'espace, le ciel, la lumière, des murs, des cheminées, une statue [etc.]. Il est possible qu'un jour nous soyons tentés par exemple de nous laisser vivre dans une nature morte, de fonder nos espoirs et nos désespoirs au flanc d'une pétale, d'une feuille ou d'un fruit. Nul ne comprendra plus alors les raisons de notre déraison et les nommera démence.[67]

Thus when Breton uses the photograph *Je prendrai pour point de départ l'hôtel des grands hommes* in *Nadja* there can be no doubt that of all the possible angles from which this photograph could have been taken, the *choice* has been over-determined by the implicit reference to de Chirico's painting and the ensemble of affective-spatial values which it holds for Breton: *the enigma of space*, as Julien Levy wrote of Tanguy's and Dalí's indebtedness to de Chirico.[68]

Within this attitude, the architectural sites favored by Surrealism – La Tour Saint-Jacques, La Place Dauphine, etc. – are (archaic) traces, symptoms within the pathology of the modern city which mark out a negative space, *fragments* within a transformed psychic envelop. It now becomes

possible to comprehend the objects (these isolated architectural-object struc-
tures) within this psychic envelop of night as partial objects linked to the
drive – to the neuroses of childhood as Breton agreed with Dalí of architec-
ture Modern' Style. For Blanchot and Surrealism, however, the partial objects
of the drive are not failed Symbolic moments. On the contrary, both Blanchot
and Surrealism valorize the Imaginary: the realm of the fascination of the
absence of time, of radical passivity, of non-dialectical time – the Neuter in
Blanchot's language – the realm of night, the Other Night in Blanchot:
in short the realm of the maternal and the feminine. Hence Blanchot in
*L'Espace littéraire*:

> Que notre enfance nous fascine, cela arrive parce que l'enfance
> est le moment de la fascination, est elle-meme fascinée . . . Peut-
> être la puissance de la figure maternelle emprunte-t-elle son éclat
> à la puissance même de la fascination.[69]

The Surrealist city enveloped in night, in which historical monu-
ments become partial objects, finds its correlate in Blanchot in which the city
of debris becomes the image of fragmentation within the body proportionate
to the city; that is, the penetration of Thomas's body as experienced by
Anne: "Morte, dissipé dans le milieu le plus proche du vide, elle y trouvait
encore des débris d'être avec lesquels elle entretenait, durant le naufrage,
une sorte de ressemblance familiale sur ses traits."[70] The city become image
(and medium, that is, support, matrice) of fragmentation, the body become a
city – which is to say, a world, an Opening – of emptiness, absence and
silences point to this: "Le bonheur de l'image, c'est qu'elle est une limite
auprès de l'indéfini."[71] The shadow, archaic city is, in other words, *la pre-
mière demeure*, and of what rests, remains, survives (*demeure*) an *image* at
once co-terminous with but yet inalterably separate from a site of origination:
the first house always latent in its contemporaneity, always contemporary in
its archaicity – there can be no progress in architecture![72] (In this *light*, do we
not here see in Gehry's Bilbao (1997) the archaic imagination evidenced in
Tanguy's canvasses of *Solar Perils* (1943) or *Closed Sea, Wide World* (1944),
the presence of mirror surfaces in water, the suggestions and hints of indefi-
nite depths and indeterminate openness, sounds of a pitch never heard, the
seduction of water and mirror marking a threshold, the beginning of trans-
ition, and separation – Symbolism for the post-modern age? If this might be
so, then the abstraction of Gehry, like the abstraction of Tanguy, is
fundamentally one that holds onto a powerful form of implicit figuration.)
Hence Blanchot could identify the nature of Surrealist experience in terms of
a radical conception of the imaginary, as a form of experience that would

enjoin the imaginary in its emphasis upon fragmentation, an "expérience de l'expérience, . . . expérience qui désarrange, à mesure qu'elle se développe et, se développant, s'interrompt."[73] To think architecture, rather than merely to build, is to think the experience of threshold and intervals (skin, surface, hymen) with embodiment in terms of the imaginary as support, and thus concomitantly in terms of the feminine. It is, in short, to think the conditions of thinking in terms of *la pensée et le feminin*. This is what Blanchot helps us to understand in Surrealism's thinking of architectural metaphoricity.[74]

## Notes

1 Which is to say, to follow Breton and Duchamp in the refusal of the academicization of Cubism.
2 On Marinetti's refusal of his Symbolist past, cf. F. Marinetti, "We Abjure Our Symbolist Masters, the Last Lovers of the Moon," in R. Flint (ed.) *Let's Murder the Moonshine: Selected Writings*, Los Angeles: Sun and Moon Press, 1991, pp. 74–76.
3 Cf. M. Tafuri, "The Stage as 'Virtual City': From Fuchs to the Totaltheater," in *The Sphere and the Labyrinth: Avant-Gardes and Architecture from Piranesi to the 1970s*, Cambridge and London: MIT Press, 1990, pp. 95–117.
4 Cf. B. Leitner, *The Wittgenstein House*, New York: Princeton Architectural Press, 2000.
5 It is worth risking literalism here to translate "Bauen Wohen Denken" closer to their infinitive forms: "Build Dwell Think."
6 M. Heidegger, "Building Dwelling Thinking," in *Poetry, Language, Thought*, New York and San Francisco: Harper and Row, 1971, p. 145.
7 Cf. K. Frampton, "Editorial: On Reading Heidegger (1974)," in K. Michael Hays (ed.) *Oppositions Reader*, New York: Princeton Architectural Press, 1998, pp. 3–6; K. Harries, *The Ethical Function of Architecture*, Cambridge, Mass. and London: MIT Press, 1997.
8 An invaluable source on Heidegger's aesthetic taste, and how the encounter with Cézanne and Provence enabled him to appreciate Picasso, Braque and Klee, is H. Petzet, *Encounters and Dialogues with Martin Heidegger, 1929–1976*, Chicago and London: University of Chicago Press, 1993.
9 On the objection to seeing these issues in historico-metaphysical terms, cf. R. Rorty, "Concluding Discussion," in K. Harris and C. Jamme (eds) *Martin Heidegger: Politics, Art, and Technology*, New York and London: Homes and Meier, 1994, pp. 247–248.
10 Cf. J. Derrida, "Between the Lines," in D. Libeskind, *Radix-Matrix: Architecture and Writings*, Munich and New York: Prestel, 1997, pp. 110–112.
11 Cf. J. Derrida, *Glas*, Paris: Editions Galilée, 1974.
12 Cf. Lesley Hill, who writes: "Take all the major French philosophers or literary critics that have become associated in Britain or America with the preposterous term of post-structuralism, thinkers like Foucault, Derrida, Deleuze, Bataille, Klossowski, Levinas, Lacoue-Labarthe, Lyotard, Nancy, Barthes, Kristeva, others I've forgotten. Then draw up a list of the most important or influential writers in French over the last fifty years: Beckett, Duras, Perec, Laporte, Antelme, Des Forêts, Char, Paulhan, Leiris, Robbe-Grillet, Jabès, who else? Finally, make up a third list including all the figures of our modernity: Sade, Kafka, Sartre, Musil, Heidegger, Nietzsche, Mallarmé, Broch, Ponge, Hegel, Woolf, Hölderlin, Rilke, Freud, Henry James, Breton, Marx, Artaud, Celan. You're allowed to add other names too if you wish. But if you then look at where these different lists connect up or intersect, you will find that

they all do in the place – but can it be called a place? – occupied by the name of Blanchot."
L. Hill, *Blanchot, Extreme Contemporary*, London: Routledge, 1997, p. 223.

13  Cf. A. Vidler, "Homes for Cyborgs" and "Dark Space," in *The Architectural Uncanny*, Cambridge and London: MIT Press, 1992.

14  Cf. N. Leach (ed.) *Rethinking Architecture: A Reader in Cultural Theory*, London: Routledge, 1997; K. Nesbitt (ed.) *Theorizing A New Agenda for Architecture: An Anthology of Architectural Theory, 1965–1995*, New York: Princeton Architectural Press, 1996; but cf. M.-C. Ropars-Weuilleumier *Ecrire l'espace*, Paris: Presses universitaires de Vincennes, 2002.

15  M. Wigley, *The Architecture of Deconstruction: Derrida's Haunt*, Cambridge, Mass. and London: MIT Press, 1993, p. 150. *La Folie du jour* – punning on *la folie toujours* – is from its opening in dialogue with that text of Valéry's so important to the Surrealists, namely, *Une soirée avec Monsieur Teste*, and it is not an accident that it is in part through Valéry – as Merleau-Ponty hinted – that Blanchot, from *Faux pas* onward, begins to read Breton's Surrealism. Is it, too, not of more than passing interest that, as Valéry noted in his preface to the second English edition of *Teste* (1925), that "Teste fut engendré, – dans une chambre où Auguste Comte a passé ses premieres années, – pendant une ere d'ivresse de ma volonté et parmi d'etranges excès de consience de soi." Paul Valéry, *Oeuvres completes*, II (Paris: Gallimard, 1960), p. 11. And the ending of *La Folie du jour* – "Comment cela! Le récit était terminé" – pure Lautréamont.

16  A. Breton, *Nadja*, Paris: Gallimard, 1928, p. 7.

17  A. Breton, "Limites non-frontières du surréalisme," in M. Bonnet *et al.* (eds) *Oeuvres complètes III*, Paris: Gallimard, 1999, p. 666 (my emphases).

18  Monnerot, to my knowledge, was amongst the first, in a critical expository account, to address what he called the tragic interpretation of Surrealism and its preoccupation with failure, "la déchéance sociale, mais aussi d'autres démissions," in terms of the movement of *parages*: "Et voici que l'incessant vampire, qui de ses morsures a tant boursouflé le romantisme, rôde dans les parages, la complaisance." J. Monnerot, *La Poésie moderne et le sacré*, Paris: Gallimard, 1945, p. 164; also, cf. M. Blanchot's essay "Réflexions sur le surréalisme," in M. Blanchot, *La Part du feu*, Paris: Gallimard, 1949 – written as a review of Monnerot's *La Poésie moderne et le sacré*. On the reception by Bataille, Blanchot and Julien Gracq of Monnerot's book, see the superb essay by A. Compagnon, "Evaluations du surréalisme: de l''illisible' au 'poncif,'" in *Cahier de L'Herne: André Breton*, no. 72, Paris: L'Herne, 1998. In noting that Breton works within a very well-defined geography of Paris, Durozoi and Lecherbonnier comment on the places and architecture of Surrealism's Paris that it is in "leurs parages que le hasard objectif aura tendance à se reveler au promeneur attentif." G. Durozoi and B. Lecherbonnier, *Le Surréalisme: Théories, thèmes, techniques*, Paris: Larousse, 1972, p. 137.

19  A. Breton, "Il y aura une fois," first published in *Le Surréalisme au service de la révolution*, no. 1, 1930; and then as the opening text in the collection of poems of *Le Révolver à chevaux blancs* (1932). All citations will be from A. Breton, *Oeuvres complètes, II*, p. 49.

20  L. Aragon, "Le Passage de l'Opéra," in *Le Paysan de Paris*, Paris: Gallimard [1926] 1979, p. 45.

21  Aragon, *Le Paysan de Paris*, p. 46.

22  M. Blanchot, "Le demain joueur (1967)," in *L'Entretien infini*, Paris: Gallimard, 1969.

23  Breton, *Nadja*, When, following Wigley, many others began to talk of *unbuilding* architecture, above all in pursuit of a politics of architecture, it is lost sight of that, at least for Derrida, "deconstructive" possibilities are announced in the movement of *désoeuvrement*. Blanchot uses "désarrangement" à propos of the real, and "désoeuvrement" à propos of work.

24  On the word *parages*, cf. J. Derrida, "Passages – du traumatisme à la promesse," in *Points de suspension: Entretiens*, Paris: Galilee, 1992, pp. 386–387.

25  Wigley, *The Architecture of Deconstruction*, pp. 60–61.

26  The introduction (*Einleitung*) to Heidegger's *Sein und Zeit* is "Die Exposition der Frage nach dem Sinn vom Sein," in M. Heidegger, *Sein und Zeit* (7th edition), Tübingen: Max Niemeyer Verlag, 1953, p. 2.

27  Martin Heidegger, "The Origin of the Work of Art," in *Poetry, Language, Thought*, p. 43.

28  Cf. P. Kaufmann, *L'Expérience émotionnelle de l'espace*, Paris: Vrin, 1967.

29  This is Reverdy's definition of the image taken over by Breton in the *Manifeste du surréalisme*, in Bonnet *et al.* (eds) *Oeuvres complètes, I*, p. 324. It should be clear that I also draw upon Jacques Nassif's Jacksonian definition of the *dimension* of place where two or more causalities find themselves intricated within the same system or structure. Cf. J. Nassif, "Le procès et le lieu," in *Freud, l'nconscient: Sur les commencements de la psychanalyse*, Paris: Editions Galilée, 1977, p. 128. For a fuller treatment of place in Surrealist thought, cf. M. Stone-Richards, "The Question of Place in Contemporary Thought," *Voice and the Enigma of Place: Surrealist Experience and the Question of Madness* (forthcoming).

30  Cf., too, the fascinating canvas *La Nature morte évangelique* (1914) by de Chirico.

31  Cf. M. Réja, *L'Art chez les fous* (1907), Nice: Z'Editions, 1999, p. 9, fig. 3. That the Surrealists are at this time specifically thinking of Réja's collection of art of the insane can be borne out by consulting *Minotaure*, no. 11 (pp. 48–51) published in the Spring of 1938 to coincide with the period of the Exposition internationale du surréalisme at the Galerie Wildenstein.

32  In *Nadja* Breton spoke of those men who, illicitly, allow themselves to be locked in a museum so that at night they might better be able to examine a portrait of a woman – with the aid of a torchlight! At the opening of the 1938 Wildenstein exhibition, viewers were given such torchlights. Cf. Breton, *Nadja*, p. 150.

33  On the Place Dauphine, cf. A. Breton, "Pont Neuf," in *La Clé des champs*, Paris: Pauvert, 1979, pp. 228–234, and M. Stone-Richards, "Encirclements: Silence in the Construction of Nadja," in *Modernism/Modernity*, vol. 8, no. 1 January 2001, 127–157.

34  Cf. Breton's comments à propos the refusal by Surrealists to accept as legitimate Patrick Waldberg's exhibition of Surrealist works at the Galerie Charpentier in 1964: "les cinq ou six expositions officielles du Mouvement organisées depuis celle de la Galerie Wildenstein (1938) ont toujours été précisément orientées pour montrer comment le Surréalisme, en fonction des problèmes de l'heure, entendait se manifester. Sur un thème déterminé il y avait toujours une mise en scène très étudiée et un catalogue faisant foi." André Breton, *Le Monde*, 15 April 1964, quoted in J. Pierre (ed.) *Tracts surréalistes et déclarations collectives, volume II: 1940–1969*, Paris: Terrain vague, 1982, p. 405.

35  On this aspect of the theater and city in Russian Constructivism, cf. C. Lodder, *Russian Constructivism*, New Haven, Conn. and London: Yale University Press, 1983: "Theatre as the Assembled Micro-Environment," pp. 170–175 and "The Reassertion of the Real Object," pp. 175–180.

36  Cf. T. Tzara, "D'un certain automatisme du goût," in *Minotaure*, nos. 3–4, 1933, p. 83.

37  Rowe and F. Koetter, *Collage City*, Cambridge, Mass.: MIT Press, 1978, p. 137.

38  Tzara, "D'un certain automatisme du goût," p. 84.

39  Aragon, *Le Paysan de Paris*, p. 21.

40  Aragon, *Le Paysan de Paris*, p. 22.

41  On this enigmatic text, "Il y aura une fois," cf. J. Chénieux-Gendron, "Pour une imagination poétique et pratique," in M. Bonnet (ed.) *Les Critiques de notre temps et Breton*, Paris: Garnier, 1974, pp. 83–97.

42  Breton, "Il y aura une fois," in *Oeuvres complètes, II*, pp. 53–54.

43  Tzara, "D'un certain automatisme du goût," p. 84 (my emphasis).

44 Cf. A. Giacometti, "Hiers, sable mouvants," in *Surréalisme su service de la révolution*, no. 5 (1933), p. 44.

45 Tzara, "D'un certain automatisme du goût," p. 84.

46 Tzara, "D'un certain automatisme du goût," p. 84.

47 Matta Echaurren, "Mathématique sensible – Architecture du temps," in *Minotaure*, no. 11, Spring 1938, p. 43.

48 Echaurren, "Mathématique sensible," p. 43.

49 A. Breton, "Situation surréaliste de l'objet," in *Oeuvres complètes, II*, p. 478. We should note that in the same paragraph Breton identifies "l'art architectural et sculptural de 1900" as having made the breakthrough.

50 Breton, "Situation surréaliste de l'objet," p. 478.

51 M.-C. Bancquart, *Paris des surréalists*, Paris: Seghers, 1972, p. 67.

52 Cf. R. Cardinal, "Soluble City: The Surrealist Perception of Paris," in D. Vesely (ed.) *Architectural Design Profiles 11*, nos. 2–3, 1978, pp. 143–149.

53 A. Breton, "Il y aura une fois," in *Oeuvres complètes, II*, p. 50. Any full study of architectural metaphoricity in Surrealist thinking would need to reflect on the strangeness, and difficulty, of "Il y aura une fois," as well as the nature of choric spatiality along with what Breton himself terms the *question of castles*. Cf. M. Stone-Richards, "Rêve Lieu Châteaux," in *Surrealism and the Work of Culture: A Book of Essays* (forthcoming). On the non-temporality of the unconscious in terms of Plato's conception of chora, cf. P. Ricoeur, *De l'interprétation: Essai sur Freud*, Paris: Seuil, 1965, p. 430.

54 B. Tschumi, "Architecture and its Double," in Vesely, *Architectural Design Profiles 11*, p. 112.

55 A. Breton, "Situation surréaliste de l'objet, situation de l'objet surréaliste," in *Oeuvres complètes, II*, p. 473.

56 On the interrelation of projection and the movement of forms as the basis of the *informe*, cf. J. Schotte, "'Héraclite parmi nous,'" in *Existence, crise et création: Henri Maldiney entouré de ses amis*, Fougères, 2001, and P. Fédida, "The Movement of the Informe," in *Qui parle*, vol. 10, no. 1, Fall–Winter 1996, pp. 49–62.

57 J. Gaulmier, "Remarques sur le thème de Paris chez André Breton," in Bonnet (ed.) *Les Critiques de notre temps et Breton*, p. 136.

58 Cf. Kaufmann, *L'Expérience émotionnelle de l'espace*, pp. 50–53.

59 Maurice Blanchot, *Thomas l'obscur*, Paris: Gallimard, p. 46.

60 Tschumi, "Architecture and its Double," p. 115.

61 On the violence of this movement of transcendence, cf. J. Beaufret, "Martin Heidegger et le problème de la vérité (1947)," in J. Beaufret, *De l'existentialisme à Heidegger*, Paris: Vrin, 1986, p. 86.

62 Blanchot, *Thomas l'obscur*, p. 66.

63 Aragon, *Le Paysan de Paris*, p. 21.

64 Aragon, *Le Paysan de Paris*, p. 20.

65 Blanchot, *Thomas l'obscur*, p. 93.

66 On analogy, cf. A. Breton, "Signe ascendant," in *La Clé des champs*; G. Ward, *Cities of God*, London and New York: Routledge, 2000.

67 P. Éluard, *Recherches expérimentales*: "Sur les possibilités irrationnelles de pénétration et d'orientation dans un tableau *Giorgio de Chirico: L'énigme d'une journée* (11 février 1933)," in *Surréalisme et service de la révolution*, no. 5, May 1933.

68 "[Tanguy's] low distant horizons were later elaborated by Dalí as one of his motifs in rendering the *enigma of space*." J. Levy, *Surrealism*, New York: Black Sun Press, 1936, p. 23.

69 M. Blanchot, *L'Espace littéraire*, Paris: Gallimard, 1955, p. 24.

70 Blanchot, *Thomas l'obscur*, p. 46.

71  M. Blanchot, "Les deux versions de l'imaginaire," in *L'Espace littéraire*, p. 266.

72  This view of the contemporaneity of the archaic is the (European) modernist view of the experiential dimension of the city of modernity. It is to be found in Benjamin, who finds authority for it in Surrealism; it is, too, the view of T.S. Eliot in his essay " 'Ulysses,' Order, and Myth (1923)," which identifies in the method of Joyce's *Ulysses* "a continuous parallel between contemporaneity and antiquity." Indeed, Eliot, here very much the disciple of Baudelaire, goes on to argue that "Psychology . . ., ethnology . . . have concurred to make possible what was impossible even a few years ago. Instead of narrative method, we may now use the mythical method. It is, I seriously believe, a step toward *making the modern world possible for art.*" T.S. Eliot, " 'Ulysses', Order, and Myth," in F. Kermode (ed.) *Selected Prose of T.S. Eliot*, London: Faber, 1975, pp. 173 and 174 (my emphasis).

73  Maurice Blanchot, "Le demain joueur," in *L'Entretien infini*, p. 618.

74  The iconography referred to in this essay is for the most part readily available and on public view, with the exception of Tanguy's *Solar Perils* (1943) and *Closed Sea, Wide World* (1944) from the Ertegun and Filipacchi Collections. Color illustrations of these two works can be found in the exhibition catalogue *Surrealism: Two Private Eyes*, New York: Solomon R. Guggenheim Museum, 1999, vol. I.

# Surrealism's unexplored possibilities in architecture[1]

*Jean La Marche*

In the latter part of the twentieth century, certain individuals in architecture cited an interest in surrealism and its techniques as the basis for truth claims for their work. The possibilities for the continuation of the surrealist project in architecture, however, are constrained by its own history, i.e., the works and interpretations of the movement itself, especially by its preoccupations with Freudian concepts. Breton's experiences as a medic during the First World War led him to experiment with Freudian techniques to assist soldiers suffering from shell shock. These experiences led him to propose the necessity of the synthesis of reason and dream as the basis for a liberated, healthy, modern existence.

Surrealists broadly accepted Freudian concepts as the basis for their work, often citing the womb, for example, as the basis for praising such works as Tristan Tzara's "intrauterine architecture" of the cave, the grotto, and the tent, and Kiesler's Endless House.[2] Although the relationship between cavities of the body and the invisible world are not straightforward, these works were considered surreal precisely because of their similarities to maternal environments associated with prenatal comfort.[3]

Breton's most important objective, however, often overlooked in surrealist discussions, was to engender a balance and synthesis between reason and the imagination, as broadly conceived. Dreams were only one of several dimensions of the human imagination used to achieve these ends. As Breton stated in the first manifesto, and subsequently considered sufficiently significant to repeat in his essay "What is Surrealism?," the objective of surrealism was to seek and to attempt to generate or uncover the unification or synthesis of a fundamental binary human condition variously characterized as "interior reality and exterior reality" ("What is Surrealism?," p. 49), "the real and the imaginary" (p. 71), "real . . . [and] imaginary" (p. 81), "reality and unreality" (p. 72), "reason and unreason" (p. 72), "reflection and impulse" (p. 72), "knowing and 'fatal' ignorance" (pp. 72–3), etc. In one of his more straightforward pronouncements, however, he is clear about his ultimate goals: "The imagination is perhaps on the point of reclaiming its rights" (p. 64).[4]

Recently, certain architects have argued that their work invites the imagination and cité dada and surrealist artists and techniques to support their claims. However, these proposals suggest alternatives to the exclusive attention to Freudian concepts that were adopted by Breton and many of the other surrealists, and possibilities for the continuation of the surrealist project in architecture which embraces the imagination more broadly conceived.

Lars Lerup, to cite only one example, has suggested that introducing or uncovering gaps in architecture makes it possible to invite the imagination. Separating the figure from the form, for example, introduces a break in the assumptions unconsciously played out in perception. Such breaks "make it accessible to the imagination. The spell of the figure is broken."[5] Such breaks give a work an "openness to interpretation and appreciation,"[6] and, for Lerup, are liberational: "The resulting tripartite figure is broken, however, allowing the family to slip out through its cracks and the client to breathe new life into the empty shell."[7] The gaps make it possible for the client to "guide meaning and invent a world that is her own."[8]

The kinds of possible gaps in architecture are numerous.[9] They can occur between reality and dream (pp. 9 and 73) or myth (pp. 20 and 25); between form and sign (p. 91), figure (pp. 29, 54, and 82), meaning (p. 73), name (pp. 90–1), or material (p. 91); between function and sign (p. 54), object (p. 53), or structure (p. 91); between object and name (p. 53), word (p. 53) or meaning (p. 79); between structure and name (p. 90), message (p. 83), or construction (p. 91); between sign and material (p. 91), language and house (p. 55), space and place (p. 91). The gap can also be endemic to human experience between reading and seeing (pp. 25 and 26) or abstraction and conscious experience (p. 15), as in "A graphic abstraction that can never be

experienced directly . . . [It] is taken for granted and is therefore experienced on the edge of our everyday consciousness" (p. 15)[10] – a characterization that is similar to the one Bernard Tschumi assumes as a necessary condition for the pleasures of architecture.[11] Much of Tschumi's work is also organized around strategies of introducing or uncovering gaps, such as those between form and function in architecture.[12]

Lerup and Tschumi both argue that the historical role that architecture has played in the past of promoting order, singularity, or union, should no longer be continued (pp. 16, 29, 31, 56, and 59). In fact, unity, closure, synthesis, "narrative" coherence must be "delayed" or resisted (p. 29): "The fixed smile of the single-family house with its two figures is broken. Like debris, fragments of house and architecture are imbricated, defying any complete readings and rejecting all dogma" (p. 56).[13] "[T]he flow of the narrative must be stopped or delayed" (p. 16).[14]

Techniques employed in works of architecture such as those by Lerup and Tschumi are similar to those practiced by surrealists themselves, such as automatic writing and the exquisite corpse game. Such techniques provided the conditions for the possibility for surrealism.

The exquisite corpse game, for example, was originally a parlor game in the late nineteenth century that was adopted by the Surrealists. The parlor game version was a verbal game in which people would write down a few words or a phrase, fold the piece of paper until only one or two of the words were showing, and pass it on for additional contributions by everyone else in the game. The final verbal construction usually made little or no sense at all. The technique got its name from the Surrealist experiment with the game, the first result of which was "le cadavre exquis boira le vain nouveau" (the exquisite corpse will drink the young wine). The game was subsequently adapted to drawing and collage games (Figure 19.1).[15] According to Michael Sorkin, "it's the greatest . . . metaphor for modern culture ever . . . [and] a perfect image of the city: our greatest, most out of control collective artifact."[16]

This technique, and several others, was developed by the surrealists in order to "bypass the circuits of knowledge" and to uncover the unconscious life which rationality obscured. Michael Sorkin points to Breton's interest in the exquisite corpse game precisely because it was capable of "fully liberating the mind's metaphorical activity." Surrealist techniques do so by inviting the imagination.

However, the imagination is engaged by works of architecture in various ways, as is manifested by the various arguments for the way in which architecture is valued. There is no unique reason at any moment in history in which a work of architecture can be identified as singularly

19.1
***Exquisite Corpse***
**(Man Ray, Yves
Tanguy, Joan
Miro, Max Morise),
1928, ink, colored
pencil and crayon
on ivory paper,
35.6 cm × 22.9 cm**
The Lindy and
Edwin Bergman
Collection
105.1991;
reproduction, The
Art Institute of
Chicago

satisfying the various issues that are assigned to it. The Vitruvian triad of *utili-tas*, *firmitas*, and *venustas* already at its inception clearly sets out the com-plexities and contradictions at the heart of architecture.[17]

Every object is multiple or multi-functioning, a condition which depends upon the ways in which we are oriented towards it. We look at objects, at different times, in terms of craft, materials, constructivity,

concept, function, form, temporality, or iconicity, to name only a few. Each object functions in these ways for us and we sustain the possibility of these ways of engaging it through culture and cultural production.

Every object is valued for various reasons, including all of the issues that maintain the multiple possibilities of engagement. Le Corbusier, for example, referred to his own form of interest in objects as the "desire of our eyes" and generalized it as the only authentically modern way of seeing.[18]

If we reflect on the various arguments put forward in the last few centuries, architecture has been valued for its utility; for its evidence of sacrifice, obedience, and humility (Ruskin); for its historicist value (Ginzburg, Giedion, Eisenman, Tschumi, and many others); as the "repository of human labor" (Rossi); for its localized and special effects on the body, the mind, the spirit, the emotions, etc. In his discussion of the novel, Bakhtin argues that

> [f]or the writer of artistic prose . . . the object reveals first of all precisely the socially heteroglot multiplicity of its names, definitions and value judgments. Instead of the virginal fullness and inexhaustibility of the object itself, the prose writer confronts a multitude of routes, roads and paths that have been laid down in the object by social consciousness. Along with the internal contradictions inside the object itself, the prose writer witnesses as well the unfolding of social heteroglossia surrounding the object, the Tower-of-Babel mixing of languages that goes on around any object.[19]

Complexity and difference

> The living utterance . . . cannot fail to brush up against thousands of living dialogic threads, woven by socio-ideological consciousness around the given object of an utterance . . .
>
> M. Bakhtin, "Discourse in the Novel"

Although Bakhtin is writing about writing, and specifically about prose, his comments are relevant as well for architecture and our relationships to it. All of the "thousands of living dialogic threads" create a dense cat's cradle of voices woven around the object and through which all language, all words that we use to name, must navigate:

> If we imagine the intention of such a word, that is, its directionality toward the object, in the form of a ray of light, then the living and unrepeatable play of colors and light on the facets of the

image that it constructs can be explained as the spectral disper-
sion of the ray-word, not within the object itself . . . but rather as
its spectral dispersion in an atmosphere filled with the alien
words, value judgments and accents through which the ray
passes on its way toward the object; the social atmosphere of the
word, the atmosphere that surrounds the object, makes the
facets of the image sparkle . . .

The linguistic significance of a given utterance is understood
against the background of language, while its actual meaning is
understood against the background of other concrete utterances
on the same theme, a background made up of contradictory opin-
ions, points of view and value judgments – that is, precisely that
background that, as we see, complicates the path of any word
toward its object. Only now this contradictory environment of
alien words is present to the speaker not in the object, but rather
in the consciousness of the listener, as his apperceptive back-
ground, pregnant with responses and objections. And every utter-
ance is oriented toward this apperceptive background of
understanding, which is not a linguistic background but rather one
composed of specific objects and emotional expressions.[20]

Bakhtin's comments about multiplicity and the difficult journey of the word
are relevant for both writing and architecture, especially if we accept the crit-
ical arguments that challenge the political and social roles that architecture
has been called on to play in the past.[21]

Desire for order

In contrast to this, however, there is also a historical propensity in architec-
ture for simplicity and unity. The following comments by a schizophrenic
demonstrate the correspondences between architectural order and psychic
stability:

When I am melting I have no hands, I go into a doorway in order
not to be trampled on. Everything is flying away from me. In the
doorway I can gather together the pieces of my body. It is as if
something is thrown in me, bursts me asunder. Why do I divide
myself in different pieces? I feel that I am without poise, that my
personality is melting and that my ego disappears and that I do
not exist anymore. Everything pulls me apart . . . The skin is the

only possible means of keeping the different pieces together. There is no connection between the different parts of my body...[22]

The patient is concerned with his fragmenting body and, simultaneously, with a melting personality, a disappearing ego that "[e]verything pulls ... apart." He is losing coherence, what he calls "poise"; he is losing that condition of being in which his identity has sufficient and specific wholeness or coherence to survive outside the doorway. When confronted with the loss of identity, the schizophrenic's imagination turns to architecture to provide both (a) relief from the maelstrom in which he finds himself, and (b) a place within which he can regain sufficient coherence in order to act. The architecture that satisfies these two interests is the doorway: it provides a place outside the spaces in which the patient feels at risk. It is the only place in which he is able to "gather together the pieces of [his] body." Architecture provides the conditions for renovation, reconstitution, and redemption.

This kind of schizophrenic hallucination is traditionally explained as the result of Boundary Loss, which is a measure of "the proportion of images ... that have poorly defined, fuzzy, or inexistent boundaries or edges. [According to clinical studies, patients] high in Boundary Loss often describe it as a feeling of disintegration [especially of those] boundaries between the self and the world."[23]

The history of architecture suggests an interest characterized by the desire for wholeness and unity over fragmentation, closure over incompletion, and stability over uncertainty. These interests are satisfied by attempts to create, and therefore replace all possible alternatives with, objects that are complete, closed, stable, and unified.

The "healthy" state that architecture has generally been called on to promulgate, or at least imply, is often most evident at boundaries.[24] "Transparency," for example, became one of the prominent interests in architecture, as the world seemed to disappear into the thin emulsions of x-rays and the inviting lenses of the camera and the microscope.[25] Truth was beautiful and diaphanous; it appeared in various "realities" to which our physical bodies had no access without prosthetics; architecture assumed the role of representation and prosthetic at the same time that it sought its own autonomy.

Having been denied by the Enlightenment all tasks they could take seriously, they [the arts] looked as though they were going to be assimilated to entertainment pure and simple, and entertainment itself looked as though it were going to be assimilated, like

religion, to therapy. The arts could save themselves from this lev-
eling down only by demonstrating that the kind of experience they
provided was valuable in its own right and not to be obtained from
any other kind of activity.[26]

The prescriptions that followed, however, were symptomatic of the complex
history of health and pathology into which romantic and idealist propensities
in architecture have propelled us.

Many contemporary academic and professional "projects" main-
tain the voluntary delusion that architecture is only legitimate if it proposes a
normal, "healthy" condition. Yet this is a condition which culture never
achieves, at least not for those who are disenfranchised. From this perspec-
tive, the city is a construction fabricated out of the various and competing
fantasies of relief and redemption that we have been able to build. One must
ask the purpose of an architecture that reminds us, for example, of Green-
berg's concern about entertainment and therapy.

For the schizophrenic, the desire for order, the *sine qua non*, was
the doorway; for the modern movement in architecture, it was space and the
transparencies that made its radically abstract limits apparent in the "real"
world through dematerializing strategies.[27]

The desire of our eyes is also for the stability that classical canons
in architecture have given us: for symmetry, balance, proportion, clarity, etc.
Under the conditions that result from this interest, history is the story of how
this desire has been satisfied by stabilizing the collective and multiple con-
ditions of architecture, or reducing or eliminating heteroglossia. The archi-
tect's role in such a history is to erase difference.

Recent criticism suggests that architecture is variously reduced
and limited by the pursuit of this classical agenda.[28] The conclusions which
are drawn from this criticism are that there are other kinds of architecture,
other ways of being or looking like architecture, other ways in which the
physical world could shape our minds, our bodies, and our spirits. Another
set of values would produce an "other" architecture, an architecture that rec-
ognizes the "other" for whom architecture is ultimately produced, even the
"other" of ourselves.[29] If we can imagine the wide array of possible values,
some of which we alluded to above, we can uncover an equally wide array of
possible architectures that remain latent, each of which might manifest and
support various other ways of being.

The Project

These arguments suggest, as well, the need for different forms of architectural education: those structured in such a manner that they support difference. The Negotiated Construction Project is an experiment that attempts to meet this challenge (Figures 19.2–19.5). Based largely on the surrealist exquisite corpse game (a comparison of the two follows a description of the project and the pedagogy), the Project is a 14-foot rather cubic construction built of eight smaller (7 foot) "cubic" projects called "Architectural Installations." Each "cubic construction" is an "octant," i.e., one-eighth of the final "cubic" construction. In the first part of the Project, students were asked to design an "Installation" that physically and psychologically promoted the idea of "shelter." They were asked to choose three items from a limited menu of architectural "elements" (wall, floor, ramp, stair, window, etc.), a binary "condition" (inside/outside, above/below, etc.), and a binary set of sensibilities (light/dark, sound/silence, etc.). These were combined to produce a design that presented the student's idea of shelter and its architectural manifestation and material condition.

**19.2**
**Final version of the 1993 Negotiated Construction Project (1)**

19.3
**Final version of the 1993 Negotiated Construction Project (2)**

19.4
**Final version of the 1993 Negotiated Construction Project (3)**

**19.5**

**Final version of the 1993 Negotiated Construction Project (4)**

Afterwards, students were divided into eight teams. They were instructed to discuss their own projects with their teammates and faculty and to select the "best" of their Installation projects. These were subsequently presented in a general class discussion that focused on a review of the criteria that teams used to make their selections.

Finally, each of the chosen projects was randomly assigned one of the eight cubic spaces that are the basis for the Project. This framework was designed specifically to present students with complex interfaces that have to be negotiated with other projects. At this point it is also important to recognize that the gaps between projects created, as suggested by Lerup, were not intended as spaces for the repetition of architectural conventions. On the contrary, like Breton's "disdain for what might result from a literary point of view"[30] in automatic writing, there was a certain disdain for architectural conventions precisely because of their repressive tendencies. (Note the large auger that was salvaged from a local dump and turned into half a stair, assisted by two cut-out footholds to the upper level on one side of the

Project. Other unusual, non-architectural solutions to problems emerged in several other places in the Project.)

The pedagogy

In the process of negotiations, it became clear all architectural issues – form and function, public and private, body and self – emerge in the gaps between the octants. Each boundary or gap between the cubes is dense with negotiation and brings us face to face with questions of intention and value, politics and poetics, and all of the choices concerned with the maintenance or erasure of difference. Each boundary is a space of interrogation in which the normal and the pathological are played out. Each is an edge that invokes scarring and invites health. The boundaries are the spaces in which the Project reveals the ingested uncertainties of inside and outside, of subjectivity and difference, as well as many of the uncertainties that architecture faces today. These uncertainties slice through the entire body of the architecture and reveal the heteroglossia at each of the gaps that can be identified in architecture.

It is the framework itself that brings different ideas about almost any content into conflict and agreement. The ideas and values motivating the designs of the individual projects must be negotiated when brought together proximally in space and time and when they become materially and structurally dependent on one another. This is precisely the point at which students and teams of students must decide what is most important to them in their attempt to retain the essence of their Installation project; that is, what are they unwilling to give up in the negotiations: is it space, material, form, tectonics, "place," concept, aesthetic, function? This project brings these hidden commitments to the surface. It uncovers these and makes them available for criticism and, thus, empowers students to come to grips with what motivates their own work.

IV.3.    It is a pedagogical instrument that assumes that
    i) there is no singular, uncomplicated, simple, certain position;
    ii) every object is multiple or multi-functioning, a condition which depends upon the many ways in which we are oriented towards, or interested in, objects;
    iii) that a work and the criticism concerning it form the various interests that define the object and the discourse about it.

As one student said, "This project raises questions; it does not answer them."

IV.4.    As a new pedagogical instrument, this project
   a) raises questions of ethics and politics;

B. Pollard: "We took over the project. We decided what the project should be."

   b) engages students with questions concerning the various values that they, and others, bring to the work;

T. Browning: "People are still struggling with it. Why do we have to project other things on it? Why can't we just see it the way it is?"

   c) makes it possible to examine closely the translation of ideas and values into physical constructions;

F. Polkowski: "We didn't know the meaning. Rather than just physical connections, negotiations were also about meaning."

Helen Liggett: "So, what you're saying is that the investment of meaning made negotiations difficult."

   d) demands a re-examination of the criteria for "good," "correct," or "beautiful" work;

R. Schneider: "The value is in the process and not the result. This is the residue."

Helen Liggett: "So this is not it. It is more about you people working on it. This really is the corpse."

## The inverted corpse

The Negotiated Construction Project is structurally the reverse of the surrealist game. The connections in the exquisite corpse drawing are lines at the edge of a drawing; these are passed on to the second and subsequent players who must use these lines in their addition to the drawing. What each player adds is that which is between the lines from the former player and the lines that the new player passes on. In the drawing, therefore, the connecting lines are given. What is "given" in the Project is what is "between the lines," and what is not given is, precisely, the connections. Thus, the Project is structurally the reverse of the exquisite corpse drawing.

However, the Project is also different than the drawing in that the drawing is in two-dimensional, linear space-time and the Project is in three-dimensional, multiple space-time. In the project, students develop individual pieces, not in linear fashion as in the game but simultaneously. Rather than

just connecting, students take the game to other levels by negotiating three boundaries and responding to the negotiations by altering the interiors of the individual projects.

The Project also does not reverse everything about the drawing. It maintains the fortuitous accidental meetings and the shock at the final results, the surprise of not knowing the final outcome. The Project uses an initial framework of not knowing to provide an environment that acts as a catalyst for new spatial and material conditions and a sequence of negotiations.

Plurality

Thus, the Project is a collective artifact.[31] Like every object, it is the repository of many "voices" embedded and embodied in it. These include those who physically produce (make or manufacture) the object, those who want to use the object, those who use it, and those who variously facilitate or obstruct production, delivery, or use.

The objects of plurality for a twenty-first century, global culture are no longer those which individual cultures can claim to control. The models of order and classical canons that were revived in the late twentieth century seem nostalgic and, as models, seem only to suggest other forms of colonialism. Others who turn to single issues – such as function, concept, tectonics, etc. – as the means of uncovering a *sine qua non* for architecture, while offering an important and exciting alternative to aesthetic and conceptual taste cultures, often replay these taste cultures even while reconfiguring the task and responsibility of architecture. In addition, they must eventually face the questions that haunt and ultimately undermine the Greenbergian, "fundamentalist" penchant for totalizing positions. The plurality and diversity that the new world seems to invoke is a condition that might depend on multiple choices. In this way, multiplicity, diversity, and undecidability will not be repressed.

Surrealism *continué*

While evidence suggests that surrealist techniques (games, procedures, processes) do not guarantee a surrealist work or a surrealist experience, it is clear that their primary purpose was to resist the hegemony of reason and convention and, by so doing, allow something else to come forward into the work. This "something else" could include dream (Breton); myth (Lerup); magic (Kiesler); otherness (Tschumi). If Lerup is correct and the multiple gaps that are overlooked or introduced into architecture invite the imagination,

several architects working in the later part of the twentieth century have been pursuing architectural practices that are motivated by similar concerns to those of the surrealists.

If these practices are effective in making it possible for architecture to be liberated from the hegemony of reason that pervades the conventions of architecture sufficiently to begin the process of engaging other ways of thinking and making architecture, it is possible to reconstruct the discipline and our understanding of legitimacy in its production and experience. The Negotiated Construction Project is one experiment in addressing an educational experience that would raise some of the questions associated with such a project.

## Notes

1  This chapter is based on an article, "The Negotiated Construction Project," published in *Intersight* IV, 1997, the journal of the School of Architecture and Planning, State University of New York, and has been revised with permission of the journal.

2  A. Vidler, *The Architectural Uncanny: Essays in the Modern Unhomely*, Cambridge, Mass.: MIT Press, 1992, pp. 151–3. See T. Tzara, "D'un certain automatisme du goût," in *Minotaure* 3–4 (December 1933), p. 84; F.J. Kiesler, "Manifesto on Correalism," in *Frederick J. Kiesler: Endless Space*, ed. D. Bogner and P. Noever, Vienna: Hatje Cantz Publishers, 2001; D. Bogner (ed.) *Frederick Kiesler: 1890–1965*, ed. Yehuda Safran, London: Association, 1989; and D. Bogner and P. Noever (eds) *Frederick J. Kiesler: Endless Space*, Vienna: Hatje Cantz Publishers, 2001.

3  See K. Seligmann's critique of this correlation, as quoted in N. Calas, H. Muller, and K. Burke (eds) *Surrealism: pro and con*, New York: Gotham Book Mart, 1973.

4  It should be noted that Freud had already argued the "interpenetration" of the dream and waking states in S. Freud, *The Interpretation of Dreams* (1900), and that the correspondence between these two states is broadly assumed.

5  L. Lerup, *Planned Assaults*, Montreal: Canadian Centre for Architecture, 1987, p. 82.

6  Lerup, *Planned Assaults*, p. 91.

7  Lerup, *Planned Assaults*, p. 19.

8  Lerup, *Planned Assaults*, p. 82.

9  Robert Venturi and Denise Scott Brown's "Duck and Decorated Shed" and Magritte's *Ceci n'est pas une pipe* are perhaps some of the best examples of such gaps.

10  Lerup, *Planned Assaults*.

11  According to Tschumi the irresolvability between the intellectual and the sensible is the basis for the inevitable and essential conditions of the architectural experience: we move constantly, without ever reaching resolution, between an intellectual experience of architecture (concept, etc.) and a sensual one (the haptic, tactile, kinesthetic, olfactory, etc.). This framework repeats that of Le Corbusier's binary structure of the subject, without, however, privileging the intellectual that is the basis for Le Corbusier's arguments concerning "the desire of our eyes." See "The Pleasure of Architecture" and "The Architectural Paradox," in B. Tschumi, *Architecture and Disjunction*, Cambridge, Mass.: MIT Press, 1994, pp. 81–96 and 27–51, respectively.

12  See Tschumi's "Parc de la Villette" as published in *Cinegramme Folio*. In his early work, he

discusses montage and Eisenstein's film-making techniques, in addition to Dalí's and Buñuel's in *Un Chien Andalou*. He also discusses Georges Bataille's concepts of the erotic in relation to these works, suggesting a means of describing the experience of the fragmented work.

13  Lerup, *Planned Assaults*.

14  Lerup, *Planned Assaults*. According to Lerup, the narrative of the typical single-family suburban home must be stopped, or delayed. Non-narrative techniques abound in *Planned Assaults*; see, specifically, pp. 18, 26, 28, 32, 53, 55, 73, 90, 91.

15  W.S. Rubin, *Dada, Surrealism, and Their Heritage*, New York: Museum of Modern Arts, 1977.

16  M. Sorkin, *Exquisite Corpse*, New York: Verso, 1991, p. 5. Sorkin participated in the final review of the Negotiated Construction Project in 1993 and considered it "coiled" but "polite."

17  Robert Venturi pointed out many of the ways in which architecture could be complex and contradictory. He also insisted that these were the conditions of an appropriate architecture for the 1970s: "Many species of high quality can inhabit the same world. Such multiplicity is indeed the highest promise of the modern age to mankind..." and "A valid architecture evokes many levels of meaning and combinations of focus: its space and its elements become readable and workable in several ways at once." See R. Venturi, *Complexity and Contradiction in Architecture*, 2nd edn, New York: Verso, 1983, pp. 10, 16.

18  I discuss this in J. La Marche, *The Familiar and the Unfamiliar in Twentieth Century Architecture*, Urbana and Chicago: University of Illinois Press, 2003.

19  M.M. Bakhtin, "Discourse in the Novel," Art and its Significance: An Anthology of Aesthetic Theory, ed. Stephen David Ross, 2nd edn, Albany: State University of New York Press, 1987, pp. 484–97.

20  Bakhtin, "Discourse in the Novel," pp. 486, 488–9.

21  The work of Georges Bataille and Michel Foucault is significant in this regard. There are also numerous deconstructivist, feminist, and other post-structuralist works that have expanded on some of the many ways in which architecture shapes our bodies, our personalities, and our gender. See Hollier, Foucault, Wigley, and Colomina.

22  P. Schilder, *The Image and Appearance of the Human Body*, London: Kegan Paul, Trench, Trubner and Co., 1935, p. 159.

23  Julian Jaynes states that this measure is "strongly correlated with the presence of vivid hallucinatory experiences." He continues: "In one study on Boundary Loss, the Rorschach was given to 80 schizophrenic patients. Boundary definiteness scores were significantly lower than in the group of normals and neurotics matched for age and socio-economic status. Such patients would commonly see in the inkblots mutilated bodies, animal or human. This mirrors the breaking up of the analog self, or the metaphor picture that we have of ourselves in consciousness. In another study of 604 patients in Worcester State Hospital, it was specifically found that Boundary Loss, including, we may presume, the loss of the analog "I," is a factor in the development of hallucinations." J. Jaynes, *The Origin of Consciousness in the Breakdown of the Bicameral Mind*, Boston: Houghton Mifflin Company, 1976, p. 425.

24  Robert Venturi, for example, claims that architecture is fundamentally concerned with the wall that becomes the meeting plane and surface for the dialogue between interior and exterior conditions. Venturi cites Aldo van Eyck who argued that the wall was the architectural element that would offer us some evidence of that which lay behind or beyond it. See Venturi, *Complexity and Contradiction*, p. 82. This practice is evident throughout the history of architecture, including and most clearly, perhaps, in western, pre-modern Catholic churches in which the nave and side aisles of the interior are expressed in the exterior

façade of the church. This is a simpler version of the later nineteenth admonition of Sullivan, expressing the desire for honesty in expression, that all buildings should express honestly their function and their structure, a widespread assumption in the conventional practice of architecture in the twentieth century that remains an important assumption today.

25  See C. Rowe and R. Slutzky, "Transparency: Literal and Phenomenal," in C. Rowe, *The Mathematics of the Ideal Villa and Other Essays*, Cambridge, Mass.: MIT Press, 1985, pp. 159–83.

26  C. Greenberg, "Modernist Painting," in G. Battock (ed.) *The New Art*, New York: Dutton, 1973, pp. 66–77.

27  See J. LaMarche, "The Space of the Surface," in *Environment and Planning* A 2001, vol. 33, pp. 2205–2218.

28  See Eisenman, Derrida, Tschumi, Hollier, and Vidler.

29  See P. Ricoeur, *Oneself as Another* (trans. K. Blamey), Chicago: The University of Chicago Press, 1982, pp. 22–3.

30  A. Breton, *Manifestoes of Surrealism* (trans. R. Seaver and H. Lane), Ann Arbor: University of Michigan Press, 1969, pp. 22–3.

31  Aldo Rossi describes the "urban artifact" as one that is not only a "physical thing in the city, but all of its history, geography, structure, and connection with the general life of the city." See A. Rossi, *The Architecture of the City* (trans. Diane Ghirardo and Joan Ockman), Cambridge, Mass.: MIT Press, 1982, p. 22. My assumption about the object is analogous in its intended breadth that includes the general life of architecture. See my discussion of this in J. La Marche, "In and Out of Type," in *Ordering Space: Types in Architecture and Design*, eds K.A. Franck and L.H. Schneekloth, New York: Van Nostrand Reinhold, 1994, pp. 209–31.

# Chapter 20

# The most architectural thing

*Kari Jormakka*

In *Murders in the Rue Morgue*, Edgar Allan Poe reminds us that

> there is such a thing as being too profound. Truth is not always
> in a well. In fact, as regards the more important knowledge, I do
> believe that she is invariably superficial ... To look at a star by
> glances – to view it in a side-long view, by turning toward it the
> exterior portions of the retina (more susceptible of feeble
> impressions of light than the interior), is to behold the star dis-
> tinctly – is to have the best appreciation of its lustre – a lustre
> which grows dim just in proportion as we turn our vision fully
> upon it.[1]

It is not only the stars that are hard to see directly. Georges Bataille points
out that one cannot look straight at the sun even though it is the source of all
illumination and vision, and goes on to identify two other sources of enlight-
enment that blind human eyes: the sexual organs and death. Bernard
Tschumi suggests yet another invisibility, including architecture among
"things that cannot be reached frontally" and require roundabout routes in
order to be grasped. Below, I will heed to these suggestions in my attempt
to make sense of Tschumi's *Advertisements for Architecture* from 1976–79.
I will go through the ads in a random order, as none seems prescribed by the
author.

1. <u>The most architectural thing about this building is the state of decay in which it is</u>
Architecture only survives where it negates the form that society expects of it. Where it negates itself by transgressing the limits that history has set for it.

2. <u>If you want to follow architecture's first rule, break it</u>
Transgression. An exquisitely perverse act that never lasts. And like a caress is almost impossible to resist. <u>TRANSGRESSION</u>.

3. <u>Sensuality has been known to overcome even the most rational of buildings</u>
Architecture is the ultimate erotic act. Carry it to excess and it will reveal both the traces of reason and the sensual experience of space. Simultaneously.

4. <u>eROTic</u>
where glass meets mould

5. <u>Ropes and rules</u>
The game of architecture is an intricate play with rules that you may break or accept. These rules, like so many knots that cannot be untied, have the erotic significance of bondage: the more numerous and sophisticated the restraints, the greater the pleasure.

"Questions of Space," Las Vegas sequence, Joint Performance with RG, 1975

6. <u>A Streetcar Named Desire</u>
*scene Kim Hunter had when she was responding to Brando calling her from the bottom of the stairs. They said it was a moment of orgasm, which only shows that the priests who are the censors don't know anything about orgasm, don't know anything about any kind of relationship between the sexes. It was nothing, it was just that she was excited by him, she was excited by his need for her, she heard his voice desiring her, and she responded to it. That's all it was, it was a perfectly natural thing.*

It is not the clash between fragments of architecture that counts, but the invisible movement between them. Desire.

7. *There was ample evidence that a strange man had been present in the room, and the police theory is that the murderer accompanied his victim to her house. None of the other residents of the quiet residential street saw him arrive, or leave after his bloody business was completed.*
Masks
Architecture simulates and dissimulates.

8. To really appreciate architecture, you may even need to commit a murder
Architecture is defined by the actions it witnesses as much as by the enclosure of its walls. Murder in the Street differs from the Murder in the Cathedral in the same way as love in the street differs from the Street of Love. Radically.

9. Gardens of Pleasure
*"An ivory labyrinth!" I exclaimed. "A minimum labyrinth."*
*"A labyrinth of symbols," he corrected. "An invisible Labyrinth of time. To me, a barbarous Englishman, had been entrusted the revelation of this diaphanous mystery. After more than a hundred years, the details are irretrievable; but it is not hard to conjecture what happened. Ts'ui Pên must have said once: I am withdrawing to write a book. And another time: I am withdrawing to construct a labyrinth. Every one imagined two works; to no one did it occur that the book and the maze were one and the same thing. The Pavilion of the Limpid Solitude stood in the center of a garden that was perhaps intricate; that circumstance could have suggested to the heirs a physical labyrinth. Ts'ui Pên died; no one in the vast territories that were his came upon the labyrinth; the confusion of the novel suggests to me that it was the maze. Two circumstances gave me the correct solution to the problem. One: the curious legend that Ts'ui Pên had planned to create a labyrinth which would be strictly infinite. The other: a fragment of a letter I discovered."*
Behind every great city there is a garden.

Labyrinths

With its excess of text and lack of sexual innuendo, *Gardens of Pleasure* looks least like commercial advertisement. Perhaps it is a good place, then, to begin the analysis. Tschumi's claim about the connection between gardens and cities echoes the classical theory of Abbé Laugier who demanded that Paris be replanned so that "the whole is divided into an infinite number of beautiful, entirely different details so that one hardly ever meets the same objects again, and, wandering from one end to the other, comes in every quarter across something new, unique, startling, so that there is order and yet a sort of confusion . . . What happy thoughts, ingenious turns, variety of expression, wealth of ideas, bizarre connections, lively contrasts, fire and boldness . . ."[2] Laugier's program later found its partial realization in Tschumi's Parc de la Villette, a park as designed as a little city with a grid providing order and the *folies* confusion, uproar and tumult, as the Abbé proscribed.[3]

Yet one should not overlook the other elements of the advertisement: the image and the large text block. In the photo we see the garden of love at Chateau de Villandry, a Neo-mudejar labyrinth of hearts and daggers. The claim that a labyrinth is behind every city is not unreasonable. Greek mythology states that Daedalus' labyrinth, a place of aimless drifting, is the origin of architecture. Also for Bataille, the labyrinth is one of the two main figures of architecture. For him, as Tschumi comments, the labyrinth was not the paradigm of a prison – instead it was full of openings. It represented excess for "one can never see it in totality, nor can one express it. One is condemned to it and cannot go outside and see the whole."[4] In his scheme, Tschumi lets the labyrinth stand for the sensual experience of architecture as opposed to the pyramid that represents the abstract dematerialization of architecture in its ontological form.[5]

Uselessness

With or without a labyrinth, gardens explore that part of architecture that is "difficult to express with words or drawings, pleasure and eroticism." Created for no other purpose, gardens illustrate another suppressed axiom: "the necessity of architecture may well be its non-necessity."[6]

To celebrate uselessness resounds with Bataille's "general economy." Postulating that sovereignty, *dépense*, consumption, and deliberate waste are the real bases of cultural value, he defined as "sovereign the enjoyment of possibilities that utility doesn't justify."[7] While animals operate

on the principle of usefulness – as Aristotle claimed, everything in nature serves a purpose[8] – man distinguishes himself by the uselessness of his actions. The ritual of the potlatch, for example, restores the sacredness of the world and saves it from mere utilitarian thingness.[9] An even better example of an activity that allows for no functional explanation is eroticism: "Sexuality is at least good for something, but eroticism . . . We are clearly concerned, this time, with a sovereign form, *which cannot serve any purpose.*"[10]

Bataille's celebration of waste, sacrifice and eroticism as examples of sovereignty finds echoes in Tschumi's criticism of functionality, but a similar position had already been defined by John Ruskin. In the *Seven Lamps*, it is argued that sacrifice is the essence of religious architecture: the more expensive, the more sacred a church. In general, only those aspects of buildings that exceed natural necessities deserve the name of architecture: "I suppose no-one would call the laws architectural which determine the height of a breastwork or the position of a bastion. But if to the stone facing of that bastion be added an unnecessary feature, as a cable moulding, that is architecture."[11] A follower of Ruskin, Le Corbusier, confessed to the same quasi-Kantian ethics and insisted that "architecture begins where calculation ends," and it excludes the practical man.[12]

Time

To define Tschumi's position in more detail, it is important not to overlook the lengthy text block in Tschumi's Ad no. 9. It is a quotation from Jorge Luis Borges' story "Garden of the Forking Paths." One of the men speaking is an English sinologist who has just solved a historical riddle concerning a particularly chaotic Chinese novel. The narrative was so confused that a person could get murdered in one chapter and return a few chapters later as if nothing had happened. What made things worse was that the language was curiously convoluted, as one word was conspicuously avoided throughout the text: the word "time." To explain this elaborate omission, the sinologist asked: "in a riddle, whose answer is 'chess' what is the one word one is not allowed to use?" The answer is, of course, "chess." He concluded that Ts'ui Pên's labyrinthine book was a riddle about time and further elaborated that the novel portrayed time as a garden with forking paths; that is, it included a depiction of all possible futures resulting from individual decisions.

An example: Working late in the office, I fall asleep only to be woken up by someone knocking on the door. What happens then could take several routes. I could take the person at the door to be a theoretician of a

more rationalist persuasion and shoot him as the door opens; or at the very last second I could realize it is my surrealist friend and instead of killing him go drink a beer together. A labyrinth with many openings, Ts'ui Pên's book would contain both of these possibilities, and more, and follow each path to its end. Sometimes the consequences might converge: I could drink too much beer with my friend and, joking about the narrowly missed accident, shoot him by chance. In any case, the sinologist in Borges' story gets murdered by the stranger who walked into his house.

Tschumi has chosen not to include the explanation of the riddle in his extensive quote from Borges. It might then be reasonable to assume that the ads are also about time. Moreover, it is perhaps significant that Tschumi's series of ads, like William Blake's *Songs of Innocence* or Borges' literary labyrinth, does not have any order but can be drifted through in any arbitrary order, perhaps suggesting the infinite choices of the future. Indeed, this is how Tschumi describes the labyrinth.

Transgression

An emphasis on time can be sensed in other advertisements, as well. In Ad no. 1, Tschumi shows the Villa Savoye in its ruined state in 1965 and comments: "The most architectural thing about this building is the state of decay in which it is. Architecture only survives where it negates the form that society expects of it. Where it negates itself by transgressing the limits that history has set for it." He points out that modern architecture refused to recognize the passage of time.[13] By decaying, the Villa Savoye made the passage of time visible and thus transgressed the taboo of modernism.

In fact, the ideal of timelessness does not only characterize modern architecture. A contemporary of Le Corbusier, Bataille, insists that architecture is atemporal by its very nature and that its essence is to cancel time by setting up a permanent structure.[14] What modernism added to the classical idea of timelessness is the notion of architecture as specifically the art of space.[15] The Villa Savoye is here a better example of transgression than, say, an Arts & Crafts building because it was an almost platonic form turned into a building, an eternal and pure geometry.

By negating society's expectations of architecture, the Villa Savoye can indeed be seen as an example of transgression, declared in Ad no. 2 to be "architecture's first rule." In his essay on "Architecture and Transgression," Tschumi quotes Bataille in the motto and in the text.[16] For Bataille, the transgression of a prohibition is the act that separates humans from animals.[17] The taboo is there in order to be violated; prohibition and transgression constitute

each other's significance.[18] Hence, without suppressing the taboo, transgression suspends it – the Hegelian sense of *aufheben*.[19]

What Ad no. 2 adds to the first one is the realization that transgression itself is a temporary act: if repeated too many times or extended too long, it becomes itself the rule. Thus, insofar as the transgression of a rule (such as the ideal of timelessness) is the essence of architecture, this essence is itself temporal and impermanent.

It is of course ironic to select a Le Corbusier building as an example of transgression, as his famous manifesto *Towards a New Architecture* contains a subchapter titled "Transgression" denouncing the violation of the rules of proper planning by an error or an inclination towards vanities.[20] It is more important to realize that this ad itself is a transgression of Tschumi's compositional rules in the series, as it is the only one without an image.

Sensuality

If the negation of society's expectations is sufficient to qualify a building as architecture, the Villa Savoye excels on at least three counts. First, its ruined condition in 1965 thematized the passage of time, rather than the eternal persistence of pure geometry. The reason why it was left to rot has to do with not meeting a second expectation – although an emblem of functionalism, it was plagued with functional and construction problems right from the beginning. Third, the villa was supposed to be "the most rational of buildings," but according to Tschumi's Ad no. 3 it is against all expectations overcome by sensuality.

To illustrate the sensuality of the villa, Tschumi includes another photograph of its decayed state in 1965. This suggests that rationality might here be opposed simultaneously both to sensuality and to decay. This would imply that decay itself is somehow sensual. Indeed, Ad no. 4 seems to suggest as much by characterizing the meeting of glass and mould as "eROTic." In this ad, eroticism seems to involve the synthesis of opposites: the favorite material of the modernists, glass, is inorganic, pure, crystalline and seemingly timeless while mould is an organic *informe* growing without a specific shape. Tschumi argues that "the contradiction between architectural concept and sensual experience of space resolves itself at one point of tangency: the rotten point, the very point that taboos and culture have always rejected. This metaphorical rot is where architecture lies."[21] Bataille connects eroticism not only with decay but with its ultimate extension, death: "What does physical eroticism signify if not a violation of the very being of its practitioners? – a violation bordering on death, bordering on murder?"[22]

According to Bataille, the taboos concerning death have two aspects: the first forbids murder, the second limits contact with decomposing corpses. He returns time and again to our disgust at "that nauseous, rank and heaving matter, frightful to look upon, a ferment of life, teeming with worms, grubs and eggs," and points out that ancient people were convinced that the spirits had been pacified and the threat of violence passed only when the bones were white and dry. Neither do architects, according to Tschumi, "love that part of life that resembles death: decaying constructions – the dissolving traces that time leaves on buildings."[23] They can only tolerate death when the bones are clean and white, as in the skeletal architecture of the Parthenon or the Cardboard Corbu houses of the New York Five.[24]

Instead of reducing architecture to abstract skeletons, Tschumi focuses on excess and claims that "eroticism is not the excess of pleasure but the pleasure of excess."[25] In Ad no. 3, he suggests that once architecture is taken into excess it becomes sensual and will reveal both the traces of reason and the sensual experience of space. The important thing is not to identify eroticism with the physical satisfaction of the senses, for that would apply to animals as well as human beings. Rather, eroticism also involves a conceptual element, the awareness of breaking a cultural prohibition. Hence, as Tschumi adds, the pleasure of excess requires consciousness as well as voluptuousness.[26] This is the point of writing "eROTic": the linguistic pun that is only comprehensible when looking at the written sign calls attention to the conventional signifier rather than any referent in the natural world. Thus, "rot bridges sensory pleasure and reason."[27]

## Desire

On the other hand, erotic pleasure, according to Tschumi, is based not on excess but rather on lack, absence or impossibility. In Ad no. 5, Tschumi shows an image of a bondage performance with Roselee Goldberg in Las Vegas. In erotic bondage, ropes add pleasure by reducing the possible movements of the body. This is for Tschumi analogous to the rules of architecture, whether dictated by the Ecole des Beaux-Arts or by Le Corbusier; he argues that unlike the necessity of mere building, the non-necessity of architecture is undissociable from architectural precedents.[28] Here, the necessity of building is analogous to the biologically determined life of animals, while the contingency or arbitrariness of architecture shows that it is the "pure creation of the spirit," to quote a Corbusian slogan. Tschumi even refers to Marquis de Sade's methodical tortures as further evidence of how erotic it is to follow rules.

Of course, the pleasure of bondage is not only an issue of restrictions. Rather, in S/M practices, the participants redefine their subjectivities by agreeing to role playing, a game of false identities, of masks. De Sade's fantasies have been analyzed by Lacan from this point of view. Even though de Sade talks about breaking the rules that society has set in order to conserve itself, Lacan sees him as a follower of a law, namely the law of the absolute right to *jouissance*. Ultimately, de Sade upheld the law not because he desired absolute mastery over his victims but because he repressed his desire, accepting what he lacked. Because desire is constituted through the renunciation of desire, mastery is always infinitely deferred.[29] In general, desire is directed toward an absence; as Lacan says, desire is a metonymy and its structure is a lack. Following Alexander Kojève's Hegelian definition of Man, Lacan sees nature as content to be and perpetuate what it is, while desire wants (to be) that which it is not. Thus, desire negates itself and instead desires the other, a non-natural object, "perfectly useless from the biological point of view," the impossible, death. Ultimately, as Hegel and Freud insisted, desire is only satisfied by death.[30]

## Absence

In Ad no. 6, Tschumi finally presents his own definition of desire as an absence rather than an object. The fragments of architecture are not the objects of desire but the invisible movement between them. As an illustration, the ad focuses on Tennessee Williams's play, which is all about something missing, about frustrated desire and the palpable lack of satisfaction.[31] Ironically, the quote in the ad is about an absence, about the 40 seconds that censors removed from Kazan's film because of excessive obscenity.

What Tschumi fails to include in this wordy add is that the author of the text quoted, director Elia Kazan, made a pact with the censors after shooting the movie and twice informed the House Committee on Un-American Activities about the leftist excesses of eight members in his Group Theatre Unit. The Un-American witch hunts and the ensuing degradation ceremonies can be seen as an example of what Daniel J. Boorstin, a historian who himself in 1953 named five of his former Harvard colleagues before the HUAC, called a "pseudo-event." A pseudo-event is "not spontaneous, but comes about because someone has planned, planted, or incited it. Typically, it is not a train wreck or an earthquake, but an interview." Further, it is planted primarily for the immediate purpose of being reported or reproduced, and the interest in a pseudo-event is always whether it really happened and what might have been the motives. Boorstin further claimed that once we

have tasted the charm of pseudo-events, we are tempted to believe they are the only important events.[32] Whether or not Boorstin would have classified the Communist trials as a pseudo-event, most collaborators with the HUAC would not have done, for they saw the process as addressing the modernist values of truth, transparency and immediacy. Thus, "Looselips" Kazan (the nickname was coined by Zero Mostel) defended naming his old friends by arguing that the way to fight totalitarian secrecy was with free-world openness. On the other hand, director Abe Polonsky, Kazan's most bitter accuser over the decades, compared his transgressions to deciding who goes to the concentration camp.[33] Upon Kazan receiving in March 1999 a lifetime achievement award from the Academy of Motion Picture Arts and Sciences, Abe Polonsky unforgivingly quipped, "I'll be watching, hoping someone shoots him. It would no doubt be a thrill in an otherwise dull evening." To his disappointment, no murderer showed up at the Oscar ceremonies.

Masks

The murderer's absence is at issue in Tschumi's Ad no. 7. Wearing a mask, the murderer was not the person he was so that the real person was absent. For Tschumi, architecture is itself a mask, or a series of masks that seduce the observer by creating illusions and hiding identities. The notion of masking as the very essence of architecture goes back at least to the eighteenth century. In his 1745 treatise *The Origin of Architecture, or the Plagiarism of the Heathen Lies Detected*, John Wood claimed on biblical grounds that the most primary roots of architecture were shame and fear. The original sin made Adam and Eve aware of their nakedness, which prompted the need for an architectural mask. The requirement of *firmitas* became a major issue once Cain murdered his brother Abel and built a strong house in his defense against a likely revenge.[34] A century later, Gottfried Semper picked up the themes of masking and argued that masks were essential elements of civilization and adornment the oldest of specifically human privileges. "No animal adorns itself; the proud crow strutting with false feathers is known to be a fable."[35] The denial of trivial, accidental and non-anthropomorphic reality is deeply human: it involves the ability to propose and prefer a transcendental ideal, or even to fabricate one as a way to justify material existence and make life bearable.[36]

From this point of view, the rationality of modern architecture is nothing but another mask, hiding the incipient sensuality that is the real essence of architecture. But there is no final truth about architecture to be uncovered by analysis: "Once you uncover that which lies behind the mask,

it is only to discover another mask."[37] In these statements, Tschumi comes close to Nietzsche who also insisted that reason is a mask and wrote of the rational philosopher: "there is something arbitrary in that he stopped *here*, looked back, looked around, that he did not dig deeper *here* but put the spade aside, – there is also something suspicious about it."[38] Nietzsche's conclusion that every word is a mask was radicalized by Heidegger who suggested that "truth, in essence, is un-truth."[39]

The deceptiveness of representations has tormented many philosophers of the twentieth century. Wittgenstein believed there was just one way to lift the veil of language and reach authentic truth – and that is pure action. To justify this idea, he nevertheless goes back to un-truth, to fiction, quoting from the *Faust*: "In the beginning was the deed."[40] In a similar vein, Tschumi insists in Ad no. 8 that "To really appreciate architecture, you may even need to commit a murder."[41] In another context, Tschumi argues that architecture is linked to events in the same way that the guard is linked to the prisoner, the police to the criminal, the doctor to the patient, order to chaos. Without the guard, the prisoner would be free to go; without the prisoner the guard would have no function. From this intimate conclusion between an event and its spatial setting, Tschumi concludes that architecture's violence is fundamental and unavoidable.[42]

Event

Tschumi continues to claim that architecture is defined by the actions it witnesses, but that the actions or events are also modified by the environment: "Murder in the Street differs from the Murder in the Cathedral in the same way as love in the street differs from the Street of Love." This idea of the mutual determination of architecture and the event seems to owe something to Hannah Arendt's famous claim that "things and men form the environment for each of man's activities, which would be pointless without such a location; yet this environment, the world into which we are born, would not exist without the human activity which produced it."[43] However, Tschumi's statement works on a very immediate and concrete level without the historical perspective implicit in Arendt's thesis.

Indeed, it may be more appropriate to relate Tschumi's notion to other writers. In Ad no. 8, he seems to use the street as a metaphor for human life in general, an elementary conceit in literature. Irwin Shaw, who has been described as being mostly interested in constructing situations rather than developing characters, describes the Champs-Élysées in Paris as follows: "Whores cruised slowly in pairs in sports cars, searching trade . . .

The flesh of Paris spinning against the flesh of Paris . . . The various uses and manifestations of the flesh. To caress, to mangle, to behead, to kill with a karate stroke on a city street, to prepare out of cloth a derisive simulacrum of the instrument of sex in a Polish prison. To cherish and despise. To protect and destroy. To clamor in the womb to become flesh. (A boy does what he has to do, Love.)"[44] Perhaps the Street of Love in Tschumi's text could be seen as referring to red light districts, such as parts of the Champs-Élysées or the Rue de St Denis. The contrasting image, love in the street, could then be understood as an impulsive act of animal desire, as in another story by Shaw where he describes a quiet side street in Paris: "The street was narrow and looked as though it was waiting to be bombed or torn down to make way for a modern prison and at the busiest times carried very little traffic. Tonight it was silent, and deserted except for two lovers who made a single, unmoving shadow in a doorway diagonally across him. Tibbell peered at the lovers with envy and admiration. What a thing it was to be French, he thought, and experience no shame in the face of desire and be able to display it so honestly, on a public thoroughfare."[45]

The above examples suggest a contrast between honest, natural impulse and dishonest simulation, or an authentic event versus a pseudo-event. In this context, Tschumi's "love in the street" could be understood as an impulsive act of animal desire, as opposed to the street of love or prostitution on the Rue de St Denis. It is significant that the word "prostitution" derives from pro-statuere, "to set forth in public," as in an exhibition or a spectacle.[46] Analogously, the murder in the street could be understood as unpremeditated gang fighting or a random freeway shooting, as opposed to the calculated ritual murder in a religious edifice – say the human sacrifices on top of Aztec pyramids.

The distinction between authenticity and simulation has been one of the favorite obsessions of modern thinkers. For Bataille, it is the element of premeditation that makes murder or prostitution into specifically human activities, for that which is not conscious is not human.[47] Thus, the human activity of eroticism substitutes voluntary play, a calculation of pleasure, for the blind instincts of the organs.[48] He writes: "Violence, not cruel in itself, is essentially something organized in the transgression of taboos. Cruelty is one of its forms . . . Eroticism, like cruelty, is premeditated."[49]

In contrast to Bataille, many modernist thinkers long for naturalness and spontaneity as opposed to premeditation. To give just one example, the concern for the authentic experience behind language also characterizes the thinking of Wittgenstein. Unwittingly paraphrasing the doctrine of Orphism, he suggests that the origin and essence of man is something not from the material world: "It is very remarkable that we should be

inclined to think of civilization – houses, trees, cars, etc. – as separating man from his origins, from what is lofty and eternal, etc. – That is a remarkable picture that intrudes on us."[50] In his aspiration to look beyond the surface of conventions, Wittgenstein longs to become Luis Vélez de Guevara's Asmodeus, from *El Diabolo Cojuelo* (1635), a devil with the power to lift the rooftops of buildings enabling him to observe the private lives of the inhabitants.[51] "Nothing could be more remarkable than seeing a man who thinks he is unobserved performing some quite simple everyday activity . . . surely this would be uncanny and wonderful at the same time. We should be observing something more wonderful than anything a playwright could arrange to be acted or spoken on the stage: life itself."[52]

Situationism

It is ironic that in his desire to gain access to real life, Wittgenstein imagines himself a voyeur removed from the action. Aside from that, his fantasy would not have been realizable anyhow, according to the dark premonitions of Guy Debord who would insist that not even a devil or a demiurge could glimpse into real life in our society of spectacle, for the concrete life of everyone has been degraded into a speculative universe.[53] With "spectacle" the situationists referred to the collapse of reality into the streams of images, products, and activities sanctioned by business and bureaucracy, masking the authentic life of the city. Other central concepts of situationism were *psychogéographie*, unitary urbanism, the construction of situations, *détournement*, and *dérive*.

"Psychogeography" meant identifying environmental units on the basis of their emotional character or ambience. Ivan Chtcheglov suggested creating such unities of ambience in urban design, including the Bizarre Quarter, the Happy Quarter, Noble and Tragic Quarter, Historical Quarter, Useful Quarter, Sinister Quarter. Naming Edgar Allan Poe "psychogeographic in landscape," the situationist magazine *Potlatch* suggested using graffiti to highlight the intrinsic qualities of urban locations. At the Rue Sauvage in Paris, for example, the magazine wanted to write "If we don't die here will we carry on further?" – a reference to the group's favorite hangout at the Morgue across the river.[54]

"Unitary urbanism" meant dissolving functionalist zoning and instead mixing work with leisure, public with private, and the spatial with the social in a *Gesamtkunstwerk* comparable to Charles Fourier's phalanstery. The city was to consist of fragments, each with its own ambience embodied in urban and architectural elements, down to a glass of beer.[55]

As a result, the city would be constituted of grand "situations" between which the citizens would endlessly drift.[56] An example of a situation was the Paris Commune of 1871 which Debord, as well as Henri Lefebvre, understood as a festival of authenticity, a moment when a revolutionary situation existed. In response, Baron Haussmann cut major boulevards all over the city in order to prevent the erection of defensive barricades, to allow for a better movement of troops and to open up rebellious working-class districts to artillery fire. However, the construction of the boulevards required such vast numbers of workers that Haussmann's contemporaries accused him of having actually increased the likelihood of revolution.[57] Half a century later, Le Corbusier announced he had found more effective ways to fight social unrest with urban and architectural measures, and completed the struggle against the workers by suppressing the street totally.[58] Modernist urban planning was the main enemy for the situationists, and its main inspiration, Corbusian rationalism, is also criticized by Tschumi. Instead of purified zones, as advocated by Le Corbusier and the CIAM, both Debord and Tschumi demanded the construction of situations. With reference to Michel Foucault, Tschumi defines an event as not simple a logical sequence of words or actions but rather the moment of erosion, collapse, questioning, or problematization of the very assumptions of the setting within which a drama may take place – occasioning the chance or possibility of another, different setting. "The event here is seen as a turning point ... I would like to propose that the future of architecture lies in the construction of such events."[59]

"*Détournement*" referred to the rerouting, hijacking, embezzlement, misappropriation, or corruption of pre-existing urban or aesthetic elements. An urban *détournement* that profoundly affected Tschumi were the barricades on Paris streets in May 1968; later he proposed some related principles such as dis-, cross- and trans-programming.[60]

Finally, "drifting" referred to a methodical wandering in the city without a preconceived plan, thus avoiding the trappings of capitalist power, like the protagonist in Borges' story "Zahir," wandering blindly in the outskirts of Buenos Aires in order to release himself of the haunting coin. As a demonstration of *dérive*, Chtcheglov drifted aimlessly in Paris for four months in the period 1953–54, and a surrealist friend of Debord's traversed through the Harz with the London Tube map.[61] The *dérive* often exhibited fetishistic, militaristic and masculine connotations. An image in the *Mémoires* by Debord and Asger Jorn, for example, contained a diagrammatic map of the cityscape compared to fragments of naked women's bodies. Equating the drifter's conquest of the city with rape and murder, Debord exclaimed, "Jack the Ripper is probably psychogeographic in love."[62]

Traces of the situationist techniques can be found not only in Tschumi's theoretical projects but also in his realized plan for Parc de la Villette in Paris. Tschumi explains the project in terms of schizophrenic dissociation and recombination of urban elements, but it could also be understood as a combination of *dérive* and *détournement*.[63] The latter technique applies to the transformation of the large slaughterhouse into a science center, which urges us to reconsider the scientific exploitation of nature and the violence of science. The basic compositional device of the design, the grid, is a prime example of *dérive* translated into space. The grid comes from Peter Eisenman's project for Cannaregio, which in turn was based on Le Corbusier's plan for a hospital in Venice. Transposed to Paris, the grid has lost whatever local meaning it might have contained, but none of its ruthless regularity. Thus, it is foreign organizational principle that cancels any preconceived notions one might entertain about the site. The grid determines the locations of the follies that employ the revolutionary industrial aesthetic of Jakob Chernikov – and are even painted red to make the reference to the workers' revolution unmistakable – but in an ironic *détournement* eschews any real function.

Spectacle

For the situationists, Paris was a particularly good example about use value being replaced by exhibition value or spectacle. For a *flâneur* wandering the boulevards and the arcades, like Charles Baudelaire or Emile Souvestre, the world was to be sampled from the streets of Paris, the "world's fairground." In *La Dernière Mode* of September 1874, Stéphane Mallarmé wrote: "Only Paris prides itself on being the sum of the entire universe, acting both as a museum and department store." Flaubert spoke of the exposition as the object of delirium in the nineteenth century, perhaps suggesting the understanding of *dé-lire* both as madness and as an obstacle to reading.[64] Etymologically, however, "delirium" refers to deviating from the straight line or the groove of the plough (Latin *lira* being either the furrow or the ridge between the furrows). In this sense, delirium can also become a road to truth, if with Nietzsche we understand conventional truths as worn-out metaphors or lies. Then a person is designated as delirious or mad when he departs from the beaten path of convention or refuses to lie according to a fixed convention.[65]

However, it is not just in modern societies that what Jean Baudrillard calls "sign value" or what Walter Benjamin called the "exhibition value" of an object seems to have overridden its use value and determined its exchange value. Most court societies, as Foucault reminds us, were about

spectacle, and architecture provided the *mise-en-scène* of power. In the *Leviathan*, Thomas Hobbes mentions the Aristotelian commonplace that "Riches joyned with liberality, is Power," but he also elaborates that "reputation of power, is Power" and "Forme is Power."[66] In this sense, French Baroque architecture is not only the staging of power but rather power itself. A symbol of sovereignty, Versailles meant much more than the palace and the garden: it set standards of design for the whole era. That is why the Swedish crown kept Daniel Cronström, a full-time ambassadorial representative, in Paris from 1693 to 1718. His charge was to report to Nicodemus Tessin, the royal architect of Sweden, on fashion and technology, including innovations such as window hooks, curtain rods and locks.

Ancient Roman architecture was no less about spectacle. Urban space was structured by the daily activities of the Roman elite, beginning with the morning ritual of *salutatio*, the reception of clients at the house; between the second and the third hours, patrons from all parts of town strolled to the forum to transact public business; at around the sixth hour their *otium* or leisure time commenced and they visited the baths; at the ninth hour, they returned home or were invited to dine elsewhere. Permanently on display, the elite were mobile and visible outside their own localities, whereas women and the lower classes were tied to their particular locality.[67] The street and the forum were carefully designed as spaces of social display, but even the house with its axial arrangement of *fauces–atrium–tablinum* was a locus of public life. The doors of noble houses were open to all, except if the family was in mourning. Thus, *tribunus plebis* Livius Drusus commissioned an architect to arrange his house so that whatever he did was visible to everybody. Within a year of the house's completion, he was murdered by a stranger who walked into his house.[68]

## Alienation

Benjamin derived his theory of shock in part from Breton's nocturnal strolls through the streets of Paris. These chance encounters brought together unexpected images, things, and people, releasing unconscious forces that let libidinal energies manifest themselves.[69] According to Benjamin, the historical city offered pleasurable streets beckoning the stroller to explore, but the modern metropolis met the spectator's gaze with shock experiences. Inevitably, the spectator had to dull his consciousness to survive, failing to record experiences in a direct and natural manner.[70] Benjamin attempted to awaken the present from the phantasmagorical spell of nineteenth-century images that still controlled consciousness: the discarded arcades, souvenirs,

street signs, railroad stations, winter gardens, and panoramas. By placing these dream images in new contexts, Benjamin sought to reawaken memory and prepare a critical awareness of the present.[71]

Similar ideas were proposed by some of the "magical realists" in Germany. One "functional poem" by Erich Kästner, his "Nocturnal Prescription for City-Dwellers," is particularly interesting, as it spells out a program to study the city:

> Take a bus, any bus.
> It can't do harm to change once.
> Where to, is all the same. You'll find it out anyway.
> But take note, it has to be night-time.
>
> In a district that you've never seen
> (this is crucial for such cases)
> get off the bus and place
> yourself in the darkness and wait there.
>
> Take the measure of everything you can see.
> The gates, gables, trees and balconies,
> The houses and the people who live in them.
> And don't think you're doing it for fun.
>
> Then walk through the streets. This way and that.
> And don't pursue any preconceived goals.
> There are so many streets, oh so many!
> And beyond every turn there are more.
>
> Take your time with the walk.
> It serves a relatively high purpose.
> It should wake up that what has been forgotten.
> After about an hour the time has come.
>
> Then it'll be as if you'd been walking for a year
> Through these streets that never end.
> You begin to feel ashamed of yourself
> And of your heart wrapped in fat.
>
> Now you know again what has to be known,
> Instead of being blinded by satisfaction:
> That you are in the minority!
> Then take the last bus
> Before it disappears in the darkness.[72]

Despite its stylistic affiliation with the 1920s hardboiled *Gebrauchslyrik* in the manner of Bertolt Brecht's *Hauspostillen*, Kästner's poem follows the Romantic tradition which understands an artist's alienation as truth. Turning *Not zum Tugend*, the artists manufactured value by presenting their forced alienation as self-willed, thus casting themselves in the roles of Zarathustra or Tonio Kröger, and insisting that alienation is a necessary condition for perspicuity and the creation of true art. The exaltation of alienation has been popular for two centuries, from the 1798 *Lyrical Ballads* of William Wordsworth and Novalis's notebooks of the same year, to Arthur Schopenhauer who argued that "to have original, extraordinary, and perhaps even immortal ideas one has but to isolate oneself from the world for a few minutes so completely that the most commonplace happenings appear to be new and unfamiliar, and in this way reveal their true essence."[73] These ideas inspired the vagabond Communard and poet Arthur Rimbaud, as well as Giorgio de Chirico and the surrealists. The same concerns also led to the glorification of madness; something we can see not only in Marinetti but even in Cesare Lombroso and Karl Jaspers. Tschumi places himself clearly in this line of thinking, for example, by explaining his scheme for Parc de la Villette in terms of schizophrenic dissociation and recombination of urban elements.[74]

The necessity of shock and spectacle as a means to reawaken authentic experience is an idea also endorsed by Bataille. After a number of unsuccessful attempts at a social and spiritual revolution, he put his hopes in a secret society named Acéphale, so named because it was meant to be a religious community without a head or god. The group met in a forest at the outskirts of Paris. Bataille's written instructions for getting there bring to mind Brecht's insistent advice to city-dwellers, "cover your tracks":

"Do not acknowledge anybody, do not speak to anybody, and take a seat at some distance from other travelers. Get off the tram at Saint-Nom, exit the station in the direction of the train and turn left. Follow the instructions of those who will meet you on the road, asking no questions, walk in groups of two or three at the most, without talking, until you reach the path that leaves the road, when you should walk in Indian file, a few meters apart. On nearing the meeting-place, stop and wait to be conducted to it one at a time. Then remain motionless and silent until the end."

What went on in the meetings of Acéphale has not been recorded for posterity, except for a few fragmented recollections. Apparently, Bataille wanted to conduct a human sacrifice. Roger Caillois comments: "The (willing) victim was found, only the executioner was lacking . . . Bataille asked me to undertake the task perhaps because, while at college, I had written a panegyric to Saint Just, and so he imagined that I possessed the necessary severity of character." Another confidante, Patrick Waldberg recounts: "[A]t the last

meeting in the heart of the forest, there were only four of us and Bataille solemnly requested whether one of the three others would assent to being put to death, since this sacrifice would be the foundation of a myth, and ensure the survival of the community. This favor was refused him."[76] Hegelian epistemology made it impossible for Bataille himself to play the role of the victim. This is because desire can only be satisfied in death, but death "reveals nothing . . . In order for Man to reveal himself ultimately to himself, he would have to die, but he would have to do it while living – watching himself ceasing to be . . . In sacrifice, the sacrificer identifies himself with the animal that is struck down dead. And so he dies in seeing himself die . . ."[77] In Bataille's thinking, this difficulty proclaims the necessity of spectacle, or of representation in general, without the practice of which it would be possible for us to remain alien and ignorant in respect to death, just as beasts apparently are.[78] Because death and sacrifice promises ultimate and absolute knowledge, sacrifice was the essence of religion and the quintessential human act: "in sacrifice, he [Man] destroyed the animal in himself . . ."[79] Inspired by Hegel and Kojéve, Bataille explains that Man differs from the natural being which he also is; the sacrificial gesture is what he humanly is, and the spectacle of sacrifice then makes his humanity manifest. Freed from animal need, man is sovereign: he does what he pleases – his pleasure.[80] Tschumi's advertisements extend this reasoning: to really understand architecture as a sovereign human activity you may even need to commit a murder.

Simulation

Even though there are strange parallels between the *Advertisements for Architecture*, situationism, surrealism, and the Romantic tradition of alienation as the gateway to truth, Tschumi's position differs from that of the precursors by virtue of its postmodern distancing. His technique in the ads resembles Debord's book *The Society of Spectacle*, which is largely made out of paraphrases and "quotations without quotation marks."[81] However, Tschumi actually presents Ads no. 5 and no. 9 explicitly as quotations. In *A Streetcar Named Desire*, the text is not from the movie or from the play with the same title, but from the book *Kazan on Kazan*: the director Elia Kazan is talking about the censors' mistaken reception of the movie. There is then a multiple distancing: it is not the life of a woman and a man that we would be able to access like Asmodeus; rather, authentic life has been recorded by Tennessee Williams in a play, the play has been transformed into a movie script and the *Drehbuch* into a film, the film has been cut by the censors, and finally the author complains about the censors.

Some of the other ads are even more textual, in particular the one about "Murder in the Street." The image is from the 1947 movie *The Brasher Doubloon* or *The High Window*, as it was distributed in Europe; the censors did not approve of the name "Brasher" because they thought it would be confused with the word "brassiere," so the movie used the title of the book it was based on, Raymond Chandler's hard-boiled novel of 1942. The story is about shame and fear, with several characters claiming to have committed the crime. The true identity of the perpetrator is revealed by the image that Tschumi shows in the ad; in the story it is used to blackmail the murderer.

Not only is the image not original with Tschumi; the accompanying aphorism is also pregnant with explicit quotations marked with capital letters. The capitalized words *"Murder in the Cathedral"* obviously refer to the title of the 1935 play by T. S. Eliot about St Thomas Becket's murder at Canterbury Cathedral in 1170. Given this association, it may not be altogether far-fetched to hear in the *Murder in the Street* an echo of Poe's *Murders in the Rue Morgue*. If this reading is correct, the premeditated, cultural deed is represented either as prostitution or as the politically motivated assassination of the archbishop; they are contrasted with spontaneous gestures of affection or with the instinctive, natural killings by a frightened orangutan (who finished his bloody business and then escaped without being seen by any residents of the quiet Rue de Morgue, just like the murderer in Tschumi's Ad no. 7 did). The important thing is that both the cultural deed and the natural occurrence are individuated by literary models. As Oscar Wilde argued in "The Decay of Lying," nature is nothing originary but merely the effect of art or culture: "At present, people see fogs, not because there are fogs, but because poets and painters have taught them the mysterious loveliness of such effects."[82]

While it is possible, then, to continue to read the sentence as the opposition between culture and nature, it becomes obvious that Tschumi's position is closer to Baudrillard than Debord in that the supposedly authentic deed is enacting a hyperreal model. In hyperreality, entertainment, information and communication technologies provide experiences more intense than everyday life. The models, images, and codes of the hyperreal control thought, experience and behavior.

Baudrillard's hyperbolic language may suggest an overly facile reading of the model affecting behavior. What is at stake concerns the general construction of the event, not the particulars of its content. Whereas death is a physiological fact rather than a matter of cultural definition, murder as an act requires the consideration of cultural issues such as cause and effect, guilt, intent, etc., and murder as an event requires a definition of beginning and end and the determination of relevant aspects.

Advertising

In a famous passage, Walter Benjamin suggested that "buildings are appropriated in a two-fold manner: by use and by perception – or rather, by touch and sight . . . Tactile appropriation is accomplished not so much by attention as by habit. As regards architecture, habit determines to a large extent even optical reception. The latter, too, occurs much less through rapt attention than by noticing the object in incidental fashion."[83] However, Benjamin felt that the new technologies of photography and film would be able to break the habitual patterns of perception and create an awareness for the built environment.[84] Another technology that could reawaken experience is advertising. In the 1930s, Benjamin wrote: "Today the most real, the mercantile gaze into the heart of things is the advertisement. It abolishes the space where contemplation moved and all but hits us between the eyes with things as a car, growing to gigantic proportions, careens at us out of a film screen. And just as the film does not present furniture and facades in completed forms for critical inspection, their insistent, jerky nearness alone being sensational, the genuine advertisement hurtles things at us with the tempo of a good film."[85]

Tschumi seems to share Benjamin's enthusiasm for advertising as a means to recondition human consciousness. In describing his Advertisements for Architecture project, he explains: "So just as ads for architectural products (or cigarettes or whiskey) are made to trigger desire for something beyond the glossy illustration, these ads have the same purpose: to trigger desire for architecture."[86] For Tschumi, desire is the space or the movement in between the fragments of architecture. In stressing in-betweenness, he comes close to Barthes' definitions in the *Pleasure of the Text*: "[I]t is intermittence, as psychoanalysis has so rightly stated, which is erotic: the intermittence of skin flashing between two articles of clothing . . ., between two edges . . .; it is in this flash itself which seduces, or rather: the staging of an appearance-as-disappearance."[87]

In order to arouse desire as in-betweenness, both architecture and advertising employ strategies of simulation and dissimulation. Barthes explains: "in order to blunt the buyer's calculating consciousness, a veil must be drawn around the object – a veil of images, of reasons, of meanings; a mediate substance of an aperitive order must be elaborated; in short, a simulacrum of the real object must be created, substituting for the slow time of wear a sovereign time free to destroy itself by an act of annual potlatch."[88] What is remarkable about this image-system constituted with desire as its goal is that its substance is essentially intelligible; it is not the object but the name that creates desire, it is not the dream but the meaning that sells.[89]

This image of advertising should be contrasted with Mallarmé's conception of poetry: he insisted that "to name an object is to suppress three-quarters of the enjoyment of a poem, which is derived from the happiness of guessing little by little; to suggest it, that is the dream."[90] The difference is that poetry triggers desire for itself whereas advertising is transcendental. In Julia Kristeva's interpretation, the network connecting the object (signifier) and the subject actually breaks in two: desire, implicating the body and history, and symbolic order, which contains reason and intelligibility. Hence, the desire of the *eteros* as a mode of *eros* indicates heterogeneity through and across the signifier in advertising, unlike poetry. "To posit that the subject is linked by its desire to the signifier is to say, therefore, that he has access through and across the signifier to what the symbolic does not make explicit, even if it translates it: instinctual drives, historical contradictions."[91]

Seduction

The word "desire" comes from the Latin *desiderare*, which has something to do with the stars (*sidus* in Latin), like the word "consider" which suggests looking at the stars. As Poe pointed out in the text quoted above, stars are best viewed by sideward glances, instead of focusing our gaze upon them. Tschumi and the situationists suggest that the consideration of the city may be at its most accurate if one avoids the center and just glimpses at the truth of the city by randomly drifting in the margins. This is also the way to feel the desire for architecture and to be seduced by the city.

Etymologically, "seduction" means "leading astray," *Verführung*. In *Seduction*, Baudrillard dwells on the relation between truth and seduction in some detail, writing: "Seduction takes from discourse its sense and turns it from its truth." It does not harbor a hidden, deeper truth that the analysis should dig out: "it is not somewhere else, in a hinterwelt or an unconscious, that one will find what leads discourse astray. What truly displaces discourse, 'seduces' it in the literal sense, and renders it seductive, is its very appearance, its inflections, its nuances, the circulation (whether aleatory and senseless, or ritualized and meticulous) of signs at its surface."[92]

Baudrillard interprets seduction as a ritual and game with its own rules and lures. A prime example of seduction, fashion as a form of pleasure takes the place of fashion as a form of communication, subverting the visual code from language to spectacle: "fashion is pure speculative stage in the order of signs. There is no more constraint of either coherence or reference."[93] In this sense, all postmodern culture aspires to the condition of fashion.

Fashion is a good illustration of Baudrillard's orders of simulacra, for clothing seems to have originated as a system of elaborate signs that often functioned as masks and developed in arbitrary, self-referential signs without origin. In his masquerade of a treatise, *Sartor Resartus*, Carlyle wrote: "The first purpose of Clothes . . . was not warmth or decency, but Ornament . . . for Decoration [the Savage] must have clothes . . . among wild people we find tattooing and painting even prior to clothes. The first spiritual want of a barbarous man is Decoration, as indeed we still see among the barbarous classes in civilized Countries."[94] Some evidence in support of Carlyle was provided by Darwin who reported that when given pieces of cloth large enough to wrap around their body, the nearly naked inhabitants of Tierra del Fuego unexpectedly tore the cloth into shreds and wore the small pieces as ornaments. Later sociologists have often maintained the same position. At the end of the nineteenth century, Edward Westermarck listed dress under the heading of "Primitive Means of Attraction" and left no doubt that he was talking about erotic desire.[95]

Such theories influenced Adolf Loos, who saw both clothing and ornamented architecture as a means to hide a terrible or banal reality – or even as the perfect simulacrum, masking the absence of meaning. Echoing Casanova's observation that a totally naked woman is without charm or mystery, Loos bluntly asserts that the naked woman is unattractive to man but fashion can create erotic significance where anatomy fails.[96] "Woman covered herself, she became a riddle to man, in order to implant in his heart a desire for the riddle's solution."[97] Clothing as a second skin transforms the woman's body into an intertextual cultural condition, independent of the material world and acceptable to the mind; architecture as the third skin functions in an analogous way if in the second or third power, masking masks.[98]

Already the natural skin is a mask, obscuring what is underneath: the English word "hide" contains both meanings of skin as a membrane to touch and a veil to conceal. Just like the Latin words obscurus, "obscure," and *cutis*, meaning "skin" (akin to the Greek and German words for "skin," *kutos*, and *Haut*), "hide" derives from the Sanskrit *skutas*, "covered" and the root *(s)keu-*. Yet, as Paul Valéry once remarked, the deepest thing in man is the skin.[99] It is the most primitive organ of man; hence situations where one touches another with bare skin are the most intimate, most instinctive and most primal. The skin is the surface others see or touch; it is a presentation of the self to others. For social animals, self-presentation is essential: it is what ultimately determines one's position in society and one's identity.

If self-presentation is understood as the fabrication of a new truth rather than revelation of a pre-existing one, it is also possible to expand

Heidegger's etymological speculations in the essay "Building Dwelling Think-ing." He derives the expression *ich bin* or "I am" from Old German *buan*, which he claims originally meant "to build" or "to live," and concludes that *wohnen* or dwelling is Man's way of being in the world.[100] It should be also mentioned that the word *wohnen*, like the word *Wahn*, "madness," comes from the Indo-European root *uen(ə)*, to "desire," whence also the Latin *venus, veneris*, "desire," "lust." Moreover, the English equivalent for *wohnen*, "dwelling," derives from the Sanskrit word *dhwer*, "to mislead" – could that be *verführen*, to "seduce"? The idea that the origin of architecture lies in desire, and that its method is seduction, is ancient. Filarete defined building as "nothing more than a voluptuous pleasure. Anyone who has experienced it knows that there is so much pleasure and desire in building that however much a man does, he wants to do more."[101] Architecture is seduction and desire.

## Conclusion

And yet, Tschumi voices surprising self-criticism against the Advertisement project, admitting that "architectural drawings and photographs are just paper spaces; there is no way to 'perform' real architecture in a magazine or through drawing. The only way is to make believe." However, this sugges-tion should be taken with a grain of salt if we accept Tschumi's axiom to the effect that architecture simulates and dissimulates for this principle entails that architecture itself (as much as any representations of architecture) func-tions on the premise of make-believe. If, furthermore, Baudrillard is also correct, then there would be no alternative to make-believe or simulation, and thus no difference between the architecture as buildings and architec-ture as text or photographs. Both architecture and advertising have the same objective – to trigger desire – and the same method – seduction by simula-tion and dissimulation.[102] For Baudrillard, advertising "is our only architecture today, great screens on which are reflected atoms, particles, molecules in motion. Not a public scene or true public space but gigantic spaces of circula-tion, ventilation and ephemeral connections."[103]

## Notes

1 E. Poe, "Murders in the Rue Morgue," in E. Carlson, *Introduction to Poe: A Thematic Reader*, Glenview, Ill.: Scott, Foresman and Company, 1967, p. 341; B. Tschumi, *Architec-ture and Disjunction*, Cambridge, Mass.: MIT Press, 1994, p. 93.

2 M.-A. Laugier, *An Essay on Architecture* (trans. W. Herrmann), Los Angeles: Hennessey and Ingalls, 1977, pp. 129–130.

3 See Tschumi, *Architecture and Disjunction*, pp. 85–86, 173–205.

4 Tschumi, *Architecture and Disjunction*, pp. 43, 49.

5 Tschumi, *Architecture and Disjunction*, pp. 43–44, cf. 49–50.

6 Tschumi, *Architecture and Disjunction*, pp. 86, 88.

7 G. Bataille, "Hegel, Death, and Sacrifice" (trans. J. Strauss), in *Yale French Studies* 78; A. Stoekl (ed.) *On Bataille*, New Haven, Conn.: Yale University Press, 1990, p. 26; G. Bataille, *The Accursed Share: Volumes II and III* (trans. R. Hurley), New York: Zone Books, 1991, p. 198.

8 Cf. Aristotle, *De Caelo* 271a35; *De Part. An.* 645a23–26, 639bl9.

9 Bataille, *The Accursed Share*, Vol. I, p. 58. See also D. Hollier, *Against Architecture: The Writings of Georges Bataille* (trans. B. Wing), Cambridge, Mass.: MIT Press, 1995.

10 Bataille, *The Accursed Share*, Vol. II, p. 16.

11 J. Ruskin, *The Seven Lamps of Architecture*, New York: Dover, pp. 9, 13–14.

12 Le Corbusier, *L'art décoratif d'aujourd'hui*. Paris: Les Éditions Arthaud, 1980, p. 86, n. 2. Le Corbusier, *Vers une architecture*, Paris: Les Éditions Crés et Cie, 1924, p. 179.

13 Tschumi, *Architecture and Disjunction*, p. 74.

14 Hollier, *Against Architecture*, pp. 46, 53.

15 Cf. G. Lessing, *Laokoon oder Über die Grenzen der Malerei und Poesie*, Stuttgart: Reclam, 1964, xvi, pp. 114–115.

16 Tschumi, *Architecture and Disjunction*, pp. 65, 73–74.

17 G. Bataille, *Erotism. Death and Sexuality* (trans. M. Dalwood), San Francisco: City Lights Books, 1986, p. 109.

18 Bataille, *Erotism*, pp. 63, 64.

19 Bataille, *Erotism*, p. 36.

20 Le Corbusier, *Towards a New Architecture* (trans. F. Etchells), New York: Holt, Rinehart and Winston, 1983, pp. 181–184.

21 Tschumi, *Architecture and Disjunction*, pp. 75–76.

22 Bataille, *Erotism*, p. 17.

23 Tschumi, *Architecture and Disjunction*, p. 75.

24 Cf. Bataille, *Erotism*, pp. 46–47, 56, 59–61, 65–67; Bataille, *The Accursed Share*, Vol. II, pp. 79–81; Tschumi, *Architecture and Disjunction*, pp. 72–73.

25 Tschumi, *Architecture and Disjunction*, p. 71.

26 Tschumi, *Architecture and Disjunction*, p. 71.

27 Tschumi, *Architecture and Disjunction*, p. 76.

28 Tschumi, *Architecture and Disjunction*, p. 88.

29 C. Dean, *The Self and Its Pleasures: Bataille, Lacan and the History of the Decentered Subject*, Ithaca, New York: Cornell University Press, 1992, pp. 193–195.

30 M. Borch-Jacobsen, *Lacan, The Absolute Master* (trans. D. Brick), Stanford, Calif.: Stanford University Press, 1991, p. 203.

31 Cf. Tschumi, *Architecture and Disjunction*, p. 96.

32 See V. Navasky, *Naming Names*, Harmondsworth: Penguin, 1981, pp. 204–206, 322–323.

33 Navasky, *Naming Names*, pp. 207, 407.

34 J. Wood, *The Origin of Building or Heathen Lies Detected*, S. and F. Farley, Bath: 1742, pp. 13, 39, 231.

35 G. Semper, *The Four Elements of Architecture and Other Writings* (trans. H. Mallgrave and W. Herrmann), Cambridge: Cambridge University Press, 1989, p. 270.

36 Semper, *Four Elements*, p. 257. Cf. F. Nietzsche, *Geburt der Tragödie*, Stuttgart: Alfred Kröner Verlag, 1964, pp. 35, 70, 71, 187, 387; F. Nietzsche, *Jenseits von Gut und Böse*, Stuttgart: Alfred Kröner Verlag, 1964, 299; F. Nietzsche, *Der Wille zur Macht*, Stuttgart: Alfred Kröner Verlag, 1964, 554.

37 Tschumi, *Architecture and Disjunction*, p. 90.

38 F. Nietzsche, *Jenseits Gut und Böse*, Stuttgart: Alfred Kröner Verlag, 1964, §289, p. 227.

39 M. Heidegger, *Der Ursprung des Kunstwerkes*. Stuttgart: Reclam, 1992, p. 53.

40 L. Wittgenstein, *Culture and Value* (trans. P. Winch), Oxford: Basil Blackwell, 1980, p. 31.

41 Tschumi, *Architecture and Disjunction*, p. 121.

42 Tschumi, *Architecture and Disjunction*, p. 122.

43 H. Arendt, *The Human Condition*, Chicago, Ill.: University of Chicago Press, 1958, p. 22.

44 I. Shaw, "God Was Here But He Left Early," p. 599; on Shaw and situations, see A. Kazin, "Foreword," p. xviii. Both are in I. Shaw, *Short Stories: Five Decades*, New York: Delacorte Press, 1984.

45 I. Shaw, "Love on a Dark Street," in Shaw, *Short Stories*, p. 602.

46 P. Hamon, *Expositions* (trans. K. Sainson-Frank and L. Maguire), Berkeley: University of California Press, 1992, p. xv.

47 G. Bataille, *The Tears of Eros* (trans. P. Connor), San Francisco: City Lights Books, 1989, p. 162.

48 Bataille, *The Tears of Eros*, p. 45.

49 Bataille, *Erotism*, p. 79.

50 Wittgenstein, *Culture and Value*, p. 50.

51 Hamon, *Expositions*, p. 27 note.

52 Wittgenstein, *Culture and Value*, p. 4.

53 G. Debord, *Society of the Spectacle*, Detroit: Black&Red, 1983, §19.

54 S. Sadler, *The Situationist City*, Cambridge, Mass.: MIT Press, 1998, p. 97.

55 Sadler, *Situationist City*, p. 119.

56 Sadler, *Situationist City*, pp. 25, 34, 117. Cf. R. Caillois, *L'Homme et le Sacré*, Paris: Gallimard, 1950.

57 S. Edwards, *The Paris Commune 1871*, New York: Quadrangle Books, 1971, pp. 7–8, 30–31, 320.

58 Debord, *The Society of Spectacle*, §172.

59 Tschumi, *Architecture and Disjunction*, p. 256.

60 Tschumi, *Architecture and Disjunction*, p. 6.

61 Sadler, *Situationist City*, pp. 11, 15, 25, 33, 76, 78, 81, 88, 120.

62 Sadler, *Situationist City*, pp. 80, 81.

63 Tschumi, *Architecture and Disjunction*, pp. 173–180.

64 Hamon, *Expositions*, pp. 9, 11, 67, 96.

65 F. Nietzsche, *Unzeitgemässe Betrachtungen*. Stuttgart: Alfred Kröner Verlag, 1964, p. 611. (F. Nietzsche, "On Truth and Lie in a Non-Moral Sense," in D. Breazeale (ed.) *Philosophy and Truth*, Atlantic Highlands, New Jersey: Humanities Press, 1979, p. 84.

66 T. Hobbes, *Leviathan*, London: J.M. Dent and Sons, 1950, pp. 69–70.

67 R. Laurence, *Roman Pompeii*, London: Routledge, 1994, pp. 128–131.

68 Livius from Velleius Paterculus 2.14.3; as quoted by A. Wallace-Hadrill, *Houses and Society in Pompeii and Herculaneum*, Princeton, New Jersey: Princeton University Press, 1994, p. 5; see also pp. 17–23.

69 M. Cohen, *Profane Illumination: Walter Benjamin and the Paris of Surrealist Revolution*, Berkeley: University of California Press, 1993, p. 224.

70 D. Frisby, *Fragments of Modernity*, Cambridge, Mass.: MIT Press, 1986, p. 261; Jennings, *Dialectical Images: Walter Benjamin's Theory of Literary Criticism*, Ithaca, New York: Cornell University Press, 1987, pp. 82–83; R. Wolin, *Walter Benjamin: An Aesthetic of Redemption*, New York: Columbia University Press, 1982, pp. 226–230.

71 B. Lindner, "The Passagen-Werk: the Berliner Kindheit, and the Archaeology of the 'Recent Past'" in *New German Critique* 39 (Fall 1986), p. 45; W. Menninghaus, "Walter Benjamin's

Theory of Myth," in G. Smith (ed.) *On Walter Benjamin*, Cambridge, Mass.: MIT Press, 1988, pp. 292–325.

72 E. Kästner, "Nächtliches Rezept für Städter," in *Doktor Erich Kästners Lyrische Hausapotheke*, München: DVA, 2000.

73 A. Schopenhauer, *Parerga und Paralipomena III*, Sämtliche Werke, Band V, her. Wolfgang Frhr. von Löhneysen (n.l.: Cotta-Verlag/Insel-Verlag), §§55, 81.

74 Tschumi, *Architecture and Disjunction*, pp. 173–180.

75 G. Bataille, *Oeuvres completes*. Vol. 1, Paris: Gallimard, 1970, p. 277.

76 R. Caillois, *Approche de l'imaginaire*, Paris: Gallimard, 1974, p. 93. For documentation, see G. Bataille, R. Lebel, and I. Waldberg (eds) *Encyclopaedia Acephalica*, London: Atlas, 1996.

77 Bataille, "Hegel, Death, and Sacrifice," p. 19.

78 Bataille, "Hegel, Death, and Sacrifice," p. 20.

79 Bataille, "Hegel, Death, and Sacrifice," p. 18.

80 Bataille, "Hegel, Death, and Sacrifice," p. 25.

81 The expression "quotations without quotation marks" comes from W. Benjamin, *Das Passagen-Werk*, Erster Band, Hrsg. Rolf Tiedemann, Frankfurt am Main: Suhrkamp, 1983, p. 572.

82 O. Wilde, "The Decay of Lying," in O. Wilde, *The Complete Works of Oscar Wilde*, Vol. V: *Intentions*, Garden City, New York: Doubleday, Page & Co., 1923, pp. 63, 47–49.

83 W. Benjamin, "The Work of Art in the Age of Mechanical Reproduction," in *Illuminations* (trans. H. Zohn), New York: Schocken Books, 1965, p. 240.

84 Benjamin, "The Work of Art," pp. 236–237.

85 W. Benjamin, *One-Way Street* (trans. E. Jephcott and K. Shorter), London: New Left Books, 1979, p. 89; W. Benjamin, "The Space for Rent," in *Reflections* (trans. E. Jephcott), New York: Schocken Books, 1978, pp. 85–86. For a critique of advertising, see H. Lefebvre, *The Production of Space* (trans. Nicholson-Smith), London: Basil Blackwell, 1991, pp. 309–310.

86 Cf. Tschumi, *Architecture and Disjunction*, p. 94.

87 R. Barthes, *The Pleasure of the Text* (trans. R. Miller), New York: Hill and Wang, 1975, pp. 9–10.

88 R. Barthes, *The Fashion System* (trans. M. Ward and R. Howard), New York: Hill and Wang, 1983, pp. xi–xii.

89 Barthes, *The Fashion System*, p. xii.

90 See A. Thibaudet, *La Poésie de Stéphane Mallarmé*, Paris, 1926, p. 110, as quoted in M. Valency, *The End of the World*, New York: Schocken, 1983, p. 43.

91 J. Kristeva, *Desire in Language* (trans. T. Gora, A. Jardine, and L. Roudiez), New York: Columbia University Press, 1980, p. 116.

92 J. Baudrillard, *Seduction* (trans. B. Singer), New York: St Martin's Press, 1990, p. 53.

93 J. Baudrillard, *Symbolic Exchange and Death*, London: Sage, 1993, p. 125.

94 T. Carlyle, *Sartor Resartus*, London: Curwen Press, 1931, p. 48.

95 C. Darwin, *Journal of Researches into the Geology and Natural History of the Various Countries Visited by H.M.S. Beagle*, New York and London: Hafner Publishing Company, 1952, p. 235 (Dec 25, 1832), p. 240 (Jan 22, 1833). Westermarck, as quoted in E. Wilson, *Adorned in Dreams, Fashion and Modernity*, New York: Tiptree/Virago Press, 1985, p. 55.

96 Cf. S. Freud, "Three Essays on the Theory of Sexuality" (trans. J. Strachey), New York: Basic Books, p. 22: "The progressive concealment of the body which goes along with civilization keeps sexual curiosity alive." Perhaps this idea is at root of Loos' definition of good taste as invisibility. A. Loos, "Die Kleidung," *Sämtliche Schriften, Vol. 1: Ins Leere Gescprochen. Trotzdem*, Wien/München: Verlag Herold, 1962, pp. 20–21. Cf. Bataille, *Erotism*, pp. 144–145.

97 V. Steele, *Fashion and Erotism*, New York: Oxford University Press, 1985, p. 15; A. Loos,

"Damenmode" in A. Loos, *Sämtliche Schriften, Vol. 1: Ins Leere Gescprochen. Trotzdem*, Wien/München: Verlag Herold, 1962, p. 158.

98 Cf. Semper, *Four Elements*, pp. 103–104, 254, 255, 305, n. 18, 19.

99 P. Valéry, "Idée Fixe: A Duologue by the Sea" (trans. David Paul), in P. Valéry, *Collected Works of Paul Valéry*, Vol. 5, New York: Bollingen Foundation, 1965, p. 31.

100 M. Heidegger, "Bauen Wohnen Denken", in *Mensch und Raum. Das Darmstädter Gespräch 1951*. Hrsg. Ulrich Conrads und Peter Neitzke. Bauwelt Fundamente 94. Braunschweig: Friedr. Vieweg & Sohn, 1991, S. 91, 101–102.

101 Filarete, *Trattato dell'architettura*, fol. 9 r–v, fol. 8r. Cf. also L. Alberti, *Ten Books on Architecture*, London: Alec Tiranti Ltd, 1955, i, 4, vi, 6.

102 B. Tschumi, "Manifesto 3," in B. Tschumi, *Architectural Manifestoes*, London: AA Press, 1979.

103 J. Baudrillard, *Ecstasy of Communication*, New York: Semiotexte, 1988, pp. 129–130.

# Chapter 21

# Acropolis, now!

*James Williamson*

For many modern historians and theoreticians of architecture – as well as some of architecture's notable practitioners – the seminal discussion of the links between architecture and Surrealism begins in a 1978 edition of *Architectural Design* edited by Dalibor Vesely and titled, aptly, *Architecture and Surrealism*.[1] The edition was important in its anticipation of the significance of Surrealism for architecture rather than its analysis of significant examples of this relationship.[2] Vesely's essay was critical in its clarification of Surrealism as an intellectual movement and theoretical construct rather than a stylistic movement – an observation not necessarily original but crucial in bringing any discussion of the movement into a discipline often distracted by the manifestations of style.

Vesely went to great lengths to separate the phenomenon of Surrealism from the by-products of it, including its role as a political and artistic movement.[3] He concentrated on the role of the occult – in particular the role of alchemy – within Surrealism and not on any semiotic reading of Surrealism. This is unfortunate, and it is especially so given the importance of Rimbaud to the Surrealists as demonstrated in "An Alchemy of Words" from *A Season in Hell* (if nothing else, this poem is a plea for the use of language in the psychic struggle for self re-invention that was such an inseparable part of the occult influences within Surrealism). In the 1978 *AD* magazine, only Cardinal[4] attempts to grapple with the importance of theories of language and their effects upon the work of architects or the interpretation of their work.

This is certainly seen more clearly in hindsight, and to be fair would require a body of thought within architectural discourse contemporary

**21.1**
**John Hejduk,**
**Prison, Garden of**
**Angels, and Cross-**
**over Bridge from**
**the Riga Masque**
© Collection Centre
Canadian
d'Architecture/
Canadian Centre for
Architecture,
Montreal

with, but only beginning at the time of, these essays. That discourse(s) is, of course, that we have come to gather under the rubric: post-structuralism – a body of thought grounded in semiotic theory and often facilitated by (as is Surrealism) a radical suspension of common reasoning and an insightful linguistic gamesmanship. Put more precisely, Surrealism is one of the fundamental groundings for post-modern semiotics, its attack on language, and the crisis of the object and the image.

As the relationship between architecture and Surrealism subsequently began to take form in the fervent and transforming years after the publication of the *AD* essays, it centered not around and about the occult but rather around the conception of language as an arbitrary and unstable system of signs open to interrogation and manipulation – and in no more surprising a place than in architecture. In architectural examples both contemporary to these essays and after, we see this relationship take markedly different forms and inventive expressions: of architectural images, of the two-dimensional and three-dimensional practices employed in the creation of these images, in the interpretation and explication of images by critics, and

by architects in their increasing use of text to accompany, explicate, or project their work.

John Hejduk's urbanism and architecture are exemplars of the relationship between Surrealism and architecture, both in relation to the alchemical and the attacks they make upon the common sense of architectural and urban thinking. They demonstrate (1) a transformation of type and program through "alchemical" resolutions of the sacred and profane, and (2) a play of language as an alchemical process that joins with the occulted to mark the significance of his work: the creation of his own "alchemy of words" and images.

Alchemy

> I would appreciate your noting the remarkable analogy in so far as their goals are concerned between the surrealist's effort and those of the alchemists. The philosopher's stone is nothing more or less than that which was to enable man's imagination to take a stunning revenge on all things.
>
> André Breton, *Manifestoes of Surrealism*[5]

After the initially provocative experiments of Surrealism, André Breton and the Surrealists turned to the hermetic and the occult, and in particular alchemy, in a move predicted by Breton's *Second Manifest du Surréalisme* in 1930 where he calls for the "profound, true occultation of surrealism" by an embrace of the hermetic as dictated by the formula of Hermes.[6] Breton writes: "Everything leads us to believe that there exists a spot in the mind from which life and death, the real and the imaginary, the past and the future, the high and the low, the communicable and the incommunicable will cease to appear contradictory."[7] Surrealism was therefore to engage in a kind of alchemical practice transcending fundamental contradictions and transforming the everyday and the banal, even the profane, into the realm of transcendence.[8]

This explains and develops the Surrealist's "deep nostalgia for archaic forms of existence," as well as their view of the poet as a "demiurge (alchemist and magician), who has the power to revolt against hyperlogical reality, and who is able to create a world which has its own logic – the logic of the dream and the fantastic."[9] Architectural allusions and references played an important role in the development of this poetic figure. Enlisted to reinforce this view were the architect, Daedalus, as demiurge (and criminal), the labyrinth as an architectural construction of both the irrational and rational and a symbol of cosmic dimension, and the Minotaur itself – half man/half beast.

Athens to Vladivostok: journeys to the East

The masque projects of John Hejduk transform the roof gardens of the Unité of Corbusier – themselves re-inventions of ancient extra-urban sacred sites such as those found at Agrigento and Segesta and, most importantly (for Corbusier), the Acropolis in Athens. This process of transformation begins with Hejduk's renovation of the Foundation Building of The Cooper Union for the Advancement of Science and Art and continues through the Berlin masques and The Lancaster/Hanover Masque, culminating in the masques for Riga, Lake Baikal and Vladivostok.[10] In these Hejduk is engaged in operations dutiful to the alchemical enterprise of Surrealism in their formal transformations, in their reconciliation or inversion of the categories of sacred and profane, and in the retrieval of a certain archaism.[11]

Greek cities were usually formed around a defensible high ground, and the Acropolis of Athens is no exception. The Athenian hill, called "Sacred Rock" or Acropolis – *high city* – had been in use for thousands of years as a ceremonial area or for dwelling and has been for much of its history the epitome of the sacred separated from the profane. Greek architecture – particularly sacred architecture – was closely tied to the geography and created a place not fully accessible to us.[12] In Heideggerian terms it can be seen as a fourfold – a symbolic manifestation of the relationships between the gods, the mortals, the earth and the heavens. The pantheistic drama that unfolds on the Acropolis includes in its construction the hill itself dedicated to polytheism, as well the distant mountains and sea. Equally important is the rising and setting of the sun and the phases of moon – the universe as the ultimate reality, the ultimate object of reverence making Nature a sacred and an inseparable part of the totality.[13] In the simplest architectural terms this was achieved by the articulation of two separate, but coexisting, contexts: the placement of temples on a high, restricted and sanctified ground segregated from the profane everyday life and character of human habitation below, and the situating of the complex in a larger and profoundly transcendent context – the landscape. A ritual path and surrounding parapet further determine the hierarchy of relationships within this elaborate cosmogony.

The roof garden of the Unité d'Habitation in Marseilles of 1947–52 is Le Corbusier's own effort to inhabit a pantheistic world as a twentieth-century man; and its relation to the Acropolis has been clearly established by others (Figure 21.2). One of his most influential late works and his first significant postwar structure, the Unité is a giant, twelve-story apartment block for 1,600 people – the late modern counterpart of the mass housing schemes of the 1920s. Structurally it is simple: a rectilinear ferro-concrete

21.2
**John Hejduk, *The House in a Maze***
© Collection Centre
Canadian
d'Architecture/
Canadian Centre for
Architecture,
Montreal

grid, into which are slotted precast individual apartment units and facilities for shopping, topped by a roof garden.

  The roof garden, like the Acropolis, is segregated from the rest of the city both by height and through its own identification with landscape. A parapet at eye-level prevents any view of the mundane city below. Corbusier noted: "The massive parapet at the top of the Unité is a little less than five and a half feet high (1m60). It protects, and it also screens out the mediocre reality of the down to earth, leaving only the seeping horizon – the mountains and the sea – visible, 'I too dwelt in Arcadia' – ten years from now this is what the 'graduates' of our Nursery School will be saying."[14] The roof garden is populated by a crèche, running track, a children's swimming pool and play area, a gymnasium, open-air theater, two solariums, "artificial mountains" and the now-famous stoic, sculptural and figural ventilation shafts – appearing like misplaced piloti from the ground beneath.[15] These multiple objects/figures reinvent the ancient temple precinct through a rewriting of the program *vis-à-vis* Corbusier's political, social and personal (bodily) affinities and thus inscribe upon the roof garden a modern Corbusian pantheism with its own rituals and processions, including annual fairs with Arcadian dances performed by the children of the Unité.

  But the relationship does not stop with the pantheism; Richard Moore and others have documented Le Corbusier's interest in alchemical

philosophy and the dialectic force of bringing opposite terms face to face. There is a parallel between the opposing elements of fire–water, sulphur–mercury, sun–ocean and the pairs of conceptual poles nature–culture, rational–irrational, machine–life, Apollo–Medusa, orthogonal–organic, vertical–horizontal, architect–engineer, day–night: reciprocally drawing value from their opposition, they sustain the duality in which Le Corbusier's discourse moved.[16]

Le Corbusier was an important and influential figure throughout John Hejduk's career. This is certainly true for that period he was associated with the so-called New York Five and the work that is exemplified in the Bye House and Wall House investigations, and continues through to the end of his career in less overt but equally significant expressions. The Unité represents a unique and unexamined case of this influence, and one that I believe is crucial in understanding the formal sources of Hejduk's masques and of their relation to the masques' alchemical ambitions. It begins with one of Hejduk's largest building commissions: the renovation of the Foundation Building at the Cooper Union.

The original Cooper Union Foundation Building was begun in 1853 and completed six years later; a forerunner of the modern skyscraper, it was widely acclaimed in New York for its innovations and design. In 1974, Hejduk completed a remarkable and prescient renovation of the interior space within the shell of the original building. At its time, it was one of the most complex construction projects in the United States because the historic shell had to be raised and preserved to accommodate the addition of a 6th floor within a previous five-floor structure.

In Hejduk's renovation, the ground floor of the building introduces you to a lobby occupied by a grand stair surrounding a round elevator shaft leading up to the second floor and facing the entrance to the library itself resting atop "The Great Hall." The library and various others parts of the building appear to be inhabited by several object/figures, including several Corbusian fragments. At every floor the elevator shaft sits like a mute, obese figure too large for the column grid encaging it – in fact the whole renovation is placed within a structure that now appears to exist independently of the building shell that, barely, contains it.

Journeying up the round elevator tower, you reach the roof and then pass through a small hallway, flanked by two square windows that create a play of reflections of the windows upon each other and the view to Manhattan that they provide. You arrive in the faculty meeting room and are confronted by a huge translucent clock face exceeding the height of the room and thus demanding that the ceiling of the room somehow accommodate it. From the center of the clock stems a thin steel rod linking the clock face with a machine (the clock mechanism) perched on squat anamorphic

metal legs and announcing itself to be the real resident of the space. From this room you may go to the roof and along the walkways where you can look back at the elevator tower against the towers of Manhattan. The dragon-like ventilation shafts that flank both edges of the walkway are not unrelated to the dragon perched atop the Casa Batllo by Gaudí. The view of the lower east side and beyond are uninterrupted by a parapet because the building shell stops short and gives way to the enchanted world of the lower east side, including another of the architectural protagonists of that landscape: the typical Manhattan water.[17]

The renovation of the building at Cooper Union constitutes Hejduk's own response to a history of reinvention and re-inscription that begins with Corbusier's roof garden and will later provide the crucial link along the lineage from the Unité and the masques. It is the renovation to which Hejduk returns when starting the masque projects and initiates the further transformations we see develop in the projects for Berlin and afterwards. Significantly, for the demonstration of the alchemical trajectory of Hejduk's work, we begin to see in the renovation a breakdown of the segregation of the sacred and the profane (and their analogs: temple district and city) that is maintained in both the ancient extra-urban precinct and in the roof garden at Marseille. This dramatically replaces the terms "city" and "nature" within that historic typology where the "garden" is now enfolded within the city and all its modern drama and banality, accompanied by a retrieval of the figural architectural objects that begin with the ventilation shafts of the Unité.

## The masques

> The whole point for Surrealism was to convince ourselves that we had got our hands on the prime matter in the alchemical sense of language.
>
> André Breton[5]

In plan, the Berlin Masque is laid out with the visible contours of the objects and wall forming a kind of mosaic or continuous tissue, but unlike the Acropolis, the Unité or the rooftop of Cooper Union, the ground is not raised – indeed, it is Berlin Ground Zero. The ground becomes an indispensable protagonist in the drama of these masques, and it carries with it all of the apocalyptically sacred that memories of twentieth century Berlin insist upon, or that the memories of the scorched eviscerated ground of the former Soviet Bloc insist upon – a ground that also acts as a kind of silent protagonist in

Hejduk's Bye House or will act as an agrarian ground in the later Lancaster/Hanover Masque.

In the Berlin Masque project, as well as in the Victims Masque, the sites are surrounded by walls, and scattered within and among the walls are the object/buildings that are enumerated in long subject/object lists and brief illusory narrative sketches. An abbreviated list from the Berlin Masque will suffice to describe them: wind tower, water tower, pantomime theater, lottery woman, house for the eldest, and waiting house.

For the Lancaster/Hanover Masque, the Russian masques, and for the Bovisa Masque for Milan, Hejduk eliminates the wall. The projects resemble village fairs where objects are dispersed and scattered and characterized by no discernible plan or otherwise organizational strategy.[18] It is in this deliberate alchemical act of dispersion that Hejduk erases the distinction between the sacred and the profane to allow the subject/objects which inhabit these grounds to exhibit their own alchemical resolutions: ordinary and *extra*ordinary co-exist and co-habitat. Unlike the carnivals outside a medieval cathedral or contemporary fairground architecture, both of which can be cited as sources for the masque projects, these things are seen to be permanent additions and weave themselves within the narrative fabric of their sites. They are, in fact, more than simple additions or collaged elements to their sites. They newly construe the narrative fabric of their sites and thereby alter these sites both from a formal standpoint and in the way that they can now be read as sites.

In opposition to Anthony Vidler's observations,[19] these are not fleeting vagabonds but a part of the very fundament of their place. And though the *repressed* may be at the source of both (the vagabond and the masque object), the repressed as vagabond moves on and thereby maintains her difference as an unreconciled other. The masque objects remain – a constant irritant and reminder. It is the architectural practice that is vagabond.

The city of ciphers: the psychic labyrinth

Hejduk states that the masque projects start with the Venice projects such as the Thirteen Towers of Canneregio and The Cemetery for the Ashes of Thought. Of the many reasons that Venice is significant, one of the most important must be its almost magical embodiment of the labyrinth. Hejduk includes labyrinthine figures in many of his projects, and their existence is deliberate and telling. Richard Cardinal refers to the Surrealist reading of Paris as a psychic labyrinth, or "an essentially intellectual" Paris "located, like some baroque metaphor, within his mind [where] to walk down the street is

thus to traverse the labyrinth within – to explore the circuits and networks of thought, the recesses of emotion and desire."[20]

In his masque projects, John Hejduk traverses and explores the networks of thought, emotion, and desire. He incorporates the tools of language (sign and narrative) and myth (whether archaic or modern) as the "physics of poetry" for his pantheism of construction. In so doing, he employs the Surrealists' and alchemists' tenants to transform, reinvent, and rewrite the urban architectural program.

Hejduk heeds the importance of language as Breton intended, and in so doing uses the everyday, the stories we all hold in common, to ascribe to the projects a diffusion of the sacred with the profane or the profane with the sacred. It is the paradoxical ordinariness of the stories that render them extraordinary. The stories, the objects, or even the individually named "tenants" may incorporate the repressed, mythological analogies, modern references, or they may simply employ functional language. The stories are the poesis of the masques. It is our recognition of the objects as objects, with social dimensions (the narratives), and the link to a particular sign (the named "tenant") that render animate *extra*ordinary presences. They are not the humanized forms of the Erechtheum or personified paradigms of early mythology, although they certainly have their animated and figural qualities. They create a new mythology, which acknowledges the need to segregate no longer the sacred from the profane, but rather to acknowledge the sacred (whether overt or through allusion) among the profane.

Hejduk's objects are a kind of image type that are carried with him from masque project to masque project, becoming familiar in the way that an ensemble cast becomes familiar and understood without the need to explain why the actors are often portraying certain types. That we recognize ourselves, or the universality of experience, in these "types" renders then familiar and striking at the same time. This simultaneous familiarity and startling newness are the result of several combined strategies: compositionally the objects are of a combinatory nature appearing part inanimate/part animate at the same time (for example, part beast and part machine or building). In their appearance Hejduk seems direct in how he uses typical techniques of Surrealist collage in the joining of figures and forms – sometimes almost glyphs – from distant realities and creates a new term or entity. In this Hejduk's working method resembles both the contemporary semiotician and the Surrealist in their "cross fertilization of orders of thought ordinarily kept apart."[21]

The masque objects are almost always joined with a list (an index) of subjects and objects, and this list is often accompanied by an index of glyphs. This notion of the index as a powerful protagonist acting behind the scenes even organizes some of the books done in collaboration with Kim

Shkapich and recalls that Breton speaks of a "Forest of Indices," and that Anna Balakain speaks toward in "Forest of Symbols" in *Surrealism, the Road to the Absolute*. Additionally, these lists are then often amended by a developed series of short ambiguous narrative sketches that significantly reveal as much as they conceal in their allegorical illusiveness – part of which is accomplished in their play with the disparity of work and image. The forcefulness of this poly-construction is dependent upon text as much as image and the fluctuating space of perception that we inhabit between those. The result is an alchemy of words, the marriage of opposites without privileging any one programmatic aspect.

Finally, the object/types/images are placed in a context that intensifies their effects through the relationships that become implied amongst them and through the dramatic transforming effects they have on the context – place – within which they are placed. These contexts must already be considered partially fictive in that their reality is always encoded with the imaginative effects of their history or memories – or our own unfamiliarity with them. There is, therefore, a coupling between the story of the city and the story of the masque – like a small village it is understandable and familiar, yet at the same time as frightening and baffling as the mass historical consciousness of our time.

## Habitability

> What Surrealism demonstrates in its modes of "reading" the city, is that signs are there not only to be coded but also to be felt. Intellectual decipherment is not enough: one must also attend to one's irrationality, to the hints of obscure emotion and unspoken desiring, in order to achieve a total illumination of the meaning of a building or a street.[22]
>
> R. Cardinal, "Soluble City"

In Hejduk's masques we dwell. They open to our physical and psychic inhabitation made possible by a profusion of signs (visual, typological, with the word and stories themselves), or, as Max Bense observes, "One moves not only amid things, but also amid signs, above all amid words ... Urban systems are only livable by virtue of their being completed and reinforced by semiotic systems. These are the intermediaries between urban architecture and urban consciousness."[23] Hejduk's own intermediaries include the profusion of signs as alchemical and linguistic mechanisms to achieve the transformation of type as a semiotic, as well as architectural, construction that

occurs at a formal level and at the level of re-contextualization. Clearly, this is a semiotic act based on a "reading" of context and the semiotic operations of a particular typology (in this case the urban landscape) and suggests the redefining of that ground as a new kind of protagonist that provides for the alchemical marriage of the sacred and the profane.

Another transformation at the formal compositional level (Surrealist collage) that occurs in Hejduk's masque projects is the nature of the architectural object itself in its embrace/personification of the repressed. Like the text of the glyphs and narratives, the objects themselves may similarly incorporate allusions to other works – though these allusions may be truncated, suggestions of memories (individual or mass-cultural), or gestures toward the fantastic. This, too, requires it own semiotic operations – in the case of the individual objects it is both an embrace of disassociated images and the acceptance of an architecture no longer devoted to strict functionalist programming or a platonic "good, true and beautiful." This rewriting of the program is part of the intellectual juggling of a cacophony of references and formal indices that constitute and explode Hejduk's "program" in an alchemy of the *extra*ordinary, the non sequitur, the possible and the physical, even as it redescribes what we might consider or define as habitable.

Finally, these first two strategies conspire together as each individual ensemble acts as a force, and then forces, which alter and transfigure the context/site and thus produce a rewriting or a reinscription of the city – its program, its system of signs, and its experience at an architectural level. This occurs through the placement of these object/images as a means of reconstructing the city's repressed narrative and rethinking the city as a field of operations at a psychic level. This is not simply replacement or an attention to sign. For example, the transformation of the Acropolis could not be achieved by the mere displacement/replacement of either its physical attributes, context or signs (re-contextualization) but can only occur through a kind of rewriting of matter *and* sign – of form *and* consciousness – such as Hejduk constructs.

What Hejduk's masques demand is that we go beyond objects themselves and engage in the urban milieu as a life to be lived outside the architectural object. Certainly there are many others who have tried to embrace a social vision for their work; however, Hejduk's masques are not just socially responsible but go beyond the utopian agendas that still inform the work of even the most "socially responsible" architect. Because they embrace suffering and/or loss – not accepted concepts of utopia – the masque projects appreciate the idea that otherness is really other, or perhaps more pointedly, the idea, in Rimbaud's words: "I is another."

It is this final point that makes Hejduk's tacit approach to the everyday transcendent work and truly alchemical. This makes it real, livable,

inhabitable, socially responsible. It makes the myth become inhabitable – but one would hope that all architecture does that. It is the attention to the social (which is always characterized in Hejduk's work) that acts as a significant counter to criticism of Hejduk's work as being unrelated to larger social, political and cultural issues and propels his work beyond the paranoiac-critical method. In the recent catalog *The Last Works of John Hejduk* we get a glimpse of this transformation: "In the Masques we encounter an architecture overtly anthropomorphic but not quite human; we see not the reflection of ourselves we had hoped for, but another thing looking back at us, watching us, situating us like Lacan's glittering can. The differential play that usually takes place along the axis between the viewer and the object is now internalized in the object itself and turned back on the viewer."[24] In the end, Hejduk's masques are inhabitable. He is saying something else (to use one of Rilke's favorite words, *unsäglich*, something unsayable – or even unpaintable) about modern myth, modern architecture, and modern lives.

## Notes

1   The full list of articles in this important issue of *Architectural Design* are: D. Vesely, "Surrealism, Myth and Modernity"; K. Frampton, "Has the Proletariat No Use For a Glider"; S. Knight, "Observations on Dada and Surrealism"; B. Tschumi, "Architecture and its Double"; P. Inch, "Fantastic Cities"; C. Fawcett, "The Chance Encounter of a Doric Column with a Gasket Window"; D. Melly, "Dada and Surrealism"; "Dada and Surrealism Reviewed" – the architectural components for the exhibition at the Hayward Gallery, an exhibition designed by A. Colquhoun and J. Miller; D. Vesely (ed.) "Salvador Dalí on Architecture"; R. Cardinal, "Soluble City"; P. Smith, "Architecture, Symbolism and Surrealism"; R. Koolhaas, "Dalí and Le Corbusier: the Paranoid-Critical Method."

2   Many of the examples of architecture cited in the essays remain in the realm of "architectural oddities," such as the "The Ideal Palace" of Facteur Cheval, or extraordinary practitioners like Frederick Kiesler whose work remained obscure or unfinished, the masterful but distant Gaudí, or the experiment with – even attack upon – Surrealism, Le Corbusier's Beistegui salon and roof garden ... If these articles had been published ten years later we would certainly see included the work of Hejduk, Rossi, Scarpa, and the subsequent theoretical and soon-to-be-built projects of Koolhaas and Tschumi, among many others.

3   "The real nature of Surrealism, its position and role in modern culture is permanently obscured by the unfortunate identification of the movement with its doctrine, as well as by the no less unfortunate analogies that are made between Surrealism and the established avant-garde (Cubism, Futurism, Dada, etc). It is still popular, even today, to believe that Surrealism was, after all, an artistic movement. To anybody who follows carefully its history since the publication of the first Manifesto in 1924, it must soon become clear that this was mainly due to external circumstances – as a response to repeated attacks and criticism, Surrealists had to formulate some of their principles in a way which tends to build a doctrine. It was merely the public face of Surrealism – taken too seriously and uncritically – that made not only so many practicing Surrealists blind to the fact that authentic Surrealism is a very different phenomenon." D. Vesely, "Surrealism, Myth and Modernity," in D. Vesely, *AD Surrealism and Architecture*, nos. 2–3, 1978, p. 87.

4   In referring to the city and surrealism, Cardinal writes: "The models of the city proposed above were, I believe, firmly established by the surrealists long before any consistent attempt was made to envisage the surrealist environment in semiotic terms. The conception of the city as a vast system of signs was, I would argue, explored 50 years ago in books such as *Nadja* and *Le Paysan de Paris*. This is to say that the mode of thinking developed in Surrealism anticipated modern semiotics on many counts, although the poetic vocabulary and style of surrealist pronouncements may tend to obscure this fact..." R. Cardinal, "Soluble City," in D. Vesely, *AD Surrealism and Architecture*, nos. 2–3, 1978, p. 148.

5   A. Breton, *Manifestoes of Surrealism*, Ann Arbor: University of Michigan Press, 1974, p. 174.

6   Laws of transmutation, as incorporated in the writings of Hermes Trismegistus. In connection with transmutation the following ancient formula is of interest. It was the basis of the alchemical work of old:

> True, without error, certain and most true; that which is above is as that which is below and that which is below is as that which is above, for performing the miracles of the one Thing; and all things were from one by the mediation of one so all things arose from this one thing by adaptation.
>
> The Father of it is the sun, the mother of it is the moon; the wind carries it in its belly and the Mother of it is the earth. This is the Father of all perfection, and consummation of the whole world. The power of it is integral if it be turned into earth.
>
> Thou shalt separate the earth from the fire and subtle from the gross, gently with much sagacity; it ascends from earth to Heaven, and again descends to earth; and receives the strength of the superiors and the inferiors – so thou hast the glory of the whole world; therefore let all obscurity fly before thee. This is the strong fortitude of all fortitudes, overcoming every subtle and penetrating every solid thing. So the world was created.
>
> Emerald Tablet of Hermes

7   Breton, *Manifestoes of Surrealism*, p. 229.

8   A brief description of some of the processes involved in alchemy will aid in the discovery of alchemical symbols in art. The first step in the alchemical process was called "conjunction," and concerns the uniting of opposites such as the four alchemical qualities of hot and cold, wet and dry. The second step was called either "coagulation" or "child's play" and concerned a balancing of the four alchemical elements, earth, air, fire, and water. Coagulation led to the third process, "putrefaction," that was said to separate the elements that had previously been joined. The last step was "purification," but since the nature of all alchemical process was cyclical, and was symbolized by the circle, purification could also be the beginning of another cycle. L. Dixon, "Bosch's Garden of Earthly Delights Triptych: Remnants of a 'Fossil' Science" in *Artforum* vol. LXIII, no. 1 (March, 1981), pp. 99–100.

9   Vesely, "Surrealism, Myth, and Modernity," p. 87. This seems to reflect Jean Paul Sartre and his notion in the "Psychology of Imagination" that the imagination, like alchemy, is a magical practice, an incantation of the world. Additionally, it parallels the fundamental understanding of the architect *vis-à-vis* the figure of Daedalus presented by Alberto Perez-Gomez in "The Myth of Daedalus," in *AA Files*, 1985 Autumn, 10, pp. 49–52. The mythological figure, Daedalus, a man of extraordinary magical powers, and the ancient Greek word *daidala*, objects possessing "mysterious" powers, are demonstrated to ground the architect and her/his products in the realm of the magically transformative. It might be noted that Daedalus' *daidalon*, a wooden cow in which Pasiphäe hides in order to copulate with a mag-

nificent bull, is not unlike a Hejduk masque object; nor, of course, is the labyrinth in which the product of this coupling, the Minotaur, must be hidden unrelated to Hejduk's masques. This is not to ignore the importance of these figures to Surrealism or the work of Surrealists like Masson.

10    In the initial introduction titled "A Matter of Fact," in *Riga, Vladivostok, Lake Baikal: A Work by John Hejduk*, ed. K. Shkapich, New York: Rizzoli International Press, 1993. Hejduk writes that the masque projects are part of a trilogy of trilogies starting with the projects for Venice: The Cemetery for the Ashes of Thought, The Silent Witnesses, and The Thirteen Towers of Cannaregio, and he includes The Berlin Masque, The Victims and The Berlin Night as part of the middle trilogy. There are also projects such as the New England Masque that may be included in this lineage. I do not wish to omit this lineage or the possible surreality of these projects, nor their relation to the subject of this chapter, but to locate the building at the Cooper Union as a pivotal part of this lineage and give the whole lineage a broader historical context. It should also be noted that masques continue in various forms in *Soundings: A Work by John Hejduk*, ed. K. Shkapich, New York: Rizzoli International Press, 1989 (for example, Church Complex B), but also, remarkably, in overt expressions of the extra-urban sacred precinct and a clear return to the Greeks with projects like Necropolis, Cemetery for the Deaths of Architecture also in *Soundings*. To describe the significance of the whole lineage or of the concluding episodes is beyond the scope of this chapter.

11    It is necessary to posit an argument at this point about the archaic relative to architectural discourse: the archaic for that discourse does not reside solely in those cultures that we might call primitive but must include those cultures that form a kind of intellectual and artistic starting point. That is not to say that architects are unaware or so unimaginative as to be unable to posit a primitive or archaic before the ancient Greeks, but that ancient Greek culture and the myths that inhabit it are a point to which the history of architecture and the discipline itself (at least in western architecture) return over and over in a search for origin – even Louis Kahn with his intense interest in the "volume zero" of history found it hard to go beyond the major ancient civilizations of the Greeks, Romans and Egyptians.

12    "They not only created an exterior environment – which it is one of architecture's primary functions to do – that was wider, freer, and more complete than other architectures have encompassed, but, as sculptural forces, peopled the Acropolis with their presences as well, in ways that changes of outlook and belief generally made inaccessible to later ages." V. Scully, *The Earth, the Temple and the Gods: Greek Sacred Architecture*, New Haven: Yale University Press, 1979.

13    The Surrealists were certainly sympathetic to the notion of the pantheism that is the Acropolis. Indeed, part of their search included the transcendence of the material – the everyday – in favor of a "physics of poetry" (Éluard); the myth of Daedalus and the labyrinth were key symbols for surrealism (see the covers of the *Minotaure* or the work of Masson). Even their games (such as the Exquisite Corpse) sought a "change of roles" for all objects. Such was the resolution of the "dilemma of substance" – Renouvier – or the passage from substantive to substance through the medium of a third term "specialized substantive" (the special act of taking the original role and using active imagination to recognize the change of roles).

14    Le Corbusier, *Nursery Schools* (trans. Eleanor Levieux), New York: Orion Press, 1968, p. 78.

15    Some of the tactics of "surrealist" displacement found here can certainly be found in the Beistegui Salon and roof terrace of 1930 as well as in the Villa Savoye of 1929–30, among others. One of Le Corbusier's drawings of the Acropolis shows the Parthenon in silhouette against a horizon bounded by the mountains and the sea. It is not just a landscape drawing but also rather a powerful intuition of the basic geometrical relationship of the temple with

its surroundings that the master constantly turned to throughout his life. Indeed, he accompanies the photographs of the roof garden of the Unité with the landscape surrounding Marseilles above the city; he calls this "a landscape worthy of Homer" in the captions accompanying the photographs.

16 "The old alchemists understood that the fusion of these two opposite principles gave rise to a third, the alchemical hermaphrodite – a recurring theme in Le Corbusier's painting – which symbolizes the triumph of spirit over matter through gnosis, the enlightenment of knowledge." J. Martínez, "Images and Metaphors of Water in Le Corbusier's Thought," in *VIA Arquitectura* 10: Water, Alicante: Papeles de Arquitectura, 2001 (www.via-arquitectura.net/10/10-008.htm).

17 I am reflecting on many of my own experiences here, both as someone who taught in the building and as someone who had the opportunity of having Hejduk point out certain aspects of the building, making anecdotal references and certain powerful "revelations" as in one particularly memorable tour of the roof at sunset.

18 D. Braithwaite, *Fairground Architecture*, London: Hugh Evelyn, 1968.

19 Vidler's appropriation of the situationists is intriguing and in accordance with the encounters that Hejduk sets up. Hejduk's juxtaposition and resolution of the sacred and profane is at once against the spectacular of culture, and is specific to urbanism; however, it is at the same time the transformation of the spectacular. That is what makes it unique and arresting. Important, too, to any reading of Vidler's text is the argument that Hejduk's objects are vagabonds. Certainly they are not. While Hejduk himself said he often took them with him to a city, they are culturally inscribed figures (such as the Lottery ticket seller) rather than nomads. In the later projects the object/subject lists begin to read somewhat differently. They include explicit references of permanence: the bargeman/the bargeman's place, the post office/the post mistress, the citizens/the farm hall, alongside of the more temporal and shifting – for example, the summer visitor/summer visitor's place, the convert/the cross-over house, the transfer, the transfer place – but the general impression remains one of permanence.

20 Cardinal, "Soluble City," p. 148.

21 Cardinal, "Soluble City," p. 148.

22 See p. 149.

23 Quoted by Cardinal, "Soluble City," p. 149; M. Bense, *"Urbanismus and Semiotik,"* in *Konzept I* (eds A. Carlini and B. Schneider), Tübingen: Studio Wasmuth, 1971.

24 M. Hays, *Sanctuaries: The Last Works of John Hejduk*, New York: Whitney Museum of Art, 2002.

# Bibliography

Adamowicz, E., *Surrealist Collage in Text and Image: Dissecting the Exquisite Corpse*, Cambridge: Cambridge University Press, 1998.

Ades, D., *Photomontage*, London: Thames and Hudson, 1976.

——, *Dada and Surrealism Reviewed*, London: Arts Council of Great Britain, 1978.

——, *Dalí*, London: Thames and Hudson, 1982.

Adorno, T., 'Looking Back on Surrealism' in *Notes to Literature*, vol. I, trans. S. Nicholsen, New York: Columbia University Press, 1991.

Agulhon, M., 'La "statuomanie" et l'histoire' in *Ethnologie française*, vol. 8, 1978.

Alberti, L., *Della Pittura* (1435/6).

——, *Ten Books on Architecture*, London: Alec Tiranti Ltd, 1955.

Alexandrian, S., 'Chapter Ten: Surrealist Architecture' in *Surrealist Art*, New York: Praeger Publishers, 1969.

Alquie, F., *The Philosophy of Surrealism*, trans. B. Waldrop, Ann Arbor: University of Michigan Press, 1965.

Aragon, L., 'Au bout du quai, les Arts Décoratifs' in *La Révolution surréaliste*, no. 5, October 1923.

——, (ed.), *Le Libertinage*, Paris: Gallimard, 1924.

——, *Le Paysan De Paris*, Paris: Gallimard, 1926.

——, *Traité Du Style*, Paris: Gallimard, 1928.

——, 'Le Passage de l'Opéra' in *Le Paysan de Paris*, Paris: Gallimard, 1926 and 1979.

——, *The Libertine*, trans. J. Levy, New York: Riverrun Press, 1993.

——, *Paris Peasant*, trans. S. Taylor, Boston, Mass.: Exact Change, 1994.

——, *The Libertine*, trans. J. Levy, London: Calder Publications, 1995.

Arendt, H., *The Human Condition*, Chicago: University of Chicago Press, 1958.

Arets, W. and van den Bergh, W., 'Casa Come Me – A Sublime Alienation' in *AA Files* 18.

Aristotle, *De Caelo*, 271a35; *De Part. An.* 645a23-26, 639bl9.

Arnheim, R., *Art and Visual Perception: A Psychology of the Creative Eye*, Berkeley, Calif.: University of California Press, 1974.

Artaud, A., *Selected Writings*, ed. S. Sontag, trans. Helen Weaver, Berkeley, Calif.: University of California Press, 1967.

Bachelard, G., 'Surrationalism' in *Inquisitions* 1, 1936.

——, *The Philosophy of No: A Philosophy of the New Scientific Mind*, New York: Orion Press, 1968.

Bakhtin, M., 'Discourse in the Novel' in *The Dialogic Imagination: Four Essays*, Austin, Tex.: University of Texas Press, 1981, pp. 259–422.

Balakian, A., *André Breton: Magus of Surrealism*, New York: Oxford University Press, 1971.

Balakian, A., *Surrealism: The Road to the Absolute*, Chicago, Ill.: University of Chicago Press, 1986.

Baldacci, P., *De Chirico: The Metaphysical Period 1888–1919*, Boston, Mass. and New York: Bulfinch Press, 1997.

Ballard, J.G., *A User's Guide to the Millennium: Essays and Reviews*, New York: Picador USA, 1997.

Bancquart, M.-C., *Paris des surrealists*, Paris: Seghers, 1972.

Barnand, M., *The Myth of Apollo and Daphne from Ovid to Quevedo*, Durham, North Carolina: Duke University Press, 1987.

Barr, A. (ed.), *Fantastic Art, Dada, Surrealism*, New York: Museum of Modern Art, 1936.

Barthes, R., *Image, Music, Text*, trans. S. Heath, New York: Hill and Wang, 1977.

Bataille, G., '*Architecture*' and '*Informe*' in *Critical Dictionary* in *Documents 1 and 2*, Paris, 1929.

——, *La Part Maudite, essai d'economi general, la consumation*, Paris: Les Editions de Minuit, 1949.

——, *Visions of Excess, Selected Writings, 1927–1939*, ed. A. Stoekl, Minneapolis, Minn.: University of Minnesota Press, 1985.

——, *Eroticism*, trans. Mary Dalwood, San Francisco: City Lights, 1986.

——, 'Hegel, Death, and Sacrifice', in *Yale French Studies* 78, New Haven, Conn.: 1990, pp. 9–28.

——, *The Tears of Eros*, trans. P. Connor, San Francisco: City Lights Books, 1989.

——, *The Accursed Share*, 2 vols, trans. R. Hurley, New York: Zone Books, 1991.

——, '*Architecture*', trans. D. Faccini, in *October* 60, Spring 1992.

——, *The Absence of Myth: Writings on Surrealism*, trans. M. Richardson, London and New York: Verso, 1994.

——, 'Architecture' in *Rethinking Architecture*, ed. N. Leach, London: Routledge, 1997.

Bataille, G., Lebel, R. and Waldberg, I. (eds), *Encyclopaedia Acephalica*, London: Atlas, 1996.

Baudrillard, J., *Ecstasy of Communication*, New York: Semiotexte, 1988.

——, *Seduction*, trans. B. Singer, New York: St Martin's Press, 1990.

——, *Symbolic Exchange and Death*, London: Sage, 1993.

Beaufret, J., 'Martin Heidegger et le problème de la vérité (1947)' in J. Beaufret, *De l'existentialisme à Heidegger*, Paris: Vrin, 1986.

Becker, L., *Louis Aragon*, New York: Twayne, 1971.

Bellmer, H., 'Poupee, Variations sur le montage d'une mineure articulee' in *Minotaure* 6.

Bellos, A., 'Tomorrow's World' in the *Guardian*, August 14, 2001.

Benelovo, L., *History of Modern Architecture*, vol. 2, trans. B. Bergdoll, Cambridge, Mass.: MIT Press, 1977.

Benjamin, A., 'Building Philosophy: Towards Architectural Theory' in *AA files* (Summer), no. 33, 1997.

Benjamin, W., 'Theses on the Philosophy of History' in *Illuminations: Essays and Reflections*, ed. H. Arendt, trans. H. Zohn, New York: Schocken, 1969.

——, *Illuminations*, trans. E. Jephcott, New York: Schocken Books, 1978.

——, *Reflections*, trans. E. Jephcott, New York: Schocken Books, 1978.

——, *One-Way Street*, trans. E. Jephcott and K. Shorter, London: New Left Books, 1979.

——, *Das Passagen-Werk*, Erster Band, Hrsg. Rolf Tiedemann, Frankfurt am Main: Suhrkamp, 1983.

——, 'Surrealism: The Last Snapshot of the European Intelligentsia' in *One Way Street and Other Writings*, trans. E. Jephcott and K. Shorter, London: Verso, 1985.

——, *The Arcades Project*, Cambridge, Mass.: Belknap/Harvard, 1999.

Bense, M., *'Urbanismus and Semiotik' in Konzept I*, eds A. Carlini and B. Schneider, Tübingen: Studio Wasmuth, 1971.

Benton, T., 'Urbanism' in *Le Corbusier, Architect of Century*, exhibition catalogue, London: Art Council of Great Britain, 1987.

Bisi, L., 'il "Girasole"' in *Abitare*, July–August 1979, pp. 8–21.

——, 'The Rotary House' in *Lotus International* 40, 1983, pp. 112–128.

Blair, L., *Joseph Cornell's Vision of Spiritual Order*, London: Reaktion, 1998.

Blanchot, M., 'Réflexions sur le surréalisme' in M. Blanchot, *La Part du feu*, Paris: Gallimard, 1949.

——, *L'Espace littéraire*, Paris: Gallimard, 1955.

——, 'Le demain joueur (1967)' in *L'Entretien infini*, Paris: Gallimard, 1969.

——, *The Infinite Conversation*, trans. S. Hanson, Minneapolis, Minn.: University of Minnesota Press, 1993.

Bötticher, C., *Der Baumkultus der Hellenen: nach den gottensdienstlichen Gebräuchen und den überlieferten Bildwerken*, Berlin 1856.

Bohn, W., 'Giorgio de Chirico and the solitude of the sign' in *Gazette des Beaux-Arts*, v.ser. 6 v117, April 1991.

Bois, Y.-A., *The Informe: A User's Guide*, Paris, 1996.

——, 'To Introduce a User's Guide' in *October* 78, Fall 1996.

Bois, Y.-A. and Krauss, R., *Formless: A User's Guide*, New York: Zone Books, 1997.

Boldt-Irons, L. (ed.), *On Bataille, Critical Essays*, Albany, New York: State University of New York Press, 1995.

Bonnet, M., *André Breton: Naissance de l'aventure surrealiste*, Paris: Librairie Jose Corti, 1975.

Borch-Jacobsen, M., *Lacan, The Absolute Master*, trans. D. Brick, Stanford, Calif.: Stanford University Press, 1991.

Botting, F. and Wilson, S. (eds), *The Bataille Reader*, Oxford: Blackwell, 1997.

Bozo, D. (ed.), *Matta*, Paris: Centre Georges Pompidou, 1985.

Braga, A. and Fernando A.R. Falcão, *Guia de Urbanismo, Arquitectura, e Arte de Brasília*, Brasília: Fundação Athos Bulcão, 1997.

Braham, W., 'What's Hecuba to Him? On Kiesler and the Knot' in *Assemblage* 36, August 1998.

Braidotti, R., 'Signs of Wonder and Traces of Doubt: On Teratology and Embodied Differences' in N. Lykke and R. Braidotti (eds), *Between Monsters, Goddesses and Cyborgs: Feminist Confrontations with Science, Medicine and Cyberspace*, London and New Jersey: Zed Books, 1996.

Braithwaite, D., *Fairground Architecture*, London: Hugh Evelyn, 1968.

Breton, A., *Les Pas Perdus*, Paris: Gallimard, 1924.

——, 'Le cadavre exquis' in *La Révolution surréaliste* 9, 1929.

——, 'Il y aura une fois' in *Le Surréalisme au service de la Révolution*, no. 1, 1930.

——, 'L'objet fantôme' in *Le Surréalisme au service de la Révolution*, no. 3, December 1931.

——, *Les Vases communicants*, Paris: Cahiers Libres, 1932.

——, 'Le message automatique' in *Minotaure*, 1933.

——, 'Souvenir du Mexique' in *Minotaure* 6.

——, *L'amour fou*, Paris: Gallimard, 1937.

——, *Nadja*, trans. R. Howard, New York: Grove, 1962.

——, *Nadja*, Paris: NRF/Gallimard, 1964.

——, *Surrealism and Painting*, Paris: Gallimard, 1965.

——, 'The Exquisite Corpse' in P. Waldberg, *Surrealism*, London: Thames and Hudson, 1965.

——, *Clair de terre*, Paris: NRF/Gallimard, 1966.

——, *Entretiens*, Paris: Gallimard, 1969.

——, *Manifestoes of Surrealism*, trans. R. Seaver and H. Lane, Ann Arbor: University of Michigan Press, 1969.

——, 'Ombre non par serpent mais d'arbre' in *Perspective cavalière*, Paris: NRF/Gallimard, 1970.

——, 'Situation surréaliste de l'objet' in A. Breton, *Position politique du surréalisme*, Paris: Pauvert, 1971.

——, *Surrealism and Painting*, trans. S. French, New York: Harper & Row, 1972.

——, *Surrealism and Painting*, trans. S. Taylor, New York: Icon Editions, 1972.

——, *What is Surrealism? Selected Writings*, ed. F. Rosemont, New York: Monad Press, 1978.

——, 'Le Mécanicien' in *La Clé des champs*, Paris: Pauvert, 1979.

——, *Mad Love*, trans. M. Caws, Lincoln, Nebr.: University of Nebraska Press, 1987.

——, 'Limites non-frontières du surréalisme' in M. Bonnet *et al.* (eds), *Oeuvres complètes III*, Paris: Gallimard, 1999.

Brock, H., 'Le Corbusier scans Gotham's Towers' in *NY Times Magazine*, November 3, 1935, p. 10.

Brotchie, A. (ed.), *Surrealist Games*, Boston, Mass.: Shambhala Redstone Editions, 1993.

Brunius, J., 'Palais idéal', trans. J.M. Richards, in *The Architectural Review* LXXX, October 1936.

Buci-Glucksmann, C., *Baroque Reason*, trans. Bryan S. Turner, London: Sage, 1994.

Buck-Morss, S., 'The Flaneur, the Sandwichman and the Whore: The Politics of Loitering' in *New German Critique* 39, 1986.

——, *The Dialectics of Seeing: Walter Benjamin and the Arcades Project*, Cambridge, Mass.: MIT Press, 1989.

Buot, F., *Tristan Tzara: L'Homme qui inventa la révolution Dada*, Paris: Grasset, 2002.

Butler, F., 'The Shadow Does Not Know: Disconnected Power' in *Via*, no. 11, 1990, pp. 116–123.

Bydzovská, L. and Srp, K. (eds), *Cesky surrealismus 1929–1953*, Prague: Argo/Galerie hlavního mesta Prahy, 1996.

Cacciari, M., *Architecture and Nihilism: On the Philosophy of Modern Architecture*, trans. S. Sartarelli, New Haven, Conn.: Yale University Press, 1993.

Caillois, R., 'Mimetisme et psychasthénie légendaire' in *Minotaure* 7, Paris: Albert Skira, 1935, pp. 4–10.

——, *L'Homme et le Sacré*, Paris: Gallimard, 1950.

——, *Approche de l'imaginaire*, Paris: Gallimard, 1974.

Calas, N., *Bloodflames 1947*, exhibition catalogue, New York: Hugo Gallery, 1941.

——, *Art in the Age of Risk*, New York: E.P. Dutton & Co, 1968.

Calas, N., Muller, H. and Burke, K. (eds), *Surrealism: Pro and Con*, New York: Gotham Book Mart, 1973.

Camfield, W., *Max Ernst: Dada and the Dawn of Surrealism*, Munich: Prestel, 1993.

Carasco, E., *Matta conversaciones*, Santiago: Ediciones Chile y America, CESOC, 1987.

Cardinal, R., 'Soluble City: The Surrealist Perception of Paris' in D. Vesely (ed.), *Architectural Design Profiles 11*, nos. 2–3, 1978, pp. 143–149.

Carlyle, T., *Sartor Resartus*, London: Curwen Press, 1931.

Carmona, M., *Haussmann: His Life and Times, and the Making of Modern Paris*, trans. P. Camiller, Chicago, Ill.: I.R. Dee, 2002.

Carrouges, M., *André Breton and the Basic Concepts of Surrealism*, trans. Maura Prendergast, University, Alabama: University of Alabama Press, 1974.

Cassagne, A., *Traité pratique de perspective*, Paris, 1873.

Caws, M., *Surrealism and the Literary Imagination*, The Hague: Mouton & Co., 1966.

——, *A Metapoetics of the Passage*, Hannover, N.H.: University Press of New England, 1981.

——, (ed.), *Joseph Cornell's Theater of the Mind: Selected Diaries, Letters, and Files*, New York: Thames and Hudson, 1993.

——, *The Surrealist Look: An Erotics of Encounter*, Cambridge, Mass.: MIT Press, 1997.

——, *Surrealist Painters and Poets: An Anthology*, Cambridge, Mass.: MIT Press, 2001.

Caws, M., Kuenzli, R. and Raaberg, G. (eds), *Surrealism and Women*, Cambridge, Mass.: MIT Press, 1991.

Chénieux-Gendron, J., 'Pour une imagination poétique et pratique' in M. Bonnet (ed.), *Les Critiques de notre temps et Breton*, Paris: Garnier, 1974.

——, *Surrealism*, trans. V. Folkenflik, New York: Columbia University Press, 1990.

Chipp, H., *Theories of Modern Art*, Berkeley, Calif.: University of California Press, 1968.

Church, T., *Gardens Are For People*, New York: Reinhold Publishing Corporation, 1955.

Cìsarov, H., 'Surrealism and Functionalism: Teige's Dual Way' in *Rassegna* vol. 15, no. 53, March 1993, pp. 78–88.

Clair, J., Szeemann, H. and Marche, C. (eds), *The Bachelor Machines*, Venice: Alfieri, 1975.

Cocteau, J., 'Opéra' in G. de Chirico, *Hebdomeros*, trans. Margaret Crosland, London: Owen, 1968.

Cohen, J. (ed.), *Monster Theory: Reading Culture*, Minneapolis, Minn.: University of Minnesota Press, 1996.

Cohen, M., *Profane Illumination: Walter Benjamin and the Paris of Surrealist Revolution*, Berkeley, Calif.: University of California Press, 1993.

Colomina, B., 'The Psyche of Building: Frederick Kiesler's "Space House" 'in *Archis*, Rotterdam: NIA Publishers, Issue 11, November 1996, pp. 70–80.

——, (ed.), *Sexuality and Space*, Princeton Papers on Architecture, Princeton, New Jersey 1992.

——, 'The Split Wall: Domestic Voyeurism' in *Sexuality and Space*, ed. B. Colomina, New York: Princeton Architectural Press, 1992, pp. 73–128.

——, *Privacy and Publicity*, Cambridge, Mass.: MIT Press, 1994.

Compagnon, A., 'Evaluations du surrealisme: de l'"illisible" au "poncif" ' in *Cahier de L'Herne: André Breton*, no. 72, Paris: L'Herne, 1998.

Coover, R., *The Grand Hotels (of Joseph Cornell)*, Providence, R.I.: Burning Deck, 2002.

Costa, L., 'Relatorio do Plan Piloto de Brasília' in *Revista Arquitectura e Enghenharia*, 44, 1957, pp. 9–12.

Crease, D., 'Progress in Brasília' in *Architectural Review* 131, 1962.

D'Harnoncourt, A. and McShine, K. (eds), *Marcel Duchamp*, New York: MOMA/Prestel Verlag, 1989.

Danto, A., *After the End of Art, Contemporary Art and the Pale of History*, Princeton, New Jersey: Princeton University Press, 1999.

De Beauvoir, S., *La force des choses*, Paris: Gallimard, 1963.

De Certeau, M., *The Practice of Everyday Life*, trans. Steven Randall, Berkeley, Calif.: University of California Press, 1984.

De Chirico, G., *Hebdomeros*, trans. Margaret Crosland, London: Owen, 1968.

De Holanda, F., 'Brasília Beyond Ideology' in *DOCOMOMO Journal*, 23, August 2000.

De la Beaumelle, A., 'Le Grand atelier' in *André Breton: La Beauté convulsive*, Paris: Centre Pompidou, 1991.

De Zegher, C. and Wigley, M. (eds), *The Activist Drawing: Retracing Situationist Architectures from Constant's New Babylon to Beyond*, Cambridge, Mass.: MIT Press, 2001.

Dekker, T. (ed.), *The Modern City Revisited*, London: Spon, 2000.

Dalí, S., 'L'Âne pourri' in *Le Surréalisme au service de la Révolution*, no. 1, July 1930.

——, 'Objets surréalistes' in *Le Surréalisme au service de la Révolution*, no. 3, December 1931.

——, 'De la beauté terrifiante et comestible de l'architecture Modern' Style' in *Minotaure*, nos. 3–4, 1933.

——, *Hidden Faces*, trans. H. Chevalier, New York: Dial Press, 1944.

——, *Hidden Faces*, trans. H. Chevalier, London: Peter Owen, 1973.

——, *Salvador Dalí*, exhibition catalogue, Paris: Centre Pompidou, 1979.

——, *50 Secrets of Magic Craftsmanship* (*c.*1948), New York: Dover, 1992.

——, *The Secret Life of Salvador Dalí*, trans. H. Chevalier, New York: Dover, 1993.

——, *Oui: The Paranoid-Critical Revolution*, trans. Yvonne Shafir, Boston, Mass.: Exact Change, 1998.

Darwin, C., *Journal of Researches into the Geology and Natural History of the Various Countries Visited by H.M.S. Beagle*, New York and London: Hafner Publishing Company, 1952.

Dean, C., *The Self and Its Pleasures: Bataille, Lacan and the History of the Decentered Subject*, Ithaca, New York: Cornell University Press, 1992.

Debord, G., *Society of the Spectacle*, Detroit: Black&Red, 1983.

Deeds-Vincke, P., *Paris: The City and Its Photographers*, Boston, Mass.: Little and Brown Company, 1995.

Deleuze, Gilles, *The Logic of Sense*, trans. M. Lester, New York: Columbia University Press, 1990 [1969].

Demos, T., 'Duchamp's Labyrinth: First Papers of Surrealism, 1942' in *October* 97, Summer 2001.

Derrida, J., *Glas*, Paris: Editions Galilée, 1974.

——, 'From Restricted to General Economy: A Hegelianism without Reserve' in J. Derrida, *Writing and Difference*, trans. A. Bass, Chicago, Ill.: University of Chicago Press, 1978.

——, *Dissemination*, Chicago, Ill.: University of Chicago Press, 1981.

——, 'Point de folie-Maintenant l'architecture' in *AA Files* 12, 1986: 65, pp. 69–75.

——, *Given Time: I. Counterfeit Money*, trans. by P. Kamuf, Chicago, Ill.: University of Chicago Press, 1992.

——, 'Passages – du traumatisme à la promesse' in *Points de suspension: Entretiens*, Paris: Galilee, 1992.

——, 'Between the Lines' in D. Libeskind, *Radix-Matrix: Architecture and Writings*, Munich and New York: Prestel, 1997, pp. 110–115.

*Devetsil: The Czech Avant-Garde of the 1920s and 30s*, Oxford: Museum of Modern Art, 1990.

Dixon, L., 'Bosch's Garden of Earthly Delights Triptych: Remnants of a "Fossil' Science" ' in *Artforum* vol. LXIII no. 1, March, 1981, pp. 99–100.

Dluhosch, E. and Svacha, R. (eds), *Karel Teige 1900–1951: L'enfant Terrible of the Czech Modernist Avant-Garde*, Cambridge, Mass.: MIT Press, 1999.

Ducasse, I., *Maldoror & the Complete Works of the Compte De Lautréamont*, trans. A. Lykiard, Cambridge, Mass.: Exact Change, 1994.

Duboy, P., *Le Corbusier, Une Encylopedie*, Paris: Centre Georges Pompidou, 1987.

Dunlop, I., *The Shock of The New*, New York: American Heritage Press, 1972.

Durozoi, G. and Lecherbonnier, B., *Le Surréalisme: Théories, thèmes, techniques*, Paris: Larousse, 1972.

——, '1944–1951 "Liberté, mon seul pirate" ' in *Histoire du mouvement surréaliste*, Paris: Éditions Hazan, 1997.

——, *History of the Surrealist Movement*, Chicago, Ill.: University of Chicago Press, 2002.

Duve, T. (ed.), *The Definitively Unfinished Marcel Duchamp*, Cambridge, Mass.: MIT Press, 1991.

Echauren, M., 'Mathématique sensible – Architecture du temps' in *Minotaure*, no. 11, Spring 1938.

——, *Interview de Matta*, special issue of *Ojo de aguijon*, nos. 3–4 (April 1986).

Eds, 'Translation from the French' in *L'Architecture d'Aujourd'hui'*, June 1949.

Edwards, S., *The Paris Commune 1871*, New York: Quadrangle Books, 1971.

Ehrlich, S. (ed.), *Pacific Dreams: Currents of Surrealism and Fantasy in California Art, 1934–1957*, Los Angeles: University of California Press, 1995.

Eisenman, P., 'The End of the Classical: the End of the Beginning, the End of the End' in *Perspecta* 21, 1984: pp. 154–173.

Eliot, T., ' "Ulysses", Order, and Myth' in F. Kermode (ed.), *Selected Prose of T.S. Eliot*, London: Faber, 1975.

Éluard, P., *Recherches expérimentales*: 'Sur les possibilités irrationnelles de pénétration et d'orientation dans un tableau *Giorgio de Chirico: L'énigme d'une journée* (11 février 1933)' in *Surréalisme et service de la révolution*, no. 5, May 1933.

——, 'Remarques' in *Le Surréalisme au service de la Révolution* no. 6, May 15, 1933.

Engler, M., *Designing America's Waste Landscapes*, Baltimore, Md.: Johns Hopkins Unversity Press, in press.

Epstein, D., *Brasília, Plan and Reality – A Study of Planned and Spontaneous Urban Development*, Berkeley and Los Angeles: University of California Press, 1973.

Ernst, J., *A Not-So-Still Life*, New York: St Martin's/Marek, 1984.

——, *Man Ray Bazaar Years*, New York: Rizzoli, 1988.

Evenson, N., *Two Brazilian Capitals*, New Haven, Conn. and London: Yale University Press, 1973.

Faerna, J. (ed.), *De Chirico*, Cameo/Abrams, 1995.

Fédida, P., 'The Movement of the Informe' in *Qui parle*, vol. 10, no. 1, Fall–Winter 1996, pp. 49–62.

Ferguson, P., *Paris as Revolution*, Berkeley: University of California Press, 1994.

*Intellectual Wilderness: A Meeting Place for Surrealist Artists* (1997).

Ferrari, V., *Matta: Entretiens Morphologiques*, Notebook No. 1, 1936–1944, London: Sistan Limited, 1987.

Filarete, *Trattato dell'architettura*, folio 9 r–v; fol.8r, Florence, C. 1465.

Finkelstein, H., *Salvador Dalí's Art and Writings 1927–1942*, Cambridge: Cambridge University Press, 1996.

——, (ed.), *The Collected Writings of Salvador Dalí*, Cambridge: Cambridge University Press, 1998.

Fletcher, V., *Crosscurrents of Modernism: Four Latin American Pioneers*, Washington, D.C.: Smithsonian Press, 1992.

Ford, O., *Towards a New Subject in Painting*, San Francisco: San Francisco Museum of Art, 1948.

Foresta, M., *Perpetual Motif: The Art of Man Ray*, New York: Abbeville Press, 1988.

Foster, H., 'Convulsive Identity' in *October* 57, Summer 1991, pp. 17–54.

——, *Convulsive Beauty*, Cambridge, Mass.: MIT Press, 1993.

Foucault, M., *Surveiller et punir: Naissance de la prison*, Paris: Gallimard, 1975.

——, *This is Not a Pipe*, trans. James Harkness, Berkeley, Calif.: University of California Press, 1982.

Frampton, K., 'Has the Proletariat No Use for a Glider?' in D. Vesely (ed.), *Architectural Design Profiles 11*, nos. 2–3, 1978.

——, *Modern Architecture: A Critical History*, London: Thames and Hudson, 1985.

——, 'Editorial: On Reading Heidegger (1974)' in M. Hays (ed.), *Oppositions Reader*, New York: Princeton Architectural Press, 1998, pp. 3–6.

——, *Le Corbusier*, New York: Thames and Hudson, 2001.

# Bibliography

Frascari, M., 'A Secret Semiotic Skiagraphy: The Corporal Theatre of Meanings in Vincenzo Scamozzi's Idea of Architecture' in *VIA* 11, 1990.

Fraser, V., *Building the New World: Studies in the Architecture of Latin America 1930–1960*, London: Verso, 2000.

Freud, S., *The Origins of Psychoanalysis, Letters to Wilhelm Fliess, drafts and notes: 1887–1900*, eds M. Bonaparte and E. Kris, trans. J. Strachey, New York: Basic Books, 1954.

——, *Beyond the Pleasure Principle*, trans. James Strachey, New York: W.W. Norton, 1961.

——, *The Interpretation of Dreams*, trans. A. Brill, New York: Gramercy Books, 1996.

Frisby, D., *Fragments of Modernity*, Cambridge, Mass.: MIT Press, 1986.

Gale, M., 'The Uncertainty of the Painter: De Chirico in 1913' in *The Burlington Magazine*, London, vol. 130, April 1988, pp. 268–276.

——, *Dada and Surrealism*, London: Phaidon, 1997.

Garrigues, E. (ed.), *Archives du surréalisme*: Vol. 5, *Les jeux surréalistes*, Paris: Gallimard, 1995.

Gaucheron, J. and Béhar, H., 'Chronologie de Tzara' in *Tristan Tzara, Europe*, nos. 555–6, July/August 1975.

Gaulmier, J., 'Remarques sur le thème de Paris chez André Breton' in M. Bonnet (ed.), *Les Critiques de notre temps et Breton*, Paris: Garnier, 1974.

Gershmann, H., *The Surrealist Revolution In France*, Ann Arbor, Mich.: The University of Michigan Press, 1974.

Giacometti, A., 'Objets mobiles et muets' in *Le Surréalisme au service de la Révolution*, no. 3, December 1931.

——, 'Hiers, sable mouvants' in *Surréalisme au service de la Révolution*, no. 5, 1933.

Gibson, I., *The Shameful Life of Salvador Dalí*, London: Faber and Faber, 1997.

Giraud, Y., *La Fable de Daphné Essai sur un type de métamorphose végétale dans la littérature et dans les arts jusqu'a la fin du XVIIe siècle*, Geneva: Librarie Droz, 1969.

Goethe, J., *Goethe's Theory of Color*, trans. H. Aach, London: Studio Vista, 1971.

Gracq, J., From 'En Lisant et écrivant', reprinted in *André Breton: 42, rue Fontaine*, Paris: CamelsCohen, 2002.

Gravagnuolo, B., *Adolf Loos*, Milan: Idea Books, 1982.

Green, C., 'The Architect as Artist' in M. Raeburn and V. Wilson (eds), *Le Corbusier: Architect of the Century*, London: Arts Council of Great Britain, 1987.

Greenberg, C., 'Modernist Painting' in F. Frascina and C. Harrison (eds), *Modern Art and Modernism: A Critical Anthology*, New York: Harper & Row, 1982.

Greene, J., *Psycholinguistics, Chomsky and Psychology*, Harmondsworth: Penguin, 1972.

Gregory, G. and Gombrich, E.H. (eds), *Illusion in Art and Nature*, London: Duckworth, 1973.

Guerri, G., *Arcitaliano: vita di Curzio Malaparte*, Milan 1980.

Hammond, P., *The Shadow and Its Shadow: Surrealist Writings on the Cinema*, New York: Columbia University Press, 1981.

Hamon, P., *Expositions*, trans. K. Sainson-Frank and L. Maguire, Berkeley, Calif.: University of California Press, 1992.

Hardgrove, J., *The Statues of Paris: An Open Air Pantheon*, New York: Vendome Press, 1990.

Harfaux, A. and Henry, M., 'A propos de l'expérience portant sur la connaissance irrationnelle des objets' in *Le Surréalisme au service de la Révolution*, no. 6, 15 May 1933.

Hargrove, J., 'Les statues de Paris' in P. Nora (ed.), *Les Lieux de mémoire*, Paris: Gallimard, 1984–1992, 2(3), pp. 243–282.

Harries, K., *The Ethical Function of Architecture*, Cambridge, Mass. and London: MIT Press, 1997.

Haslam, M., *The Real World of The Surrealists*, New York: Rizzoli, 1978.

Hauptman, J., *Joseph Cornell: Stargazing in the Cinema*, New Haven, Conn.: Yale University Press, 1999.

Hays, M., *Modernism and the Posthumanist Subject: The Architecture of Hannes Meyer and Ludwig Hilberseimer*, Cambridge, Mass.: MIT Press, 1992.

——, (ed.), *Hejduk's Chronotope*, New York: Princeton Architectural Press, 1996.

——, *Sanctuaries, The Last Works of John Hejduk*, New York: Whitney Museum of Art, 2002.

Heidegger, M., *Sein und Zeit* (7th edition), Tübingen: Max Niemeyer Verlag, 1953.

——, 'Building Dwelling Thinking' in M. Heidegger, *Poetry, Language, Thought*, New York and San Francisco: Harper and Row, 1971.

——, 'Origin of the Work of Art' in M. Heidegger, *Poetry, Language, Thought*, trans. A. Hofstadter, New York: Harper & Row, 1975.

——, 'Building Dwelling Thinking' in M. Heidegger, *Basic Writings*, ed. D. Krell, New York: Harper and Row, 1976.

Hejduk, J. (ed.), *Mask of Medusa*, New York: Rizzoli, 1985.

——, *Pewter Wings, Golden Horns, Stone Veils*, New York: Monacelli Press, 1997.

——, *Soundings*, New York: Rizzoli, 1993.

——, *Vladivostok*, New York: Rizzoli, 1993.

——, 'Cable from Milan' in *Domus*, Milan, April 1980, pp. 8–13.

Helmholtz, H., *Helmholtz's Treatise on Physiological Optics*, trans. J. Southall, New York: Dover, 1962.

Henderson, L., *Duchamp in Context: Science and Technology in the Large Glass and Related Works*, Princeton, New Jersey: Princeton University Press, 1998.

Hersey, G., *The Lost Meaning of Classical Architecture*, Cambridge, Mass.: MIT Press, 1988.

Heynen, H., *Architecture and Modernity*, Cambridge, Mass.: MIT Press, 1999.

Hobbes, T., *Leviathan*, New York: Viking Press, 1982.

Hoffman, W., 'Un Réalisme ouvert et fermé à la fois' in *La Révolution surréaliste*, Paris: Centre Pompidou, 2002.

Hölderlin, F., *Some Poems of Friedrich Hölderlin*, trans. Frederic Prokosch, Norfolk, Conn.: New Directions, 1943.

Holford, W., 'Brasília, A New Capital City For Brazil' in *Architectural Review* 122 (731), December 1957.

Hollier, D., *The College of Sociology, 1937–39*, Minneapolis: University of Minnesota Press, 1988.

——, *Against Architecture: The Writings of Georges Bataille*, trans. B. Wing, Cambridge, Mass.: MIT Press, 1989.

Holmes, J.D. (ed.), *Emerald Tablet of Hermes Trismegistus*, Edmonds, W.A.: Holmes Publishing Group, 1997.

Holston, J., *The Modernist City: An Anthropological Critique of Brasília*, Chicago, Ill.: University of Chicago Press, 1989.

Hubert, R., *Surrealism and the Book*, Berkeley, Calif.: University of California Press, 1988.

Hulten, P. (ed.), *Marcel Duchamp: Work and Life*, Cambridge, Mass.: MIT Press, 1993.

Imrie, R.F., 'The Body, Disability, and Le Corbusier's Conception of the Radiant Environment' Exeter, England: RGS/IBG Annual Conference, 1997.

Jaguer, E., *Les Mysteres de la Chambre Noire: Le Surrealisme et la Photographie*, Paris: Flammarion, 1982.

Jameson, F., *The Prison-House of Language*, Princeton: Princeton University Press, 1972.

Jarry, A., *The Ubu Plays*, trans. C. Connolly and S. Taylor, New York: Grove Press, 1980.

——, *Exploits and Opinions of Dr. Faustroll, Pataphysician*, trans. Simon Watson Taylor, Boston, Mass.: Exact Change, 1996.

Jay, M., *Downcast Eyes: The Denigration of Vision in Twentieth-Century French Thought*, Berkeley, Calif.: University of California Press, 1993.

——, *Force Fields: Between Intellectual History and Cultural Critique*, London: Routledge, 1993.

Jaynes, J., *The Origin of Consciousness in the Breakdown of the Bicameral Mind*, Penguin, 1993.

Jean, M. (ed.), *The Autobiography of Surrealism*, New York: Viking Press, 1980.

Jennings, M., *Dialectical Images: Walter Benjamin's Theory of Literary Criticism*, Ithaca, New York: Cornell University Press, 1987.

Jormakka, K., *Heimlich Manoeuvres*, Weimar: Verso, 1996.

Kachur, L., *Displaying the Marvelous: Marcel Duchamp, Salvador Dalí, and Surrealist Exhibition Installations*, Cambridge, Mass.: MIT Press, 2001.

Kassler, E., *Modern Gardens and the Landscape* (revised edition), New York: Museum of Modern Art, 1986.

Kästner, E., 'Nächtliches Rezept für Städter' in *Doktor Erich Kästners Lyrische Hausapotheke*, München: DVA, 2000.

Kaufmann, E., 'The Violent Art of Hanging Pictures' in *Magazine of Art*, March 1946, pp. 108–113.

Kaufmann, P., *L'Expérience émotionnelle de l'espace*, Paris: Vrin, 1967.

Kiesler, F., 'Das Railway-Theater' in *Katalog der Internationalen Ausstellung neuer Theatertechnik*, Vienna, 1924.

——, '*Ausstellungssystem Leger und Trager*' in *De Stijl* Serie XII nos. 10 and 11, 6 Jaar 1924–1925.

——, 'Manifesto of Tensionism' in *Contemporary Art Applied to the Store and its Display*, New York: Bretano's Publishers Inc., 1930.

——, 'Project for a "Space-Theatre" Seating 100,000 People' in *Architectural Record*, May 1930.

——, 'Metabolism Chart of the House', Kiesler Private Foundation Archives, Vienna, 1933.

——, 'Architectural Solution', Kiesler Private Foundation Archives, Vienna, 1933.

——, 'Notes on Architecture: The Space House – Draft', Kiesler Private Foundation Archives, Vienna, 1933.

——, 'Notes on Architecture: The Space-House' in *Hound & Horn*, January–March 1934.

——, 'Space House' in *Architectural Record*, vol. 75, January, 1934, pp. 44–61.

——, 'Design-Correlation: From Brush-Painted Glass Pictures of the Middle Ages to [the] 1920s' in *Architectural Record*, vol. 81, May 1937, pp. 53–59.

——, 'On Correalism and Biotechnique: A Definition and the New Approach to Building Design' in *Architectural Record*, September 1939.

——, 'Frederick Kiesler's Endless House and its psychological lighting' in *Interiors*, November 1950.

——, 'Kiesler's Pursuit of an Idea' in *Progressive Architecture*, July 1961.

——, 'The "Endless House": A Man-Built Cosmos' in *The 'Endless House': Inside the Endless House: Art, People and Architecture: A Journal*, New York: Simon and Schuster, 1966.

——, 'Design-Correlation, Marcel Duchamp's "Big Glass" ' in S. Gohr and G. Luyken (eds), *Frederick J. Kiesler: Selected Writing*, Stuttgart: Verglag Gerd Hatje, Ostifildern, 1996.

Kitayama, K. and Uzawa, T., 'Villa Malaparte, Capri, Italy' in *Space Design*, February 1984.

Klein, J., 'French Architect Arrives with Plans to Rebuild City' in *New York Evening Post*, 23 October 1935.

Kluver, B. and Martin, J., *Kiki's Paris: Artists and Lovers 1900–1930*, New York: Harry N. Abrams, 1989.

Kofman, E. and Lebas, E. (eds), *Writings on Cities – Henri Lefebvre*, Oxford, UK: Blackwell 1995.

Koolhaas, R., *Delirious NY*, New York: Oxford University Press, 1978.

——, *Delirious NY: A Retroactive Manifesto for Manhattan*, New York: The Monacelli Press, 1994.

Kristeva, J., *Desire in Language*, trans. T. Gora, A. Jardine, and L. Roudiez, New York: Columbia University Press, 1980.

Krauss, R. and Livingston, J., *L'Amour fou: Photography and Surrealism*, New York: Abbeville Press, 1985.

——, *The Optical Unconscious*, Cambridge, Mass.: MIT Press, 1993.

Kruft, H.-W., *A History of Architectural Theory*, New York: Princeton Architectural Press, 1994.

Krustrup, M., *Le Corbusier, L'Iliade Dessins*, Copenhagen: Borgen, 1986.

Kubitschek, J., 'Interview' in *L'Architecture d'aujourd'hui*, 90, June–July 1960.

Kuenzli, R. (ed.), *Dada and Surrealist Film*, Cambridge, Mass.: MIT Press, 1996.

Kulka, H., *Adolf Loos*, Vienna: Löcker Verlag, 1979.

La Marche, J., 'The Space of the Surface' in *Environment and Planning A* 2001, vol. 33(12) December, pp. 2205–2218.

——, 'In and Out of Type' in K. Franck and L. Schneekloth (eds), *Ordering Space: Type in Architecture and Design*, New York: John Wiley & Sons, 1994.

——, *The Familiar and the Unfamiliar in Twentieth Century Architecture*, Urbana, Ill.: University of Illinois Press, 2003.

Lacan, J., 'Kant avec Sade' in *Écrits*, Paris: Editions du Seuil, 1966.

——, *Le Séminaire livre VII, L'éthique de la psychanalyse*, Paris: Éditions du Seuil, 1986.

——, *Ecrits*, trans. Alan Sheridan, New York: W.W. Norton and Co., 1977.

——, *The Four Fundamental Concepts of Psycho-Analysis*, trans. A. Sheridan, New York: W.W. Norton and Co., 1977.

——, 'Kant with Sade', trans. J. Swenson, Jr., in *October* 51, Winter 1989.

Lahiji, N., 'The Gift of the Open Hand: Le Corbusier Reading George Bataille's *La Part Maudite*' in *Journal of Architectural Education*, vol. 50, no. 1, 1996.

Lavin, S., 'Open the Box: Richard Neutra and the Psychologizing of Modernity' in *Assemblage*, no. 40, Cambridge, Mass.: MIT Press, 1999, pp. 6–25.

Laugier, M.-A., *An Essay on Architecture*, trans. W. Herrmann, Los Angeles, Calif.: Hennessey and Ingalls, 1977.

Laurence, R., *Roman Pompeii*, London: Routledge, 1994.

Le Corbusier, *Vers une architecture*, Paris: Les Éditions Crés et Cie, 1924.

——, *L'art décoratif d'aujourd'hui*, Paris: Editions Crès, 1925.

——, *Précisions sur un état présent de l'architecture et de l'urbanisme*, Paris: Crès et Cie, 1930.

——, *La Ville radieuse*, Boulogne sur Seine: Editions de l'Architecture d'Aujourd'hui, 1935.

——, 'La ville radieuse' (speech), New York: Museum of Modern Art, 1935.

——, 'Louis Soutter, L'inconnu de la soixante', in *Minotaure* 9, October 1936.

——, *Quand les cathédrals étaient blanches: voyage au pays des timides*, Paris: Plon, 1937.

——, *When the Cathedrals Were White: Caravaggio and Surrealism*, New York: McGraw-Hill, 1964.

——, *The Radiant City: Elements of a Doctrine of Urbanism to be Used as the Basis of Our Machine-Age Civilization*, London: Faber and Faber, 1967.

——, *Nursery Schools*, trans. Eleanor Levieux, New York: The Orion Press, 1968.

——, *Towards a New Architecture*, New York: Praeger 1972.

——, *The City of Tomorrow and Its Planning, The Voisin Scheme and the Past*, Cambridge, Mass.: MIT Press, 1975.

——, *L'art décoratif d'aujourd'hui*, Paris: Les Éditions Arthaud, 1980.

## Bibliography

——, *Towards a New Architecture*, trans. F. Etchells, New York: Holt, Rinehart and Winston, 1983.

——, *The Decorative Art of Today*, London: Architectural Press, 1987.

——, *Precisions on the Present State of Architecture and City Planning*, Cambridge, Mass.: MIT Press, 1991.

Leach, N. (ed.), *Rethinking Architecture: A Reader in Cultural Theory*, London: Routledge, 1997.

Leder, D., *The Absent Body*, Chicago, Ill.: University of Chicago Press, 1990.

Lefebvre, H., *The Production of Space*, trans. D. Nicholson-Smith, London: Basil Blackwell, 1991.

Lefebvre, H., *Writings on Cities*, trans. E. Kofman and E. Lebas, London: Blackwell, 1996.

Lefort, C., 'The Question of Democracy' in *Democracy and Political Theory*, trans. D. Macey, Minneapolis, Minn.: University of Minnesota Press, 1988.

Leiris, M., *Biffures*, Paris: NRF/Gallimard, 1988.

Leiris, M., 'The Bullfight as Mirror', trans. A. Smock, in *October* 63, Winter 1993.

Leitner, B., *The Wittgenstein House*, New York: Princeton Architectural Press, 2000.

Leperlier, F., *L'écart et la metamorphose*, Paris: Jean-Michel Place, 1992.

Lerup, L., *Planned Assaults: The Nofamily House. Love/House, Texas Zero*, Cambridge, Mass.: MIT Press, 1987.

Lessing, G., *Laokoon oder Über die Grenzen der Malerei und Poesie*, Stuttgart: Reclam, 1964.

Lévi-Strauss, C., *View from Afar*, trans. J. Neugroschel and P. Hoss, New York: Basic Books, 1985.

Levin, D. (ed.), *Modernity and the Hegemony of Vision*, Berkeley, Calif.: University of California Press, 1993.

Levy, J., *Surrealism*, New York: Black Sun Press, 1936.

——, *Memoir of an Art Gallery*, New York: G.P. Putnam's Sons, 1977.

——, *Surrealism*, New York: Da Capo, 1995 [1936].

Levy, S., 'René Magritte and Window Display' in *Artscribe*, no. 28, March 1981, pp. 24–28.

——, (ed.), *Surrealism: Surrealist Visuality*, New York: New York University Press, 1996.

Lewis, H., *The Politics of Surrealism*, New York: Paragon House, 1988.

Libeskind, D., *Between Zero and Infinity*, New York: Rizzoli, 1981.

Lindner, B., 'The Passagen-Werk: the Berliner Kindheit, and the Archaeology of the "Recent Past"' in *New German Critique* 39, Fall 1986.

Lodder, C., *Russian Constructivism*, New Haven, Conn. and London: Yale University Press, 1983.

Lomas, D., *The Haunted Self: Surrealism Psychoanalysis, Subjectivity*, New Haven, Conn. and London: Yale University Press, 2000.

Loos, A., 'Damenmode' in A. Loos, *Sämtliche Schriften*, Vol. 1: *Ins Leere Gescprochen. Trotzdem*, Wien and München: Verlag Herold, 1962.

Loubet del Bayle, J.-L., *Les Non-Conformistes des Années* 30, Paris: Seuil, 1969.

McLaurin, T., *The River Less Run: A Memoir*, Asheboro, North Carolina: Down Home Press, 2000.

McCoubrey, J., *The American Tradition in Painting*, New York: George Braziller, 1963.

McLeod, M., 'Bibliography: *Plans*, 1–3 (1931–1932); *Plans* (bi-monthly), 1–8 (1932); *Bulletin des groups Plans*, 1–4 (1930)' in *Oppositions* 19/20, Winter/Spring 1980.

——, 'Urbanism and Utopia: Le Corbusier from Regional Syndicalism to Vichy' Unpublished Ph.D. dissertation, Princeton University, 1985.

McShine, K. (ed.), *Joseph Cornell*, New York: Museum of Modern Art, 1980.

McWilliam, N., 'Monuments, Martyrdom and the Politics of Religion in the French Third Republic' in *Art Bulletin*, vol. 77, no. 2, June 1995, pp. 186–206.

Malaparte, C, *Coup d'état, the Technique of Revolution*, Paris, 1932.

——, *Pelle* (English: *The Skin*), trans. D. Moore, Marlboro, Vt.: Marlboro Press, 1988.

——, *Kaputt*, trans. C. Foligno, Evanston, Ill.: Northwestern University Press, 1995.

Magritte, R., *Écrits Complets*, Paris: Flammarion, 1979.

Marinetti, F., 'We Abjure Uur Symbolist Masters, the Last Lovers of the Moon' in R. Flint (ed.),
     *Let's Murder the Moonshine: Selected Writings*, Los Angeles: Sun and Moon Press, 1991.

Marmande, F., *Georges Bataille politique*, Lyon: Presses Universitaires de Lyon, 1985.

Martin, R., *Fashion and Surrealism*, New York: Rizzoli, 1987.

Martínez, J., 'Images and Metaphors of Water in Le Corbusier's Thought' in *VIA 10: Water/Agua*,
     Cambridge, Mass.: MIT Press, 2001.

Masson, A., Letter to D.-H. Kahnweiler, 1 January 1935, in *Les Années surréalistes:
     Correspondance 1916–1942*, La Manufacture, Paris 1990.

Mauss, M., *The Gift. The Form and Reason for Exchange in Archaic Societies*, trans. W. Halls,
     New York: W.W. Norton, 1990.

Melly, G., 'Bourgeois Visionaries' in *American Home and Garden*, November 1984, pp. 48–59.

——, *Paris and the Surrealists*, New York: Thames and Hudson, 1991.

Menninghaus, W., 'Walter Benjamin's Theory of Myth' in G. Smith (ed.), *On Walter Benjamin*,
     Cambridge, Mass.: MIT Press, 1988.

Merleau-Ponty, M., *Phenomenology of Perception*, trans. Colin Smith, London and New York:
     Routledge, 1962.

Metz, C., *The Imaginary Signifier*, Bloomington, Ind.: Indiana University Press, 1977.

Mical, T., 'The Origins of Architecture, after de Chirico' in *Art History*, vol. 26, no. 1, February
     2003, pp. 78–99.

Michelson, A., Krauss, R., Crimp, D. and Copjec, J. (eds), *October: The First Decade,
     1976–1986*, Cambridge, Mass.: MIT Press, 1987.

Miller, D. (ed.), *Home Possessions: Material Culture Behind Closed Doors*, Oxford: Berg, 2001.

Miller, J.-A. (ed.), *The Seminar of Jacques Lacan, Book I: Freud's Papers on Technique,
     1953–1954*, trans. J. Forrester, New York: W.W. Norton, 1988.

——, *The Seminar of Jacques Lacan, Book II: The Ego in Freud's Theory and in the Technique of
     Psychoanalysis, 1954–1955*, trans S. Tomaselli, New York: W.W. Norton, 1988.

——, *The Seminar of Jacques Lacan, Book VII: The Ethics of Psychoanalysis 1959–1960*, trans.
     D. Porter, New York: W.W. Norton, 1992.

Monnerot, J., *La Poésie moderne et le sacré*, Paris: Gallimard, 1945.

Mundy, J. (ed.), *Surrealism: Desire Unbound*, New York: Princeton University Press, 2001.

Nadeau, M., *The History of Surrealism*, trans. R. Shattuck, New York: Macmillan, 1968.

Nassif, J., 'Le procès et le lieu' in *Freud, l'inconscient: Sur les commencements de la
     psychanalyse*, Paris: Editions Galilée, 1977.

Navasky, V., *Naming Names*, Harmondsworth: Penguin, 1981.

Nesbitt, K. (ed.), *Theorizing a New Agenda for Architecture: An Anthology of Architectural
     Theory, 1965–1995*, New York: Princeton Architectural Press, 1996.

Niemeyer, O., 'Mes Experiénces a Brasília' in *L'Architecture d'Aujourd'hui*, 90, 1960.

——, *Les Courbes du Temps*, Paris: Gallimard, 1999.

——, *Minha Arquitectura*, Rio de Janeiro: Revan, 2000.

Nietzsche, F., *Werke in drei Bänden*, Her. Karl Schlechta, München: Carl Hanser Verlag, 1954.

——, *Jenseits Gut und Böse*, Stuttgart: Alfred Kröner Verlag, 1964.

——, 'On Truth and Lie in a Non-Moral Sense' in D. Breazeale (ed.), *Philosophy and Truth:
     Selections from Nietzsche's Notebooks of the Early 1870s*, trans. and ed. Daniel Breazeale,
     Atlantic Highlands, New Jersey: Humanities Press, 1979.

Noel, B., *Marseille NY: A Surrealist Liaison*, trans. Jeffrey Arsham, Marseille: André Dimanche,
     1985.

# Bibliography

Nora, P., 'Lavisse, The Nation's Teacher' in P. Nora and L. Kritzman (eds), *Realms of Memory: The Construction of the French Past*, Vol. 2: *Traditions*, trans. Arthur Goldhammer, New York: Columbia University Press, 1997, pp. 151–184.

Norberg-Schulz, C., *The Concept of Dwelling: On the Way to Figurative Architecture*, New York: Rizzoli, 1985.

Nougé, P., *Subversion des images*, Brussels: Les Lèvres nues, 1968.

Olin, L., 'Form, Meaning, and Expression in Landscape Architecture' in *Landscape Journal*, vol. 7, no. 2, Fall 1988.

Olsen, D., *The City as a Work of Art: London, Paris, Vienna*, New Haven, Conn.: Yale University Press, 1986.

Ovid, *Metamorphoses*, trans. A. Melville, London: Oxford University Press, 1986.

Pastoureau, H., *Ma Vie surréaliste*, Paris: Maurice Nadeau, 1992.

Penrose, A., *The Lives of Lee Miller*, New York: Holt, Rinehart and Winston, 1985.

Peret, B., 'La Nature Devore, Le Progres et le depasse' in *Minotaure* 10.

Perez-Gomez, A., 'The Myth of Daedalus' in *AA Files* 10, Autumn 1985, pp. 49–52.

Petzet, H., *Encounters and Dialogues with Martin Heidegger, 1929–1976*, Chicago, Ill. and London: University of Chicago Press, 1993.

Phillips, L., *Frederick Kiesler*, New York: Whitney Museum of American Art, 1989.

Pierre, J. (ed.), *Tracts surréalistes et déclarations collectives*, Vol. II: *1940–1969*, Paris: Terrain vague, 1982.

Pinder, D., 'Meanders' in S. Harrison, S. Pile, and N. Thrift (eds), *Patterned Ground: Ecologies of Nature and Culture*, London: Reaktion, 2004.

——, 'Utopian Transfiguration: The Other Spaces of New Babylon' in I. Borden and S. McCreery (eds), *New Babylonians*, London: John Wiley and Sons Limited, 2001.

Plato, *Sophist*.

Polano, S., 'Verona – Marcellis, Villa Il Girasole' in *Guide all'architettura italiano del Novecento*, Milano: Electa, 1991.

Poling, C., *Surrealist Vision and Technique*, Atlanta, Ga.: Michael C. Carlos Museum, 1996.

Polizzotti, M., *Revolution of the Mind: The Life of André Breton*, New York: Farrar, Straus and Giroux, 1995.

——, *Revolution of the Mind: The Life of André Breton*, London: Bloomsbury, 1996.

Rajchman, J., *Constructions*, Cambridge, Mass.: MIT Press, 1998.

Rank, O., *The Trauma of Birth*, New York: Dover, 1993.

Ratcliff, C., 'NY Letter' in *Art International* 14, September 1970.

Ray, M., *Photographs*, London: Thames and Hudson, 1982.

Ray, P., *The Surrealist Movement in England*, Ithaca, New York: Cornell University Press, 1971.

Reed, C. (ed.), *Not At Home*, London: Thames and Hudson, 1996.

Reinhardt, A., *Art-as-Art: The Selected Writings of Ad Reinhardt*, ed. Barbara Rose, Berkeley and Los Angeles: University of California Press 1991.

Réja, M., *L'Art chez les fous* [1907], Nice: Z'Editions, 1999.

Remy, M., 'La ville déplacée du surréalisme anglais' in *Les Mots la vie*, no. 6, 1989.

——, 'British Surrealism: Disqualifying Cities' in G. Bonifas (ed.), *Lectures de la ville. The City as Text*, Nice: Faculté des Lettres, 1999.

*Rétrospective Magritte* (exhibition catalogue), Brussels: Palais des Beaux-Arts, 1978.

Richards, J., 'Brasília: Progress Report' in *Architectural Review* 125 (745), February 1959, pp. 94–104.

Ricoeur, P., *De l'interpretation: Essai sur Freud*, Paris: Seuil, 1965.

——, *Oneself As Another*, trans. Kathleen Blarney, Chicago, Ill.: University of Chicago Press, 1992.

Robert, J.-P., 'Cap Malaparte' in *Architecture d'aujourd'hui*, October 1993.

Ropars-Weuilleumier, M.-C., *Ecrire l'espace*, Paris: Presses universitaires de Vincennes, 2002.

Rorty, R., 'Concluding Discussion' in K. Harris and C. Jamme (eds), *Martin Heidegger: Politics, Art, and Technology*, New York and London: Homes and Meier, 1994.

Rossi, A., *A Scientific Autobiography*, trans. Lawrence Venuti, Cambridge, Mass.: MIT Press, 1981.

Roudinesco, E., *Jacques Lacan & Co.: A History of Psychoanalysis in France, 1925–1985*, trans. Jeffrey Mehlman, Chicago, Ill.: Chicago University Press, 1900.

——, *Jacques Lacan*, New York: Columbia University Press, 1997.

Rowe, C. and Koetter, F., *Collage City*, Cambridge, Mass.: MIT Press, 1978.

Rowe, C. and Slutzky, R., 'Transparency: Literal and Phenomenal' in *The Mathematics of the Ideal Villa and Other Essays*, Cambridge, Mass.: MIT Press, 1976, pp. 45–54.

Royle, N., *The Uncanny*, New York: Routledge, 2003.

Rubin, W.S., *Dada, Surrealism, and Their Heritage*, New York: Museum of Modern Art, 1977.

——, (ed.), *'Primitivism' in 20th Century Art*, New York: Museum of Modern Art, 1984.

Ruskin, J., *The Seven Lamps of Architecture*, New York: Dover, 1989.

Sadler, S., *The Situationist City*, Cambridge, Mass.: MIT Press, 1998.

Safran, Y. and Wang, W. (eds), *The Architecture of Adolf Loos*, London: Arts Council, 1985.

Sandercock, L., *Towards Cosmopolis: Planning for Multicultural Cities*, London: Wiley, 1998.

Sartre, J.-P., *The Psychology of the Imagination*, Secaucus, New Jersey: The Citadel Press, 1972.

Savi, V., 'Orphic, Surrealistic: Casa Malaparte in Capri and Adalberto Libera' in *Lotus International* 60, 1988.

*Alberto Savinio*, exhibition catalogue, Milan: Electa, 1972.

*Alberto Savinio*, exhibition catalogue, Ferrara: commune di Ferrara, 5 July–5 October 1980.

Sawin, M., *Surrealism in Exile*, Cambridge, Mass.: MIT Press, 1995.

——, *Roberto Matta, Paintings and Drawings 1937–1959*, Beverly Hills, Calif.: Latin American Masters/México, D.F.: Galería López Quiroga, 1997.

Sayag, A. and Lionel-Marie, A. (eds), *Brassaï: 'No Ordinary Eyes'*, London: Thames and Hudson, 2000.

Schilder, P., *The Image and Appearance of the Human Body*, London, Routledge, 1999.

Schopenhauer, A., *Parerga und Paralipomena III*, Sämtliche Werke, Band V, her. Wolfgang Frhr. von Löhneysen (n.l.: Cotta-Verlag/Insel-Verlag), §§55, 81.

Schotte, J., ' "Héraclite parmi nous" ' in *Existence, crise et création: Henri Maldiney entouré de ses amis*, Fougères, 2001.

Schroder, T., *Changes in Scenery: Contemporary Landscape Architecture in Europe*, Basel: Birkhauser-Publishers for Architecture, 2001.

Scopelliti, P., 'Breton et Tzara collectionneurs' in *Mélusine*, no. 17, 1997.

Scolari, Massimo, *Hypnos*, Cambridge, Mass.: Harvard GSD/Rizzoli, 1986.

Scully, V., *The Earth, the Temple and the Gods*, New Haven, Conn.: Yale University Press, 1979.

Secrest, M., *Salvador Dalí: The Surrealist Jester*, London: Collins, 1988.

Semper, G., *The Four Elements of Architecture and Other Writings*, trans. H. Mallgrave and W. Herrmann, Cambridge: Cambridge University Press, 1989.

Shaw, I., *Short Stories: Five Decades*, New York: Delacorte Press, 1984.

Sherman, D., *The Construction of Memory in Interwar France*, Chicago, Ill.: University of Chicago Press, 1999.

Shlovsky, V., 'Art as technique' in Lemon and Ries (eds), *Russian Formalist Criticism*, Lincoln, Nebr.: University of Nebraska Press, 1965.

Silverman, K., *The Threshold of the Visible World*, New York: Routledge, 1996.

——, *World Spectators*, Stanford, Calif.: Stanford University Press, 2000.

Smith, E., 'Crushed Jewels, Air, Even Laughter' in *Matta in America: Paintings and Drawings of the 1940s*, Chicago, Ill. and New York: Museum of Contemporary Art, 2001.

Smith, R., *Gaston Bachelard*, Boston, Mass.: Twayne Publishers, 1982.

Soby, J., *The Early de Chirico*, New York: Dodd, Mead and Company, 1941.

Solomon, D., *Utopia Parkway: The Life and Work of Joseph Cornell*, New York: Farrar, Straus and Giroux, 1997.

Sontag, S., *On Photography*, London: Allen Lane, 1978.

Sonzogni, V., 'Correspondence Frederick Kiesler–Tristan Tzara in the Bibliotheque Littéraire Jacques Doucet' in the Kiesler Private Foundation Archive, Vienna.

Sorkin, M., *Exquisite Corpse: Writings on Buildings*, London and New York: Verso, 1994.

Spiller, N., 'Architectural Education and Critical Paranoia' in *Architectural Design*, 71 (1), February 2001, pp. 60–65.

Spiteri, R., 'Surrealism and the Political Physiognomy of the Marvelous' in R. Spiteri and D. LaCoss (eds), *Surrealism, Politics and Culture*, Aldershot: Ashgate, 2003.

Srp, K. (ed.), *Karel Teige 1900–1951*, Prague: Galerie Hlavního Mesta Prahy, 1994.

——, *Karel Teige*, Prague: Torst, 2001.

Stafford, B., *Visual Analogy: Consciousness as the Art of Connecting*, Cambridge, Mass.: MIT Press, 1999.

Starr, S., *Joseph Cornell: Art and Metaphysics*, New York: Castelli, Feigen, Corcoran, 1982.

Stechow, W., *Apollo und Daphne*, Studien der Bibliothek Warburg herausgegeben von Fritz Saxl, vol. XXIII, Leipzig and Berlin: B.G. Teubner, 1932, reprinted 1965.

Stich, S., *Anxious Visions: Surrealist Art*, Berkeley, Calif.: University Art Museum, 1990.

Stoekl, A., 'The Death of Acéphale and the Will to Change: Nietzsche in the Text of Bataille' in *Glyph*, no. 6, 1979.

——, (ed.), 'On Bataille' in special issue of *Yale French Studies*, 1990.

——, (ed.), *On Bataille*, New Haven, Conn.: Yale University Press, 1990.

Stoeltie, B., 'After Magritte' in *The World of Interiors*, April 1986, pp. 142–149.

Stone-Richards, M., 'Encirclements: Silence in the Construction of Nadja' in *Modernism/Modernity*, 8 (1), January 2001, pp. 127–157.

——, 'Failure and Community: Preliminary Questions on the Political in the Culture of Surrealism' in R. Spiteri and D. LaCoss (eds), *Surrealism, Politics and Culture*, Aldershot: Ashgate, 2003.

Subotincic, N., 'Anaesthetic Induction: An Excursion into the World of Visual Indifference' in *Chora* 1994, vol. 1, pp. 217–272.

Suleiman, S., 'Between the Street and the Salon: The Dilemma of Surrealist Politics in the 1930s', in L. Taylor (ed.), *Visualising Theory: Selected Essays from V.A.R. 1990–1994*, London: Routledge, 1994.

Sullivan, C., *Drawing the Landscape* (2nd edition), New York: John Wiley and Sons, 1997.

Surya, M., *Georges Battaile, An Intellectual Biography*, London and New York: Verso, 2002.

Sutter, L., 'L'Inconnu de la Soixantaine' in *Minotaure* 9, October 1936, pp. 62–65.

Svácha, R., 'Surrealismus a architektura' in L. Bydzovská and K. Srp (eds), *Cesky surrealismus 1929–1953*, Prague: Argo/Galerie hlavního mesta Prahy, 1996.

Sylvester, D., *Magritte*, London: Thames and Hudson, 1992.

Tafuri, M., *Architecture and Utopia: Design and Capitalist Development*, Cambridge, Mass.: MIT Press, 1976.

Tafuri, M. and F. Dal Co, *Modern Architecture*, vols. 1–2, trans. Robert Wolf, New York: Rizzoli, 1976.

——, ' "*Machine et memoire*": The City in the Work of Le Corbusier' in H. Brooks (ed.), *Le Corbusier*, Princeton, New Jersey: Princeton University Press, 1987.

——, *The Sphere and the Labyrinth: Avant-Gardes and Architecture from Piranesi to the 1970s*, Cambridge, Mass.: MIT Press, 1990.

Talamona, M., 'The Casa Malaparte and the Capo Massullo' in *Daidalos* 63, March, 1997.

——, *Casa Malaparte*, New York: Princeton Architectural Press, 1992.

Tashjian, D., *A Boatload of Madmen: Surrealism and the American Avant-Garde, 1920–1950*, New York: Thames and Hudson, 1995.

Taylor, L. (ed.), *Visualising Theory: Selected Essays from V.A.R. 1990–1994*, London: Routledge, 1994.

Temkin, A., 'Habitat for a Dossier' in S. Davidson (ed.), *Joseph Cornell/Marcel Duchamp . . . in Resonance*, Ostfildern-Ruit, Germany: Hatje Cantz Publishers, 1999.

Tester, K. (ed.), *The Flâneur*, London: Routledge, 1994.

Thibaudet, A., *La Poésie de Stéphane Mallarmé*, Paris: Gallimard, Éditions de la Nouvelle revue française, 1926.

Thirion, A., *Revolutionaries Without Revolution*, London: Cassell, 1975.

Tolmein, G., *Die Villa Malaparte*, Hamburg: Häuser, 1984.

Tournikiotis, P., *The Historiography of Modern Architecture*, Cambridge, Mass.: MIT Press, 1999.

Treib, M., (ed.), *Modern Landscape Architecture: A Critical Review*, Cambridge, Mass.: MIT Press, 1998.

Tschumi, B., 'Architecture and its Double' in D. Vesely (ed.), *Architectural Design Profiles 11*, nos. 2–3, 1978.

——, 'Manifesto 3' in B. Tschumi, *Architectural Manifestoes*, London: AA Press, 1979.

——, *Cinegram folie: Le parc de la Villette*, New York: Princeton Architectural Press, 1987.

——, *Architecture and Disjunction*, Cambridge, Mass.: MIT Press, 1994.

Tsiomis, Y. and Rolin, J., 'Brasília' in *L'Architecture d'aujourd'hui* 313, October 1997, pp. 76–87.

Turner, J. (ed.), *The Dictionary of Art*, New York: Macmillan, 1996.

Tzara, T., 'D'un certain automatisme du goût' in *Minotaure*, nos. 3–4, 1933.

Underwood, D., *Oscar Niemeyer and Brazilian Free-Form Modernism*, New York: Braziller, 1994.

——, *Oscar Niemeyer and the Architecture of Brazil*, New York: Rizzoli, 1994.

Utzeri, F., *Oscar Niemeyer: o Arquitecto do Século. Entrevista a Fritz Utzeri*, Rio de Janeiro: Fundação Oscar Niemeyer, 2001.

Valency, M., *The End of the World*, New York: Schocken, 1983.

Valéry, P., 'Idée Fixe: A Duologue by the Sea', trans. David Paul, in P. Valéry, *Collected Works of Paul Valéry*, Vol. 5, New York: Bollingen Foundation, 1965.

Van Valkenburgh, M. (ed.), *Transforming the American Garden: 12 New Landscape Designs*, Cambridge, Mass.: Harvard University Graduate School of Design, 1986.

Vegliani, F., *Malaparte*, Milan: Edizioni Daria Guarnati, 1957.

Venturi, R., *Complexity and Contradiction in Architecture*, New York: Museum of Modern Art, 1994.

Verene, D., *Vico's Science of the Imagination*, Ithaca, New York: Cornell University Press, 1981.

Vesely, D. (ed.), *Architectural Design Profiles 11*, nos. 2–3, 1978.

Vidler, A., 'The Building in Pain' in *AA Files*, no. 19, Spring 1990, pp. 3–11.

Vidler, A., *The Architectural Uncanny: Essays in the Modern Unhomely*, Cambridge, Mass.: MIT Press, 1992.

Vitruvius, *The Ten Books of Architecture*, trans. Morris Hicky Morgan, New York: Dover, 1960.

von Moos, S., 'The Politics of the Open Hand: Notes on Le Corbusier and Nehru at Chandigarh' in R. Walden (ed.), *The Open Hand, Essays on Le Corbusier*, Cambridge, Mass.: MIT Press, 1977.

## Bibliography

Vovelle, J., *Le Surréalisme en Belgique*, Brussels: De Rache, 1972.
——, 'Utopie et Surréalisme: Éros et "Les Architectes"' in R. Barbanti and C. Fagnart (eds),
    *L'Art au XXe siècle et L'Utopia*, Paris: L'Harmattan, 2000.

Waldberg, P., *Surrealism*, London: Thames and Hudson, 1965.
Waldman, D., *Joseph Cornell: Master of Dreams*, New York: Harry N. Abrams, 2002.
Walker, P. and Simo, M., *Invisible Gardens: The Search for Modernism in the American
    Landscape*, Cambridge, Mass.: MIT Press, 1994.
Wallace-Hadrill, A., *Houses and Society in Pompeii and Herculaneum*, Princeton, New Jersey:
    Princeton University Press, 1994.
Ward, G., *Cities of God*, London and New York: Routledge, 2000.
Weigel, S., *Body- and Image-Space: Re-reading Walter Benjamin*, London: Routledge, 1996.
Weston, D., 'Surrealist Paris: The Non-Perspectival Space of the Lived City' in A. Perez-Gomez,
    *Chora* vol. 2, 1996, pp. 149–178.
Wigley, M., 'Untitled: The Housing of Gender' *Sexuality and Space*, ed. B. Colomina, New York:
    Princeton Architectural Press, 1992, pp. 327–389.
——, *The Architecture of Deconstruction: Derrida's Haunt*, Cambridge, Mass.: MIT Press, 1993.
Wilde, O., 'The Decay of Lying' in O. Wilde, *The Complete Works of Oscar Wilde*. Vol. V:
    *Intentions*, Garden City, New York: Doubleday, Page and Co., 1923.
Williams, T., 'The House that Turns to the Sun' in *House and Garden*, February 1987,
    pp. 150–157.
Wilson, E., *Adorned in Dreams, Fashion and Modernity*, London: Virago Press, 1985.
Wittgenstein, L., *Culture and Value*, trans. P. Winch, Oxford: Basil Blackwell, 1980.
Wolin, R., *Walter Benjamin: An Aesthetic of Redemption*, New York: Columbia University Press,
    1982.
Wood, J., *The Origin of Building or Heathen Lies Exposed*, Bath, 1742.
Wright, C. and Turkienicz, B., 'Brasília and the Ageing of Modernism' in *Cities* 4, November
    1998, pp. 347–364.

# Index

Italic page numbers indicate figures and illustrations not included in the text page range.
References to notes are prefixed by 'n'.